Figure Drawing

FOR

DUMMIES®

by Kensuke Okabayashi

WILEY

Wiley Publishing, Inc.

Figure Drawing For Dummies®

Published by
Wiley Publishing, Inc.
111 River St.
Hoboken, NJ 07030-5774
www.wiley.com

WILEY

About the Author

Kensuke Okabayashi is a professional freelance illustrator/sequential artist. Born and raised in Princeton, New Jersey, Kensuke has been inspired by classic illustrators such as Harvey Dunn, Dean Cornwell, J.C. Leyendecker, and Charles Dana Gibson.

After studying music and psychology at Wheaton College in Illinois, Kensuke shifted his focus from playing the piano to honing his art skills. He earned his BFA in Illustration at the School of Visual Arts in New York City after studying traditional painting and further developing his drawing skills. Upon graduating, he began picking up illustration and storyboard clients, including LG Electronics Worldwide, Wendy's, Diet Coke, Nestlé, Camel, Canon Digital, Saatchi & Saatchi, Absolut Vodka, Marvel Comics, and Anheuser-Busch.

Kensuke also actively illustrates for mainstream entertainment industry clients, such as Wizards of the Coast, Takara Toys U.S.A., Nickelodeon, Kensington Books, Skyzone Entertainment, Loew-Cornell, Wiley Publishing, Inc., and Jossey-Bass.

Inspired by his experience of working long hours at a well-known coffee shop corporation, Kensuke developed and illustrated his creator-owned graphic novel *JAVA!*, which attracted attention and was picked up by Committed Comics. His main character, Java (a high-powered caffeine girl who fights crime), received positive reviews from major book review sites as well as from readers and distributors. Kensuke's first written and illustrated title in the *For Dummies* series, *Manga For Dummies,* is currently translated into French and German and marketed internationally. His most recent illustrated graphic novel, *The Five Dysfunctions of a Team (Manga Edition),* is based on the New York Times Best-Seller by Patrick M. Lencioni and is currently being released internationally through Jossey-Bass. His upcoming publication projects include Arcana Publishing and Archaia Studio Press.

Kensuke's illustrated juried works have also been exhibited in the Society of Illustrators in New York City as well as Mercer's Artist Showcase in New Jersey.

On the side, Kensuke continues to draw from life and teach art. He taught illustration courses at Mercer College of New Jersey for several years. When he's not drawing or painting at his studio loft in Kearny, New Jersey, Kensuke still enjoys playing the piano from time to time and socializing at coffee shops during late nights in the city. He still draws from live models on weekends in Soho and Brooklyn and gives live demonstration events at the Brooklyn Museum in New York. You can see Kensuke's online portfolios at his Web sites, www.piggybackstudios.com and www.javacomics.com.

Dedication

This book is dedicated to my brothers, Yusuke and Saichan, for their love and support. We all have such different talents and personalities, yet we complement each other nicely.

Author's Acknowledgments

I wish to thank the staff at Wiley Publishing. I would like to thank my acquisitions editor, Michael Lewis, my project editor, Georgette Beatty, and my copy editors, Sarah Faulkner and Megan Knoll, for all their hard work, advice, and support while I was writing this book. I want to thank the composition department for taking care of the large amount of artwork throughout this book. In addition, I want to thank Professor James R.C. Adams at Manchester College for his role as technical editor. My biggest thanks goes to my family, Michio, Sahoko, Yusuke, and Saichan, who have been my greatest supporters and fans. None of this would have been remotely possible without their help. Thank you and God bless you!

Publisher's Acknowledgments

We're proud of this book; please send us your comments through our Dummies online registration form located at www.dummies.com/register/.

Some of the people who helped bring this book to market include the following:

Acquisitions, Editorial, and Media Development

Senior Project Editor: Georgette Beatty

Acquisitions Editor: Michael Lewis

Senior Copy Editor: Sarah Faulkner

Assistant Editor: Erin Calligan Mooney

Editorial Program Cordinator: Joe Niesen

Technical Editor: James R.C. Adams

Editorial Manager: Michelle Hacker

Editorial Assistant: Jennette ElNaggar

Cover Photo: Kensuke Okabayashi

Cartoons: Rich Tennant (www.the5thwave.com)

Composition Services

Project Coordinator: Lynsey Stanford

Layout and Graphics: Carl Byers, Reuben W. Davis, Melissa K. Jester, Brent Savage, Christin Swinford, Christine Williams

Proofreader: Shannon Ramsey

Indexer: Sharon Shock

Special Help Megan Knoll

Publishing and Editorial for Consumer Dummies

Diane Graves Steele, Vice President and Publisher, Consumer Dummies

Kristin Ferguson-Wagstaffe, Product Development Director, Consumer Dummies

Ensley Eikenburg, Associate Publisher, Travel

Kelly Regan, Editorial Director, Travel

Publishing for Technology Dummies

Andy Cummings, Vice President and Publisher, Dummies Technology/General User

Composition Services

Gerry Fahey, Vice President of Production Services

Debbie Stailey, Director of Composition Services

Contents at a Glance

Table of Contents

Introduction

In today's fast-paced society, where days and weeks seem to rush by more quickly than ever, it seems the only time we stop to appreciate our amazingly constructed figures is at 6 a.m. when we look in the mirror to brush our teeth or apply makeup. Most people aren't even in touch with what their bodies look like (especially the backside). Our bodies, which come in all shapes and sizes, are complex and wonderfully crafted works of art that deserve more attention.

Figure-drawing students approach me on the first day of class claiming they can draw only stick figures, but most gain two things by the end of the first session. One: they realize how beautiful yet complex the body is. Two: they realize not only how talented they are, but also how fun it is to apply their skills to drawing the human figure. Whether you're an art student, a professional illustrator wanting to brush up on your figure-drawing skills, or just someone who likes to doodle and wants some guidance on drawing the figure, *Figure Drawing For Dummies* is a great place to start.

About This Book

Because so many figure drawing books are out there, it's important that I distinguish this book by declaring what it's *not*. *Figure Drawing For Dummies* is *not* an anatomy book crammed with detailed drawings of each and every muscle fiber in the human body. In my opinion, basic anatomy is important for understanding the overall surface structure of the figure, but completing a fulfilling drawing of the figure doesn't require the knowledge of a surgeon (nor should it). The purpose of this book is to present the art of drawing the human figure to beginning art students in a way that hones your knowledge of theories and techniques, and also encourages the development of your observational skills. As a beloved instructor at art school mentioned to me one day, "The drawing is not up there [pointing to the posing model] but down here [pointing to my drawing pad]." Throughout this book, my focus is to provide just enough basic knowledge and theory on the figure so you become excited about recording your reaction to what's happening up on the model stand.

All tips, advice, and drawings that I provide are based on my own experience, both as a professional illustrator/sequential artist and as a former art student. I designed this book to take you through various techniques on figure drawing. As you become familiar with anatomy and your drawing medium, you may want to combine different elements to come up with your own individual style.

Throughout this book, I cover a variety of popular topics, and you can pick and choose what you want to read at any time. You don't have to read this book from cover to cover if you don't want to (but I won't mind if you do!). I introduce basic drawing materials (including some of my personal favorites) and drawing techniques to get you started. In addition to describing the body's basic proportion and anatomy from head to toe, I give you helpful visual and sketching exercises. I wrap up by showing you how to sharpen your skills with advanced techniques, composition, and perspective.

Conventions Used in This Book

I use a few conventions to help you navigate this book more easily:

- ✔ Numbered steps and keywords appear in **boldface.**
- ✔ Whenever I introduce a new term, I *italicize* it and define it.
- ✔ Web sites and e-mail addresses appear in `monofont` to help them stand out.
- ✔ When this book was printed, some Web addresses may have needed to break across two lines of text. If that happened, rest assured that I haven't put in any extra characters (such as hyphens) to indicate the break. So, when using one of these Web addresses, just type in exactly what you see in this book, pretending as though the line break doesn't exist.

What You're Not to Read

I didn't spend hours upon hours writing this book and drawing all the illustrations because I want you to skip over them. However, to be honest, you can skip over certain elements in this book and still get the gist of what's being covered. The sidebars (the gray boxes) contain information that's interesting yet nonessential, so if you're pressed for time or just not into anything that isn't essential, feel free to skip them. You won't hurt my feelings (much).

Foolish Assumptions

When I sat down to write this book, I made a few assumptions about you, dear reader. This book is for you if

- ✔ You enjoy spending time looking at figure drawings and paintings at art museums.
- ✔ You're curious about the figure and how it moves.
- ✔ You like doodling on your own (hopefully not caricatures of your professor during class like I once did).
- ✔ You want to learn how to draw faces so you can do portraits.
- ✔ You're a beginning art student looking to develop your figure-drawing skills outside of class.
- ✔ You're a graphic artist who wants to hone your drawing skills away from the computer.
- ✔ You've always wanted to learn to draw the figure but were put off by those thick anatomy drawing books!

How This Book Is Organized

This book is broken up into five different parts. Following is a summary of each of these parts so that you can decide what appeals to you.

Part I: Figure Drawing 101

Think of this part as your first day in a class for your favorite subject. This part tells you what tools you need to start drawing the figure and includes some basic drawing exercises to get your brain and your hand moving.

Part II: Off to a Head Start

Here I show you how to draw the essential components of the head and its facial features (eyes, ears, nose, and mouth). I devote the entire part to the muscle structure behind the facial features and how to form various types of facial expressions. In addition, I go over basic hairstyles (I wouldn't want to leave you stranded over that issue!).

Part III: Building the Body

This part covers the basic proportion and anatomy of the human figure. I introduce you to drawing stick figures and mannequins, and I break down the figure's muscle structure. In addition, I go over various action poses.

Part IV: Sharpening Your Figure-Drawing Skills

Ready to take your figure drawing to a higher level? In this part, I cover various types of clothing and shoes. I also provide advanced shading techniques, fun drawing exercises, and basic perspective tips and tricks that give a more realistic, three-dimensional look to your figure drawings. In addition, I share composition templates that add narrative to your figures' poses.

Part V: The Part of Tens

In this part, I share various tips based on personal experiences. Here I list ten places to study and draw the figure. In addition, I present ten ways to organize, store, and present your figure drawings. You can use the tips in this part as a starting list, which you can modify or build upon to suit your needs.

Icons Used in This Book

Throughout this book, you see various icons in the left margins. These icons serve as flags to draw your attention to important or helpful information. Each specific icon carries its own meaning, as listed here:

As you may have guessed, this icon points out concepts or other information that you don't want to forget.

When you see this icon, get out your pencil, open your sketchbook, and get ready to spend some quality time drawing. These exercises will help you improve your drawing skills.

Look for this icon to provide you with helpful tricks and shortcuts to make your figure-drawing life easier.

If you need some help getting the creative juices flowing, seek out this icon.

This icon alerts you to various mistakes and pitfalls that you want to avoid.

Where to Go from Here

Based on your interests, you can visit chapters in any order, and you'll find that each section takes you step by step through accomplishing an objective. If you have drawing experience, the beauty of this format is that you can select whichever topic you want to know more about and dive into it. However, if you're new to figure drawing or don't have any prior drawing experience, I recommend starting with Part I and working your way through this book in order. Even if you're an experienced artist but new to figure drawing, brushing up on the basics by starting with Part I isn't a bad idea; then you can choose the section you're interested in.

Regardless of where you start, I recommend reading all the way through the chapter you choose before sitting down at the drawing table and working through its steps. Give yourself time to first digest the basic proportions and basic muscle shapes (as I show you, these shapes are deceivingly sophisticated, but you don't need to learn every single anatomical detail).

Finally, I can't stress enough the importance of attending live figure-drawing sessions where you can apply these chapters to a live model. Even with a busy schedule, I do my best to attend a figure-drawing session every Saturday morning. To find a live drawing session in your area, check your+ local academic institution's art department, a local art council organization, or search online.

Part I
Figure Drawing 101

The 5th Wave By Rich Tennant

"I painted still-lifes for a long time, but I'm slowly getting into figure drawing."

In this part . . .

Welcome to Figure Drawing 101! Whether you're drawing the human form for the first time or you're a serious artist looking to hone your figure-drawing skills, this part is designed to get you started off on the right foot. No matter your background, you're in for an awesome ride.

In this part, you get up to speed on rounding up the necessary drawing materials so you can get started on basic drawing principles and techniques. Throughout this part, you try some basic drawing exercises that are designed not only to loosen your wrist, but also to help you become familiar with the tools. You can think of them as warm-up exercises.

If you're ready, turn the page and prepare to discover the world of figure drawing!

Chapter 1

Welcome to the Joys of Figure Drawing

People surround you on a daily basis (unless you're on a deserted island), yet the art of figure drawing remains full of puzzles and surprises. As someone who draws the figure, your mission (should you choose to accept it!) is to record your reaction to a figure's pose or action.

Whether you're a beginner who's new to drawing the human figure or a serious art student looking to hone your figure-drawing skills, you're in good hands. In this chapter, I introduce you to the fundamentals of figure drawing, including the materials and techniques you need. Sharpen your pencil, get out your sketchbook, and get ready to draw!

Finding the Right Drawing Materials

Like using the correct eating utensil at the dinner table, finding the right materials for figure drawing is important. Why? Nothing is more frustrating than trying to get a certain line quality (such as the fine line of an eyelid) when you have the wrong tool (like, in this instance, a thick charcoal stick).

In Chapter 2, I provide a list of drawing materials for your consideration. Although you don't need to buy all the materials I list there at once, start off by visiting your local art store and trying out some pencils. I recommend starting with softer pencils, such as the Faber-Castell 9000 8B. Depending on how much time you have to draw, you may want to get at least five. In addition, I recommend bringing an 18-x-24-inch sketchpad to your figure-drawing class; it's large enough to let you experiment with drawing various sizes, and it also gives the instructor enough space to make notes or drawing corrections on the side of your figure drawings.

If you're new to drawing the figure, don't worry about splurging on fancy equipment at first. However, make sure your working area is well lit so your eyes aren't strained. I notice many students are used to working in dimly lit situations (perhaps due to the habit of working with computer monitors). Depending on how many hours you work, strain on the eyes can lead to irritation and possible damage in the long run. In my case, I set up two lights on my desktop surface. Check out Chapter 2 for full details on setting up a drawing studio.

Getting a Grip on Drawing Basics

Before you dive into drawing the figure, you need to warm up your drawing muscles. Flip to the exercises in Chapter 3, which are simple and fun to do; in addition to serving the purpose of loosening up your wrist, you're also training your hand to become more familiar with using your drawing tools. Here's what you can expect:

- ✔ I start with exercises on lines, curves, and basic geometric shapes.

- ✔ I introduce basic principles of lights and shadows. By changing the light source, you change the narrative mood of the figure.

- ✔ The types of hatching and other shading techniques that I apply to the figure enhance the illusion of a three-dimensional object "popping" off a two-dimensional flat surface.

- ✔ Part of what makes figure drawing so spontaneous is that you don't have to completely erase the lines that may appear to be errant. I demonstrate tips you can use with or without your kneaded eraser.

Drawing the Head

No part of the human figure draws more attention than the head. It's the area we use to recognize one another. The features that incorporate all five senses are also located on the head. In Part II, I give you a heads-up on the following topics:

- ✔ **The head's basic shape:** In its most simple form, the basic head shape is essentially a spherical object that at first glance looks like an egg. As the figure matures from infancy to adulthood, the bone structures adjust to the growing proportion of the body in part by fusing together. In Chapter 4, I walk you through different techniques for drawing the basic shape of the head at different ages and from different views.

- ✔ **Facial features:** When you examine the head more closely, you'll find that it consists of a series of complex interlocking bones covered with cartilage for the nose and ears and multiple layers of muscle groups that control the movements of the jaw and mouth. And don't forget the eyes! I explain how to draw all these features realistically in Chapter 5.

- ✔ **Hair:** Although hair consists of hundreds of individual stands, they cluster together in an organized fashion to form waves and curls (or they simply cascade down like a waterfall). In Chapter 6, I walk you through exercises that explore using different textures to add realism to the hairstyles and types without worrying about drawing every single strand (that's an in-hair-ently insane task).

- ✔ **Facial expressions:** Our facial muscle structure is literally skin deep! Just the slightest twitch or reaction gives away the most subtle thought going through the mind (I, for one, have a terrible poker face!). However, these nuances make the face the center of attention in most figure studies. In Chapter 7, I describe the muscle structure of the face and give you pointers on drawing a wide variety of facial expressions.

Putting Together the Body

Creating and piecing together the body is similar to a putting together a jigsaw puzzle or playing a satisfying game of Tetris. Individual shapes snap together to form a larger shape. Check out the following topics in Part III, which is all about building the body:

- ✔ **Bone structure, shape, and proportion:** Understanding the basic proportion of the human figure helps the artist not only measure the head-to-body ratio, but also establish how large or small other figures need to be drawn in situations in which you can see more than one figure. Learning every bone structure of the body isn't important for understanding the overall structure. Rather, identifying certain "landmark" points, where the bones and joints protrude out of the body, is more essential. Chapter 8 explains what you need to know about bones, shape, and proportion.

- ✔ **Assembling a stick figure:** Resist the urge to think of the stick figure in Chapter 9 as a crutch or symbolic substitute for drawing the human figure (like a hangman). Sculptors create a stick figure (commonly referred to as *armatures*) out of wire as a base around which they build the figure form. In Chapter 9, I also demonstrate how to use the stick figure as a basis to draw and build basic geometric body shapes.

- ✔ **Muscles:** If you thought the number of bones in the figure was mind-boggling, check out just how intricate the muscle groups are in Chapter 10. My objective there is to group the smaller shapes of muscles into larger shapes.

- ✔ **Depicting the body in motion:** Regardless of how accurately you draw the figure in a still pose, applying body rhythm and motion is what distinguishes your figure from a stiff mannequin. In Chapter 11, I explain how to draw realistic figures with movement.

Advancing Your Drawing Skills

In Part IV you go through exercises that address the clothed figure, other fun drawing techniques, composition, and perspective. These exercises are designed to jazz up your figure drawing based on the basic fundamentals you discover earlier in this book. Read on for more detail:

- ✔ **Clothing your figures:** Becoming familiar with the clothed figure is important, because some fabric shapes not only simplify the complex anatomy, but also help you see how to draw the figure by using different shapes. In addition, the wrinkles and folds that run along the joints, limbs, and torso of the body help you understand the rhythmic flow and energy in a pose. In Chapter 12, I go over various types of clothing from the loose comfortable sweatshirts to the tighter jeans. In addition, I cover how to draw footwear (ranging from waterproof boots to open air sandals).

- ✔ **Experimenting with fun drawing techniques:** Chapter 13 incorporates various drawing exercises that provide not only a change of pace but also the opportunity to hone your hand-eye coordination. These exercises include contour and cross-contour drawings in which you observe and draw the model without looking down at the paper. In

addition, I provide tips on varying the edges and shading of your drawings, and I get you started with building a photo reference library.

✔ **Applying composition and perspective:** Regardless of how well you execute the figure drawing, it needs a frame of reference (where the model is situated in relation to the page). In Chapter 14, I present several basic templates that help plan the positioning of the model (otherwise known as composition). In addition, I go over basic perspective principles (one-point, two-point, and three-point perspectives). Perspective in figure drawing is the art of creating the illusion of three-dimensional figures in a believable environment by using the horizon line, vanishing point, and perspective guidelines to determine which body parts need to be drawn a certain size or position in relation to the others.

Chapter 2

Gathering the Goods for Figure Drawing

● ●

In This Chapter

▶ Buying what you need without going broke

▶ Checking out different drawing supplies

▶ Setting up a studio

▶ Drawing on the go

● ●

For me, stepping into my local art supply store is like reliving my childhood memories of stepping into a giant toy store — so many materials, each with its own unique characteristics and usage. Even coming prepared with my "to-buy" list, I still find myself wandering around picking up new drawing materials I have yet to try.

In this chapter, I list basic art supplies that are great for drawing the figure. If you plan on taking a figure-drawing class, these materials are excellent to take with you on your first day. Be careful, though; buy only the necessities for your budget, skill level, and interest in figure drawing. You can always buy more supplies later! I also explain how to set up a studio (in your home or another indoor space) and what to pack when you're drawing on the go.

Buying Supplies without Breaking the Bank

Despite all those stockpiles of paints, canvases, brushes, turpentine, and so on at the art store, the basic materials you need to start drawing the figure are only a pencil and paper. But wait, the good news doesn't stop there! Unlike paints and brushes, whose costs can add up to hundreds of dollars, a basic assortment of drawing tools is pretty inexpensive.

If you're currently in a figure-drawing session, you don't need to purchase all the materials I describe in this chapter (getting the in-class recommended supplies is sufficient). You can always come back to this chapter for additional supplies when you want to try a different type of medium.

The following list provides some facts of life that may affect a professional or student artist's spending habits:

⮑ **Growing pains:** When you're first starting out, you may stick with paper, a few different pencils, an eraser, and a couple of other basic tools. As your individual figure-drawing style/skills advance, however, you may find the pencils you once liked no longer suit your needs. You may need to bite the bullet and buy new pencils or other supplies you've outgrown.

✔ **Consistency issues:** Although you like to think that the certain brand of paper you're buying today is the same exact quality as the one you bought last week, that's not always the case. You don't want to be stuck with a stack of paper that's subpar. So, be prepared to restock supplies that turn out to be of lower quality than you want.

✔ **Accountability:** Simply buying more doesn't necessarily make me more accountable for my belongings. In fact, from past experience I find it makes me even more carefree. Looking back, I realize that if I'd been more careful with the supplies I had, I could've spent my money on newer/fancier materials instead of spending it to replace the basic stuff I lost. When you buy fewer supplies, you value them more. That's one incentive for sticking to a tight budget!

✔ **Referrals:** Most of the materials I currently use have been referred to me by other artists and colleagues. Make sure you leave some room in your drawing bin for fresh recommendations — after you've been drawing for a while, set aside a little spending money so you can experiment with new supplies.

✔ **Overdependence:** Sad, but true — some brands simply go out of business (it's a tough, competitive market). You don't want to become too reliant on a single brand and not know how to adapt to products from a different brand when your favorite product is gone. Be prepared to spend more money to replace a discontinued brand you love; you're in luck if you find replacements that cost less than the originals!

✔ **Intimidation:** When selecting paper as an art student, I remember feeling intimidated by trying out new techniques on expensive paper, such as thick-ply Bristol. Although setting the good paper aside and using the cheaper drawing paper for experimentation is wise, sometimes your experiments will work best with thicker, better-quality paper (newsprint, for example, can't withstand water or strong pressure from drawing pencils unless the lead is soft). I recommend having a small "experiment" pad set aside specifically for these purposes (8-x-10-inch smooth Bristol will suffice).

Be careful, especially with newsprint brands, whose quality deteriorates over the course of a short period of time (as early as just a few days!).

Surveying the Wide World of Drawing Supplies

Are you ready to shop for drawing supplies? Before you walk out the door, remember this fact: You don't want to blindly invest all your art-supply cash on drawing items you may use only once or twice, only to realize you don't like them after all. This is especially true if you plan on buying material online, where you don't have the opportunity to even try a medium on the sample sheets that are usually provided upon request at the art store. After you try different materials and know what you like, feel free to buy online; try www.pearlpaint.com, www.utrechtart.com, www.dickblick.com, or www.fineartstore.com. Just make sure you have a good idea of what you need and what you like before you set out. In the following sections, I describe a variety of supplies that are useful in figure drawing.

If you don't live near an art store, online resources are an excellent option, but don't totally count out the office-supply stores. Although the quality and selection of materials are limited when compared with art stores, you can find such items as plastic erasers, sharpeners, mechanical pencils, and markers that are also found in art stores.

Most art supply stores are pretty fussy when it comes to returning art materials. Some stores don't give refunds on items like portfolio cases or opened sets of pencils. If you buy a drawing pad and draw as much as a single line on one of the sheets, you won't get a refund. However, most stores have no problem giving you a full refund or exchange if a product is still sealed in the original condition you bought it in (just make sure you don't lose the receipt!).

Paper

If you're walking through the paper aisle of the art store for the first time, you can easily become overwhelmed by the vast selections. When selecting your drawing paper, consider a few general issues:

✔ You need to choose between individual sheets of paper and drawing pads.

✔ You need to make sure you select the appropriate size of drawing paper.

✔ You want to be selective with the weights and textures of paper that you work on.

I explain what you need to know in the following sections.

Individual sheets versus drawing pads

Most stores offer paper in individual sheets, but I find that these products are usually specialty papers that are not only more expensive, but also large (up to a whopping 23 x 29 inches) and cumbersome to carry out of the store. You can have a store employee cut them down to a specified size, but that's really not worth the effort or cost (talk about a nasty pay-per cut)! For this reason, I buy my drawing paper in pads. The pads are cheaper and easier to store and organize in my drawing archives cabinet. (I discuss archiving supplies later in this chapter.) Most pads come with a strong cardboard backing and a thick front paper jacket, which protects your drawing of the day.

As you develop your figure-drawing skills, you may want to try a certain quality of drawing paper that's sold only in individual sheets. When you do, ask the store staff to roll and wrap the sheet of paper so it isn't damaged on your way back to the studio. If you don't have immediate plans to use the paper, unroll it and store it flat (few things are more frustrating than trying to draw on paper that curls up on your hand like a Venus' flytrap). And don't waste the wrapping paper; use it for sketches!

If you desperately want to test a sheet of paper from a drawing pad, talk to the store manager or an employee. Stores usually have a small test pad set aside for customers to scribble on before committing to purchasing the entire pad.

All sizes large and small

Drawing paper comes in all sizes. It can start as small as 2 x 3 inches and go larger than 18 x 24 inches. If you're preparing to take a figure-drawing class at an art school, you need to get an 18-x-24-inch drawing pad. This size is ideal for a class/instructional setting where you can place a single large figure on the paper or draw multiple smaller figures on the same page. It's also large enough for instructors to provide useful instruction during class critiques. If the pad is too small, your figure drawing is difficult to see, and the size doesn't allow you to go into as much detail as you want.

Personally, having the extra real estate on my drawing pad was essential when I was in art school because my figure-drawing instructor could use that space to draw and give demonstrations as he was making his rounds through the classroom. Currently, I require my students to bring the larger 18-x-24-inch drawing pads because I use a thick red marker or charcoal stick to provide instruction.

In addition to having an 18-x-24-inch drawing pad, I carry smaller 5-x-7-inch and 8-x-10-inch artist sketchbooks with me whenever I'm away from my studio. They're small enough that I can stuff them in my messenger bag and take them out to draw the people around me when I'm in public. If you decide to buy smaller sketchbooks for drawing outside the classroom or away from your studio, make sure these booklets have a thick, hard cover on both sides so that your drawings don't get damaged from being tossed around in your bag during transit. Although these pads cost more than the cheaper cardstock paper, they're definitely worth the price.

If you're wondering what size is "too small," measure with the size of your hand. If the pad is smaller than your hand, you may want to choose a larger pad.

Weights and textures

Not all paper types are created equal. Witness these differences:

- Papers that have a heavier ply are higher quality and more expensive. *Ply* refers to a single layer of paper material that's then stacked on top of another to create a thicker sheet of paper; you measure ply by the total number of layers of paper material that are stacked together. The average ply for drawing paper is three ply. Higher quality paper can be as thick as five ply.

- Although losing weight is often considered a good thing, packing on the pounds carries a lot of weight when it comes to choosing drawing paper. Paper comes packaged in stacks, or *reams,* which usually consist of 500 pieces of paper. Generally, the more pounds each ream of 500 sheets weighs, the higher the density and the thickness of the paper (which is measured in *caliper* micrometers).

- The texture of the surface varies from smooth to rough. The rougher the texture is, the more *tooth* the paper has. Here are the pros and cons of the surface textures:

 - Papers with smooth surfaces are great for rendering detailed drawings with very fine gradations between dark to light values. If you're using a very fine lead mechanical pencil, for example, papers with a smooth texture give you better control over making details, such as the pupils of the eyes and details of the lips. On the other hand, the smooth surfaces of certain brands feel waxy and are often difficult to blend with your fingers after you apply the medium, because the smooth surface of the paper doesn't retain the particles of the drawing medium. If you erase a section of a drawing on smooth paper and go over that section with your drawing medium and fingers to patch up the white hole, re-creating the original smooth transition is difficult, because the values don't blend easily.

 - Papers with rougher surfaces are great for soft mediums, such as vine charcoal, compressed charcoal sticks, and soft drawing pencils. Because the textures hold on to the medium particles, using a cloth or your finger to blend or push around the values is a lot of fun. The disadvantage of using rougher textured paper is that the fine tip of your drawing pencil snags into the grooves of the paper, making details of fine rendering difficult.

Run your fingers over the paper when choosing the type of surface you want to try. Different brands have their own classifications of "textured" (also referred to as "vellum" surfaces) versus "smooth" surfaces.

The following are some types of paper surfaces commonly found in most art stores:

- **Bristol board:** Bristol board comes in smooth and rough textures. It's a thicker, sturdier quality surface (100 pounds) that's great for illustrations. The smooth surface is designed for fine pen and ink, pencil, and fine rendered drawings; the rougher or vellum surface has a slightly toothy texture that makes it suitable for soft dry media (pencil or charcoal) and wet media (water color or gouache).

- **Charcoal paper:** More porous and has a rougher surface. Major brands such as Strathmore carry acid-free charcoal paper created from 100 percent cotton fiber. Many art stores also sell these in individual sheets (which come in 64 pounds) in various colors and values. Having an initial color or value gives students a middle ground to start with to build up the color and value of the figure. This texture helps grab the charcoal particles so you can get a better range of values depending on how hard you press the charcoal against the paper. (I discuss charcoals in more detail later in this chapter.)

- **Drawing paper:** The more commonly used surface, drawing paper is a higher-quality version of the sketching paper (70 to 80 pounds). Drawing paper has a light surface texture that makes it suitable for most dry media, such as pencil and charcoal. This paper can withstand light usage of wet media (for example, inks).

- **Newsprint paper:** Newsprint is distinguishable by its gray tint and is sold in smooth and rough surfaces. Although economical, it's thin and not very durable (definitely not suited for a water-based medium). It's ideal for practicing and working out ideas on. Major brands, such as Strathmore, weigh in at 35 pounds.

Although you don't need to purchase the most expensive drawing paper, avoid buying newsprint drawing pads if possible. Although most brands, such as Strathmore and Canson, currently manufacture acid-free newsprint products, the quality still leaves something to be desired. It's cheaper than standard white drawing paper, but newsprint's structure is fragile and easily damaged. (In addition, I don't care much for the dark gray tint.) If your budget gives you no other option, I recommend at least getting newsprint with a smooth surface.

- **Sketching paper:** General-purpose, light-textured drawing surface is suitable for classroom experimentation and usually comes in 50 pounds. Sketching paper can withstand light usage of wet media (for example, inks), but it's best suited for dry media. Think of this type of paper as the economical alternative to drawing paper.

- **Tracing paper:** This highly transparent parchment comes in 25 pounds. Great for tracing over your work or making corrections over your drawing without marking up the original. This paper surface is lightly textured, which makes pencils and thin markers good mediums to work with.

Make sure your paper is marked "acid free" or "pH neutral." Papers that are made from wood-based pulp contain a natural chemical compound called lignen that causes paper to turn yellow and deteriorate after a period of time. If you use papers that don't have the lignen removed, you risk having your artwork damaged, especially if the paper is under direct sunlight or exposed to heat.

Drawing tools

After you have paper and all the necessary accessories, you're ready to select your drawing tools. You have a wide variety to choose from; the most popular by far is the pencil, but charcoals and markers are other tools you may want to consider.

Pencils

Pencils are the go-to tool for artists drawing the figure. Pencils are an easy-to-use medium that you've likely handled since childhood. They come in diverse forms of softness and hardness, and have various types of chemical makeup. Different companies manufacture their own flagship pencils (which for whatever personal reason end up being consistently recommended in art classes). My favorite happens to be the Faber-Castell 9000. One often overlooked benefit of using pencils is that they produce results quickly; unlike oils or acrylics, you don't need turpentine or a messy side medium to improve the viscosity or quality of the line. Another benefit (which happens to be my favorite) is that it's easy to maintain. You don't have to clean a messy paintbrush (which can take up to 30 minutes) or use a spray to secure the medium onto paper. Simply toss the pencils into a zippered sandwich bag and off you go!

As with paper, you have a lot of pencils to choose from. Unlike office-supply stores, drawing pencil manufacturers sell a variety of pencils with a wide range of graphite softness or hardness. Graphite grades range from the following: 9H (hardest), 8H, 7H, 6H, 5H, 4H, 3H, 2H, H, F, HB, B, 2B, 3B, 4B, 5B, 6B, 7B, 8B, 9B (softest). H stands for "hard" while B stands for "black." The higher the H, the harder the lead; the higher the B, the softer the lead.

In general, the common #2 general-purpose pencil correlates to HB. However, there is no universal grading method that's shared by pencil manufacturers. Each manufacturer has its own way of determining what constitutes different grades of hardness and softness. Although harder pencils are preferred by technical drafters (such as architects and mechanical engineers), softer lead pencils are favored by artists. I don't recommend using anything harder than a 2B for figure drawing (just was never meant *to be!*).

When I test a pencil on a sheet of drawing paper, I look for the way the medium drags across the paper. A *drag* refers to the amount of friction or resistance the lead or compressed charcoal puts up when you move it across the paper. Although some softer pencils have less drag, some soft compressed charcoal sticks are so dense that they have more drag than some of the harder pencils on the smoothest paper. I personally prefer less drag because it's easier on the wrist and doesn't inhibit my drawing speed. Another good way to test the drag is by making strong, short (no more than ½ inch in length), thick-to-thin cross-hatch marks. See how each pencil grips the tooth of the paper compared to others. The more smoothly you create the marks, the less drag you get.

The following are just some of the many companies that make great drawing pencils:

- **Faber-Castell 9000 Drawing Pencil:** The company's signature water varnish based pencil. Available in ranges from 8B through 6H. These are currently my favorite figure-drawing pencils.

- **Derwent Graphic Pencil:** Uniquely composed from clay and graphite. These pencils boast a wide range of 9H through 9B. Its casing is designed to feel lighter in the hand.

- **Design Drawing 3800 Pencil Untipped:** Encased in their classic alligator-skin design, these pencils range from 6H through 6B.

- **General's Ebony Layout Pencil:** These pure, smooth, black graphite pencils are one of the most popular pencils in art classes. The thicker graphite center gives you a wider side to use for shading in values in large areas. This pencil comes in only one type: jet-black extra smooth.

- **General's Flat Sketching Pencil:** Recognized by its flat-shaped wooden casing, this uniquely shaped graphite core gives you the flexibility to create thick-to-thin lines with the rotation of the pencil. These pencils come in choices of 2B, 4B, and 6B.

- **Staedtler Mars Lumograph:** Widely used by architects/designers for its ability to sustain a sharp point. These pencils range from 6H through 8B.

- **Tombow Mono Professional Pencil:** Boasts a high-density graphite that's not only break-resistant, but also smearproof (a storyboard artist's dream). These pencils range from 6H through 6B.

- **Turquoise Drawing Pencil:** Its balanced composite of clay and graphite makes this pencil less prone to breakage. Used widely in studios and classrooms. These pencils range from 7H through 6B.

- **Wolf's Carbon Pencil:** Has a unique composite of charcoal and graphite. Encased in cedar wood, these pencils are easy to sharpen and are great for detail work. Choices include B, 2B, 4B, and 6B.

- **Prismacolor Woodless Drawing Pencil:** A pure graphite drawing pencil that needs no sharpening in order to draw (although you may want to sharpen the tip just a little from time to time). This pencil is an excellent choice for artists who feel the standard wood casing pencils are too light. You have the choices of 2B, 4B, 6B, and 8B.

- **Faber-Castell PITT Graphite Pure 2900:** Faber-Castell's version of the woodless drawing pencil comes in choices of HB, 3B, 6B, and 9B.

Although my personal favorite drawing pencil is the Faber-Castell 9000 (and I definitely recommend giving it a try for starters), you need to figure out what best suits your own needs. Here are some points to consider as you embark on your journey in search of a compatible drawing pencil:

- Beware that products that carry the same degree of hardness or softness but come from two different brands may not be identical. I find that some brands tend to have a more flexible labeling system.

- I recommend trying three or four grades of softness or hardness from a single brand (say H, 2B, 6B, and 8B). If you're new to drawing, stay away from pencils harder than H. Leads with harder tips are great for drawing technical drawings with precise details, but they don't provide as much diverse line quality as the softer leads do.

- Trying out pencils before committing to buy them is important. If stores don't have a test pad to try out, I recommend carrying a piece of drawing scrap paper with you when you enter the store. Although stores don't allow you to pop open a box of fresh pencils to test one out, some stores have individual pencils in an open display. Those stores may be lenient in letting you draw a couple of lines on a piece of scrap paper to test the pencil.

Charcoals

One reason I like using charcoal is that it allows me to cover large areas of paper with fewer strokes than using a drawing pencil does. In addition, the loosely compressed carbon in charcoals allows me to easily smear and blend the strokes to get the effects I want (something not easily done with a grade-H lead drawing pencil).

Here are a few different charcoal types to consider:

- **Vine charcoal sticks:** These are sold in boxes in various hardnesses (hard, medium, and soft). They're great for loosely blocking in the overall shape of the figure and applying shading on areas of the body. I like using the extra-soft vine sticks when I'm shading in my figure because they're quicker and I can get darker shadows without pressing too hard against the paper.

- **Thick charcoal sticks:** Just as the name suggests, thick charcoal sticks are the thicker versions of the thinner vine charcoal. Though not practical for small figures or detail, they make excellent shading tools (especially on very large drawings, such as a close-up of the torso on an 18-x-24-inch drawing pad).

- **Compressed charcoal pencils:** These come in various degrees of hardness (hard, medium, and soft). Think of them as pencils with charcoal instead of graphite. I like using them for drawing details of the figure (such as the eyes, nose, and fingernails). Charcoal pencils come in handy when your figure drawing is smaller than 8 x 10 inches.

- **Compressed charcoal sticks:** These cylindrical charcoal sticks also come in hard, medium, and soft variations. I like using them to draw loose gesture lines and curves of the figure. The advantage of using these rather than the charcoal pencils is that you never have to worry about having to shave away any wooden casing around the charcoal — the powder charcoal particles are tightly compressed by using binders.

You may find that using a smooth versus rougher paper surface affects which type of charcoal you use. If you're planning to draw from the figure continuously for a long period of time (for example, an all-day figure-drawing session), I recommend using softer charcoal over harder charcoal because it eases the resistance on the paper and ultimately the stress on your hand. Softer charcoals also make it easier to get a deeper range of values without having to press hard on the paper.

Markers

Markers are a versatile figure-drawing medium. They deliver consistent line quality and shades of value by using your natural strength, which makes sketching and drawing quick and fun. Because markers don't require a separate inkwell, they're great for quickly sketching figures in your journal sketchpad.

I don't recommend working exclusively with markers (for one thing, they're expensive; for another, they smell quite awful), but they make a good supplement or sidekick to the pencil figure drawings. When my drawing lines become less clear from all the smudging and shading, I like to use a fine black micron marker (which I mention in the upcoming list) to mark in the lines that I want to emphasize over the smudged out lines. In addition, you can use the thin markers to accentuate detailed areas, such as the facial features.

Make sure you're certain which lines you want to emphasize over others. After you place down inked lines, you can't erase them.

I give just a few types of markers in the following list:

- **Design markers:** These markers come in a wide array of colors and have two ends (one side has a broad, flat edge, and the other has a fine tip). Although I use the colored markers to render my advertising storyboards, the various shades of "cool gray" markers make excellent shading tools for my small figure studies.

- **Microns:** This product is a popular drafting pen brand used by designers and illustrators. What makes these pens so great is that they come in various widths and deliver a smooth, consistent line. They're some of my favorite markers to take along in my figure-sketching journal.

- **Brush pens:** If you want a brush-like ink quality in your figure sketches, consider getting a brush felt marker. The tip is shaped like a brush, which allows you to create both thick and thin expressive strokes. Bear in mind, however, that these tips typically don't last very long, so you don't want to overuse them on filling in large, dark areas.

- **Permanent markers:** They're inexpensive and relatively durable. I use them a lot in giving drawing demonstrations on a large pad in front of a large audience. Although they come in various widths, I don't recommend them for students who are just learning to draw the figure because they dry very quickly, produce a stinky odor, and can be a bit awkward to hold and use when drawing detailed lines or parts of the figure. I typically use black Sharpie markers, but Sanford makes Mister Sketch permanent markers that are less likely to dry out if you leave the cap off. The Mister Sketch markers come in 12 colors and in both scented and unscented varieties.

Here are a few considerations for buying and using markers:

- Make sure the markers you buy are marked "permanent" (indicating that they're waterproof and *lightfast* [don't fade from exposure to light]). The last thing you want is to spend time on your figure drawing only to have the lines smeared by a couple of raindrops or spilled coffee!

- If your budget permits, I recommend buying several markers with different widths so you're not stuck with just one marker that can deliver one line. When I carry my 5-x-7-inch sketch journal with me, I make sure I have a narrow, medium, and thick marker. These markers don't need to be from the same brand.

- Markers can be rather expensive, so make sure you keep the cap on after each usage. If the ink dries, it's the end of the line!

Erasers

You need two types of erasers — a kneaded eraser and a soft plastic eraser.

- **The kneaded eraser** (which reminds me of children's play putty), is great for getting rid of charcoal or pencil and clearing away large areas of stray lines or light lines. If the eraser becomes dirty, all you need to do is squish it so that the dirty sections are tucked away. You can also mold the shape of the kneaded eraser to a point so that you can erase away sections of your drawing without taking away the surroundings (for example, you can erase the eyeball without touching the eyelid). Another great quality of this type of eraser is that it doesn't produce the dust that general erasers do (talk about a clean getaway).

- **The soft plastic eraser** is great for erasing darker, thicker lines that are usually tougher to get rid of because the graphite or charcoal dust is heavily engrained into the drawing paper. Make sure the plastic eraser is soft; you don't want to over-erase a single section, because the eraser can damage the surface of some kinds of paper. If the surface of the plastic eraser gets dirty, simply run your thumb over the area to rub away the dirt.

Sharpening tools

Drawing a lot leads to dull pencils and charcoals. Have no fear, though; use one of the following tools to stay sharp.

Pencil sharpeners

A standard pencil sharpener the size of your thumb does the job. Consider paying a few more cents for one with an attached case to save yourself trips to the trash can.

As you use the sharpener, the blade dulls and needs to be replaced regularly.

X-Acto blades

Using X-Acto blades is an effective and economical alternative to buying and replacing pencil sharpeners. I buy them in packs of ten blades, which is enough to last me a very long time.

If you're not comfortable handling sharp objects, I don't recommend using these blades to sharpen your pencils. They're extremely sharp and dangerous; keep them away from children at all times. Always cut away from your body, using the thumb of the hand holding the pencil to slowly and firmly guide the blade along the wooden casing at the tip of the pencil. Use the index finger and thumb of the other hand to firmly hold the blade.

An alternative option to the X-Acto blade is using a *pen blade* (a smaller triangular blade fixed at the end of a long handle).

Sandpaper

Sandpaper is a great tool for sharpening compressed charcoal and charcoal pencils. I recommend getting finer sandpaper, which can deliver a smoother refined point than using a blade.

I also recommend wrapping a sheet of sandpaper around a small piece of wood and using it as a sanding block. The wood makes holding the sandpaper against the charcoal much easier.

Rulers

Two types of rulers come in handy when you draw the figure:

- **A straight-edge ruler (12 to 16 inches long):** Useful in drawing the perspective guidelines that I explain in Chapter 14. Rulers are also useful in sizing the height of the head to determine the rest of the body proportion (which I explain in Chapter 8).

- **A triangle ruler (30 to 60 degrees):** Useful in aligning shapes that are perpendicular to the floor. In addition, a smaller ruler may be easier to use because of its smaller size and easier-to-grasp shape.

You don't need to get more expensive metal rulers for figure drawing — a plastic one is all you need. But make sure any ruler you buy has a raised edge that prevents ink or dirt from seeping under the ruler.

A drawing backboard with a clip

A drawing backboard with a clip is essential when you take your drawing pad away from your drawing table. These backboards, usually constructed out of firm masonite board, are slightly larger than 18 x 24 inches to accommodate the size of most large sketchpads. A backboard is great for propping your drawing against an object so you don't have to worry about your drawing pad bending away from you as your pencil applies pressure. The clip holds the paper securely against the board, which is essential in preventing the page from blowing around.

Another useful addition to the clip is a thick sturdy rubber band stretched across the board to hold the sketchpad in place.

A composition grid

A composition grid is great for planning where you want to place your figure. Although some art stores sell ready-made composition grids, creating your own is fun and easy. Take a 5-x-7-inch sturdy art board and cut a 3-x-5-inch square opening at the center. Next, wrap two thin rubber bands across the top and bottom of the art board and position them so they divide the opening equally. Figure 2-1 shows the final product.

By holding the grid window up against a model, I can roughly position where I want to place the head or body in relation to my drawing pad. This helps eliminate the disappointment of working hard on a section of the body only to realize I don't have enough space on the paper to draw the rest of the figure.

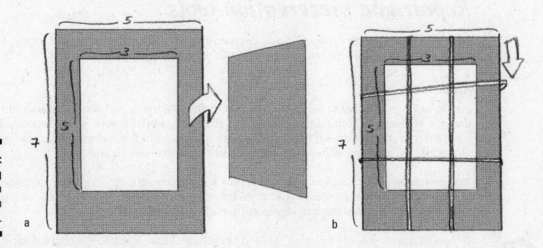

Figure 2-1:
Creating your own composition grid.

A portfolio case

A portfolio case lets you transport your work and protect it from bumps, scratches, windy weather, and rain. You need a portfolio case that can hold an 18-x-24-inch pad. If you intend to carry your own drawing board, you want to be sure the case can at least accommodate the width of the board.

You don't need to shell out the big bucks to get a decent case. You can find a vinyl case for less than $15 at www.pearlpaint.com.

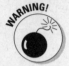

Don't choose a really cheap portfolio carrying case; you get what you pay for. I don't recommend portfolio cases made out of paper cardstock, because they aren't water-resistant, which means they tear apart like wet toilet paper when it rains (talk about money being flushed down the drain!). It also means your artwork will get wet and ruined. For a few additional dollars, you can get a sturdy hard-surface portfolio case with plastic handles (another must) that's geared to meet the economical needs of the art student. Acid-free polypropylene portfolio cases are water-resistant and scuff-proof.

A case for your tools

A case for your drawing tools, erasers, rulers, and sharpening tools can be anything from a used cookie tin to a large re-sealable plastic bag. You don't necessarily need to spend an arm and a leg to get a fancy carrying case at the art store. It just needs to have a lid or seal to ensure that all the contents don't spill out during transit. If possible, get a transparent case so you can see which items are inside without opening and scrounging through.

Repair and preservation tools

After you finish a figure drawing, you certainly don't want it to fall into disrepair. Luckily, two tools are available to help you: artist tape and spray fixative.

Artist tape

The advantage of using artist tape over standard masking/packaging/transparent tape is that it's acid free (which means it doesn't yellow or go brittle over a long period of time). In addition, removing it doesn't tear the papers underneath. A good-quality artist tape should also maintain a strong adhesive strength and be moisture-resistant.

Aside from its general usage (such as repair and attaching torn edges), artist tape is useful in keeping the borders around your final figure drawing clean. Simply place long pieces of tape around your drawing and remove them after you're finished.

When I'm drawing at my drawing table in my studio, I use short strips of artist tape to secure my drawing paper to my slanted drafting table to prevent my drawing from sliding down to the floor.

Spray fixative

You can find fixative sprays at most art stores. Spray fixative comes in handy when you want to preserve and/or transport a figure drawing (especially drawings that you rendered

with soft charcoal or extra-soft pencils that smudge easily). Before storing your final drawing in your portfolio or sketchpad, take several seconds to spray the surface of your drawing. This practice prevents the charcoal from smearing around.

The chemicals found in the fixative cans are harmful when inhaled. Make every effort to use the spray in a well-ventilated area. I recommend taking the drawing outside before using the spray. Also make sure the sprayed drawing has plenty of time to settle before you transport it. I recommend letting the drawing settle for five minutes before taking it back inside your studio or storing in your portfolio case.

If you feel uncomfortable using spray adhesive, I recommend using wax sheet paper to cover the final drawing before you put it back in your portfolio case. Although it's not perfect, it's better than leaving the surface completely unprotected.

Setting Up Your First Studio

In this section, I explore the environment and basic equipment you need to set up your figure-drawing studio. Depending on your budget and personal comfort, you need to choose what's right for you. Some points to keep in mind are the following:

- Do you need complete solitude in order to draw?
- What top five disruptions tend to distract you?
- Are you more productive during the evening or morning?
- What's you budget plan? What items can you get now versus later down the road?

Don't worry if you're unsure as to what environment and equipment work best for you at first. Sometimes only time and experimentation can determine what makes you tick.

Ask other artists and colleagues about their working habits and environments. Then try implementing them into your strategy to see which are most effective. This method saves time and energy because your friends have probably already weeded out the terrible ideas.

Selecting the best space for your needs

Your drawing space is an area that needs experimentation. Each person has his or her own preference. For example, I have two separate studios (one at home and another shared studio space at a separate location). I find that although I enjoy working by myself in complete solitude (especially during extremely tight deadlines), I need to have active interaction with a colleague from time to time.

If you're not sure where to start in your quest to find that right environment, try taking your sketchbook to a coffee shop to draw. Are you able to concentrate with the hustle and bustle around you, or do you find yourself so distracted that you can't concentrate on anything you draw? If you're too distracted, maybe you need to have your own quiet studio without any distractions (including e-mail)!

If you live in a family environment with constant interruption from a curious five year old and no easy access to a quiet home studio, you may want to consider rearranging your

time or renting a cheap studio at a separate location. If you work better away from home, consider getting involved with off-site live figure-drawing classes to interact with other artists sharing the same experience of drawing from the same model. A group setting is also a great place to build networking relations (both business and casual friendship). Some of my closest art friends I've had for the past ten years are those I met at drawing sessions.

If you don't have a problem working with the everyday distractions around your home, working at a home studio may be efficient, especially if you have control over the environment without worrying about inconveniencing others.

Another factor to consider is how efficiently you work during specific times of the day. The common myth is that the harder you work, the more you get done. As much as I want to think that's true, my body and mind function better toward the evening than they do in the morning. Therefore, I organize my schedule around my efficiency habits so that I do most of my drawing later in the day.

Lighting your way

You absolutely need proper lighting in your studio. Unless you're working in a live figure-drawing class with plenty of large windows providing adequate natural lighting, you need to have more than just the single bulb in your room to provide the main source of light. If you're drawing the figure away from the live model, you need to invest in one or two studio lamps that you can attach to your drafting table.

I recommend getting two studio lamps (I keep one on each side of my drafting table). Each lamp has two different types of bulbs. One is the regular tungsten 100-watt bulb, and the other is a circular fluorescent tube that fits around the first bulb. Used together, the two bulbs emulate natural daylight.

Art studio lamps are a bit pricier than cheaper office lamps, but they're definitely worth the price. As an artist, your vision is a priceless commodity, and you should use it under the best working conditions possible. Working under dimly lit conditions can add harmful stress to your eyesight. Studio lamps are available at art stores. If your budget is tight, however, cheaper substitutes are halogen work-lights, which are available at most hardware stores.

Picking out a drawing table

One common mistake beginners make is to assume all table working surfaces are equally suited for drawing. Flat surfaces are okay for short-term drawing, but working on a completely flat surface for a long period of time can create added pressure on your back and eyes. On the other hand, working on your drawing at an angle eases the pressure on your eyes, neck, and back. Although drafting tables can cost hundreds of dollars, you don't need to break the bank to purchase one; you can find inexpensive adjustable tables at select office-supply stores and economical furniture stores such as IKEA. As long as you can position the drawing table at an angle, you're set.

If you already have a separate table surface, you can cheaply and easily prop the surface on top of your regular flat surface desk at an angle to create the solid drafting table. If you decide to go this route, make sure you prop the drafting table against something stable, such as an empty plastic storage box or a stack of books. You also need to affix two screws

or a clamp at the front of the table to prevent the angled desk surface from sliding down. Although each individual artist has his or her own preferred angle at which to work, the ideal working surface is tilted so the drawing is perpendicular to your line of sight. This angle prevents an odd perspective that may lead to drawing figures with elongated torsos and legs.

Choosing a drawing chair

A drawing chair is an ergonomic essential for artists who sit at the drafting tables in a studio for a long period of time. If your chair isn't cushioned for support, you're likely to experience a bit of discomfort at the end of the day. Although good quality drafting chairs are comfortable, they're fairly expensive (but still cheaper than a season pass to your local chiropractor).

Don't be alarmed by the price tags on some of the more expensive drafting chairs. Fortunately, plenty of inexpensive options are available in the furniture sections of office stores for half the cost. This increased availability just goes to show you how important the general public considers taking good care of your back posture. If you decide to go this route, I recommend visiting the stores and seeing which chairs make you feel comfortable.

Besides adequate cushioning, your chair needs to have good back support so you can lean back and stretch your arms. Make sure the height of the chair is adjustable (there's usually a lever that controls the height underneath the seat cushion). Setting the right level for your seat is important; you don't want to be left with your feet dangling in mid-air. Last, your drafting chair should have wheels attached to the bottom of the legs. Chances are you need to get up and away from the drafting table so you can stretch or run errands between drawing sessions. Regular chair legs scratch and damage the floor over a period of constant friction. Wheels ensure that you maintain mobility while seated without damaging the floor.

Getting organized with a side table

Side tables help better organize your workspace — especially when you have a lot of drawing supplies. A good side table should be about the height of your elbow when you're seated in drawing position. This level allows you to easily access the drawing tools you need as you work.

Although purchasing an artist's side table that comes with wheels and small container bins at the art or office supply store is welcome, finding a table at home with the proper height is sufficient.

Storing your work in archival boxes and folders

Before long, you start to see how quickly your drawings accumulate over a short period of time. Archival boxes are great for storing smaller drawings; larger cardstock folders are better suited for storing your larger drawings. I like the fact that the archival boxes are uniform and stackable, because that makes organizing the storage area straightforward and neat. Be sure to label and date the boxes and folders so you have some point of reference years from now.

Look for an "acid free" label on these storage boxes. If you're not sure whether the boxes are acid free, ask the staff at the store. The drawings you store inside a storage box will yellow over time if the box isn't acid free.

Make sure the boxes and folders aren't stacked directly on the floor or near leak-prone pipes. The last thing you want is flooding or leaking water destroying your artwork. If you live in an area where flooding is an issue, make sure you wrap the folders with sheets of plastic, which you can get at your local hardware store.

Cleaning up with baby wipes and paper towels

Baby wipes and paper towels are essential in helping you keep your workspace clean throughout the day. Dirty hands are a nuisance when you're working on areas of the figure that require intricate detail. The last thing you want to do is waste your time erasing smudges transferred from your dirty hands. A good day's worth of hard work deserves a good, refreshing cleanup using baby wipes for your hands and damp paper towels for your drawing table.

Keep your work area as clean as possible. When I fall into the habit of not cleaning my workspace constantly, a little bit of a mess here and there adds up pretty quickly and creates a complete psychological wipeout!

Considering other optional equipment

Over the course of teaching and drawing, I've come across some extra supplies that I find to be useful. Some are affordable, but others are likely to be added to the long list for Santa. Don't worry — you don't need these more expensive supplies in order to learn or start drawing the figure.

- ✔ **Light box:** A light box is basically a couple of fluorescent bulbs inside a metal casing covered with a thick, frosted plastic board. It's great for tracing over your figure drawings to correct mistakes.

- ✔ **Art bin:** If you plan on carrying more than just a few pencils and an eraser, having an art bin is a great way of storing your drawing tools. They typically come with a compartmentalized tray inside where you can store your pencils, erasers, charcoal sticks, and so on. A tool box or fishing tackle box is a comparable substitute.

- ✔ **Side tray:** A side tray is my favorite side table substitute; I use it to store markers, pencils, rulers, erasers, and much more. It's a large, elongated, compartmentalized tray that you attach to the side of your drawing table with screws. You may need to order the item online (because many art stores don't sell it separately from the drafting table).

- ✔ **Presentation portfolio:** A presentation portfolio is a great way of showing your best figure drawings to the public. Portfolios range in sizes, but I find that 8 x 10 inches is a comfortable size for resized reproductions of my original figure drawings. Anything larger tends to be a bit cumbersome to casually display to friends, and smaller sizes tend to make seeing and appreciating the detail of the work more difficult. I recommend browsing the portfolio section on your next visit to the art store to see what types of cases are available. Although the fancier ones are delectable (Pratt makes nice ones), less expensive options, such as the Itoya presentation cases, are popular.

✔ **Mats and frames:** Buying precut mats and presentation frames comes in handy when you decide which figure drawings are worth displaying. Make sure these mats are acid free and listed as "archival quality"; you don't want them to yellow over time. You can buy mats and inexpensive clear acrylic frames at most art and office-supply stores.

✔ **Kitchen egg timer:** If you decide to work with a model privately, having an egg timer to track the time of the pose is very handy. When you're engrossed in your drawing, the last thing you need is the distraction of constantly having to look at your watch. A digital timer is better and more accurate than the cheaper and less reliable wind-up model.

✔ **Digital tablet/computer:** Although not cheap, Wacom manufactures these awesome tools for artists who are serious about taking figure drawing into the digital realms. A *digital tablet* is a computer drawing board with a pressure-sensitive drawing device designed to emulate various types of traditional drawing/painting media. These digital tablets go hand in hand with popular software including Adobe Photoshop and Corel Painter.

✔ **Printer and archival printer paper:** With printers that are capable of printing professional-quality images on various paper surfaces, this investment may be worth your piggy bank! If you plan on editing your drawings on the computer or scanning your drawings to create digital prints to sell to potential clients, this purchase actually saves money in the long run. Many serious artists are choosing this route to make their own art prints (to sell at conventions and such) rather than paying outside professional digital labs for the job. If you stop at a photo/video store, take time to visit the printer/paper section. Depending on the size of the store, paper surfaces range from canvas printing paper to thick watercolor paper (and much more).

✔ **Scanner and digital camera:** As I explain in Chapter 16, I scan my artwork that I plan to post on my online blog or portfolio. For drawings that are too large to fit on the conventional scanner, using a digital camera to digitally capture and store your work on your computer is an excellent alternative. Make sure you have plenty of adequate lighting around the drawing you're photographing. Most cameras have adequate pixel resolution to print decent photos up to 8 x 10 inches on your printer.

Packing Up a Portable Studio

Working outside your studio is like getting a breath of fresh air. Switching your physical and psychological working environment from time to time is essential. Here are some helpful materials and equipment to bring along with you in addition to your drawing pad, assorted tools, and portfolio case:

✔ **Portable folding chair:** If you're drawing on location (say, drawing figures in a public park), folding stools are compact, sturdy, and inexpensive. Although they don't offer back support to lean on, their lightweight structures make this option an ideal travel companion — especially when you're likely to be toting a full-scale portfolio case and drawing equipment with you.

✔ **Carrying case (small or large):** As I mention earlier in this chapter in the section "A case for your tools," you want to have either a small plastic (preferably see-through) bag or container for your drawing tools. If you plan on carrying a wide range of drawing media along with you, consider getting an art bin (as I describe in the earlier section "Considering other optional equipment").

✔ **Baseball cap:** A baseball cap is handy when you don't want a strong light source shining into your eyes. Having plenty of light on your drawing paper is a good thing, but having to look directly into the path of a 100-watt light bulb isn't such a bright idea. This is true even in natural daylight settings, where the light from the sun reflects off your cheek and bounces back into your eyes (which is why football and baseball players sport those dark marks underneath their eyes). Having the hood of the baseball cap shielding your general eye section reduces these distractions.

✔ **Drawing board with neck strap and clip:** In addition to having a drawing board with a clip as I mention earlier in this chapter, having a neck strap that stabilizes the drawing board comes in handy when you don't have a place to sit and draw. It's not unusual to walk into a crowded figure-drawing session or a café with very limited seating.

Don't use the neck strap for prolonged periods of time; the pressure on the drawing board increases the pressure and strain on the neck.

✔ **Water and snacks:** Studies have found that a majority of the population doesn't consume enough water to meet the recommended standards. Water not only replenishes your fluids but also helps increase your mental productivity. Be sure to carry a bottle of water with you, especially during a hot summer or if you know you're about to engage in a long drawing session. Keep your snacks simple. I usually like to carry a bag of chips or a piece of fruit that I can quickly munch on during breaks.

✔ **Music player:** Although it's not for everyone, having a music player is a popular choice for many artists and can help you concentrate on your drawing. Sometimes I find it helpful to use my player with noise-canceling headsets to block out distractions (people chattering, babies crying, cars honking, and so on).

Proper etiquette is to lower the volume of your music player when drawing in quiet figure-drawing sessions with a lot of other artists drawing in close proximity. Many people forget that sounds leak out of headsets and are distracting to others.

✔ **Blanket:** When drawing outside for a long period of time, you want to stay warm. Most people forget how much heat their bodies lose, especially when their minds are focused intensely on a single task. You don't need a large blanket — a mini blanket big enough to cover your lap is sufficient. Camping stores are great places to find these.

✔ **Sunscreen:** When drawing on location, don't forget to bring protection! Long exposure to ultraviolet rays is dangerous to the skin. The more attention you pay to your drawing, the less conscious you become of your actual surroundings. Take a few minutes to apply sunscreen to your exposed body areas. It'll save your neck!

Chapter 3

Starting with Figure-Drawing Basics

After you have your drawing tools and environment set up (see Chapter 2 for details), it's time to get started on the basics of drawing the figure. When broken down into its parts, the drawn human form is really nothing more than lines (short and long, straight and curved, dark and light) and shapes (circles, rectangles, and so on) assembled in a particular way and shaded to create the impression of depth. These, in essence, are the tools you need. In this chapter, I demonstrate various tips, examples, and steps on creating basic realistic forms, using lines, curves, shapes, light, and shadow.

Different Strokes: Knowing How Much Pressure to Apply When You Draw

One important consideration for *anything* you're drawing — a straight line, a simple curve, a basic shape, or something more complex like shadows — is how much pressure to use. Depending upon how hard or soft you press down on your drawing pencil/charcoal/pen, you can change the thickness or thinness as well as the darkness or lightness of the stroke. These qualities are vital in emphasizing the rhythm and flow of the figure. Equally as important, you can apply hard and soft strokes to emphasize or draw the viewer's attention to shapes of the body. Using the same stroke quality to draw an entire figure can be rather boring.

Change the look of your drawings by using different types of pressure:

✔ **Thick strokes:** For thick strokes, apply pressure to the paper by using the dull tip of a pencil. Use these strokes to shade in larger areas of the figure that are cast in shadow. Thick strokes are also great to describe generally larger body shapes, such as the buttocks, round stomachs, and thighs.

✔ **Thin strokes:** For thin strokes, apply pressure to the paper by using the sharp tip of a pencil. Use thin strokes to draw the finer details of the figure; examples include the facial features (eyes, nose, mouth, and ears).

✔ **Dark strokes:** To get a dark stroke, use a soft pencil (as high as 8B level of softness) to apply relatively strong pressure to the paper. Apply these strokes to sections of the body that have pressure between body parts due to applied force or gravity (for example, underneath the buttocks when the model is seated). Dark strokes are also useful in adding contrast to the line quality of the overall drawing of the figure; when, for example, you use thin or light lines to draw one part of the body, use dark strokes to render another section of the body.

✔ **Light strokes:** For light strokes, use a harder lead (5H or higher) to apply light pressure. Light strokes are useful in rendering the sides of the body facing a strong light source. They're also useful for de-emphasizing sections that appear awkward as a result of extreme foreshortening or because they're partially overlapped by other body shapes.

Take about 15 to 30 minutes to try your hand at creating a series of lines going from hard to soft. See some examples in Figure 3-1.

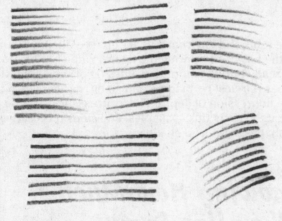

Figure 3-1: Experiment with different pressures to achieve various weights.

You may find that pencils with harder leads are sturdier, but they're tougher to use to create a variety of strokes. I recommend using softer leads like Faber-Castell 9000 water-based varnish drawing pencils (which run as soft as 6B to 8B). Their lead tips can take quite a bit of pressure (or "abuse" as I like to refer to it) without breaking.

I recommend gripping the pencil closer to the tip to gain better control. But watch out! A common and overlooked mistake made by beginners and even professionals is gripping the pencil too tightly. This results in cramping and unneeded strain on the wrist. If you find your wrist tightening up, put the pencil aside for a moment and gently shake your wrist to loosen up your hand a bit.

Looking at Lines, Curves, and Shapes

In figure drawing, you create all sorts of different types of "marks," including different lines (straight and curved) and a variety of shapes. These marks are the basis of all your figure drawings, so getting a handle on them is important.

The long and short of straight lines

Straight lines are useful for applying a variety of crosshatching strokes in figure drawing. Depending on your goal, you can use short or long lines.

Although using rulers to draw lines is certainly permissible, you want to keep it from becoming a crutch. I strongly feel that taking the plunge and getting used to drawing lines freehand (sans ruler) is essential. Don't be afraid; after some regular practice, you'll find the drawing process more time-efficient and more natural. And you'll also have the added boost of confidence in your drawing skill! If this is your first time drawing straight lines freehand, make sure you don't rush through practicing.

Short lines

Drawing short, tapered lines is useful when making crosshatchings (which I discuss in detail later in this chapter). Figure 3-2 shows some short, tapered lines (both horizontal and vertical). The key to applying the right amount of pressure is letting the gravity from the natural weight of your hand and arm rest upon the tip of your pencil. Without the application of the pressure, all the short lines end up looking monotonous and boring (I discuss the amount of pressure to apply for different strokes earlier in this chapter.)

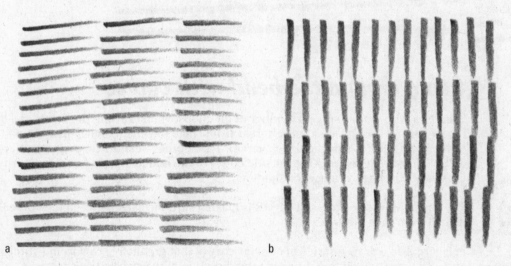

Figure 3-2: Drawing short, tapered lines.

a b

The trick to getting these marks to look right is to gently flick your wrist away from your body and away from your drawing arm.

Don't make the strokes too long. The length of these lines should be no more than a half-inch long. The longer they are, the more difficult it is to control the consistency.

Long lines

Although no long lines pertain directly to the human figure, learning to draw them without a ruler serves two important functions (see Figure 3-3):

✔ Straight lines are great for drawing the background geometric shapes, such as walls, floors, and chairs upon which the figure rests. Without being able to draw a convincing environment, the figure drawing appears to be floating in space without a sense of belonging.

✔ Practicing drawing straight lines hones your observation skills, which help you pair and visually align body limbs. This is useful when making sure the measurements and proportions of the figure are correct.

Figure 3-3: Drawing long, straight lines.

Going around the bend with curves

Exercises with curves serve a number of functions when drawing the figure. In Figure 3-4a, I draw several arcing lines that progress from small to wide to small. In addition I vary the order (from wide to small and vice versa). These types of short-to-long curves are the foundation of drawing not only the outside edges of the human figure, but also the rhythmic crosshatching lines you use for shading.

The key to drawing successful curves is making sure the gaps between the curves are equidistant from each other.

In Figure 3-4b, I draw a series of circular curves that gradually grow from lighter to darker and vice versa. In addition, I reverse the direction of the swirling curve marks. In Figure 3-4c, I draw a series of wavy curves in lieu of circular curves. These types of curves are useful when rendering the texture of hair or clothing.

Trying your hand at basic shapes

Believe it or not, in spite of all the body's complex muscles and bones, many old classic masters of figure drawing have used simple geometric shapes — such as circles, squares, triangles, and rectangles — to simplify the human figure. In this section, I show you some drills for honing your skills at drawing these shapes.

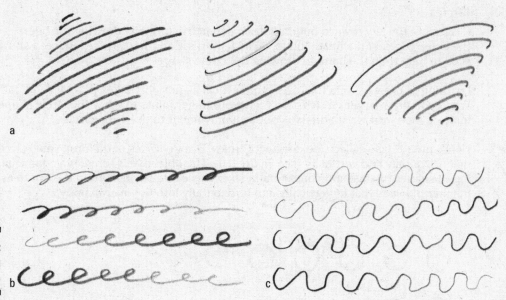

Figure 3-4:
Drawing
curves.

Here are a couple of useful exercises for practicing any shape (see Figure 3-5):

✔ **Shapes within shapes:** Remember those pranks you played on your siblings where they kept opening a present from you only to find a smaller box inside? If so, this exercise is for you! Start with a small shape of your choice (such as a square or a circle) and draw a series of larger shapes around the smaller one (see Figure 3-5a). As the shapes get larger, don't be concerned about maintaining the same proportions. Your goal is to make sure the spacing between each incrementally larger shape is consistently uniform. This exercise helps you develop better control of drawing shapes consistently, and gets you into the habit of building a solid drawing by starting from the center of the body.

✔ **Overlapping shapes:** Draw a string of overlapping shapes. Make sure to vary the sizes (see Figure 3-5b). This exercise helps develop your conceptualization so you can see how overlapping forms and shapes in a figure establish depth.

Figure 3-5:
Drawing
smaller
shapes
within larger
shapes and
overlapping
shapes.

a

b

Circles

Circles are the key toward building basic geometric forms in drawing the figure. They mark the outer edges of the head, joints, facial features, and torso. The exercises I show in this section help train the hand in drawing the circle shape.

Learning to draw a circle that's as symmetrical as possible takes practice and patience. When you draw larger circles, don't use your finger joints to draw the circle shapes; instead, lock your wrist and use your arm movement to draw the circles.

Here's an exercise called Cookie Sheet Circles. Draw a series of uniform, small circles lined up horizontally and vertically (see Figure 3-6). The objective is to maintain focus in keeping all shapes relative and consistent in size. This exercise helps train the eye to assess the number of heads that fit vertically and horizontally into the overall body.

Figure 3-6:
Playing around in circles.

Squares

When you draw the basic geometric shapes of the figure from the front, some shapes — such as the cylinder — appear as squares. In addition to its direct application to the figure, I use squares as the default shape of the borders I use to frame my compositions.

Try your hand at an exercise called Cascading Squares: Just like that classic (and addictive) game, Tetris, draw a series of squares randomly falling from the sky (see Figure 3-7). These squares can go in any order and don't have to stack perfectly on top of each other. Cascading Squares helps you see how smaller shapes that are visible on the surface of the figure (such as shadows and lights) fit together to form larger objects.

Figure 3-7:
Squaring off
with some
drawing
exercises.

Rectangles

Rectangles are useful in describing the basic geometric shapes of the pelvis and the palms of the hand.

In Figure 3-8, I show another set of drills that use the rectangle.

- ✔ **Dominos:** Start with a slim rectangle and draw a series of rectangles arranged in a dominos fashion, winding up and down (see Figure 3-8a). Try to keep the size of each domino consistent. This exercise helps you better draw rectangular body limbs and parts that tilt at different angles.

- ✔ **Brick Builder:** If you feel up to a challenge, try this one. Start with a small rectangle on its side (see Figure 3-8b). Draw small rectangles below and above the first, overlapping each at the midpoint. As you fill in the rest of the rectangles to form a brick wall, see whether you can keep the rectangles the same size. Brick Builder increases awareness of where objects and shapes of the figure align to form the larger shape.

Figure 3-8:
Fun
exercises
using
rectangles.
a b

Triangles

Triangles are one of the most stable and versatile geometric shapes. In general, triangles appear in the form of shadow and light shapes within the body. Many negative shapes (empty spaces that form between limbs) also are triangular.

In Figure 3-9, I demonstrate some drills involving the triangle.

- ✔ **Pizza Triangles:** Start with a single slice, and then draw a succession of slices to complete the rest of the pie. Try your best to keep all slices the same size (see Figure 3-9a). This exercise helps you see how smaller light or shadow shapes within the body group together to form different geometric shapes (in this example, the individual slices form a circle).

- ✔ **Flip-Flop:** Draw a series of triangles right side up followed by another series attached upside down. Continue this succession while trying to keep the triangle sizes the same (see Figure 3-9b). This exercise comes in handy when piecing together light and shadow shapes that scatter throughout the body. It's important to keep these shapes connected in sequential form so that the figure holds together as a whole larger entity.

Creating Dimension and Depth through Shading

Shading is one of the most important tasks in figure drawing. It gives the illusion of a three-dimensional object turning in space on a flat two-dimensional paper. In the following sections, I show you how to detect lights and shadows so you know where to shade and how to create your own value scale. I also give you tips and tricks on shading techniques and blending for effects, and to wrap up, I tell you how to put everything together to give dimension to simple shapes.

Knowing what to shade: Lights and shadows

Without the interaction between lights and shadows, your surroundings would be flat and boring. For example, a round, shiny bowling ball would look like a plain, circular dinner plate without any highlights or shadows on itself or on the ground that it rests on. Lights and shadows let you know the time of day and, when applied on a person's face, they let you know the mood or personality of that person. In this section, I describe various types of lights and shadows; this information is helpful in practicing shading, which I cover later in this chapter.

Figure 3-9:
Various
exercises
using
triangles.

a

b

Seeing the light

Light gives your surroundings dimension and ultimately meaning. Without it, you're literally left in the dark (not an issue to make light of). Lighting on a figure is a result of a light source. This can be anything from the outdoor sun to a tungsten clamp light inside a figure-drawing studio. Four light source positions are useful narrative tools in lighting the figure. Each method has its own purpose. In light of the situation, take this opportunity to examine the following setups.

No matter what type of light source you use in a figure drawing, you can see two different types of light on the subject:

✔ Highlights are small spots that are the brightest brights of an object. Depending upon the material or texture of the shape, they may appear sharper and more intense. For example, metallic objects, such as steel ball bearings, reflect a more intense highlight than a rubber ball does. Highlights are the result of surfaces (or planes) of an object perpendicularly facing the light source. The perpendicular planes that are the closest to the light source receive the brighter highlights.

In Figure 3-10, pay attention to the location and shape of the highlight. As the planes of the sphere gradually recede farther away from the light source, the shadows begin to gradually appear darker.

✔ As shown in Figure 3-10, the little patch of light in the shadow is a result of light bouncing off the ground and back into the shadow of the sphere. This type of light is known as *reflective lighting*, or fill light. The eye is easily deceived into thinking that the reflective light is as bright as the highlight on the opposite side of the sphere — the side facing the light.

Here's an important rule of thumb to help you from being fooled by those lights in the shadows: The lightest light in the dark side of an object can never be lighter than the darkest dark in the light side of that object.

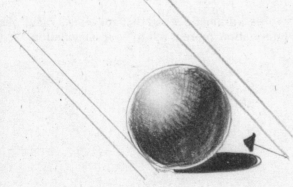

Figure 3-10:
Examining highlights and reflective lighting.

Top lighting

Top lighting is moving the light source directly above the figure's head, as shown in Figure 3-11. The parts that receive the most light are the forehead, the top of the nose, and the top plane of the lower lip. If you're drawing the whole body, you'll see that the shoulders and

upper sections of the torso also receive a lot of light. For the female figure, the top planes of the breasts catch the most light.

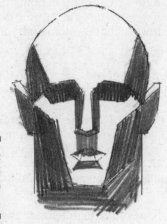

Figure 3-11: Observing the top lighting.

Top lighting sets the following qualities of mood in my figure drawing:

- ✔ Angelic and divine
- ✔ Peaceful and tranquil
- ✔ Clean and honest

Back lighting (rim lighting)

Back lighting (also known as rim lighting) is lighting the figure from behind (see Figure 3-12). When drawing from a live model, this choice of lighting isn't ideal because a lot of information, including the anatomy, is no longer seen from the viewer's vantage point. The shadow covers the entire figure. Not to mention the inconvenience of having the light shining directly into the viewer's eyes (ouch)! The sunset is an example of a light source used in back lighting.

At the same time, back lighting evokes a dramatic mood that suggests a range of emotional responses. When you have less information, more is left to your imagination.

Figure 3-12: Examining the back lighting.

Back lighting sets the following qualities of mood in my figure drawing:

- ✔ Romance
- ✔ Loneliness and solitude
- ✔ Warmth (physical temperature) and fuzzy feelings
- ✔ Solemnity and sadness
- ✔ Mysticism

If you insist on using this method of lighting, I recommend adding a second light source (to function as a reflective light) pointed at the front of the figure, which is in shadow. Be sure, however, to keep the intensity of this secondary light lower than the primary light source in the back.

Frontal lighting

Frontal lighting, as you can guess, is a light source directly in front of a figure (see Figure 3-13). It's commonly used in fashion/celebrity photography. Although it isn't popularly used in figure-drawing studios (it basically negates the shadow), it's great for erasing out imperfections of the skin (moles, pimples, bad tattoos, a third eye). The areas that receive the most light depend on where the light source is in relation to the figure. Although the entire figure appears to receive equal light (because there's little or no shadow), objects that are farther away from the light source grow dimmer.

Figure 3-13: Examining the frontal lighting.

Unless you're aiming for a specific purpose, I recommend avoiding this type of light source. It basically flattens out the geometric shape.

Rembrandt lighting (three-quarter lighting)

Rembrandt lighting, also known as three-quarter lighting, is the classic lighting method that's widely used in many art school settings. In this case, you place the light source to the upper left of the subject (see Figure 3-14). The complete opposite of the frontal lighting, this type of lighting provides the most definition of the human form. The sections of the overall figure that receive the most light are the upper left portions of the shoulders, upper torso, and left of the thighs.

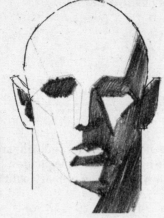

Figure 3-14: Looking at the Rembrandt lighting.

The name Rembrandt lighting came about in part because some of the self-portraits of the famous, classic, Dutch painter Rembrandt incorporated this type of lighting. Although this lighting doesn't have any specific narrative character types, its versatile usage is perfect for a wide array of drawing and photography.

Scoping out shadows

Into the twilight zone you go! I call your attention to two types of shadow forms: form shadows and cast shadows:

- **Form shadows** (also known as core shadows) are a result of a light source hitting a three-dimensional form. As I show in Figure 3-15, form shadows have softer and wider transitions into the lighter side of the object.

Use the flat side of a soft 6B to 8B pencil or extra-soft vine charcoal to create the edge of the form shadows and the smooth transition of the shadow. Hold the pencil close to the tip of the head and gently balance both sides of the pencil with your thumb and middle finger as a pivot point while applying pressure to the tip of the pencil with your index finder.

- **Cast shadows** are a result of one object casting a shadow on another object. The two objects are usually on different planes. As I show in Figure 3-15, cast shadows usually have sharp, narrow shadow shapes. The larger the object that's casting the shadow, the darker the shadow is.

Having a soft 8B pencil with a sharp point to etch in the shadow shapes is useful. If the shadow shapes are dark, apply pressure to the sharp pencil point to fill in the shadow shape. In addition, pay close attention to the edges of the cast shadows. The farther away the cast shadows fall from the object casting the shadow, the softer the edges become.

So how does this apply to drawing the figure? Observe in Figure 3-15 how the combined harmony of shadows brings out the realistic dimension of the form. As you observe, pay close attention to which shadows are labeled as cast versus form. Also note the contrast between the soft versus hard edges of the shadows.

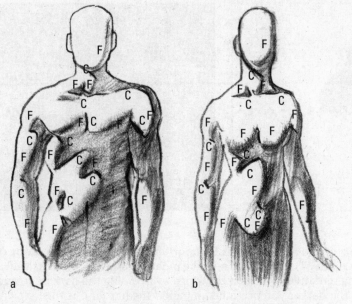

Figure 3-15: Exploring form shadows (F) versus cast shadows (C).

a b

Creating your own value scale

A *value* is how light or dark an object is. Academically, the values of objects range from a numeric scale of lowest — zero (white) — to middle — five (gray) — to highest — ten (black). I like to break down the categories of a value into two groups:

- **Natural value:** This value is defined as the shade of lightness or darkness of an object without light or shadow. For example, if a black cat is perched upon a white fence, as shown in Figure 3-16a, the cat's natural value is pure black and the fence is painted bright white. Therefore, according to natural value, I can confidently declare the cat's natural black fur is black and the white fence's natural value is white.

- **Relative value:** This value is defined as the shade of lightness or darkness of an object in relation to different degrees of light intensity. In the evening, the neighbors respond to the noisy cat singing on the fence. The bright light from the neighbor's flashlight upon the cat's shiny fur causes the cat to appear brighter than the white fence that's now shrouded in the darkness of night. The black cat's relative value is gray and the white painted fence's relative value is now black (see Figure 3-16b).

I remember in art school having to mix my own paint values, ranging from one through nine (zero and ten were freebies because they were pure white and pure black respectively). The challenge was to make sure that each transition in value between each step was evenly distributed. Talk about getting your values confused — it took me about a week of mixing the right amount of paints to get satisfactory results.

Over the course of time, I've found that reducing the number of steps to five is best. Try your hand at creating your own set of five step values.

Figure 3-16:
A demon-
stration
of natural
value versus
relative
value.

You may be asking this question: "So why is it important to go through the agony of trying to create my own value scale?" A common mistake most beginning artists (as well as photographers) make is being tentative with their drawings by avoiding the dark or strong shades of darkness. After all, the darker you press into a paper, the harder it is to erase or correct any possible mistakes. As a result, the overall final illustrations appear grayish and appear to fade away when viewed from a distance. To give your drawings dynamic range, be aware and take advantage of where your darkest darks are versus your lightest lights.

I recommend using a soft pencil for the following exercise. Try to use a drafting pencil between 6B and 8B in order to take full advantage of being able to lay down the darker values:

1. **Draw a horizontal narrow rectangle and lightly divide it into five equal sections.**

 See Figure 3-17a for value squares one through five, from left to right respectively.

2. **Shade in squares three and five.**

 Because value five is my darkest dark, I fill this square in as dark as I can. As shown in Figure 3-17b, the middle value is gray while square one is blank (white). For now, don't worry about getting value three accurate right off the bat. You adjust this square after filling in value squares two and four.

3. **Complete the gray scale by adding in value squares two and four.**

 In Figure 3-17c, I adjust the center value three to ensure the value transitions between each step are smooth. Check to see whether each value in each square is equally distributed by taking two blank sheets of white paper and covering up both sides of the value strip, revealing only two squares at a time. After checking the contrast between the first two squares, slide over to the next set of two squares and make sure the degree of contrast is consistent with the previous set.

Make sure that each square corresponding to each individual value is completely filled. Leave no white areas between the squares. I also find that the sharper your pencil, the easier it is to create precise, darker, solid lines and shading. The blunter your pencil is, the easier it is to create softer, broader lines. That's why I strongly recommend having at least two sets of pencils (one sharp and one blunt).

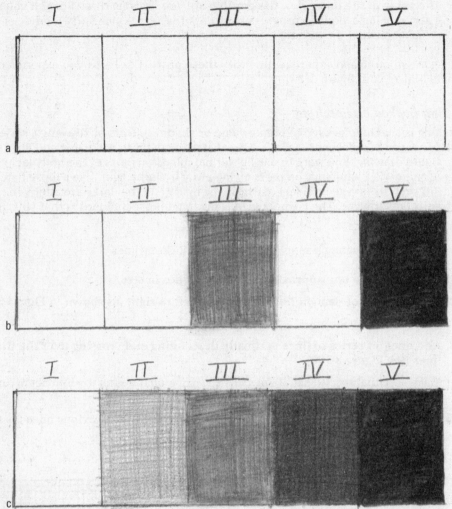

Figure 3-17:
Creating
your own
five-square
value
system.

Checking out different shading techniques

After you know how to see light and shadows in drawings and how to create your own set of values, you can shade your work properly. There isn't one correct method to developing your shading techniques. In this section, you discover basic hatching and crosshatching techniques in addition to other useful scribbling skills.

As you go through the exercises in the following sections, here are some questions worth asking:

- **The distance between the lines:** How far apart are you making these individual lines? What happens when you shift the distance?

- **The thickness versus thinness:** How thick or thin are your lines? Do they progress from thick to thin (or vice versa)? Or do they remain the same width?

✔ **The value of the lines:** How dark or thin are you drawing these lines? If you're drawing a series of lines, do they progress from dark to thin (or vice versa)? Or does the value remain constant throughout?

Paying attention to and experimenting with these properties helps you experiment with the overall look of your figure drawing.

Getting hooked on hatching

Hatching is a technique used to create value or shading effects by drawing a series of closely spaced parallel lines, and it's a great starting point to add value and ambiance to your figure drawing. You want to use lighter hatchings on parts of the body facing the light source and darker hatchings on parts facing away from the light. Use a loose hatching technique to sketch out a general feel of where the lights and the darks are after you're done with your line drawing. The advantage of using hatching techniques is that you can achieve results quickly.

Try your hand at creating a simple hatching by using long lines:

1. **Begin with one box approximately 3 x 3 inches in size.**

2. **Draw a series of straight lines going from left to right (as shown in Figure 3-18a).**

 Keep the lines light.

3. **Add another series of lines vertically descending and crossing over the first set of lines (see Figure 3-18b).**

 Make sure this second set of lines has the same qualities as the first set of lines (light in the first box and getting darker).

4. **Repeat Steps 2 and 3, but draw the strokes between the previous ones (as shown in Figure 3-18c).**

Figure 3-18: Hatching long lines.

Next, try using shorter, parallel strokes to create this hatching:

1. **Begin with one box approximately 3 x 3 inches in size.**

2. **From the upper-left corner, draw four short, parallel lines equidistant from each other (as shown in Figure 3-19a).**

3. **Right next to the ends of the four lines, draw the same parallel lines, but draw them vertically and perpendicular to the ones in Step 2.**

 Don't leave a gap between the two sets of lines (see Figure 3-19b).

4. **Repeat Steps 2 and 3 until you fill the entire box, as shown in Figure 3-19c.**

 Make sure you alter the starting sequence each time you complete a row going across. I begin the second row with four vertical lines because I begin the first row with four horizontal lines.

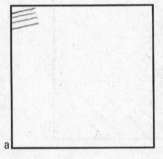 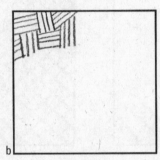

Figure 3-19: Hatching short lines.

Moving to the next level with crosshatching

Crosshatching produces smoother gradation from dark to light surfaces than simple hatching does. The difference from hatching is you draw the strokes overlapping. Crosshatchings can make a simple line drawing look more sophisticated (thus making the illusion you put more effort into the drawing than you actually did). In this section I share a few useful crosshatching techniques.

Here are some tips to pay attention to as you practice making crosshatches:

- ✔ Rotate the paper. It makes drawing certain angles a bit easier. As you make each line, experiment with varying the gap distance between each line.

- ✔ Increase the distance between each crosshatching to decrease the overall value. Vice versa, draw each crosshatching mark closer to the next to increase the darkness of the overall value.

- ✔ Make crosshatches consistent with speed and motion. Each mark should be created with a gentle flick of the wrist.

- ✔ As you go through each set of crosshatchings, gradually ease up on the pressure of the drawing pencil.

Crosshatching diagonally on the body's flat planes

The following form of crosshatching is widely used, especially on relatively flat body planes (such as the flat portions of the back, male chest, or abdomen):

1. **Draw a box no larger than 3 x 3 inches by using a soft pencil (6B to 8B).**

2. **From left to right, draw a series of diagonal lines going from thick to thin (see Figure 3-20a).**

 You can either start from bottom to top or from top to bottom.

3. **Draw another set of diagonal, thick-to-thin lines crossing the opposite way (see Figure 3-20b).**

 Don't worry if your lines aren't perfectly straight in the beginning. This ability usually comes with a little practicing and patience.

Figure 3-20: Applying simple, diagonal, crosshatching techniques to flat planes.

SKETCHBOOK

Crosshatching with vertical and tilted lines on the body's cylindrical shapes

If you want to apply a series of crosshatchings to a cylindrical object on the body, try your hand at the following steps. These hatching techniques are great for describing the arm, leg, or fingers.

1. **Start with a square no larger than 3 x 3 inches.**

2. **Starting from the left, draw a series of diagonal, thick-to-thin crosshatching marks, as shown in Figure 3-21a.**

 Place each line close together. Don't worry if the lines you draw aren't perfectly aligned or evenly spaced.

3. **As shown in Figure 3-21b, repeat the same crosshatching marks from the previous step except make them slightly at a more tilted angle.**

 For now, don't worry about getting the exact degree of tilt.

4. **Repeat Step 3 until you reach the opposite side of the square, as in Figure 3-21c.**

Figure 3-21: Applying simple cross-hatching techniques to cylindrical shapes.

Crosshatching with zigzags on the body's rounded surfaces

This crosshatching technique is useful when you're defining rounded surfaces on the figure. I later show how this technique is also applicable to defining spherical objects. I use this type of crosshatching quite a bit on facial features, rounded joints (knees and shoulders), and breasts:

1. **Draw a square no larger than 3 x 3 inches.**

2. **Starting from the upper-right corner, lightly draw a band of zigzag marks (see Figure 3-22a).**

 Pay close attention to the band's slight curve.

3. **Underneath, keep repeating Step 2 while gradually increasing the pressure on your pencil (see Figure 3-22b); repeat these steps until you reach the bottom left of the square (see Figure 3-22c).**

 Make sure the bands slightly overlap so the value transition is smooth.

Figure 3-22: Applying the zigzag cross-hatching technique to rounded surfaces.

Taking a shot at other shading techniques

The rich diversity of hatching and crosshatching styles adds value to your drawing experience. After you get the hang of it, feel free to combine parts from different styles to come up with a shading technique that's fun for you to use. As you continue exploring different types of techniques, observe how some styles have shorter versus longer lines. Also observe how certain hatch marks are thinner/thicker, straighter/curvier, and closer/farther apart.

Here are two particularly useful shading techniques that don't involve hatch marks: squiggles and curves:

✔ **Squiggles:** Do you think lines are all that count when it comes to shading? Don't count out scribbling with squiggles! Try this shading technique when you're drawing the hair of the figure. It's a great way of showing texture in addition to value. (See Figure 3-23a to get an idea of what I mean. In Figure 3-23b, note how I let some stray squiggle lines poke loosely out of the hair for added realistic effect.)

 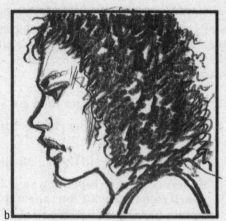

a b

Figure 3-23:
Shading
with
squiggles.

TIP

For beginners, I recommend starting your scribbles by moving your pencil in small, circular, repetitive strokes and then reversing them. They should be continuous and you should feel free from having to draw perfect circles. In fact, the less perfect the circles you draw, the more natural and realistic your final hair will appear.

✔ **Curves:** These linear hatching curves follow the contour of the figure form and are great for accentuating the rhythm within the shadows (both lighter and darker; see Figure 3-24). These curve shapes are great for shading in large areas of the figure that are hidden in shadow and therefore have less visible detail. As I describe in depth in Chapter 11, these curves are useful in accentuating the shadow shapes that run along the contrapposto *S*-shapes of the figure.

Figure 3-24:
Shading
with curves.

Mixing it up with blending techniques

Ever marvel at the beautiful color a blender makes when you insert a red tomato and yellow banana together (I do all the time)? Think of blending as a quick method of creating or smoothing out a gradation between two values. Although blending can get a bit messy and unpredictable at first, it's a relatively simple and fun way to get instant results. In this section, I share effective techniques that you can use to smooth out shadows' edges to create beautiful gradations as well as unify sections of the figure where values throughout may appear spotty.

Using your fingers

As you probably know, the skin of your fingers releases natural oil on a constant basis. This natural oil acts as an excellent and effective blending agent (especially if you're trying to blend soft vine charcoal).

The index and middle fingers work best as finger-blending tools. You can use your index finger to blend small areas or use both fingers to blend larger areas. I recommend going up and down between the values while moving the fingers in a rapid, zigzag, horizontal motion. Don't press too hard — your fingers may wipe away too much charcoal. Gently run your fingers up and down the blend to smooth out the uneven, unwanted texture.

Figure 3-25 is a before-and-after example of using your finger to blend two values. In this case, both sides are done with soft vine charcoal.

Figure 3-25: Blending two values by using your fingers.

a b

Be very careful at what you decide to blend with your fingers. Although graphite and most charcoals aren't toxic, materials such as some conté crayon colors have cadmium toxics, which aren't finger-licking good! If you use these materials, make sure you wash your hands before drinking, eating, or retiring for the day.

Using a soft cloth

In addition to avoiding dirty nails, using a soft piece of cloth is effective for blending large areas of a drawing. In Figure 3-26, I use a piece of cloth to unify the shadows of a sphere.

In Figure 3-26a, the shadows are placed correctly, but I want to get rid of all the distracting white spots that I didn't have time to finalize. In Figure 3-26b, I use the soft cloth to gently rub left and right to unify the overall value. I get a smoother and more solid drawing as a result.

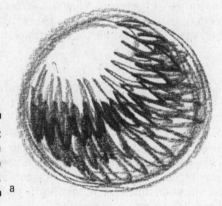 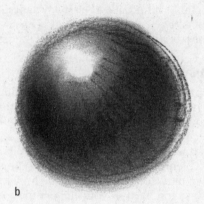

Figure 3-26: Using the cloth to unify values.

a b

The best way to use the cloth is to hold most of it in your palm while using your index and middle fingers to apply pressure behind the cloth against the paper.

Using an eraser to create effects

Your kneaded eraser may come in handy when you're blending and pulling out highlights on your figure drawing. Unlike your regular grade-school eraser, these soft rubbery tools can do more than just erase your mistakes. You can use the kneaded eraser to add some effects to make your drawings appear more lifelike.

Personally, I try limiting the role of the eraser, using it for effects and *not* for erasing mistakes. Using your eraser to delete mistakes is the equivalent of having a crutch; each line you draw carries less weight because you can easily delete it. And it takes up valuable time when the posing model is being timed.

In Figure 3-27a, I start with a torso without any reflective lighting (I show you how to draw a shaded sphere later in this chapter). By gently dabbing the shadow area with the kneaded eraser, I get a soft, washed-out, gray area that becomes my reflective lighting. In Figure 3-27b, I shape the kneaded eraser to form a narrow point at the end; this helps me pinpoint where my highlight needs to be. I then rub the point on my torso to pull out the brightest highlight section.

Take several minutes to stretch and pull at your kneaded eraser to soften it up with heat and friction between your fingers, especially during the cold season. A cold, hard kneaded eraser isn't as effective at picking up stray pencil marks.

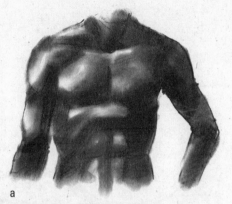
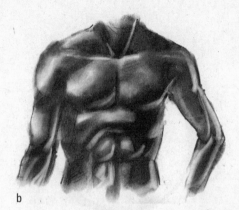

Figure 3-27: Using an eraser to create light.

a b

Putting it together: Adding dimension to shapes

Time to dust off those old geometry textbooks and get dimensional! In drawing, realism is the creation of an illusion of a three-dimensional object that exists on a flat two-dimensional space. The French refer to a series of realistic techniques as *trompe l'oeil* (fooling the eye).

Although creating these shapes (all of which have a Rembrandt three-quarter angle light source) may be a review for you, consider this an opportunity to revisit memory lane. If this is your first time drawing these objects, you may want to check out Chapter 14 where I talk about the structure behind these drawings. For now just follow along with the steps in the following sections.

Starting with spheres

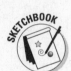

Body parts associated with the sphere-based objects are the head, joints, and torso (which is more ovalesque than spherical). Start putting it all together by drawing and shading a sphere:

1. **Draw a circle (as shown in Figure 3-28a).**

2. **Add a narrow oval for the cast shadow (as shown in Figure 3-28b).**

 Unlike the other geometric shapes, showing the three-dimensionality of a sphere is impossible unless you indicate the shadow shape. (See the earlier section "Scoping out shadows" for more about cast shadows.)

 Make sure the shadow shape slightly angles away toward the upper left.

3. **Clean up the extra pencil marks, add crosshatching form shadows on the sphere, and darkly shade in the cast shadow.**

 I use the zigzag crosshatching that I use to describe the body's rounded surfaces, as shown in Figure 3-28c.

4. **Use your fingers to soften and unify the edges of the form shadow as well as soften the edges of the cast shadow (see Figure 3-28d).**

Figure 3-28:
Building a
sphere.

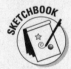

Creating cubes

Body shapes associated with the cube are the hands, feet, and hips. Try your hand at drawing the cube by following these steps:

1. **Draw a square (as shown in Figure 3-29a).**

2. **Draw another square that's the same size and slightly above and to the right of the first square (as shown in Figure 3-29b).**

 Before moving on to Step 3, I erase the overlapping portions of the second square lines to give the illusion that the front square shape is in the foreground.

3. **Complete the cube by connecting all four corners of the second square to the corresponding corners of the first square, and sketch in the cast shadow shape.**

 As I show you in Figure 3-29c, the cast shadow edge shape slightly angles up toward the right.

Figure 3-29:
Creating
a cube.

4. **As shown in Figure 3-29d, use the flat end of your charcoal pencil to shade in the values on the front and right sides of the cube.**

In addition, I use my fingers to lightly go over the values of the cube and cast shadow to make the cube look dimensional and realistic. Although the right side of the cube (facing away from the light) is darker than the front of the cube, the cast shadow is still darkest. If the side facing away from the light is too dark, use your kneaded eraser to lighten up the entire side to show the reflective lighting. Keep the top side white or lightly shaded because it's receiving the most amount of light from the direct light source.

Rounding out with cylinders

Body objects associated with the cylinder are the neck, arms, and legs. Follow these steps to draw a cylinder:

1. **Draw approximately a 1¹/₂-inch-wide oval as shown in Figure 3-30a.**

Vary the height by making this oval wider or narrower. This is the top of the cylinder you're about to create. Don't make your ovals too roundish; if you do, the illusion of the three-dimensionality begins to diminish.

2. **Draw a second oval about an inch below the first to create the bottom portion of the cylinder.**

 Make both shapes roughly the same size and shape. Unless, of course, you want to create a geometric shape that appears to have an uneven opening on either side.

3. **Complete the cylinder shape by connecting the top oval to the bottom oval with two straight parallel lines and drawing the shadow shape that angles toward the upper-right corner (see Figure 3-30b).**

4. **Erase the upper portion of the curve on the bottom oval shape, and shade in the shadow shapes of the cylinder with the point of your charcoal pencil (see Figure 3-30c).**

 I leave the top portion of the cylinder white or lightly shaded to reflect the direct light source from above. I shade in the right half of the cylinder in addition to lightly shading in the left outer edge of the cylinder.

 See the values on the side facing toward the light? The key to making them appear dimensional is to keep them lighter.

5. **Use your fingers to refine the shadow edges of the cylinder to make the overall shape appear three-dimensional (as shown in Figure 3-30d).**

 I use my kneaded eraser to pull out some of the value; that produces the reflective lighting effect toward the right side of the cylinder shadow facing away from the light. I also use the end tip of the eraser to pull out the vertical highlights, which run down the midsection of the left half of the cylinder facing toward the light.

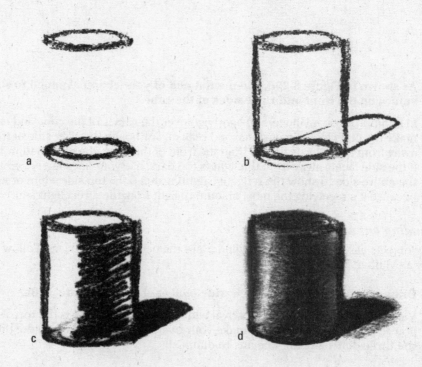

Figure 3-30:
Drawing a
cylinder.

Getting to the point with cones

In general, you don't find obvious shapes in the human body that take on a representation of a cone. I usually think of the cone as the pointed fingertips of a lady — or a circus hat (which really doesn't count because it isn't part of the figure . . . but I do cover accessorizing the body in Chapter 12). Follow these steps to create a cone:

1. Draw a 1¹/₂-inch-wide oval for the bottom base of the cone.

2. Mark a small x approximately 2 inches above the center of the diameter of the oval base to indicate the top point of the cone (as shown in Figure 3-31a).

3. Draw two straight lines to connect both sides of the cone (as shown in Figure 3-31b).

 I also sketch the pointed shadow shape that angles toward the upper-right corner.

4. Erase the upper curve of the bottom oval shape, and shade in the shadow shapes with your charcoal pencil, as shown in Figure 3-31c.

 I shade in the right half of the cylinder in addition to lightly shading the left outer edge of the cylinder.

5. Use your fingers to refine the shadow edges of the cone to make the overall shape appear three-dimensional (as shown in Figure 3-31d).

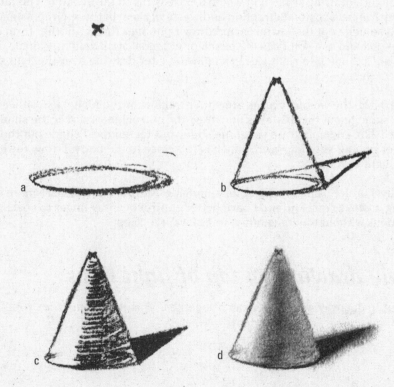

Figure 3-31: Completing a cone.

Fixing Bloopers with Ease

Mistakes — everyone makes them. But the good thing about figure drawing is that bloopers don't always have to be completely eradicated in order for your overall drawing to look cool. The important issue is dealing with them efficiently.

Erasing gently

Say your drawing needs a fresh new start. Take your kneaded eraser (which needs to be stretched and warmed up, no matter how large or small the area you need to erase) and gently go back and forth until the lines are completely gone. The advantage of using a kneaded eraser is that you can mold it into any shape that fits your hand and your needs. Also, as I mention in Chapter 2, you don't end up with eraser shreds from erasing large areas.

An alternative to a kneaded eraser is a soft cloth to rub out the mistake lines. You'll find that lines made with soft charcoal pencils are easier to rub out with the cloth technique. Darker lines, however, are more difficult to erase with a kneaded eraser. Use the corner end of your plastic eraser to rub out darker lines.

Smudging out the lines

During a figure-drawing session in which a pose is timed for five to ten minutes, picking up the eraser can be a costly distraction and waste of time. In these circumstances, use your fingers to smudge out the mistakes and draw right over them. Another form of smudging is using the dull end of a soft drawing pencil or charcoal stick to lightly shade out the mistake by applying a thin left-to-right zigzag shade and later drawing over the light shading with the correct lines.

In Figure 3-32a, the woman's arms are either too low or too high. I use either a soft cloth or finger to smudge out the mistakes and draw the correct marks over the smudged-out errors. In Figure 3-32b, I demonstrate using the shade-out technique. I shade out the outer side of the model's upper shoulder/arm, which is too close to the body. I draw the correct mark over the light shading.

Personally, I prefer using my finger for smudging. Natural body oils are more effective in smudging mistakes quickly, and I have better control over my finger to specifically erase certain portions without touching other areas I want to keep.

Simply drawing on top of light lines

Ever want to do away with the eraser altogether? This technique is for you!

Figure 3-32: Using the smudge technique to correct drawings.

a

b

During longer drawing sessions when you have more time to draw from the figure (or when you're drawing an illustration of a figure without a model), you have the luxury of starting your lines lighter. Because the lines are light to begin with, you don't have to worry about them standing out too much when you later go back with stronger lines (as I demonstrate in Figure 3-33).

This method is especially effective if you find yourself erasing lines only to repeat the exact same mistake (a waste of time and energy). Your goal is for the eraser, in effect, to become a drawing tool.

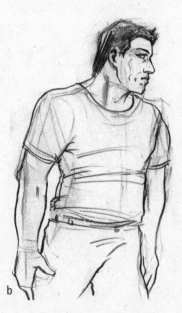

Figure 3-33: Starting with light lines.

a

b

This method also works well with shorter poses when you have only 30 seconds to a minute to draw a figure. In Figure 3-34, I show you that even figure drawings with thick line mistakes aren't the end of the line. You can still use thick lines to draw the lines you want and get effective results.

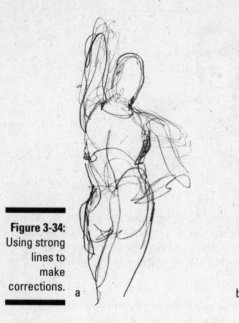

Figure 3-34:
Using strong
lines to
make
corrections.

a

b

Part II
Off to a Head Start

In this part . . .

Are you ready to face off and head toward a new part? Here I start by showing you how to break down the basic shape of the head from a variety of views. You also discover how to draw the eyes, nose, mouth, and ears. And don't forget about the hair! You'll find out how to draw hairstyles that range from the slick and trim to the wild and frizzy.

As a part of this package, I take you step by step through drawing various facial expressions, including happy, sad, angry, disgusted, mischievous, and much more. I also show you the basic facial muscle structure that makes expressing all these emotions possible.

Chapter 4

Getting Inside the Head

*I*f you're ready to draw the head of the human figure, you're headed in the right place! At first glance, the head resembles an egg-shaped, ovalesque object. On closer examination, however, it's made up of two separate groups. The first is the cranium, which is the upper/rear ovoid portion of the head. The second category is the face, which rests below the cranium and toward the front of the head. Although people identify with the face, many students still wrestle with placing the face in relation to the cranium. In this chapter, I walk you through the general parts you need to know when you draw the head and provide guidance on a couple of drawing methods.

Getting Familiar with the Parts of the Head

Beginners often have a tough time drawing the entire head because a certain facial feature catches their attention and they miss the overall picture. Being drawn (no pun intended) to individual features isn't a bad thing. After all, these features make people distinctly unique. However, focusing on the head itself when you draw is important. Not seeing the features in context with the entire head is like trying to identify where the tail of the donkey is while you're blindfolded. Each feature has its aesthetic purpose and function only when it's drawn in the proper location in relation to the entire head.

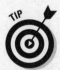

Think of the head as the globe. If you want to identify where to draw the epicenter mark (which represents, say, the facial features), you need to be able to locate the proper central location of the globe before making the mark. Without knowing where to place the mark in relationship to the outside edges and size of the globe, attempts at drawing the epicenter mark is guaranteed to be more difficult.

In this section, I describe the parts of the head from several angles. Don't worry about drawing yet; just sit with a cup of coffee and enjoy the ride.

The front view

In Figure 4-1, I show the front view of the human head. Keep the following basic structures and tips in mind when drawing the front view of the head:

✔ You can roughly divide the head vertically into thirds.

✔ Ideally, both sides of the face are symmetrical.

✔ The forehead takes up a large chunk of the head (approximately $1/3$ of the entire head).

✔ The top of the head is wider than the lower portion (the jaw) of the head.

✔ The top of the head has a slight bump.

✔ Depending upon the build of the figure, the neck lines on each side connect behind the ears (as opposed to being in front of either ear).

✔ The eyes are smaller and more spaced out than most people initially assume.

Figure 4-1:
The front overview of the human head.

The three-quarter view

In Figure 4-2, I illustrate the three-quarter view of the head. The side plane of the head, which includes the ear and sideburn shapes, is partially visible.

The straight-on view of this angle appears simple. Pay close attention, however, to the way the features that rest on the side plane of the head shift relative position in relation to the front side of the face as the head tilts up, down, or sideways. This shift is due to the change in perspective of the entire head (I talk more about perspective in Chapter 14). Don't be frustrated if, when trying to draw this angle, it doesn't click at first. The three-quarter angle is deceptively complex. For this reason, I recommend first getting familiar with drawing the three-quarter angle from a straight-on vantage point.

Take a few seconds to look in the mirror from a three-quarter angle. Use your ear as a landmark "anchor point," and observe how the placement of the ear shape changes position as you go through the motions of tilting your head back, forward, and sideways. The higher

you tilt your head, the lower the ear appears to sink in relation to the features on the front of your face. At the same time, the lower you tilt your head, the higher the ear appears to rise in relation to the features on the front of your face.

Keep the following basics in mind when drawing the three-quarter view of the head:

✔ The features on the half of the face that's farther away from the viewers are slightly narrower than the features that are closer to the viewers.

✔ The top of the ear is slightly lower than the eyebrow.

✔ The left side of the neck aligns with the outer edge of the left eye. The back edge of the neck protrudes out from underneath the ear lobe.

✔ The rear portion of the cranium sticks out farther beyond the neck edge line and ears (a common mistake is to align the neckline with the edge of the cranium).

Figure 4-2:
Drawing the three-quarter view of the head.

The side view

In Figure 4-3, I show the side view of the human head. In my opinion, the profile is the fun view to draw; you don't have to worry about drawing the other symmetrical side of the face, whether you're drawing from a live model or from memory. Artists commonly overlook the following when drawing the side view of the head:

✔ The overall profile is much wider than the front view (see the earlier section).

✔ The front of the face is slanted at an angle.

✔ The back of the head is as wide as the front section of the head.

✔ The ears rest at an angle along the jawbone line.

✔ The neck comes at an angle when the figure is standing erect.

✔ The bottom of the nose is roughly level to the bottom of the back of the head.

✔ The features create a triangular overall shape.

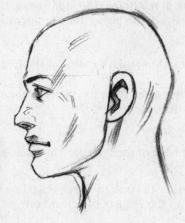

Figure 4-3:
The side overview of the human head.

The back view

In Figure 4-4, I show the rear view of the human head. This side is probably the most overlooked. Beginners as well as experienced artists assume that if the head is facing the other way, all they need to draw is a bunch of hair to cover the back of the head. Not true! Here, I list some key features that get overlooked in the drawing process:

✔ The back of the head is approximately $2/3$ of the vertical height of the entire head (that's quite a bit of space for your brain!).

✔ The neck (or top of the spine) emerges from underneath the back of the *occipital* bone (the large back section of the skull).

✔ Depending on the person, the *mandible* (jawbone) may be visible.

✔ The top of the head has a slight bump.

✔ From behind, the ear doesn't rest flush against the head.

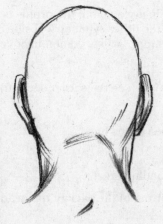

Figure 4-4:
The rear view of the human head.

Drawing the Shape of the Head

Pick up your pencil and get ready to draw your first head from scratch. In this section, I walk you through the steps to proportion the head accurately with careful measurements on a template. I also show you how to approach drawing the face without having to go through as many stages, which is handy if you're strapped for time.

I've found that students identify with their eyes more than other features of the face. Most students begin drawing self-portrait assignments with the eyes. Use the eyes as your "measuring stick" to build the basic dimensions of the head and as you figure the placement of the main facial features (eyes, nose, mouth, and ears).

As you block in the features, you may find that they occupy less space on the head than you think. Hair conceals the forehead as well as some of the top portion of the head that's visible from the front. Keep this fact in mind throughout the remainder of this chapter. (See Chapter 6 for full details on drawing hair.)

Easing into it: Drawing the front view of the head with measuring tools

Drawing the head by carefully measuring proportions and features is a good idea for beginners because it encourages you to use detailed guidelines that may fix or adjust any erroneous assumptions you have about the head proportions. I show you how to draw the head of an average-build adult in the following sections (I explain how to draw heads of different ages later in this chapter). You need a compass, ruler, and a kneaded eraser in addition to your drawing pencil and paper.

In this method, laying down the large shapes as accurately as possible is helpful, because the rest of the smaller shapes (which represent the facial features) rest on this foundation. A compass is a great tool for drawing large, symmetrical circles (see Chapter 2 for more details about this and other drawing tools).

Although the following approach is useful for understanding the structure of the human head, it's a generalized method that's meant to supplement your drawing and observation skills. The heads you encounter or draw won't necessarily abide by this technique. In addition, these stages take time to execute. So if you're drawing from a live model for the first time, applying every stage isn't easy — unless the live model is able to stand still for at least an hour (not likely). In these cases, consider using the method in the later section "Drawing the head freehand from different angles."

Measuring proper proportions

Follow these stages to create the precise proportions of the head:

1. **Using a ruler, draw a straight line (approximately 3 inches) at the middle of your drawing paper and divide it into five spaces (as shown in Figure 4-5a).**

 Each division unit represents the width of one eye.

2. **Mark the center of the line with your pencil (approximately at the 1¹/₂-inch mark) and use it to draw a circle with your compass (see Figure 4-5b).**

 This circle represents the upper portion of the head. I refer to this circle as circle 1.

Figure 4-5:
Start to
build your
head with a
straight line
and a circle.

a b

3. **Establish the centerline of the head and the landmarks for the bottom of the face.**

 As shown in Figure 4-6, draw a vertical line approximately 5 to 6 inches long going through the centerline. Make the bottom portion (from the horizontal lines dropping down) longer than the upper. Use this line to align the center of the face when you place the nose and mouth.

Figure 4-6:
Create the
measure-
ment units.

4. **Use your ruler to measure one of the division units that represents the width of an eye (see Step 1) and use it to mark A, B, and C starting from the bottom outside of the circle, as shown in Figure 4-6.**

 A marks the bottom of the nose. B indicates the bottom of the lower lip (you use this mark later to find the location of the mouth). C marks the bottom of the chin.

5. **Start to draw the lower front section of the head.**

Measure and create the midpoint, D, between A and B so you can use your compass to draw a circle as shown in Figure 4-7. Make sure the bottom of the circle meets with C. This shape represents the lower portion of the head. I refer to this portion as circle 2.

The easy way to do this step is to start the circle by placing the needle point at D and placing the lead point at (and start drawing from) C. This is much quicker than guessing how wide of an angle you need to set the compass.

Figure 4-7:
Draw the lower portion of the head.

6. **With your ruler, find the midpoint between the center of circle 1 and the bottom of circle 1 (point A); label this midpoint E.**

 After marking E, draw a straight line across the circle to create points F and G (as shown in Figure 4-8). This line where the eyes rest should be parallel to the centerline right above it.

7. **Complete the outline of the head by drawing two slightly rounded arches for the right and left cheeks (extend from the left and right outer edges of circle 1) down to the chin (C).**

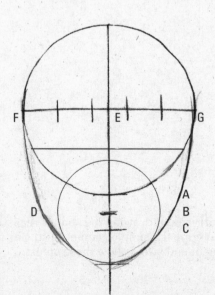

Figure 4-8:
Indicate the guides for the eyes and block in the cheeks.

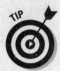

Use the roundness of the cheeks to control the age as well as the physical build of your subject. I make the cheeks of younger individuals rounder (I explain how to draw heads of different ages later in this chapter). I draw the cheeks angling outward for individuals who are muscular.

8. **Draw two lines for both sides of the neck to complete the basic head shape, as shown in Figure 4-9.**

Here are some key points to keep in mind when drawing the neck:

- The length of the neck from the ear down to the clavicle (collarbone) is about the same as the distance from the bottom of the chin to the eyebrows.

- For children and females, the edges of the neck curve in toward the center.

- For aesthetic purposes, I draw female necks slightly more elongated than the necks of males or children.

- Ideal necks on males are the same width as the head. Although I draw these lines vertically straight down, using a ruler isn't necessary.

- Heroic male necks (the Schwarzenegger types) start the same width as the head and bulge outward, away from the center of the neck.

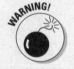

Don't make the common mistake of leaving the neck out of your composition when drawing the head. Compositionally, portrait artists will never crop out the neck; if they do, it looks like the head is floating in space with no foundation.

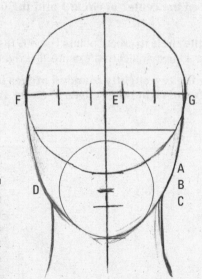

Figure 4-9:
Indicate both sides of the neck with two lines.

Adding simple facial features

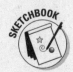

When blocking in the facial features, don't worry about drawing the shapes realistically (I cover these topics in Chapter 5). For now, just copy the simple geometric shapes that I use. Pay more attention to the accuracy of placement and size. Follow these steps:

1. **Use your ruler to lightly draw six vertical, parallel lines along the markings of the upper portion of the skull.**

 As shown in Figure 4-10a, draw the lines long enough that they stretch from above the head down past the chin (C). With this step, you now have five equally spaced sections, and each is the width of one eye.

 To make the remaining steps easier to follow, I label each segment with numbers 1 through 5.

2. **Use the spaces 2 and 4 to lightly block in the shapes for the eyes along the segment FG (as shown in Figure 4-10b).**

 For the purpose of this demonstration, I use a narrow almond shape as a place holder for both eyes.

 To ensure proper proportions, be sure that both tips of the almond-shaped eyes touch the vertical parallel lines.

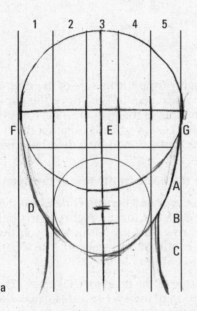
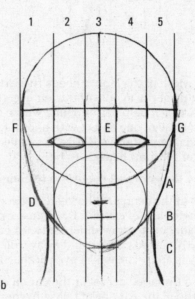

Figure 4-10:
Lightly draw
the vertical
guides and
the eyes.

3. **Draw the simple nose, as shown in Figure 4-11.**

 Draw a concave arc in section 3 to indicate the placement of the nose. Draw the arc right along point A.

 Make sure both edges of the arc are touching the left and right lines of section 3 to ensure proper proportions.

4. **Draw the simple mouth (see Figure 4-11).**

 To represent the mouth, draw a short line along point D. Make sure the line for the mouth is parallel to segment FG.

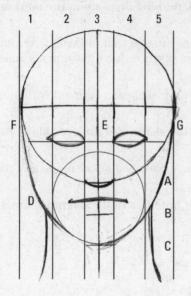

Figure 4-11:
Lightly
indicate the
nose shape
and locate
the mouth
position.

The width of the mouth needs to start roughly from the middle of the right eye and end roughly at the middle of the left eye. (In the next section, you draw the pupils of the eyes, which help better define where the middle of the eyes are.) I use a ruler when I want to align one object with another. In this case, vertically position the ruler where the center of the eye is. Use the same vertical position to then determine where the end of the mouth needs to be.

5. **Draw the ears and eyebrows to complete the basic front view of the head.**

 Start at the center of the head, between the eyes and between line E and the central diameter line of circle 1. Draw an arc over each eye for the eyebrow (in Chapter 5, I explain how to draw different types of eyebrow shapes). I draw the eyebrow shape slightly angled upward and away from the center of the forehead. The top of the eyebrow is approximately 1 eye width from the bottom of the eye.

 Add a C-shaped curve for the ear on each side of the head (see Figure 4-12). Make sure the top of the ear doesn't pass beyond the top of the eyebrow. Also, make sure the lower portion of the ear doesn't go beyond the bottom of the nose (point A). I remove most of the labels for visual clarity so you can see the final image.

Drawing the head freehand from different angles

When you're new to figure drawing, drawing the human head with the longer and more thorough method in the previous section is key; it helps you become comfortable with basic proportions and shapes. After you get the hang of the previous method, though, you can explore the shorter method to mapping out the basic proportions of the head. This shorter method gets the job done more quickly and also allows you more time to focus on other parts of the figure. (I use this approach when I draw from life or work on characters in graphic novels; I usually don't have time to flesh out specific measurements as thoroughly as I do in the previous section.) Although both approaches are great for beginners, the

approach in this section builds your drawing confidence because it forces you to rely on your own observation skills rather than a formula.

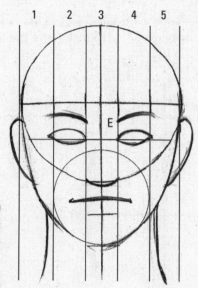

Figure 4-12:
Finish with the ears and eyebrows.

Try this approach to drawing the basic proportions of the human head. I cover three angles of the head (front, side, and rear view). For this method, you need only a soft drawing pencil (6B–8B) and drawing/sketch paper (acid free).

Although it takes some time getting used to, judging size and space relations without measuring everything trains your observation skills. Just keep practicing!

The front view

In my life-drawing class, I have students start with the front view of the head because it helps them see the head and its facial features without having to worry about drawing multiple sides of the head at once. Many beginners make the mistake of starting by drawing the head from complex or extreme angles and become frustrated as a result. Dealing with the head and its features as a flat, two-dimensional object on a flat piece of paper is more practical and efficient.

Because we have only one model per studio class, not everyone gets the front view. So I have students take turns posing for each other for ten minutes. (A longer pose is better, but unlike professional models, mortals can't sit still for long without going crazy!)

Follow these steps to draw the front view of the head freehand:

1. **At the center of a fresh sheet of drawing paper, draw an oval shape that somewhat resembles an upside down egg (I refer to this shape as oval 1; see Figure 4-13a).**

 Don't make the head too large. I keep the initial shape no more than 4 inches tall. Throughout these stages, you need to visually assess measurements without using the ruler. The larger the shape, the more difficult it is to make those quick visual judgments. See the sidebar "When in doubt, start small" for more info.

2. **Draw a horizontal line and a vertical line to form a "cross" shape (as shown in Figure 4-13b).**

Roughly divide the shapes evenly. These lines provide a sense of which direction the head is facing.

If you have trouble making the initial oval in Figure 4-13a symmetrical, don't panic yet. Use the dividing cross-hair lines, as shown in Figure 4-13b, to make sure the left and right are as equal as possible.

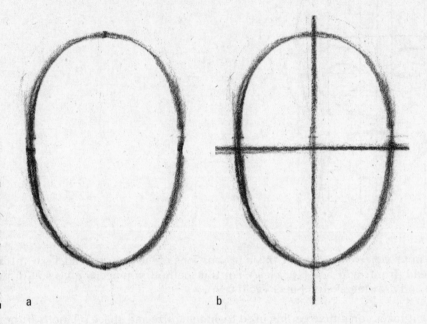

Figure 4-13:
Draw the basic shape and lightly sketch the center guidelines.

a b

3. **Draw the eyes and eyebrows along the horizontal guideline (see Figure 4-14).**

I place one small circle on each side for the center of the eyes. These circles represent the pupils of the eye, and I draw them roughly at the midpoint between the vertical centerline and the edge of the head.

Lightly draw an arc above the center of each eye. The width of the arc should be no more than approximately $1/5$ of the width of the head.

Finally, draw another slightly larger arc above each eye to indicate the eyebrow shape. Make sure each arc slightly angles down toward the center of the guidelines.

Because we identify so closely with our face and facial features, a lot of people make the common mistake of assuming that the face accounts for the entire front of the head. This happens especially in the initial stages of drawing the head without the hair (which I discuss in Chapter 6). As a result, students place the eyes much higher than they should be, intruding into forehead territory. Although the eyes are drawn at the midpoint of the head, keep in mind that the hair covers up to $1/3$ of the top portion of the head, creating the appearance that the eyes are higher toward the top of the head. The face is approximately the same size as the height of the spread hand. Place your hand in front of your face for size verification, and then identify where your eyes are in relationship to the height of the hand. This technique will help you better assess where the eyes need to go.

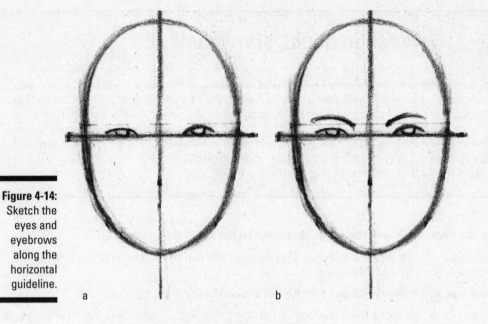

Figure 4-14:
Sketch the eyes and eyebrows along the horizontal guideline.

a b

4. Draw the simple nose and mouth.

As shown in Figure 4-15a, draw a small concave arc for the nose so that the bottom of the arc is approximately halfway between the bottom of the chin and the top of the eyes. Make the width of the concave arc approximately 1 eye width.

Indicate the mouth shape with a line, as shown in Figure 4-15b, halfway between the bottom of the nose and the bottom of the chin. Make sure you place the line shape for the mouth symmetrically along the vertical guideline.

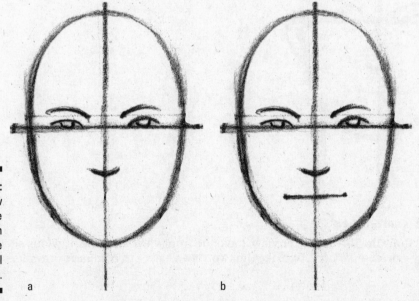

Figure 4-15:
Lightly draw the nose and mouth along the vertical guideline.

a b

When in doubt, start small

Many beginners assume that drawing large on an 18-x-24-inch drawing pad is *always* the best way to start studying the figure accurately. The fact of the matter is that human hand-eye coordination is strongest when your drawing is no larger than the size of your hand. The smaller the object you draw, the more accurate and comfortable you'll feel drawing it. I can prove this theory to you right now. Take a few seconds to draw a series of even arcs that get progressively larger (start small — say about 1 inch). When the arc and wrist movements are small, your arcs are fairly even and smooth. As they get larger, your hand must move to accommodate the fact that your compact wrist movement can no longer handle the size of the object. The result is a series of uneven and asymmetrical arcs.

5. **For the ears, draw a *C* shape on each side of the head (see Figure 4-16).**

 Make sure the top of the ear doesn't go beyond the top of the eye and the bottom of the ear doesn't go past the nose.

6. **Draw two short parallel lines for the neck (see Figure 4-16).**

 Start to draw each line from the bottom of the *C* ear shape on both sides. The length of the line should be ½ the length of the head.

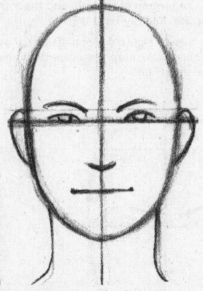

Figure 4-16: Draw the ear and neck shape to finish the front view.

The three-quarter view

When you draw the three-quarter view, have the front view from the previous section ready for side-by-side comparison. To make the two views easier to compare, draw lines dividing

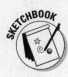

the head into thirds. I label the lines from top to bottom: A, B, C, and D. These guidelines also help ensure that my drawing sizes are consistent within each viewpoint.

Follow these steps to draw a three-quarter view of the head:

1. **Between lines A and C, draw a slightly elongated oval (see Figure 4-17).**

 I refer to this oval as oval 2.

2. **Draw five vertical guidelines, using your ruler, to divide oval 2 evenly (as shown in Figure 4-17).**

 I label the guidelines from one through five. Three is the midpoint of oval 2.

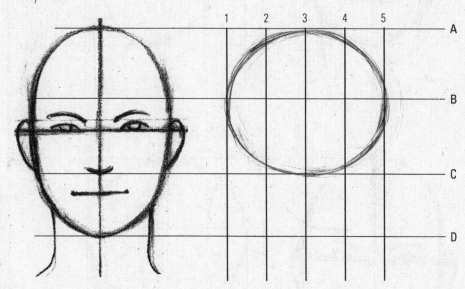

Figure 4-17: Starting the three-quarter view of the head.

3. **Lightly sketch the upper jaw (maxilla) and lower jaw (mandible), as shown in Figure 4-18.**

 Lightly sketch a diagonal guideline from the top of intersection 1B to line 2 at the midpoint between C and D. This diagonal line gives you the angle and position of the maxilla. The mandible starts from the bottom of the chin at line 4 and curves up to connect with the maxilla at the midpoint of the horizontal guidelines C and D.

4. **Draw an _S_ curve line to separate the front and side planes of the head, as shown in Figure 4-19.**

 From the top left of the back of the cranium, draw the first curve, which meets at B2, to indicate the top side plane of the head. Complete the rest of the _S_ curve guideline, which angles down and to the right, to connect at C2 before continuing on its path toward the bottom of the chin at D3.

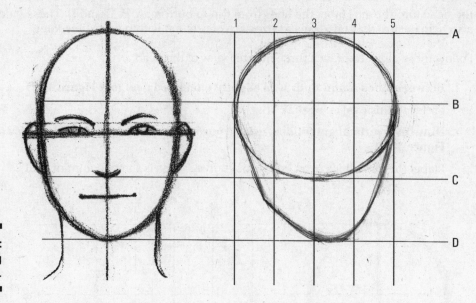

Figure 4-18:
Sketching
the jaw.

Figure 4-19:
Completing
the outside
edge of the
head.

5. **Lightly sketch the cross-hair guidelines for the facial features (as shown in Figure 4-20).**

 Lightly sketch a slight convex arc that stretches across the midsection between lines B and C to align the placement of the eyes. The eye level is close to the level of the eyes from the front view of the head.

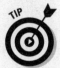

Slightly lift the end of the curve closest to you higher than the end of the curve that's farther away from you. Although this lift is subtle, it gives the overall features a more dimensional and realistic positioning that's consistent with the rule of the perspective theory (I talk about perspective in depth in Chapter 14).

Draw a second subtle arc that vertically connects between lines 3 and 4, from the top to the bottom of the head, to align the placement of the nose and mouth.

Figure 4-20:
Adding
cross-hair
guidelines.

6. Lightly block in the facial features.

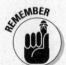

The facial features you draw in the three-quarter view are the same as the features you draw in the front view (see the previous section). However, the size and alignment of the individual features are different due to the slight transition in perspective that happens between the side and front planes. These slight differences remind you that the head isn't a flat object.

I use the front view of the head (from the previous section) to block in the placement of the features. I recommend starting with the eyes and eyebrows (as shown in Figure 4-21), followed by the nose and the mouth (as shown in Figure 4-22). Here are key points to keep in mind:

- The features on the side of the face closer to the viewers are slightly larger and wider than the features on the side of the face farther away from the viewers. Although you don't see the details, the lips and the nostril closer to the viewers are larger and wider to match the shift in the eye scale proportion and seemingly off-centered placement. Drawing objects that are closer to the viewers larger than the objects that are farther away creates depth.

Figure 4-21:
Drawing in
eyes and
eyebrows.

- Use space between lines 3 and 4 as you center most areas of the face.

- When you look at the three-quarter angle, you see that the eyes tilt downward slightly.

- When you look at the three-quarter angle straight-on, you see that the bottom of the chin as well as the mouth tilt at a slight upward angle to accommodate the perspective of the front plane of the face.

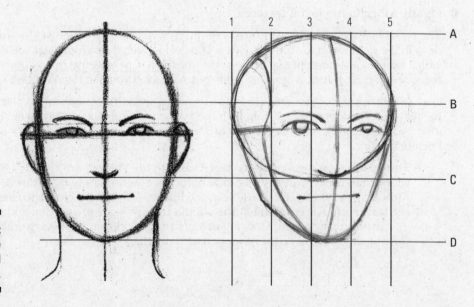

Figure 4-22:
Drawing the
nose and
mouth.

7. Draw the ear shape (as shown in Figure 4-23).

The top and bottom of the *C* shape ear line up with the horizontal top of the eyebrows down to the bottom of the nose respectively.

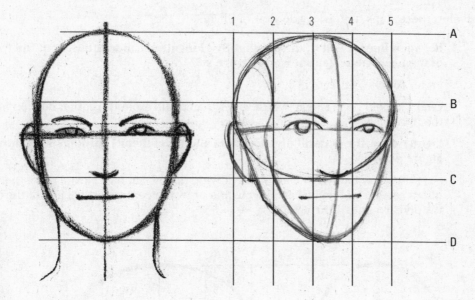

Figure 4-23: Drawing the ears.

8. Complete the three-quarter view of the head by drawing the lines for the neck, as shown in Figure 4-24.

I draw both curving lines of the neck at an angle for a more natural head position. In addition, I taper the ends curving away from each other. The neck curve at the back of the head intersects at the base of the ear. I draw the front of the neck curve aligned with the right side of the nose.

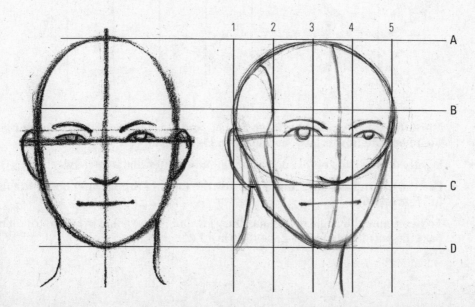

Figure 4-24: Sketching in the neck.

The side view

When you draw the side view, have either the front and/or the three-quarter view from the previous sections ready for side-by-side comparison. Use the dividing lines from the section on the three-quarter view.

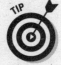

Follow these steps to draw a side view of the head:

1. **Between lines A and C, draw a slightly elongated oval to the right of the front view of the head model (as shown in Figure 4-25).**

 I refer to this oval as oval 3.

 Oval 3 should be ½ a head width wider than oval 1 from the earlier section on drawing the front view.

2. **Lightly draw the vertical division lines and label them 1 through 5 (as shown in Figure 4-25).**

 I use the brow line, B, to horizontally divide the oval in half. Next, I mark the vertical quarter marks of the oval and locate and draw the center vertical line of the oval. Label the division lines 1 through 5.

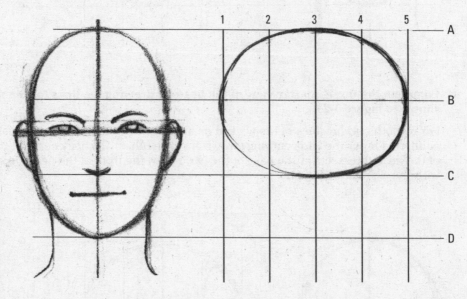

Figure 4-25: Draw the elongated oval to start the side view of the head.

3. **Mark the halfway point between lines C and D where the maxilla (upper jaw) meets the mandible (lower jaw), as shown in Figure 4-26.**

 Lightly draw a horizontal line to indicate the center distance between lines C and D.

4. **Use the quarter marks 2 and 3 to draw the maxilla (upper jaw) bone line (as shown in Figure 4-26).**

 To determine the angle of the maxillary jaw line, draw a line from the top of mark 2 past the bottom of mark 3. Label this line EF.

Figure 4-26:
Measure
and draw
the angle of
the maxilla
jaw line.

5. **Draw the front of the face (as shown in Figure 4-27).**

 From the right edge of the oval (mark 5), lightly draw a line that starts at line B and
 very slightly curves in toward the left until it meets line D. Notice that the bottom of
 the chin matches the level of the chin from the front view of the head.

 Don't overdo this curve. The degree to which the front of the face curves in isn't
 extreme.

6. **Connect the bottom of the maxilla with the front of the face to form the bottom of
 the jaw (mandible), as shown in Figure 4-27.**

 From point F, draw a diagonal line to connect with the bottom of the front of the face
 along line D. For now, don't worry about the appearance of the pointed chin. Just be
 aware of the angle of the bottom of the jaw.

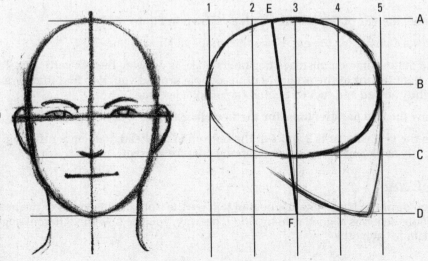

Figure 4-27:
Draw the
front of the
face and
complete
the lower
portion of
the profile
head.

7. **Draw the eyes, nose, and mouth features (see Figure 4-28).**

Draw a slightly skewed triangle for the eyes approximately $\frac{1}{2}$ an eye width below line B.

Think of the profile of the eye as an arrow-shaped triangle with the bottom right corner sliced off.

For the nose, draw a 30-degree angle down and away from the head, starting at the same level of the top of the profile eye. The line continues to line C. To complete the nose, draw a 45-degree line to intersect with the front of the face.

Finally, use the same mark between lines C and D to locate the mouth position. I use a simple short line (make sure it doesn't go past the eye).

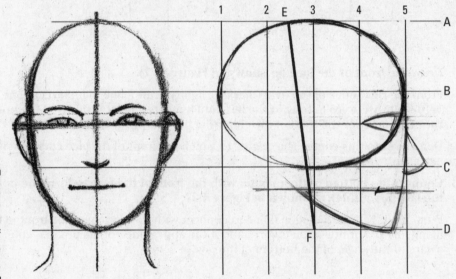

Figure 4-28:
Draw the main facial features of the profile head.

8. **Sketch the ear of the profile head, as shown in Figure 4-29.**

Draw a *C* shape for the ear. Place this shape flush with line EF.

One of the common mistakes beginners make is drawing the ear vertically. Take a moment to look at the profile of other people around you. You find that ears are slightly angled and tucked behind the maxilla jaw line.

9. **Draw the two parallel lines for the neck (see Figure 4-29).**

Use the vertical marks 2 and 4 at the bottom of the head. Remember that the neck is slightly at an angle even when the body posture is erect.

The back view

When you draw the back view, it's helpful to have the front or side views of the head from the previous sections aligned side by side. This way, you see how the different angles of the head relate to each other.

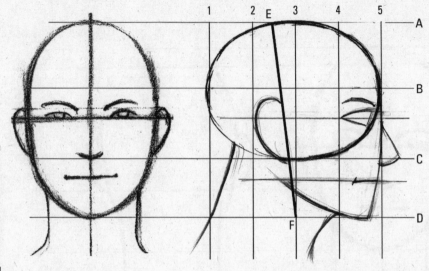

Figure 4-29: Sketch the ear and neck to complete the head profile.

Try your hand at drawing the back view of the head by following these steps:

1. **Sketch the same oval head shape you use to draw the front side of the head (as shown in Figure 4-30).**

 I call this oval 4; draw it to fit within the confines of lines A and D. Be sure the top and bottom of the oval touch the guidelines. Be sure to extend all guidelines (A through D) into the oval.

2. **Between lines B and C, draw a *C* shape for the ear on each side (as shown in Figure 4-30).**

 Make sure the top of the ear doesn't touch line B; it should be level with the top of the eye. I use the eye from my profile head as a reference.

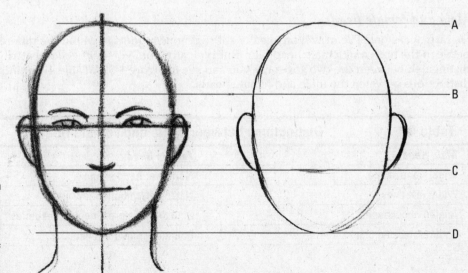

Figure 4-30: Draw the ears for the back view of the head.

3. **Draw the neck lines to complete the back view of the head (see Figure 4-31).**

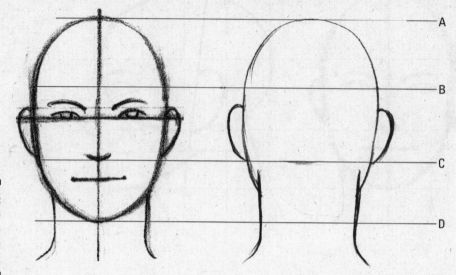

Figure 4-31: Draw the neck shape to finish the back view.

Drawing heads of different genders and ages

Not all heads are created equal. In the following sections, I provide tips on tweaking your basic head shape drawings to depict men and women, and I list general key physical changes to the human head that occur throughout the developmental stages.

When you draw people of different genders and ages, it helps to observe your public surroundings (people watching, if you will). See Chapter 15 for ideas on places for studying and drawing the figure.

Male and female heads

On rare occasions, I've drawn physically androgynous models in whom the differences between the male and female head blur. But typically, some distinct general attributes help distinguish between the two sexes (as you can see in Figure 4-32). Table 4-1 points out the distinctions between the male and female heads.

Table 4-1	Distinctions between Male and Female Heads
Male Head	*Female Head*
Wider head shape	Narrower head shape
Wider jaw lines	Narrower/smoother jaw lines
Angled cheekbones	Rounder/less prominent cheekbones
Square/chiseled chin	Rounder/smoother chin

Male Head	Female Head
Narrow/smaller eyes	Rounder/larger eyes and longer eyelashes
Wider/larger nose	Thinner/smaller nose with smaller nostrils
Thinner/smaller lips	Fuller/larger lips
Wider/shorter neck	Thinner/longer neck

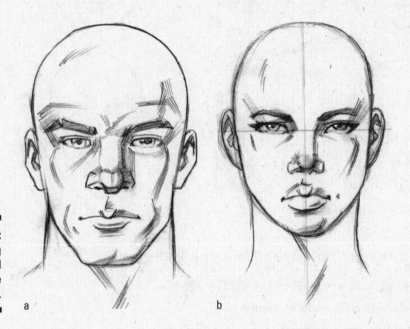

Figure 4-32: Comparing male and female heads.

a b

When emphasizing the differences between the sexes, I recommend experimenting with *slightly* skewing the circle you initially draw for the shape of the top of the head (if you're using measuring tools) and making the overall oval shape slightly thinner (if you're drawing freehand). Make the circle wider for the male and narrower for the female. Don't overdo the skew — you'll lose the overall proportion of the head.

A timeline of different ages

In this section I give you some ideas for observing and tweaking your head shape drawing to portray an array of ages. Use Figure 4-33 as a timeline guideline.

Babies (see Figure 4-33a) have the following traits:

- Significantly larger upper skull mass compared to the rest of the head (approximately 65 to 70 percent of the head)
- Larger forehead space as opposed to the lower half of the head where the rest of the features almost appear to be crammed
- Very round cheeks
- Eyes, nose, and mouth have yet to develop
- Neck is barely visible until the first year

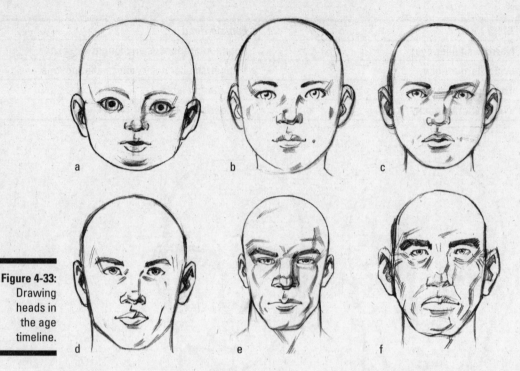

a b c

Figure 4-33:
Drawing
heads in
the age
timeline.

d e f

Children (see Figures 4-33b and 4-33c) have the following traits:

- Face grows narrower (well established by age 12)
- Jaw and chin become more prominent
- Bridge of the nose is defined
- Distinct hairline along the top of the forehead
- Size of the ear is larger and close to being fully formed by age 12
- Females have a rounder chin and slightly wider eyes than males

Teenagers (see Figure 4-33d) have the following traits:

- A larger lower portion of the head accommodates the growing facial features
- A more defined chin (still retains the roundness from "baby fat")
- Eyes, nose, and mouth are fully formed
- Jaw and cranium develop, making the ear appear smaller
- Neck muscles begin to develop but the differences between the sexes aren't drastically different
- Females have fuller lips and higher foreheads (they mature earlier than males)

Young and mature adults (see Figure 4-33e) have the following traits:

- A fully formed lower portion of the skull in the young adult (late teens to early 20s)
- More defined jaw, chin, and cheekbones (at this stage the male and female structures grow distinct)
- Shapes and corners around the eyes and mouth begin to droop, sag, and wrinkle as the adult ages
- The beginnings of sagging skin in the cheek muscles around the cheekbones
- The overall shape of the nose begins to grow rounder
- Neck muscles become significantly different between male and female

Senior citizens (see Figure 4-33f) have the following traits:

- The lower portion of the skull begins to contract
- Cheekbones continue to sag
- The corners of the eyes and mouth droop
- Ears and nose shape expand
- Chin shape contracts

Chapter 5

Adding Facial Features

It's time for an exciting feature presentation — the face. In this chapter, you discover how to draw those distinct characteristics that help others identify you as . . . well, *you!* I explain how to draw the eyes, nose, mouth, and ears.

In this chapter, I explain how to draw each individual feature, and then I show you how to put all those features together on the head. If you're new to drawing facial features, I recommend first reading Chapter 4 on drawing the head. From my experience, it's important to have an understanding of the foundation upon which the facial features rest. Think of the head as a canvas and the facial features as the actual painting. No matter how beautiful the actual artwork is, if the canvas isn't prepared properly, the artwork may not last as long. In addition, if you aren't familiar with drawing basic geometric shapes, you need to read Chapter 3 before continuing on.

Keeping Your Eye on the Prize

There's a saying that the eyes are the windows to the soul. People establish meaningful communication through proper eye contact. Even pets, like dogs and cats, can't help but look into your eyes when seeking attention. It's no wonder that drawing the eyes is such a fascinating and popular part of building the figure! Take time in this section not to lose sight of how amazing the eyes are.

Beginning with the basic eye structure

In this section, I walk you through the steps to drawing the basic front view of the eye from start to finish. (I go over the three-quarter and side views later in this chapter.) I show you how to approach the eyeball, the iris, and the pupil, followed by the lids, lashes, and brows.

The eyeball

The eyeball is essentially a spherical object that's tucked into each eye socket in your skull. Don't worry about making the shape perfectly circular; you'll later cover about half of the entire structure with the bottom and upper lid shapes.

Although I don't have any problem with students resorting to using circular object templates (such as a cap or lid) to create the eyeball, I strongly encourage you to take the plunge of faith and draw it freehand. Drawing freehand builds not only confidence in the way you handle your drawing tools, but also speed (after all, who wants to lug around all those templates everywhere you go just so you can draw a "perfect" eyeball?).

Drawing the eyeball itself is a snap. I make the size of the eyeball shape approximately 1 inch wide. The diameter of an infant's eye is small (18 mm versus 25 mm for an adult), but the eye grows rapidly during the first years of development. At the center of your drawing paper, lightly sketch a sphere and a cross-hair guideline to locate the center of the basic eyeball structure, as shown in Figure 5-1. Keep the pencil cross-hair lines light. Doing so ensures that the darker lines you later draw for the rest of the eye structure stand out.

The iris and the pupil

When you identify someone's eye color, you look at the color of their iris. The pupil takes on a dark and almost black appearance, which is, for the most part, universal among humans.

Think of the iris and the pupil as two separate, overlapping disks; the pupil is the smaller disk that rests above the larger iris. Follow these steps to draw them:

1. **Draw a large circle for the iris at the center of the eyeball.**

 The circle should occupy approximately half the diameter of the eyeball, as you see in Figure 5-2a. The space between the iris and the outer edges of the eyeball should be roughly the same.

2. **With a blunt soft pencil, lightly shade the iris with an even gray tone, as shown in Figure 5-2b.**

 As I demonstrate in Figure 5-2 when I shade in the iris, the blunt tip of a soft pencil is great for delivering smooth shades of gray. The larger the area you need to shade, the easier it is to use a duller and softer pencil tip. (See Chapter 2 for details on drawing tools.)

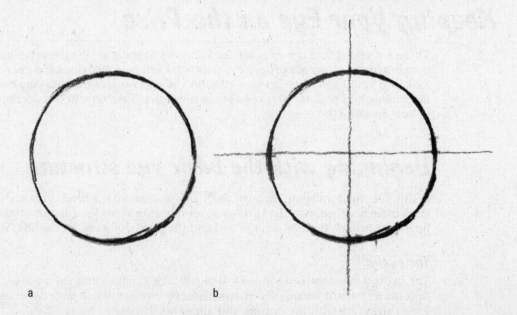

Figure 5-1:
Drawing the eyeball and cross-hair guidelines.

a

b

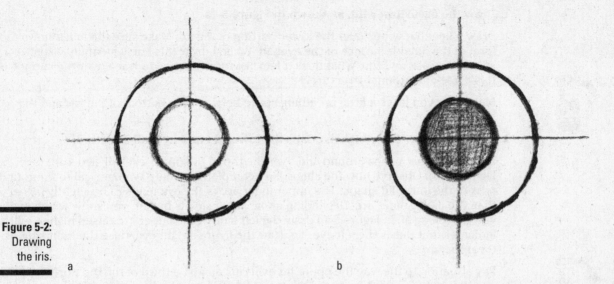

Figure 5-2:
Drawing
the iris.

a b

3. **Draw a smaller circle for the pupil at the center of the larger circle from Step 1.**

 The diameter of the pupil should be approximately half the size of the iris that rests underneath (see Figure 5-3a).

4. **With a sharp soft pencil, darkly shade in the pupil.**

 Although Figure 5-3b indicates that the pupil rests on top of the iris, in reality, the iris is above the pupil. Think of the iris as the larger disk shape with a hole at the center that allows the pupil to peek through.

Figure 5-3:
Drawing the
pupil on top
of the iris.

a b

The lids, lashes, and brows

The lids, lashes, and brows wrap around the eyeball structure and help give the eyes realism and personality. Follow these steps to draw them:

1. **Draw the basic lower lid, as shown in Figure 5-4a.**

 Draw a line that wraps over the lower portion of the lid. Make sure the line follows the form of the outside surface of the eyeball. When I draw this line, I mentally visualize a sphere and ask myself, "What does it feel like for my pencil to trace over the surface of this three-dimensional structure?"

 Make sure you leave a little breathing space between the bottom of the iris and the bottom lid.

2. **Draw the upper lid, which overlaps the lower lid and eyeball structure.**

 Draw a line that wraps around and over the top of the upper eyeball structure (see Figure 5-4b). Observe how the shape isn't completely evenly symmetrical to the roundness of the lower lid shape. The upper inner arc of the eye tends to be slightly *higher* than the upper-outer arc. Depending upon which side is higher, you know which eye you're looking at. In Figure 5-4 I draw the left side of the upper arc raised higher, which indicates that this is the left eye. To draw the figure's right eye, raise the right side of the upper arc.

 Pay attention to the way the upper lid overlaps almost a third of the top portion of the iris. In fact, it comes close to touching the pupil. Depending upon the individual, some upper lids actually touch the top of the pupil.

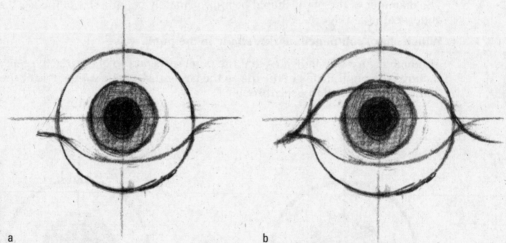

Figure 5-4:
Drawing the
lower and
upper lids.

a b

3. **Lightly draw the eyelash shape and darken the upper lid as well as the edges of the lower lid.**

 Don't draw eyelashes like spider legs shooting evenly out of all sides of the eye. When you're drawing the eye from even a short distance away from the model, eyelashes cluster together to form an arc shape that's darker and thicker on the upper lid (especially toward the outer ends, as shown in Figure 5-5a).

 In this figure, I make the eyelashes a bit thicker (typically associated with drawing the female eye). For added effects, I draw the pointed shapes around the outer edges of the eyelashes on both the upper and lower lid. (For male eyes, I keep eyelashes to a bare

minimum. In lieu of drawing eyelashes on the male, I slightly thicken the upper eyelid structure — be careful not to make the line too thick in case it's mistaken for eye-shadow makeup!)

For creating softer and more realistic eyelashes, soft vine charcoal sticks work especially well.

4. **Use the natural oils of your fingertips to gently smudge or soften the edges of the eyelashes (see Figure 5-5b).**

Don't press too hard with your fingers! You don't want to completely rub away too much of the shape. You can also mold your kneaded eraser to create an end tip to use instead of your finger.

5. **Use the sharp point of your soft drawing pencil to add the sharp, darker lines for the details of the eye structure (as shown in Figure 5-5c).**

These dark lines, which some artists refer to as "accents," represent creases where two forms tightly press against one another. In Figure 5-5c, I go over the thinner lines to darken the upper lid.

In addition to darkening both ends of the lower lid, I add an additional short line on each side, slightly below the lower lid line, to indicate the top plane of the lower lid. Pay special attention to the short line I draw on the right side of the outer edge of the lower lid; it extends slightly past the lower eyelash shape. These lines are essential in creating the illusion that the lids of flesh that cover the eye structure aren't flat (even though the drawing itself is flat).

To complete this step, draw a short curve at the inner eye that connects with the top and bottom eyelid. This line completes the tear duct, which you can see in the mirror when looking closely at your face.

6. **Sketch the eyebrows and shade in areas of the eye for an added realistic effect.**

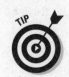

As shown in Figure 5-5d, first lightly sketch the basic eyebrow shape. Then gradually apply stronger shading toward the inner eyebrow to commit to a darker value.

Observe the tilt at which the eyebrow angles down toward the center of the forehead. Try to avoid drawing the infamous "elbow macaroni" eyebrow!

For added realism, I gently shade the upper lid below the eyebrow. This step establishes the illusion that the upper eyelid protrudes forward in front of the eyeball. To top things off, I use the end tip of a kneaded eraser to bring out the round highlight in the eye. This trick gives the eyeball a glossy, wet texture. You can also use the end corner of a rubber eraser or even the end tip of an eraser from a regular office pencil.

7. **Lightly draw three lines to show where the upper lid rests comfortably in the eye socket (see Figure 5-5e).**

Use the side and top round edges of the eyeball sphere as a guide to place the side and top lines of the upper lid.

The key to getting this shape right is to have both sides of the upper lid slightly angle inward. Pay attention to the way the top plane of the upper eyelid angles slightly upward toward the eyebrow.

Before moving on, erase the circle edges of the original eyeball shape.

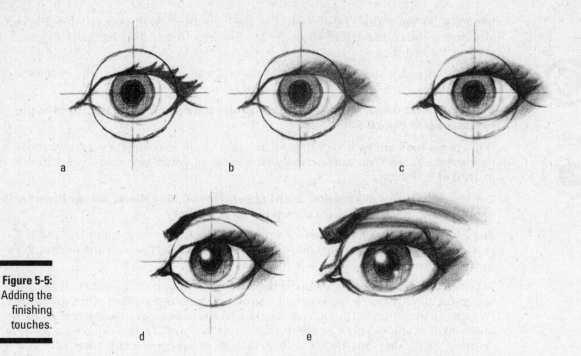

Figure 5-5: Adding the finishing touches.

Drawing the eyes from different angles

After you know how to draw the eye from the front, you can explore how the eye looks from different angles. Notice how the shapes of the eyeball sphere skew slightly from the perspective.

Figure 5-6 shows you how the shapes that you draw from the front view change in the three-quarter and side views. Pay close attention to these differences:

✔ As the angle of the eye shifts from the center toward the side, the shape of the iris and pupil appears to narrow (see Figure 5-6a). You also get a better view and sense of how the upper and lower lids wrap around the eyeball. To draw the lid from this angle so it appears to wrap convincingly around the eyeball, I shift the dip of the curve of the upper and lower lids toward the angle the eye is facing.

In this case, because the eye and head are angled slightly toward the left, I move the dip of the curve of both the upper and lower lids from the center of the eye toward the left. From the three-quarter angle view, draw the eyelash shape so it curves from underneath the upper lid toward the direction the eye is turned.

Although the eyelash shape shifts from the outside edge toward the center left, the lashes aren't physically moving from one end to the other. Eyelashes are attached all around the edges of the upper and lower lid. But as the perspective of the eye changes, you see *less* of the eyelashes that are attached to the edges of the upper and lower lid facing toward you and *more* of the eyelashes that are attached to the edges of the upper and lower lid facing away from you.

✔ From the side view in Figure 5-6b, the iris and the pupil take on an even slimmer, narrower shape. The iris shape protrudes out in front of the eyeball like a rounded button.

The shapes that rest on top of the eye aren't flat like an image painted on a wall — all these shapes have mass. From the side view, the eyebrows angle down and taper off to a point right in front of the upper eyelid.

Avoid making the common mistake of drawing a short straight line or a symmetrical N-shaped curve for the eyebrow. This flattens the shapes of the brow ridge and eyeball.

The top of the upper lid shoots out more in front of the lower lid. Watch the way the eyelashes curl slightly upward from underneath the upper eyelid; most students make the mistake of drawing the eyelashes starting from the front of the upper lid.

Figure 5-6:
Studying the three-quarter and side views of the eye.

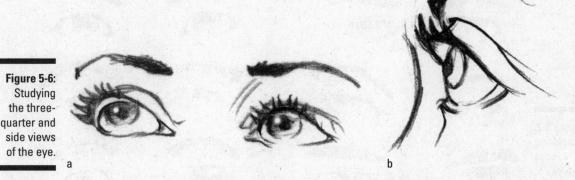

a b

Here's a killer tip that I use in drawing eyes from different angles. Note that the upper lid resembles a banana or a rounded boomerang. This shape changes to conform to the angle of the eyeball. *Try drawing this shape first, before drawing the rest of the eye structure.* This approach helps you align the position of one eye with the other eye at the front of the face and establish a consistent and accurate perspective shape. Think of this shape as a direction arrow for the eye gaze. In Figure 5-6a, the position of the banana-shaped upper eyelid is to the upper left of the eyeball structure, reflecting the direction of the eye gaze. As the eye keeps turning, the shape of the boomerang narrows in width. In Figure 5-6b, the boomerang shape, while still there, is barely recognizable. When you draw this shape from the three-quarter angle, compare the overall boomerang-like crescent shape to the hood shape of the upper lid. The lashes should mimic the shape of the hood of the upper lid.

Looking at eyes of all shapes and sizes

Everyone has different eye shapes. Use the following descriptions along with Figure 5-7 to compare just some of the many types of eye shapes:

- Narrow eyes (see Figure 5-7b, Figure 5-7c, and Figure 5-7e) convey a stern and mature personality (for example, adults).

- Eyes that are rounder with larger pupils (see Figure 5-7a, Figure 5-7d, and Figure 5-7f) convey innocence and youth (children and teenagers).

✔ Alter the thickness and thinness of the eyebrows to vary the level of attitude of your eyes (thicker brows suggest more masculinity and confidence while thinner ones suggest a more feminine and delicate persona). Figure 5-7a, Figure 5-7b, and Figure 5-7f show thinner eyebrows, while Figure 5-7c and Figure 5-7e show thicker eyebrows.

✔ Generally speaking, males (as I show in Figure 5-7e) have thicker, bushier eyebrows and less pronounced eyelashes than females (as you can see in Figure 5-7b).

✔ When the top lid is angled up and toward the center, it creates a more inquisitive or naïve personality (see Figure 5-7e). When the eyes angle down, as they do in Figure 5-7b, they appear more assertive and scheming.

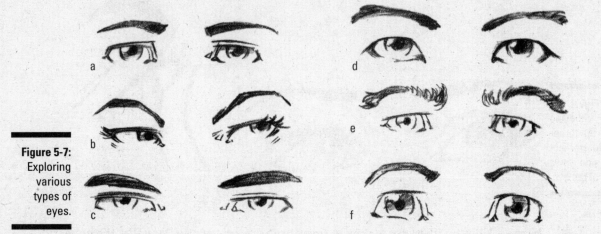

Figure 5-7: Exploring various types of eyes.

Getting Nosy

Although the appearance of the nose changes depending upon the angle at which the head is tilted, the basic structure that lies underneath is the same. Many beginning students are intimidated by drawing the nose because so many variations exist. The most common mistake I see in beginning students is drawing only the sides of the nose base and adding in two oval circles for the nostrils. Without drawing in the overall foundation or structure of the nose, your drawings end up looking flat or, as I like to refer to them, pug-nosed.

In the following sections, I walk you through the process of drawing the nose's basic structure from the front view and explain how the three-quarter and side views are different. I also give you a sampling of different noses to observe.

Structuring the nose

In this section I help you build the basic nose shape. Start by building the bridge of the nose. Then create the top planes followed by the bottom planes of the nose. Without further delay, follow your nose!

Building the nose bridge

The bridge of your nose consists of three basic planes (two sides and one front). Most of this section isn't bone; it consists of cartilage that merges into the nose opening of the skull. Follow these steps to draw the bridge of the nose:

1. **Very lightly draw a center guideline for the bridge of the nose (as shown in Figure 5-8a).**

 Establishing a center guideline first helps you dictate how wide you want to set the bridge of the nose. It also helps you determine where to place the rest of the nose features. In Figure 5-8a, I draw a center guideline that's approximately 2 inches long. Don't make the nose too large; it shouldn't be larger than actual life size.

2. **Draw the edges of the top front plane of the nose bridge.**

 In Figure 5-8b, I draw the side edges at a slight angle. Make sure the lines are equidistant from the center guideline. Connect the bottom two ends of the lines so they intersect along the center guideline.

3. **Draw the side planes.**

 In Figure 5-8c, I add a slightly curved line on each side of the bridge. Note that the curved shape roughly mirrors the edges of the top front plane of the nose bridge.

 Although not visible from the front view, bear in mind that the overall front of the bridge of the nose angles toward the front. The nose isn't a flat, vertical surface! Depending on the type of nose, the degree of angle varies.

Figure 5-8:
Drawing the planes of the nose bridge.

a b c

Drawing the top planes of the nose head

The head of the nose has three basic top planes: the center plane (the "ball" of the nose) and the two side flaps. If your figure stands directly underneath a direct light source, these three planes face up toward the sky and therefore catch more natural light than the bottom nose planes. If you alter the light source so that it shines from beneath the nose, these top planes catch less light.

Follow these steps to draw the top planes of the nose head:

1. **Begin from the center of the top plane of the nose head by fitting in two narrow hexagonal shapes, as shown in Figure 5-9a.**

This portion, which I call the ball of the nose, is the highest point of the nose structure. I refer to it as the ball because of the overall round shape that appears under natural sunlight. Note that the bottom of the nose bridge acts as a "wedge" that fits between the two hexagonal shapes.

Pay attention to the way the sides of the hexagon facing each other are flatter than the outer side. This helps give the tip of the nose its "peak." It also establishes the short flat edge that the bottom center plane is attached to.

2. **Draw the side flaps of the nose, which look like the tip of a boot, as I show in Figure 5-9b.**

Observe that the bottom of this quadrilateral diamond-shaped flap slightly angles up toward the center of the nose. This gives you the room to include the bottom plane of the nose in the following section.

Figure 5-9: Drawing the top plane of the nose.

a b

Drawing the bottom planes of the nose head

As with the top planes from the previous section, three planes (the center and the two side nostril planes) make up the bottom section of the nose. Unlike the top planes, the bottom planes face the ground and are therefore darker than the top.

The value distinction between the top and bottom planes of the nose creates the illusion of a realistic three-dimensional nose on a flat, two-dimensional sheet of paper. (Flip to Chapter 3 for an intro to values.) As I show in Figure 5-10d, if the value of the top plane ranges between 1 and 2 on my 5-step grayscale bar, the value of the bottom plane is between 4 and 5.

Follow these steps to complete the basic nose structure:

1. **Use the width of the ball of the nose (from the top plane) as a reference point to draw an upside down symmetrical trapezoid, as shown in Figure 5-10a.**

Keep this shape short. Making this shape too long distorts the proportional balance of not only the nose, but also the rest of the facial features.

When the light source is cast down from anywhere above the nose, the section where the edges of the center plane meet with the edge of the ball of the nose is the darkest of the nose's shadows.

2. **For the nostril planes, draw a pair of diagonal lines that connect the bottom outside corners of the top side planes down to the bottom corners of the trapezoid shape (see Figure 5-10b).**

3. **To complete the nostril portion of the nose, draw a pair of thin triangles that rest flush along the bottom of the diagonal line that you draw in Step 2 (see Figure 5-10c).**

4. **Apply some shading to the final image (see Figure 5-10d).**

 Use a soft charcoal pencil to apply crosshatching shading to the side and bottom planes of the nose. I use my fingers to smooth out some of the texture of the paper and charcoal medium. I use my kneaded eraser to pull out the rim lighting of the edges of the underplane that's facing the light. This shading demonstrates just how important it is to indicate the distinction between the top and bottom planes of the nose.

5. **Clean up the final image of the nose by erasing the center guideline and softening the edges of the bridge of the nose (see Figure 5-10e).**

 I use my fingers to soften the edges. Where the front plane of the nose bridge meets with the left plane, I use my kneaded eraser to pull out the long highlight streak, which gives the illusion of a plane shift within the light.

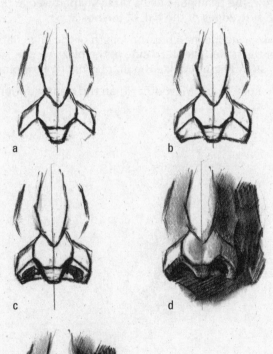

Figure 5-10:
Drawing the bottom planes of the nose.

Drawing the nose from different angles

After you know how to nose your way around the front view, you can explore the three-quarter and side views of your fine smelling friend. Because the nose varies so widely from person to person, take a moment to look at your nose in the mirror while you slowly rotate your head from the front vantage point toward the profile position. Use this quick exercise to compare the following points:

- The width of the receding half of the nose in the three-quarter view is narrower than the other half, which is closer to the viewer (see Figure 5-11a). The nostril is closer to touching the center bottom plane of the nose as a result of the narrow distance.

- Be sure to draw that slight bump on the bridge of the nose in the side view, as shown in Figure 5-11b (this bump indicates the juncture where the nose cartilage bones and nasal bone of the skull unite). To indicate this bump, draw a slightly curved line for the front of the nose.

- Although they may be less pronounced on one person than another, the bottom center planes sharply angle down and then back up toward the nostrils, as I show in the side view. For the underplane of the nose, draw a short, slightly angled curve that goes down toward the bottom of the nose at a 45-degree angle.

- Slip in the triangle-shaped plane between the front ball of the nose and the side planes. As I show in the side view, the triangle is like a pizza-shaped wedge that lodges between the side plane and the side edges of the ball of the nose.

The length of the sides of the pizza wedge matches the length of the edge flap of the nose and the edge of the ball of the nose. The third side of the pizza wedge, which faces away toward the head, is slightly curved like the pizza crust (try topping that!).

Without this pair of shapes, the nose in any view other than the front view looks flat.

Figure 5-11:
Showing the three-quarter and side views of the nose.

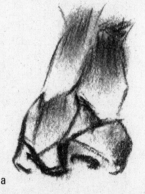

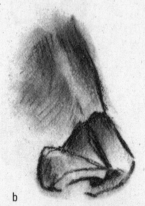

a b

Sniffing out noses of all shapes and sizes

Although you see many nose shapes, don't be intimidated — after all, they all share the same basic structure. When experimenting by drawing different types of noses, draw the center

guideline so you're aware of how wide you're making the bridge of the nose. Changing the width of the nose from the front view and the size of the bump on the nose bridge determines the uniqueness of the nose.

In Figure 5-12, I lay down various types of noses:

- ✔ Female noses generally are either straight or slightly curved upward (like a ski jump), as you can see in Figure 5-12a (front view) and Figure 5-12b (side view).

- ✔ Male noses have higher and more pronounced nose bridges as well as wider nostrils when compared to female noses (see Figure 5-12c and Figure 5-12d).

- ✔ Wider noses have more pronounced hexagonal edges at the tip (usually found in older or heavyset figures); see Figure 5-12e.

- ✔ Leaving out some of the bridge lines or side planes of the upper nose structure on younger faces (children and teens) is perfectly fashionable; check out Figure 5-12f.

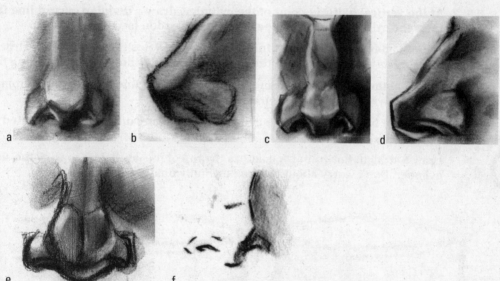

Figure 5-12:
Looking over various types of noses.

Mouthing Off

The mouth is probably one of the most overlooked structures of the face (second to the ears, which I cover later in this chapter). Some of my beginning students tend to think of the mouth as a symbolic line that curves up and down to show expression (in addition to the ubiquitous watermelon and *O* shaped openings). In actuality, the mouth consists of two sets of flesh (better known as the lips) that wrap around the upper and lower sets of teeth. Their function mirrors that of the eyelids, which wrap around the eyeball (as I explain earlier in this chapter). The noticeable difference rests in the fact that unlike the eye, in which the upper lid does most of the movement, the mouth's lower portion does most of the movement because it follows the dynamics of the lower jaw.

In this section, I walk you through the process of drawing a mouth from scratch. I also show you how to draw the mouth from different views and give you a few examples of mouths ranging in shape and size.

Taking a bite out of the jaw structure

Instead of drawing the upper and lower jaw starting from tooth to tooth, treat the upper and lower jaw as two flat, narrow, thin half cylinders that stack up on each other. After you get these two shapes down, adding the teeth is much easier. Try your hand at drawing the upper and lower jaw structures in the following steps:

1. **As shown in Figure 5-13a, draw a thin, flat cylinder (approximately 2 x 3 inches).**

 Because this is more or less a front view, draw the oval for the top plane of the cylinder narrow and elongated.

2. **At the vertical halfway point of the cylinder, draw a dividing curved line that separates the cylinder into the upper and lower section (see Figure 5-13b).**

3. **At both ends of the cylinder, indicate the angled position of the teeth structure by drawing an angled line from the top of the cylinder down to the dividing line.**

4. **Draw another angled line from the center dividing line back to the bottom corner of the cylinder (as shown in Figure 5-13c).**

5. **Delete the back portion of the cylinder jaw and any other stray, unwanted lines (see Figure 5-13d).**

 Draw a straight horizontal line across the top of the jaw before erasing the sides of the cylinder. Don't worry about drawing the individual teeth at this stage.

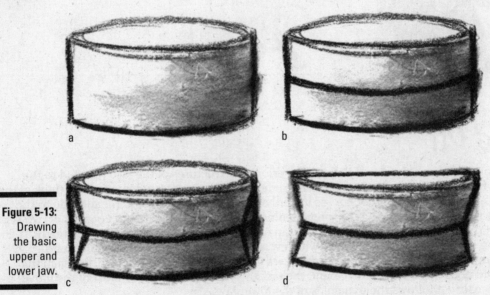

Figure 5-13: Drawing the basic upper and lower jaw.

Pucker up buttercup! Drawing lips

After you complete the basic structure of the jaw, it's time to pucker up those lips. In the following sections, I walk you through the basic steps of showing how to identify and draw the plane structures of the lower and upper lips.

The lower lip

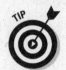

The lower lips generally receive more light than the overlapping upper lip structure. This is because the planes of the lower lip face the sky, whereas the upper lips face the ground. Try your hand (or mouth) at drawing the lower lips:

1. **Starting with the basic upper and lower jaw shape, draw the top of the lower lip that slightly arcs along the contours of the center line (as I show you in Figure 5-14a).**

 To give the lips a realistic feel, attach a sharp, short curve that angles downward at each end of the arc. Note that the arc doesn't completely mirror the teeth line where the upper jaw and lower jaw meet. In addition, the line doesn't go all the way across from the left to the right.

2. **Draw the lower arc of the lower lip shape (as shown in Figure 5-14b).**

 Here's where you dictate how "juicy" you want to make your lips. The lower and rounder you draw in this arc, the more you increase the sex appeal of the figure. For the purpose of showing how these lips can apply to both male and female figures, I keep the lower lip naturally thin (I know, I'm a party-pooper).

 Pay attention to the fact that both ends of the arc *don't* touch the top line. You want to leave a small gap.

3. **Draw a pair of diagonal lines to indicate the division of the lower lips (see Figure 5-14c).**

 The diagonal lines angle away from each other. Depending on where the light source originates, one of the three planes gets more light than the others. For the purpose of clarity, I label the front plane A and the two side planes B.

Figure 5-14:
Breaking
down the
lower lip
shape.

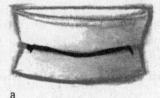 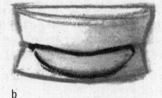 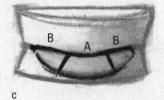

a · · · · · · · · · · · · · · · b · · · · · · · · · · · · · · · c

The upper lip

The upper lip has a three-plane structure similar to its lower lip counterpart. However, unlike the lower lip, which tilts up to receive light, the planes of the upper lip face down toward the ground. Hence, all three planes are darker. (A common mistake beginning art students make is misreading the reflective lighting under the upper lip and making the overall value too light.)

Follow these steps to draw the upper lip:

1. **Draw two concave curves that come together at the center point of the mouth to form a peak (see Figure 5-15a).**

 Note that while you start to draw both curves from the opposite ends where the top of the lower lip begins, both curves angle down to overlap the lower lip shape.

2. **From both ends of the mouth, as I show in Figure 5-15b, draw an *M* line (which can resemble a mountain or volcano depending upon your figure) to complete the basic shape of the upper lip.**

 The small "dip" I draw at the top of the upper lip is a short concave curve. This dip aligns with the center of the nose.

 Be careful not to make the upper lip too tall. Although the upper and lower lips have distinct shapes, the heights are approximately equal.

3. **Block in the basic geometric planes of the upper lips with two short diagonals that start slightly to the left and right of the "dip" and angle toward the center of the mouth.**

 As you see in Figure 5-15c, this shape resembles a keystone shape. I label the center plane C and the two side planes D.

4. **Apply shading to the upper and lower lips to show the separation in form (see Figure 5-15d).**

 Generally, the portions of the side planes labeled D appear darker than the center plane, C, because both planes recede back in space (around the jaw shape). Additionally, reflective light doesn't have much room to bounce back from the lower lip.

 When shading the lips, shade the darkest region before shading the lighter areas. After I shade in the D planes, I go on to shade planes C, B, and A respectively. Don't worry if you find one plane that appears to be too light after you're done shading all the planes; you can always go back and adjust the planes so the shaded values properly relate to one another.

 I also pull out a highlight shape that runs across the intersection corners where the left plane B meets with the center plane of the lower lip, A. In addition, I shade in the final dark cast shadow beneath the lower lip to give the overall structure realism (the contrast between the two extreme values pushes the lower lip forward).

5. **As I show in Figure 5-15e, use your kneaded eraser to clean away the cylinder guidelines.**

What a smile: Baring the teeth

The lower jaw is responsible for most of the mouth's natural movement (opening, closing, chewing). You're more likely to see the lower teeth rather than the upper teeth, because the upper lip stretches tautly across the upper teeth — hiding them — when the jaw drops loose naturally. However, when a person raises the lips and/or flares the nostrils to show emotion, the upper teeth peek behind the curled lip. The front teeth are also exposed when you smile.

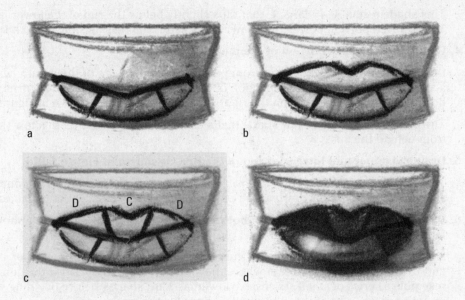

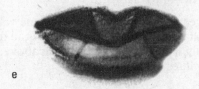

Figure 5-15:
Adding the
overlapping
upper lip
structure.

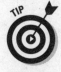

A common mistake when drawing the teeth inside an open mouth is counting and trying to draw each tooth. Teeth are individually formed, but trying to draw all those small shapes without first sketching the upper and lower jaw shapes is like pulling teeth (sorry, you have to grin and bear that one!). Ultimately, what makes a convincing set of teeth isn't so much defining each gap and every line of each and every tooth. Instead, lightly sketch the gum shape to suggest to viewers that all the teeth are there.

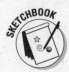

For this exercise, you need to first complete the previous section on drawing the basic jaw shape. Follow these steps (and take a look at Figure 5-16) to draw an open mouth with the teeth showing:

1. **Split the cylinder shape in half and angle the halves apart facing the front (see Figure 15-16a).**

 The top and bottom shapes of the cylinder are ovalesque due to the perspective.

2. **Draw a centerline going across the center between the upper and lower jaw shapes.**

 I mark the points with an X on each side to show where the upper and lower mouths connect.

3. **Start from point X on the left side and draw the lower portion of the mouth stretching down and across the lower jaw to connect back up at point X on the right side (as shown in Figure 15-16b).**

This shape resembles a large *U* that dips slightly below the rim of the lower jaw shape. The exposed portion of the lower jaw is the teeth, which are visible from this position.

4. Complete the upper portion of the mouth.

Draw a giant *N* shape that starts from point X on the left side of the mouth, wraps across and overlaps the front portion of the upper jaw shape, and then turns back down to connect at point X on the right side of the mouth (as shown in Figure 15-16c).

The portion of the upper jaw shape that's exposed is where the teeth show through from behind the lips.

5. Draw the upper and lower portion of the lips, as shown in Figure 5-16d.

The upper lip shape resembles two rounded mountains that taper off to a point on both sides. The lower lip dips down at the center to form a thin crescent or banana shape.

6. Draw the gum line at the top and bottom of the exposed jaw shapes (as shown in Figure 5-16e).

Lightly sketch the lines to indicate the separation of the teeth first (after all, it's important to have the two front teeth where they're supposed to be). Draw the gums so they resemble a series of small successive lowercase "m" shapes before deciding whether or not to erase or keep the light dividing lines for the teeth.

7. Shade in the values for the lips and inside of the mouth, and erase the guideline marks with a kneaded eraser (as shown in Figure 5-16f).

Even with the shape of the upper and lower lips stretched out, the same value assignments apply to the planes of both lips. As I show in Figure 5-16f, apply the darker values on the side planes, D and B. If the light source is coming from above, the overall value of the upper lip is darker than the values of the lower lip.

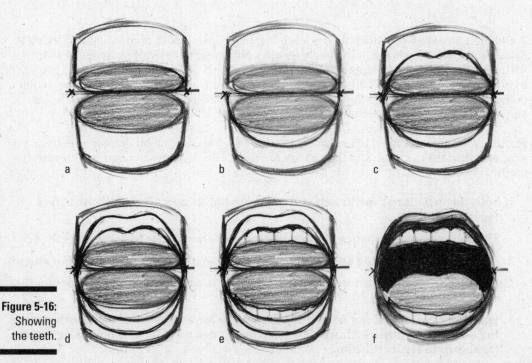

Figure 5-16:
Showing
the teeth.

Drawing the mouth from different angles

After you know how to draw the mouth from the front view, check out the way the upper and lower lips look from the three-quarter and side views in Figure 5-17. Here are some points to keep in mind when approaching these two angles:

✔ From the three-quarter view in Figure 5-17a, the side plane that's farther away is shorter in width than the side plane that's closer to the viewer. Also note that I slightly skew the shape of the lower arc for the lower lip. As the curve advances toward the viewer, the dip is slightly deeper and rounder.

✔ The side view in Figure 5-17b shows you more clearly how the top lip rests past the bottom lip. Also pay attention to the way the top lip angles inward (receiving less light) as opposed to the bottom lip, which angles outward (receiving more light).

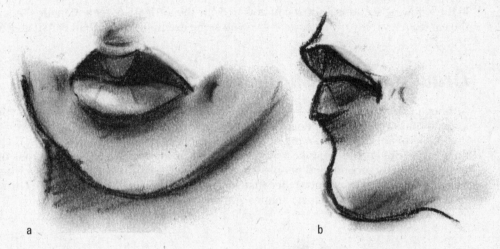

Figure 5-17:
Drawing the three-quarter and side views of the closed mouth.

a b

Checking out mouths of all shapes and sizes

In Figure 5-18, I demonstrate various mouth shapes and positions. Here are some basic mouth and lip movements and angles:

✔ Female lips (see Figure 5-18a) are fuller than male lips (see Figure 5-18b).

✔ Babies have smaller and shorter lips (see Figure 5-18c). The lower lip is fuller than the upper lip.

✔ Teenagers' lips grow wider than babies' lips, but the lower lip is still fuller than the upper lip for both females and males (as shown in Figure 5-18d).

✔ Lips tend to get thicker when the mouth puckers up (for example when giving a kiss); see Figure 5-18e.

✔ When drawing the open mouth from a profile view, draw the inside portion of the other side of the mouth as well as the rounder *C* shape curve for the mouth (as shown in Figure 5-18f).

✔ When drawing lips at a three-quarter angle, draw the side of the mouth that's facing away from the viewers shorter (as shown in Figure 5-18g and Figure 5-18h).

✔ When pouting, the lower lip sticks out while the corners of the mouth turn downward (as shown in Figure 5-18i).

Lending Your Ears

Ears are the most fascinating features to draw on the human head . . . and, in my opinion, probably the most overlooked feature of the head. Of course it would help if we only had eyes on the sides of our heads so we could see the full front shape of our ears every morning in the mirror! If you study your (or someone else's) profile, you may wonder how so many folds and details can be crammed into such a small shape.

In the following sections, I show you how to draw the intricate outer and inner shapes, describe the ear from a variety of angles, and give you some examples of different ear shapes and sizes.

Drawing outer and inner ear shapes

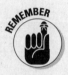

Although I show you, step by step, how to draw the basic ear in the following sections, bear in mind that rarely do two people have the exact same ear shape. My barber even tells me that my left ear is larger than my right (which explains my lopsided sideburns!). The next time you're out and about, take a moment to look around at all the various types of ears you see (I personally recommend people-watching at coffee shops and bookstores where people don't move around that much). Because of its uniqueness in shape and form, I draw an overall diagram to identify the basic shapes within the ear in Figure 5-19.

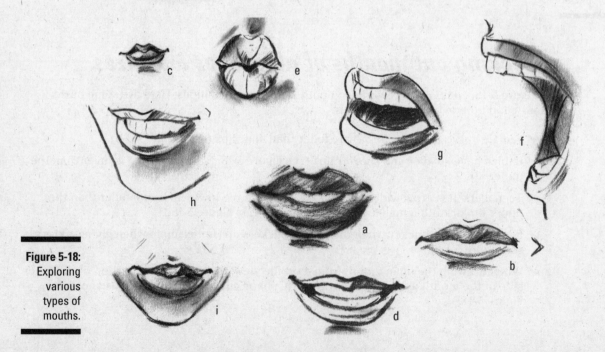

Figure 5-18:
Exploring various types of mouths.

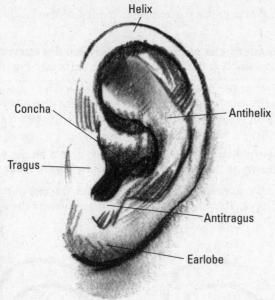

Helix

Concha

Tragus

Antihelix

Antitragus

Earlobe

Figure 5-19:
Looking
over the
basic ear
parts.

At this stage you don't need to memorize all the names and shapes; it's more important just to know that they exist. If you compare your ear with your next door neighbor's or best friend's ear, you'll likely notice the differences in shapes. For example, perhaps your neighbor has a larger earlobe than you do, while your best friend doesn't seem to have much of an earlobe at all! I know it all sounds a bit "eerie," but seeing a wide array of ear variations — smaller, larger, wider, narrower, and so on — is common. Many people overlook the fact that your uniquely shaped ear is what helps give your overall look its unique appearance. "Well," you say, "if there are so many different types of ear shapes, which one am I supposed to use as my default when I'm drawing the figure away from a live model?" The answer is simple — yours!

When drawing the ear for the first time, look at it in two basic sections:

✔ **The outer ear** is the outermost region of the ear and consists of the helix, earlobe, antitragus, and tragus.

✔ **The inner ear** group includes the antihelix and the concha.

Outer ear shapes

Think of the outer ear as the frame for a painting. All the smaller inner ear shapes must fit comfortably within the outer ear boundaries. I advise my students to take time when placing and drawing this shape (either on a drawing of the head or by itself). Make sure the placement of the basic outer ear shape is accurately established before fitting in the contents. Going through all the work to draw the inner ear shapes only to realize that the outer shape around it is too big or misaligned in relation to the head is frustrating.

Use the following steps to draw the outer ear shape (I show a left ear here):

1. **As shown in Figure 5-20a, draw a *C*-shaped curve for the outer helix shape.**

 Make sure this shape is slightly wider at the top and narrower toward the bottom.

Draw the *C* shape at a slight angle, because the ear rests alongside the jaw line, which is also tilted.

2. **Start from the opening of the outer helix and draw another, smaller curved shape (which almost resembles a *9*) to establish the inner side of the helix (see Figure 5-20b).**

 Make sure you leave a gap between the bottom of the inner *9* shape and the lower *C* shape. This gap ensures that your ear has a proper earlobe (where else are you going to place those fancy earrings?). In Figure 5-20b, the gap between the inner *9* and outer C shape is, for the most part, equally spaced.

3. **Between the left gap of the figure *9* curve, I draw a small reverse *S* shape to represent the tragus (commonly known as the ear tab), as shown in Figure 5-20c.**

 When drawing this small curve, I make sure that a gap separates the top of the reverse *S* and the figure *9* shape from Step 2. This shape sets up the placement of the antitragus.

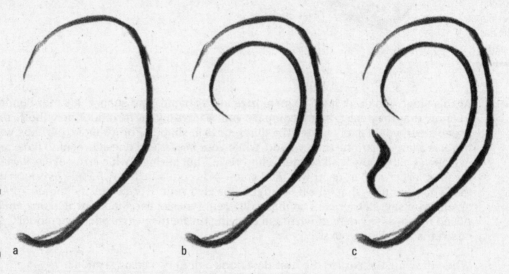

Figure 5-20: Drawing the outer ear.

a b c

When you draw the right ear, which faces the opposite direction, flip the direction of the basic shapes, starting with the *C* shape and *9* shape of the helix. Flip the reverse *S* for the tragus so it becomes a regular *S* shape.

Inner ear shapes

Most of the parts of the inner ear (with the exception of the tip of the midpoint of the antihelix) recede toward the inner side of the concha. When drawing the inner ear shapes for the first time, I advise my students to start drawing the lines of each step lightly. This way, they can easily erase mistakes or cover them up with darker shading after the drawing is complete.

The lines you make in the following steps represent the edges of rounded folds of flesh that flow toward the center of the ear. Knowing that these shapes become clearer when you apply shading, follow these steps to map out the inner ear:

1. **Start with the concha (see Figure 5-21a) by drawing a shape that resembles a C-clamp (you can find one at your local hardware store).**

The concha represents the innermost recessed section of the ear right before the ear tunnel. You shade this area later.

Make sure the top of the curving shape of the concha connects with the inner side of the figure *9* part of the helix that you draw in the previous section. The bottom of the concha curves at the end to connect with the bottom of the tragus (the reverse *S* shape). The bottom small bump that connects with the tragus is the antitragus. Think of the connection between the concha and tragus as a spiral staircase that winds down from the lower portion of the outer ear toward the centermost part of the inner ear.

To complete the basic concha shape, draw a narrow half oval connecting from the figure *9* inner helix shape to the top of the tragus. This creates the three-dimensional illusion that the upper portion of the outer shape helix winds down toward the inner ear in addition to the lower portion of the outer ear.

2. **Right above the concha shape, draw the recessed groove shape of the antihelix.**

 In Figure 5-21b, observe how this shape resembles half a kidney bean slightly angled down from the upper-left corner of the *9* shape.

 When drawing abstract shapes such as the antihelix, I draw the negative space that's usually indicated by shadows that are typically caused by grooves and folds of flesh. I shade these shapes later in the final stages to boost the contrast and perception of dimension.

3. **Complete the antihelix by drawing a curve alongside the helix to map in the remaining negative shape.**

 Pay close attention to the way the slightly curved short line completes a slingshot-like *Y* shape (see Figure 5-21c).

4. **Shade in the small negative shapes to create the illusion of a dimensional image in which the positive shapes stand out (see Figure 5-21d).**

 For extra credit, use your fingers to smear or soften the edges of the shaded negative shapes. This gives your ear an extra kick of realism.

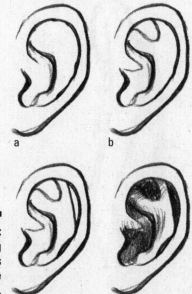

Figure 5-21: Completing the shapes for the inner ear.

To draw the inner portion of the opposite ear, flip the *C* shape for the concha so that it looks like a regular *C* shape next to the tragus (which is now a regular *S* shape to accommodate the change of ear). Place the antihelix line and the kidney-bean shape within the reverse *9* shape.

Drawing the ears from different angles

After you're a bit more familiar with the ear shape from the full view, take a moment to explore the ear from other angles. Use this list of observational descriptions when you study the ear from the three-quarter, side, and rear angles of the head in Figure 5-22:

- From the front view of the head in Figure 5-22a, note that the midsection of the antihelix protrudes outward like a mountain. To draw this protrusion, lightly sketch the entire helix shape before sketching in the antihelix shape.

 The individual ear shapes you see from the front view vary based on the degree to which the ear tilts from the back.

- Observe in the three-quarter angle (Figure 5-22b) how the overall shape of the helix becomes narrower.

- When drawing the rear view (Figure 5-22c), all inner shapes are hidden by the helix shape. To draw the helix from this view, lightly sketch a narrow *S*-shaped curve from the top of the ear all the way to the bottom where the tail of the *S* curls back up toward the front of the ear. Pay attention to the base shape of the ear, which is responsible for raising the back of the ear away from the head. It also tilts the ear toward the viewers when you're looking at the figure's head face-to-face. In addition, you see how the helix wraps around the base shape of the ear.

- Observe how in all three views, the outer edges of the ears tilt slightly at an angle.

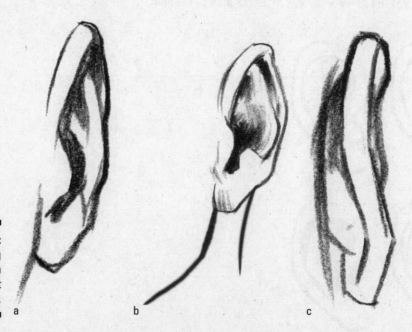

Figure 5-22: Drawing the ear from different angles.

a b c

Examining ears of all shapes and sizes

Ears come in all shapes and sizes. In addition to observing the ears of people who surround you (including yourself), I find that referring to photographs or portraits helps a great deal; pay particular attention not only to the type of ears, but also to the age of the person. Here are a few typical differences:

- ✔ In general, babies have round ears and smaller earlobes (see Figure 5-23a).

- ✔ Older individuals have wrinkles and/or longer and larger earlobes (see Figure 5-23b and Figure 5-23c).

- ✔ Some ears stick out farther away from the head (giving it a larger appearance), as you can see in Figure 5-23d and Figure 5-23e. To create the appearance of ears that stick out a bit, I elongate the top of the ear (including the helix and antihelix). In the front view, I angle the top portion of the ears away from the head at an approximate 45-degree angle.

- ✔ As shown in Figure 5-23f, children and teenagers have a larger helix and antihelix.

- ✔ Some adults have a more pointed ear (as shown in Figure 5-23g). To create this shape, draw the top portion of the helix slightly pointed at the top rather than curved.

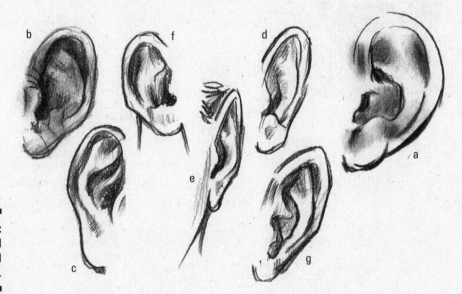

Figure 5-23:
Ears of all shapes and sizes.

Placing the Features on the Head

In Figure 5-24, I use the basic geometric head shape from Chapter 4 as a foundation to place the facial features that I show you in this chapter. Use these tips to place the features:

- ✔ **Eyes:** The head is approximately 5 eye-widths across. When placing the eye on the face, therefore, leave 1 eye-width between the left and right eyes as well as 1 eye-width between the eye and the edge of the head.

✔ **Nose:** The width of the nose in relation to the eyes is 1 eye-width wide. As I show in Figure 5-24, the nose aligns with the 1 eye-width gap between the left and right eye.

✔ **Mouth:** Although some classes teach that the corners of the mouth align with the center of the pupils, my experience in drawing from life indicates that the corners of the mouth align closer to the inside edges of the iris (as shown in Figure 5-24). I feel that this placement produces a more natural-looking head proportion.

✔ **Ears:** As I mention in Chapter 4, the top and bottom of the ears align with the eyebrows and bottom of the nose plane respectively.

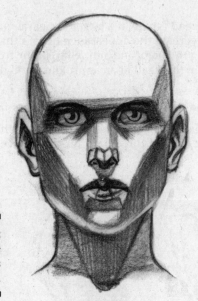

Figure 5-24:
Completing
the features
on the head.

Chapter 6

Going to the Top with Hair

- -

In This Chapter

▶ Drawing hairlines, widow's peaks, and parts

▶ Exploring curly, straight, light, and dark hair

▶ Drawing male, female, and kid styles

- -

Hair, hair, everywhere! Some individuals are blessed — if you're like my brothers, who inherited the right genes, you no doubt have plenty of hair. Others, like me, get to be like Mike! In this chapter, I go over the basics of drawing hair, including texture and color, and explain how to draw various types of hairstyles commonly seen today.

Keep in mind that hairstyles come and go just like fashion trends, so you'll wind up drawing a lot of different looks over time. So where's the next hair trend headed? I'm no professional hairstylist, but I recommend looking at celebrities and the trends they emulate. Most (though not all) trends spring up because of what celebrities are sporting. I also recommend checking out fashion catalogs to see what trends are catching on.

Just one hairy issue that needs to be addressed so that you don't feel stranded. You need to be familiar with the overall head structure before moving on. If you're new to drawing the head, I recommend reading Chapter 4 before moving . . . ahead (just couldn't resist).

The Root of the Issue: Examining Hair Essentials

Many different types of hair exist in the world, but everyone has a few essential elements in common. In the following sections, I describe the basics of hair: the scalp bordered by the entire hairline, the widow's peak found at the front of the hairline, and the part going through the scalp.

The hairline and the scalp

When rendering hair, start with the basics — the scalp bordered by the entire hairline. In Figure 6-1, I illustrate the front, three-quarter, side, and rear views of a general shaved head. Pay close attention not only to the shape of the hairline along the scalp but also to how the line follows the contour of the head's geometric planes, which I lightly indicate with my pencil. This basic shape is the most commonly overlooked shape of the human figure because it's concealed by hair for the most part. In the following sections, I make some key observations about the shape of the hairline along the scalp. Use the angles in Figure 6-1 as a point of reference.

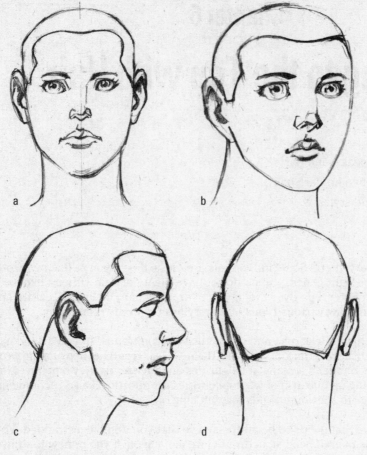

Figure 6-1:
A side-by-side comparison of the front, three-quarter, side, and rear views of the scalp.

The front view

Notice the following scalp and hairline traits in the front view of the head (refer to Figure 6-1a):

✔ **The front of the hairline doesn't run horizontally all the way across the top of the forehead.** The front of the hairline dips down at the center to form the widow's peak (which I discuss later in this chapter) before angling up toward the side planes of the head.

✔ **Pay close attention to how the hairline wraps around across the front of the forehead and connects with the sideburn line on the side planes of the head.** Starting from the center of the forehead hairline, draw two symmetrical curves heading in opposite directions. These curves resemble the top of a candy cane. The end of the curve aligns just beyond the outside edge of the eyebrow shape. From there, draw a slightly curved diagonal line that connects with the tragus of the ear to complete the front edge of the sideburns (see Chapter 5). Beginning students make the mistake of drawing the hairline from one outer edge of the head to the other outer edge of the head. The result is that the top portion of the head looks like the lid that rests on top of a pot you use for cooking.

Depending upon the age of the person or the shape of the head, the sideburns from the front view either widen by angling in toward the center of the head or narrow by angling straight down (which generally is apparent with mature males).

- ✔ **The distance between the front hairline and the top of the nose bridge is about the same as the distance between the top of the nose bridge and the bottom of the nose underplane.** The common mistake of placing the hairline either too high or too low results in creating a disproportionately large or small forehead (ouch!).

 As men grow older, they commonly see the front hairline slowly receding. A friend of mine who began losing his hair at an early age (and is currently bald as a bowling ball) jokingly refers to the process as a slow but steady retreat of the front battle line. To adjust the hairline of balding men, raise the candy-cane-shaped front hairline higher toward the top of the head. To go all out with the "bowling ball" fashion, don't connect the bottom end of the candy-cane curve with the front of the sideburns; instead, connect the ends of the sideburns to the top of the side of the head with a short diagonal line — this establishes the new boundary between the hair and scalp. Last but not least (close to being gone, to be exact), don't forget to erase the front hairline altogether. For older bald men, the ends of the sideburns move out toward the ears.

The three-quarter view

The scalp and hairline shape of the front and side planes of the head shift in size and width (as shown in Figure 6-1b) in the three-quarter view of the head. Observe the following when you draw this view:

- ✔ The right side of the front hairline is cut off from the viewer's vantage point as it wraps around the other side of the head. As a result, the left side of the front hairline is wider than the right side.

- ✔ As the side of the head turns toward the viewer, the width of the sideburns increases. To complete the sideburn shape, draw the bottom flat end (as shown in Figure 6-1b), which tapers along the top of the tragus.

- ✔ The length of these sideburns tapers off past the tragus depending on the person's hairstyle. As I show you later in this chapter, some sideburns extend all the way down to connect with the beard.

- ✔ Make sure the curving dip at the center of the front hairline aligns with the center of the forehead. I draw a vertical curving center guideline down the front of the face to help me correctly align the front hairline.

The side view

The side view of the head (refer to Figure 6-1c) shows the following traits of the scalp and hairline:

- ✔ **The front of the hairline is still partially visible as it wraps around toward the sideburns on the side planes.** A common misconception is that all shapes that are viewable from the side view exist on the same side plane — you have to keep in mind that the hairline emphasizes the three-dimensional nature of the head's generally spherical form.

- ✔ **Pay close attention to the distinct angular shape of the sideburn.** This shape is pivotal in helping the artist not only correctly reassess the width of the side view but also correctly place the ear. If the shape of the sideburn is correct, the distance between the front of the ear in relation to the front of the face is correct. Most mistakes involving a misplaced ear are the result of an incorrect sideburn shape.

When drawing the sideburn from the side view, think of the lower right section of the state of Texas; the sideburn mimics this shape. (I discuss sideburns in more detail later in this chapter.)

A tip for getting the sideburn shape is paying close attention to how the hairline at the front of the side plane follows the geometric plane of the head and angles toward the eyes. Generally, this line runs parallel to the bridge of the nose. Depending on the age of the individual, the shapes and angle of the front of the side plane are less angled.

✔ **As the hairline curves toward the back of the head, observe the gap between the back of the ear and the hairline.** Because this section is often concealed by long hair, it's difficult to see that the hairline from the bottom of the sideburn travels over and slightly behind the top of the ear before angling diagonally downward to taper off at the base of the cranium. As a result, although there's no gap between the hairline and the top portion of the ear, there's a gap between the front and back of the ear shape. Without this gap shape, certain hairstyles (such as ponytails) end up looking like helmets. (I explain how to draw ponytails later in this chapter.) The gap between the sideburn and the hairline in front is created by an *L*-shaped curve that goes behind the back of the ear. The gap between the hairline and the back of the ear is created by a diagonal line that angles away from the back of the ear. The hairline at the base of the neck tapers off to a short, flat end.

The back view

Check out the following traits of the scalp and hairline in the back view (refer to Figure 6-1d):

✔ **The bottom of the rear hairline tapers off at the base of the *cranium* (skull).**

A common mistake is to make the hairline too low — I remember a student letting the hairline drop down to the bottom of the neck. It was an honest mistake; she'd had long hair since she was six.

✔ **In some common cases, the bottom hairline angles slightly upward to meet at the center *nape* (back) of the neck.** This shape is often prominent in younger children.

✔ **The hairline from the side view is still visible as it angles downward toward the bottom of the rear view.**

Widow's peaks

Widow's peaks are usually inherited and generally recognized as a prominent *V*-shaped dip at the center of the front of the hairline. In Figure 6-2, observe how the shape or size of the forehead makes the perception of the widow's peak more prominent over others.

✔ In Figure 6-2a, I draw what most consider a neutral or normal widow's peak. At the center of the hairline, I lightly sketch in a small *V* shape. Note that the wideness of the forehead diminishes the presence of the peak shape. After I make sure the tip end of the peak is properly centered, I go back over the lighter line with a darker, thicker line to solidify my decision.

✔ Figure 6-2b is recognized as the classic *V* shape. More prominent in women than in men, this overall hairline shape resembles a heart.

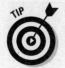

A common error when drawing the widow's peak is actually drawing the end of the *V* shape down past the forehead. This action often leads to freaky results and isn't recommended for the faint of heart. Instead of drawing the shape farther down over the forehead, lightly draw the front of the side hairline closer to the center of the forehead. Use a thin line to map out the symmetrical round curves that connect the front of the sideburn hairline with the front hairline on both sides of the head. Make sure both symmetrical curves form a large narrow *m* shape before tracing over the shape with a darker line.

✔ In Figure 6-2c and Figure 6-2d, compare the two different shapes of widow's peaks that are most prominent in adult men. In Figure 6-2c, which represents yours truly, I lightly draw a thin convex curve that stretches across the front hairline. Note how the ends of the *m* shape drop vertically at a slight angle away from the center of the head (instead of curving back in to form a peak above the eye). In Figure 6-2d, I sketch a similarly wide peak by first using a light thin line except the corners on both sides of the forehead hairline angle up to form a sharp peak. The result is an uppercase *M* shape. I go back and trace over the lighter lines with darker ones in both illustrations after I clearly establish the difference in shape between the lowercase and uppercase *m* hairline shapes.

Figure 6-2:
Drawing different variations and degrees of the widow's peak.

a

b

c

d

The lore behind widow's peaks

Though most people have different variations of the widow's peak, the original term is said to come from English folklore, where a lucky woman with a widow's peak would outlive her husband (talk about a hairy issue!). As a child, I remember my mother telling my brothers and me a more uplifting twist: Different types of widow's peaks reflect different sets of character virtues. Although this story didn't exactly pique my interest at the time, today it fascinates me to see how widow's peaks shape the way in which I perceive others' personalities.

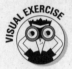

Take a few seconds to examine your widow's peak in the mirror. Those of you with longer hair may need to pull it back over and behind your head. See whether you can identify any of the shapes that I list in this section. Do you recognize the same shape in any of your siblings? How about your parents or relatives?

The part

A part is like the epicenter of a wave current that dictates which way the wave is expected to flow. Depending on the type of hair you have (fine, coarse, straight, or curly), your hair is likely to naturally part in certain ways.

In Figure 6-3, I illustrate some common parts. I bring out the top view of the head with the center toward the back marked with an *X*, which represents the center point of the hair. Some often refer to it as the "bald spot" region. Refer to the following list of categories:

- **All back:** As shown in Figure 6-3a, this pattern is commonly seen in ponytails and with long or shoulder-length hair pulled back and secured with the help of headbands. Starting from the front and back of the head, I apply pressure lines that taper from thick to thin. I draw each line following the contour of the spherical head shape. The gap between the tapered lines that forms at the center of the head represents highlights and adds more realism and the illusion of a smooth texture.

- **Center part (pigtail):** As shown in Figure 6-3b, this pattern is commonly seen in pigtails worn by children and young adult females (sorry guys!). Pigtails are secured on both sides of the head with a hair accessory (such as a ribbon). The pigtails can also be simple braids. Starting from the centerline of the head, I apply short pressure lines that taper from thick to thin and go toward the source of tension of the hair. I apply the same thick-to-thin strokes from the opposite sides of the head starting from the source of tension (where the hair band fastens to the side of the head). Some pigtails fasten at the scalp above and behind the ears, while other individuals fasten the pigtail lower, toward the bottom of the cranium.

- **Diagonal parting (shoulder-length hair):** In Figure 6-3c, I show a part that's popular among females who want to push the volume of the hair forward (especially effective for those with fine hair and a bob cut). Here, I draw a diagonal line from the back right side of the head toward the front left side. I apply thick-to-thin strokes that taper away toward the outside edges starting from the diagonal part line. I taper off the bangs at the front hairline, but keep in mind that bangs used in bob cuts hang lower (usually down past the chin).

✔ **Curved parting (shoulder-length hair):** As shown in Figure 6-3d, this part is another popular unisex style. Females use this part for longer hairstyles that run at least down to the shoulders. Adult men with shorter hairstyles (usually styled with hairspray or gel) commonly use this part as well. I draw the curve for the part lines starting from behind the bald spot to the front edge of the hairline. I apply thick-to-thin strokes that taper away toward the outside edges. For females with longer hair, I apply thick-to-thin strokes that taper back toward the center curve part. Because the part is located toward the left side of the head, the strokes I use on the left side of the part are shorter and don't taper as much as the strokes to the right.

✔ **Multidirectional:** As the name suggests, this style (see Figure 6-3e) is popular in a number of styles ranging from the short bob to the long and wavy fashion. This unisex style is popular with younger men with longer hair that tapers past the ears and eyes (especially the "emo" look). Starting from the center "bald spot" region of the head, I apply thick-to-thin strokes that taper away toward the outside edges of the head in a spiral pattern. This pattern is similar to the eye of the storm on those weather forecast television stations.

✔ **Three-way part (bangs):** As shown in Figure 6-3f, this part is commonly seen with a variety of hairstyle lengths with straight bangs. Starting from the center vertical part line that divides the top center of the head, I apply thick-to-thin strokes that taper away toward the outside edges. The part line doesn't connect from the front to the back of the hairline (as it does in the pigtail example earlier in this list). Young adult women with naturally curly long hair, however, may part the front bangs while keeping the centerline part to fasten pigtail braids right at the shoulders.

Figure 6-3: Drawing different parts.

a b c

d e f

Now that you see how parts look from above, follow how the parts unfold from different angles. In Figure 6-4, I show you the front, three-quarter, side, and back views of the multidirectional part:

- **Front view:** As I show in Figure 6-4a, the bangs take on a triangular shape that tapers off across the eyebrows. Note how some of the hair shapes curve or fall in across the forehead diagonally.

- **Three-quarter view:** The front portion of the bangs is narrower due to the perspective (see Figure 6-4b). The sides of the hair shapes are visibly wider.

- **Side view:** From the side (see Figure 6-4c), the hair curves out slightly toward the front of the head before curling back toward the back of the head.

- **Back view:** From the rear view (see Figure 6-4d), the hair slightly curves to the right and left sides of the back of the head before tapering off at the base of the neck.

Figure 6-4:
Drawing a
part from
different
angles.

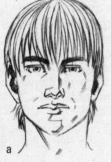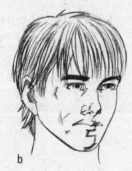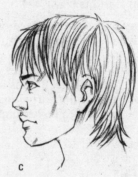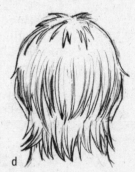

a b c d

Drawing Different Types of Hair

Hair tends to stir up frustration among beginning figure-drawing students. They tend to see hair as individual strands rather than clusters. I find two distinct approaches to rendering hair when it comes to drawing the figure:

- Choosing to emphasize texture of the overall hair shape (curly/coarse versus straight/smooth).

- Emphasizing value (light hair versus dark hair).

In the following sections, I show you some nifty tips on how to render different types of hair convincingly without having to count every single strand!

Before you draw different types of hair, brush up on the various types of shading techniques in Chapter 3. You also need to have five different types of pencils with various degrees of hardness ranging from 3B to 8B; see Chapter 2 for more about types of drawing pencils.

Drawing clusters for any type of hair

Hairs naturally group in clusters, which I like to simplify as ribbon-like planes that weave in and out. The next time you look through a style magazine and spot a headshot of a model

with the latest trend, see whether you can identify the ribbon-shaped clusters of hair and how they twist, turn, or cascade downward.

You can create your own "mock" hair-cluster-shaped ribbon in Figure 6-5 when you draw any type of hair. Follow the steps below:

1. **Draw a long wavy horizontal line, as shown in Figure 6-5a.**

2. **Either above or underneath, draw another wavy line equal in length (as shown in Figure 6-5b).**

 Observe how the two almost touch each other at one point before curving away.

3. **At the point where the two almost touch, complete the ribbon shape by drawing a third short horizontal curve that connects both curves.**

 The key to making the ribbon look like it's three-dimensional and twisting in space is to make sure that the third curve, which connects the top and bottom curves, flows continually from one end to the other as shown in Figure 6-5c.

Figure 6-5: Drawing a "mock" hair cluster.

If you're drawing curly hair, make the lines wavier. For now, don't feel that you need to make every curve identical to one another. Ironically, the different shapes and sizes you create give the overall hair shape a more natural appearance.

If you need a visual example or model to better illustrate this example, I recommend the following: Hold up a thin strip of paper under a lamp or any direct light source. While holding both ends of the paper, twist it counterclockwise and observe how the flip side of the strip turns over to face the light. Whichever side is lighter is the upper plane. Whichever side is darker is the bottom plane.

Curly versus straight hair

Curves and straight hairs cluster together to form larger general shapes that build the overall structure of the hairstyle. In this section, I show you how to render the two different hair types — curly and straight — by using the ribbon shape you create in the previous section.

Curly hair

The two types of wavy hair textures are coarse and smooth.

To draw hair with a coarse/wavy texture, use the following steps:

1. **Using the flat end of the pencil, apply a series of zigzag shading marks that run perpendicularly between the top and bottom lines while following the path of the ribbon (see Figure 6-6a).**

 Make sure to leave some space between each of the shading marks. Repeat these marks until you hit the point where the two planes meet.

2. **Change the pressure on the pencil to either reflect the lighter plane or darker plane (as shown in Figure 6-6b).**

 Making the next plane darker makes the ribbon shape appear three-dimensional. In general, if you make one plane lighter, the next plane needs to be darker.

3. **In Figure 6-6c, repeat the series of zigzag markings while changing the order of pressure; this gives the illusion of planes weaving in and out of each other.**

 Start drawing the ribbon shape in Step 1, and draw a series of zigzag shapes either from above or below the ribbon shape. Note how the path of the zigzag shapes loosely follows the directional path of the ribbon from Step 1. As you follow the path of the ribbon shape, constantly change the pressure on your pencil to create contrasting zigzag shapes.

Don't feel you need to draw every mark exactly identical to one another. Quite the contrary, the more randomly you create marks, the more added texture effect you get. As long as they loosely follow the pattern of the original first ribbon shape, you won't feel stranded!

To create a full head of hair, simply draw more random zigzag lines stacking on top of each other. To make these clusters of coarse wavy texture flow vertically, simply turn your paper 90 degrees clockwise. In contrast, if you already drew the head and need to render the hair, I recommend rotating your drawing 90 degrees counterclockwise so that the repetitive zigzag motions are easier on your wrist.

In Figure 6-7, to produce more variety of flow, simply increase the number of curving shapes. You can also modify the texture by using squiggly lines that flow and randomly taper off in the direction of the ribbon planes. At the ends of the hair clusters, I lightly sketch the squiggly lines that taper off. By easing off the pressure on my pencil, I create the illusion of stray strands of hair sticking out from the larger cluster.

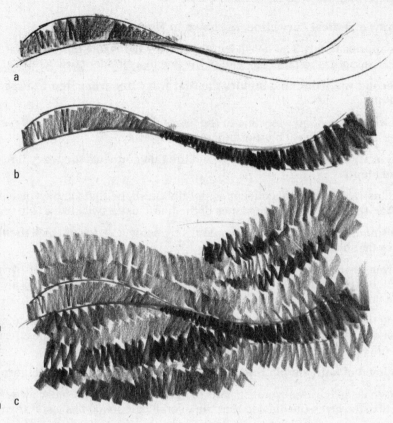

a

b

Figure 6-6:
Creating
curly,
coarse hair.

c

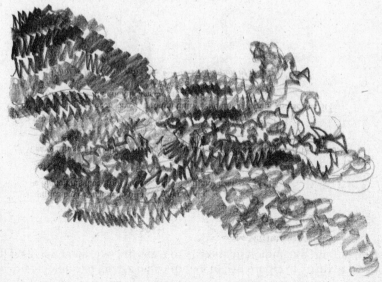

Figure 6-7:
Creating
other
patterns of
coarse hair.

Follow these steps to draw smooth textured curls:

1. **Lightly draw a vertical curvy line, as shown in Figure 6-8a.**

 My line is approximately 3 inches in length. The key to making this type of wavy texture appear smooth is to taper the end of the line in a circular curl.

2. **Draw a second wavy line that mimics the first wavy line from Step 1 (as shown in Figure 6-8b).**

 When drawing the second wavy line to the left of the first line, watch how parts of the wavy lines almost touch each other before moving away.

3. **As shown in Figure 6-8c, add a third wavy line that connects the wavy lines from Step 1 and Step 2.**

 This line illustrates the same concept as the ribbon shape that I show you earlier in this chapter; the top and bottom planes of the hair cluster twist like a thin paper strip.

4. **Draw the smooth texture of the wavy planes by using a series of thick-to-thin hatching strokes (as shown in Figure 6-8d).**

 Starting from the top end of each plane, apply curving strokes that taper off from dark to light. Each stroke runs along the path of the curving shape. Repeat this step for each new plane until you reach the end of the curve.

 Controlling the direction of the flicking of your wrist is awkward and difficult when you're working from top to bottom. Therefore, rotate the drawing while alternating the direction of your strokes between top to bottom and left to right.

5. **For a full head of hair, simply repeat Steps 1 through 4 (as shown in Figure 6-8e).**

 For added realism, I draw several strands of light stray lines that taper away from the cluster. This step gives the illusion that the overall hair shape has a soft texture.

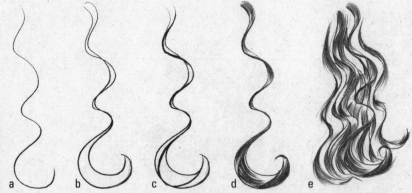

Figure 6-8: Creating smooth wavy curls.

a b c d e

Straight hair

When drawing straight hair, a common mistake is to treat the overall shape as if it were a block of ice with no texture. In Figure 6-9, in lieu of using zigzag or squiggly lines (as I do with curly hair in the previous section), I use a series of long curving lines that follow the path of the ribbon (from the earlier section "Drawing clusters for any type of hair").

Essentially, you're following the same steps to create curly hair, but you use longer and straighter marks as opposed to zigzags and short curves. To reflect the straighter quality that I want, observe how I decrease the curve and twist of the overall path shape.

Because it's easier for the hand to draw certain line qualities differently, I recommend changing the direction of the hair plane from horizontal to vertical. Personally, I tend to draw flowing curvy lines better when I allow my arm and elbow to work in conjunction with the force of gravity against my tilted drafting table.

The key to getting this smooth, long hair texture to look as if it's right out of a shampoo commercial is varying the line pressure from thin to thick. In addition, leading the movement of the pencil with your elbow motion rather than the flick of your wrist/fingers helps.

No matter how straight you try to comb your hair, the edges of the hair planes are equidistant from each other. Especially toward the bottom, as the hair falls away from the head, the lines tend to overlap each other (more so for longer hair).

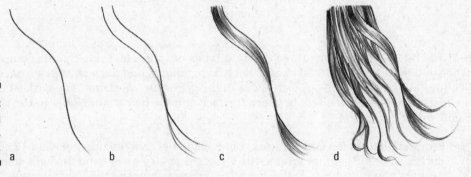

Figure 6-9: Creating smooth, straight hair.

a b c d

Light versus dark hair

From blonde to brunette to black — different hair values need different shades of light (for highlights) versus darks (for shadows). In the following sections, I provide tips on organizing your values and shading a variety of hair colors.

Assigning light and dark values to hair

In Chapter 3, I show you how to create a scale of five values, from light to dark. In Figure 6-10, I re-create this scale for shading hair. Each value of hair has its own range of lights (highlights), mediums (the original true value), and darks (shadows). In addition to these three values, all hair types have what I call the *darkest darks,* which are the small areas with so very little light that the region appears black (5). With the exception of rendering black hair, use this value sparingly. Use this list with the illustration I provide in Figure 6-10:

- ✔ **Blonde:** 1 through 3
- ✔ **Brunette:** 2 through 4
- ✔ **Black:** 3 through 5

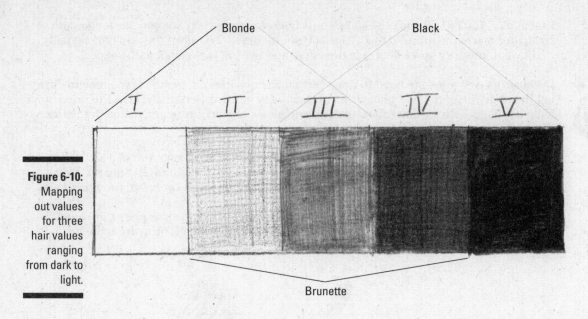

Figure 6-10:
Mapping out values for three hair values ranging from dark to light.

In Figure 6-11, I illustrate the three different types of values in a side-by-side comparison. When you want to add special effects, such as highlights and deep shadows from extreme lighting, sparingly use the opposite sides of the grayscale spectrum. The darkest darks (5) are marked in along the edges between the face and the hair shape. Refer to the grayscale in Figure 6-10.

- ✔ **Blonde:** Blondes have larger areas of highlights (1) and its original value (2). The darker values (3) gather around the shapes that face away from the light source (both primary and reflective). In this case, the darker values are the lower portion of the bangs and the top right of the hair.

- ✔ **Brunette:** In comparison to the blonde, the brunette's darker (3 and 4) areas increase as the lighter highlights decrease along the sides of the hair. In addition, the darkest dark accents (5) get bigger along the side of the face.

- ✔ **Black:** Unless the figure is surrounded by white walls, which create reflective lighting to lighten up and define the shapes of the head, 95 percent of black hair is occupied by values 4 and 5. Smoother hair produces larger shapes of highlights than coarse or wavy textures.

Figure 6-11:
Same hairstyle yet different shades of gray.

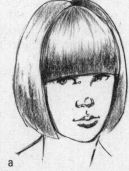
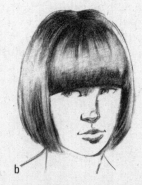
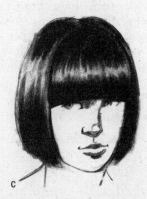

a b c

Don't let this shading theory (or any theory for that matter) completely restrain your observation or artistic freedom. I use this system as a filter to help make sense of what I see in front of me (when I'm drawing from a live model). No, I don't carry a value scale with me wherever I go. Yes, I consciously break the rules by making certain shades of shadows darker to create the narrative mood of the pose. Observation is still vital and irreplaceable — especially when you're drawing the figure from life.

Checking Out Male Hairstyles

Although men's hairstyles continue to change along with the youth and modern pop culture, classic short cuts still manage to have a say. I show you how to draw a variety of men's hairstyles in the following sections. For these exercises, you need to know how to draw the basic facial features as well as the head shape.

Classic and short

Classic trim and short cuts fall into two categories: the mature adult and the urban youth. These types of hairstyles stick close to the scalp guidelines I mention earlier in this chapter.

The mature "classic" cut

Mature adults (around 35) often have the short hair I show in Figure 6-12. Follow these steps to draw this cut:

1. **Lightly sketch the general head and hair shapes, as shown in Figure 6-12a.**

2. **Refine the shape of the hair, as shown in Figure 6-12b.**

 Toward the top of the hair shape, I draw the peak points to show the ends of the short hair tapering off.

3. **Using the flat end of a soft 6B to 8B pencil, block in the general planes of the hair starting from the front hairline (as shown in Figure 6-12c).**

 For the front hairline, create a series of short dark strokes that angle up vertically. This gives the illusion that the hair doesn't simply rest flat against the scalp. For the sides of the hair, shade in a series of short parallel dark lines from the front of the side hairline down to the sideburns in front of the ears.

 Fill in the rest of the empty area with the same short strokes, but make them lighter to show that this area is facing the light. At the top of the hair, the strokes angle up and away from the head to give the overall shape a slight jagged texture.

4. **Complete the head by rendering the facial features (as shown in Figure 6-12d).**

Using your kneaded eraser to wipe out the highlights in the classic hairstyle is a bit tedious because the area of highlights is quite small. Instead, leave the gaps between the short strokes at the top and sides of the hair that face the light source. These small gaps do a great job of mimicking the small highlights that the jagged hair shapes catch.

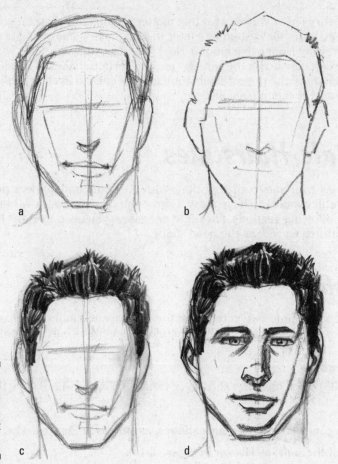

Figure 6-12:
Creating
a smooth,
mature adult
hairstyle.

The urban mod youth

The mod style in this section is popular among young adults (late teens to mid-20s). The bangs are long enough to cover either the left or right side of the eye region. Follow these steps to draw the urban mod youth:

1. **Lightly sketch the helmet-like hair shape over the head as well as the curve for the bangs that cross over the right eye (as shown in Figure 6-13a).**

 The sides of the hair taper off at the bottom of the ear region (ears are completely covered by this hairstyle and don't show).

2. **As shown in Figure 6-13b, refine the jagged shapes of the hair's edges by using darker lines over the lighter shapes you make in Step 1.**

 I draw the jagged shapes of the hair on the sides and the front. The top portion of the hair is, for the most part, round and smooth.

3. **Sketch the zigzag highlight patterns on the sides and front of the bangs before shading the darkest value of the hair (see Figure 6-13c).**

 By sketching the highlights, you don't have to worry about wasting your energy by forcefully erasing to create them later.

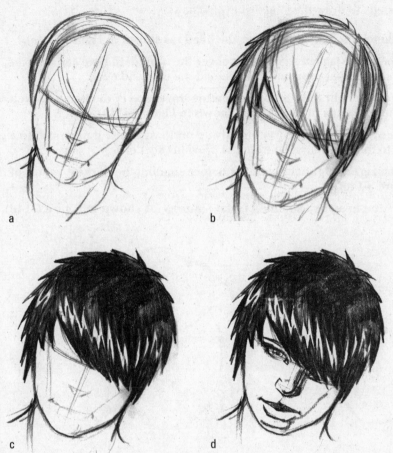

Figure 6-13:
Creating
a spikier
urban hair-
style.

TIP

When drawing the zigzag highlight shapes, mimic the angled pointed edges of the hair.

4. **Complete the head by rendering the facial features (as shown in Figure 6-13d).**

Going long

In this section, I show you two styles of long hair for men: the long disheveled look and the classic ponytail style.

The long disheveled look

Commonly referred to as the "shaggy hairstyle," the long disheveled look (see Figure 6-14) runs over and across the face and past the ears. Typically, this style has a curving part at the top so the bangs almost conceal one eye and leave the other open. Men who wear this hairstyle are typically in their 20s to late-30s.

Follow these steps to draw the long disheveled hairstyle:

1. **Lightly sketch the hair shape over the head (as shown in Figure 6-14a).**

 In addition to the jagged shapes that cover the front of the eye and the ears, I sketch the long shapes that protrude from behind the ears and neck.

2. **Trace over the light lines to further define the shape of the bangs as well as the jagged tapered ends of the hair (as shown in Figure 6-14b).**

 Make the edge of the hair curve slightly up or down before it tapers off to a point (in contrast to the mod hairstyle from the previous section).

3. **Sketch the zigzag highlight patterns before shading the darkest values of the hair (see Figure 6-14c).**

4. **Complete the head by sketching facial features (as shown in Figure 6-14d).**

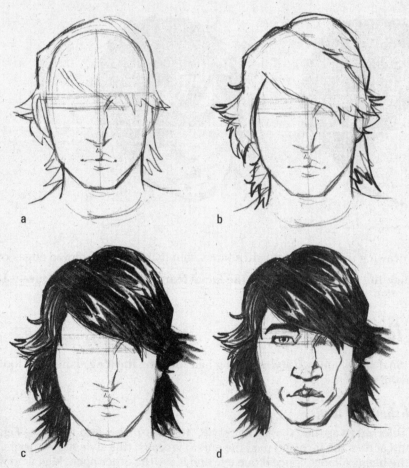

Figure 6-14: Drawing the shaggy hairstyle.

a b c d

The ponytail

Though not as common as it once used to be, a man's ponytail is still in full swing. Many men still tie a portion of the top section of their hair in a short ponytail, while some wear

the all-back ponytail, which is similar to the female fashion. A great number of men in their late 40s and even 50s sport this type of fashion.

1. **Lightly sketch the profile shape of the head (as shown in Figure 6-15a).**

 Because the ponytail presses tightly against the head, you don't need to draw any specific hair shape over the scalp.

2. **Block in the general shape of the ponytail at the back of the head in addition to the front and side view of the widow's peak hairline (as shown in Figure 6-15b).**

 The individual I'm drawing has a receding hairline, so I slightly raise the front hairline shape above his forehead (someone better tell him to enjoy his hair while it lasts!).

3. **Draw the details and values for the ponytail hair shape (as shown in Figure 6-15c).**

 I draw thick-to-thin lines from the front, side, and back of the hair shape. I leave the midsection of the hair shape open and unshaded to show that this individual has gray hair. To show the mass the ponytail has in the back, I use the soft tip of my drawing pencil to darkly shade the shadow shapes of the underplane of the ponytail shape.

4. **Render the facial features (as shown in Figure 6-15d).**

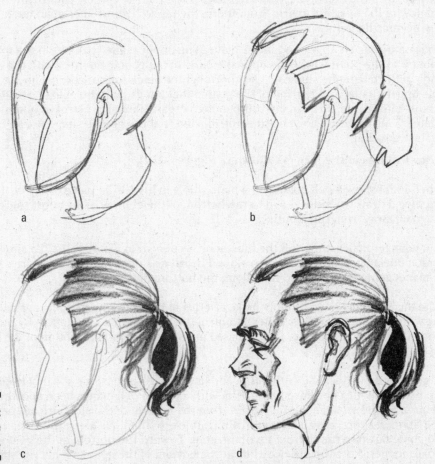

Figure 6-15: Drawing the ponytail.

a

b

c

d

Facial hair and sideburns

Different age categories have facial hairstyles that are sure to be fashion winners. Follow these steps to draw a goatee on a bald bodybuilder type of guy:

1. **Lightly sketch the general goatee shape at the lower portion of the head (as shown in Figure 6-16a).**

 First, draw the symmetrical mustache shape between the bottom plane of the nose and the upper lip. This shape slightly tapers off past the sides of the mouth. Leave a gap between the mustache shape under the center of the nose.

 Next, draw the bottom goatee shape; it resembles a banana split sundae with a cherry on top (don't ask where I get these image associations; I'm always thinking of food). Leave a small gap between the center "cherry" shape and the centerline for the mouth so that the lower lip has space to fit in. I let the bottom shape of the goatee hang past the chin.

2. **Render in the texture of the facial hair by using a series of thick-to-thin short strokes, as shown in Figure 6-16b.**

 Starting with the mustache, make the lines darker at the center, underneath the shadow of the nose structure. From there, the tapered short lines span out and gradually become lighter.

 The goatee has an upper and lower plane. The upper plane spans from the front of the chin up to the point where the opposite ends of the goatee connect with the outside ends of the mustache shapes. I use short, lighter, thick-to-thin vertical lines to describe this upper shape. Any portion of the goatee that hangs past the chin is considered to be the underplane, so I use my soft pencil to create dark short strokes under the upper goatee. This value contrast creates the illusion that the goatee shape doesn't rest flat against the chin.

3. **Draw features of the face (as shown in Figure 6-16c).**

In Figure 6-16d, I show a half goatee on a male who's in his 30s. In place of the bottom half of the goatee, I draw the sides down to the bottom of the chin by using short thick-to-thin strokes going away from the mouth.

For even younger males, taper off the mustache, as shown in Figure 6-16e. To show that this person doesn't yet have a fully developed beard or sideburns, I draw a series of short stipple marks going from thick to thin along the bottom of the chin.

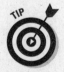

To create this stippling effect, simply make a series of light pecking motions against the drawing with a soft pencil (6B or softer). Control the thick-to-thin taper effect by pulling the direction of the pecking motions (in this case I'm pulling the pecking motion of the hand coming toward me).

Longer goatees that cover the entire chin and jaw line are extensions starting from the bottom of the sideburn hairline shape. Start with a profile of a male's head sporting a regular sideburn, as shown in Figure 6-17. Start from the bottom of the sideburn shape and draw a combination of short, zigzag lines with short, thick-to-thin lines along the sides of the jaw line and going down to the bottom tip of the chin. Toward the bottom of the goatee, make the strokes longer. Note the little cowlick at the bottom of the goatee; it curves slightly upward.

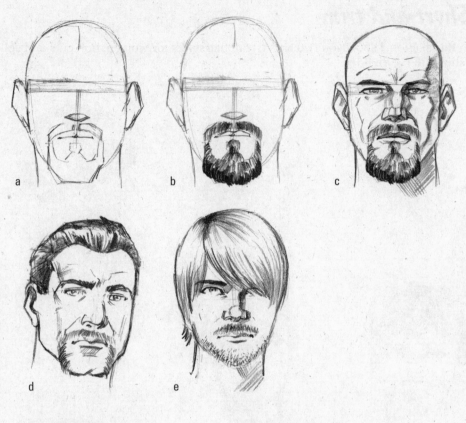

Figure 6-16:
Drawing
various
types of
facial hair.

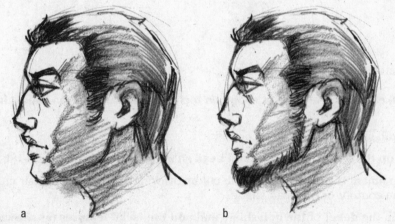

Figure 6-17:
Surveying
sideburns.

Focusing on Female Hairstyles

With so much variety in women's hairstyles, drawing them won't ever bore you! Check out the different styles you can draw in the following sections.

Short and trim

In this section, I show you two short, trim hairstyles for women: bob cuts and spiky styles (shown in Figure 6-18).

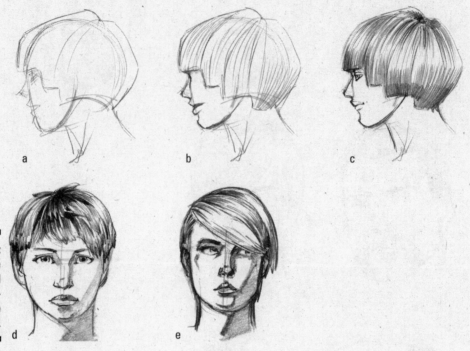

Figure 6-18:
Drawing the short and trim hairstyles of the female.

The bob

Follow these steps to draw the bob hairstyle:

1. **Lightly sketch the general hair shape on top of the head shape, as I show in Figure 6-18a.**

 The overall shape resembles a scooter.

2. **Tighten up the edges of the hair and head shape, as shown in Figure 6-18b.**

 I begin to hint at the planes of the bob cut by drawing the lines of the hair clusters that follow the contour of the head shape.

3. **Render in the detail of the bob shape and add the facial features (as shown in Figure 6-18c).**

 Use the side of your drawing pencil to lightly draw a series of wide lines that taper from thick to thin, starting from the top of the head. Repeat this process, going in the opposite direction, starting from the bottom of the hair shape. Leave the center portion of the hair unshaded to suggest highlights.

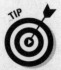

 To add more dimension to show the round volume of the hair shape, apply pressure to your drawing pencil to create a series of short dark sections of the hair that face away from the light source. Here I apply the darker value to the front of the bangs, the bald spot region, and at the bottom of the hair shape.

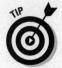

To draw trim, layered styles (as shown in Figure 6-18d), I apply the darker values from Step 3 to larger sections of the hair. In this case, apply these values to the top front portion of the bangs to create the contrast and the illusion that the side portions of the hair overlap the center portion.

A spiky style

In Figure 6-18e, I draw another short hairstyle that has bangs parting across the front of the head. When drawing this style, I apply the same dark values toward the upper left of the bangs and at the lower right section where the bangs tuck behind the ear. These values strengthen the three-dimensional illusion that the front portion of the bangs is closer to the viewer than the other layers of the bangs that are higher toward the top of the head.

Shoulder-length styles

As shown in Figure 6-19, most shoulder-length hairstyles use the curving part at the top of the head. Unlike the male counterpart, the bangs usually don't cover the front eye. Follow these steps to draw a shoulder-length style with bangs:

1. **Draw the general hair shape, as shown in Figure 6-19a.**

 At first glance, the overall shape resembles a ghost costume (the one that requires only a simple bed sheet). The left front of the bangs curves down and flattens out along the eyebrow region.

2. **Tighten up the edges of the hair and head shape, as shown in Figure 6-19b.**

 Start sketching lines that define the hair cluster shapes. When drawing an overall rounded hairstyle, curl the bottom ends of the hair slightly toward the inside of the neck.

 Make the width of the hair cluster shapes on the bangs wider than the cluster shapes off to the side of the head to create the illusion that the bangs are closer than the rest of the hair.

3. **Render in the value of the hair in addition to the facial features, as shown in Figure 6-19c.**

 Use the soft end of your drawing tool to block in the darkest darks toward the top of the head where the part begins. Also block in the gap between the neck and the hair.

For edgier shoulder-length cuts, draw the sides branching away from the head, as shown in Figure 6-19d.

Long and beautiful

As shown in Figure 6-20, long ponytails on women are similar to ponytails on men. In addition, other long styles have ends that slightly curl upward. Follow these steps to draw the long styles:

1. **Draw the general hair shape, as shown in Figure 6-20a.**

 From the curving part, draw the front of the long hair parting off to the sides of the face to create a triangular framing effect.

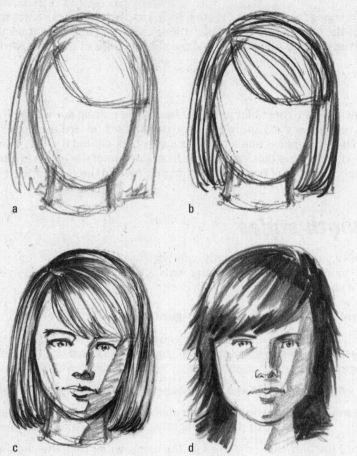

Figure 6-19:
Shoulder-
length
hairstyles.

a

b

c

d

2. **Use the fine tip of your drawing pencil to lightly define the values and hair planes as they wrap around the head shape (as shown in Figure 6-20b).**

 Change the direction of your lines to show the shift in the hair planes as the hair extends down to the shoulders.

3. **As shown in Figure 6-20c, draw the facial features and add in the dark accents to the hair.**

 Here you add the darkest darks to the hair shapes next to the neck. This adds to the three-dimensional illusion that the hair has various layers.

For wavier hair with texture (as shown in Figure 6-20d, Figure 6-20e, Figure 6-20f, and Figure 6-20g), I block in the outer edges of the hair shape first before placing general hair cluster shapes at the sides. For brunettes, I use thicker lines to render the thick-to-thin texture and value lines along the planes of the hair.

For women's ponytails, large bangs are common (as I show in Figure 6-20h). Younger females in their 20s may sport bangs that cover one eye. To create the illusion that the planes at the back of the head wrap around a spherical object, I add the darkest darks toward the top of the head and the back of the cranium.

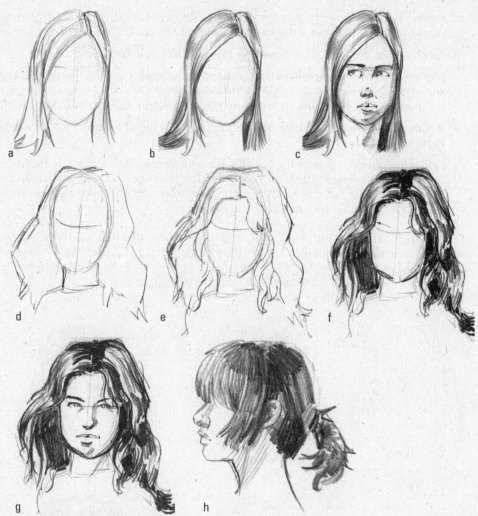

Figure 6-20: Longer hairstyles.

Staying Simple with Kids' Styles

In general, kids' haircuts are simple because the hair is still soft and fine. Drawing these cuts is just as simple, as you find out in the following sections.

Short cuts

As shown in Figure 6-21, short cuts are short and clean. Follow these steps to draw a child's style with bangs:

1. **Draw the general hair and head shape, as shown in Figure 6-21a.**

 Using the curving part, draw the diagonal curves that run across the forehead without covering the eyes. The length of the hair doesn't reach the shoulder, but tapers off slightly past the bottom of the chin.

When I'm drawing short cuts for kids and I don't have a model, I slightly exaggerate the roundness and volume of the hair shape in relation to the smaller head shape.

2. **As shown in Figure 6-21b, draw the lines to indicate the hair clusters.**

 The lines on the bangs follow the rounded contour shape of the forehead. Unlike the smooth shoulder-length hairstyle for the adult female (which I discuss earlier in this chapter), hair shapes for children are more rounded (especially on both sides of the head).

3. **Render in the details of hair planes and add the facial features (as shown in Figure 6-21c).**

 I keep the overall value of the hair lighter with limited darkest darks. In this example, I use the darks only at the top of the hair along the curving part. To create the softer texture, I use the flat side of my drawing tool to render the thick-to-thin lines along the sides of the hair as well as across the bangs.

In Figure 6-21d, Figure 6-21e, and Figure 6-21f, I illustrate the steps to drawing a hairstyle for boys; these steps are similar to the steps for drawing a "classic" male haircut, which I describe earlier in this chapter. Observe how the top side of the hair shape is slightly flatter (see Figure 6-21e) than the "classic" cut, which spikes up more.

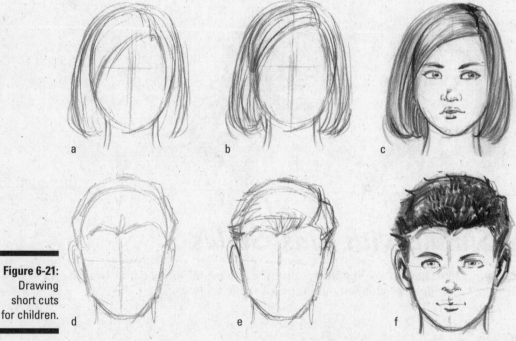

Figure 6-21: Drawing short cuts for children.

Pigtails

Girls use the dividing lines to create the two tails on each side of the head. These tails, shown in Figure 6-22, are located behind and above the ears. Follow these steps to draw the pigtail:

1. **Draw the general hair shape (as shown in Figure 6-22a) over the basic head shape for a child.**

 Here I use the center part to divide the hair shapes into equal halves.

2. **As shown in Figure 6-22b, define the shape of the pigtails.**

 Observe how the overall pigtail shape resembles an *S* curve on the left side and a reverse *S* on the right. At the bottom of each curve, the ends curl slightly upward. The lines for the hair clusters within the pigtail shapes mimic the outside *S* shapes.

 For the hair clusters that closely wrap around the spherical head shape, I draw a series of curving lines that start from the center of the part and angle away toward the braids.

3. **Add the zigzag shapes along the planes of the pigtail shape, as shown in Figure 6-22c.**

 Here I use a coarse wavy texture. At the end of the pigtail shapes, I add some light scribbles for the stray strands of hair to give the overall illusion that the hair is soft.

 For the hair planes that curve around the head, I add thick-to-thin lines that stem from the center dividing hair plane and head toward the braids. In addition, I apply the darkest darks to the left of the plane and off the sides of the head. Pay attention to the highlight shape that forms along both sides on top of the head.

Figure 6-22: Drawing pigtails.

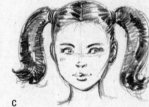

a b c

Young and punk

You may see teenagers who have the same styles as adult men and women (which I discuss earlier in this chapter), but you're also likely to see some young punk styles.

- ✔ The young punk style for boys has the front side of the hair going slightly past the forehead (representing a small Mohawk).
- ✔ For girls, the ends of the hair rise up in a spikier fashion.

Follow these steps to draw the short spiky punk hairstyles:

1. **Draw the general hair shape, as shown in Figure 6-23a.**

 Observe how the edges of the general head shape float high above around the top of the head. This is to accommodate the large amount of space needed to draw the more detailed individual shapes, such as the spiky bangs that I already begin to lightly sketch toward the front of the head.

2. **Refine the basic hair shape, as shown in Figure 6-23b.**

 I divide the shapes into three sections: the center bang shape, and the two shapes on each side of the head.

 A common mistake is to make all the spikes stick straight up like porcupine quills. Rather, as I show, the tips of the spikes follow along the curving form of the spherical head shape.

3. **Use the flat end of a soft pencil (6B or higher) to shade in the shapes of the hair with short strokes that taper off from thick to thin along the outside edges of the hair shape (see Figure 6-23c).**

 Notice the small gaps between the strokes that I leave either unshaded or partially gray. As you apply the short strokes branching out in multiple directions, you find that these gaps happen naturally. Don't worry; ironically, these side effects help add character and texture to the overall hairstyle.

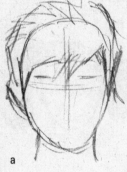
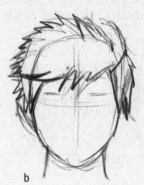
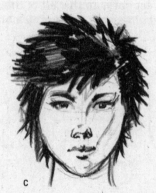

Figure 6-23: Young and punk male and female hairstyles.

a b c

Chapter 7

Presenting Emotions in Facial Features

• •

• •

With the slightest twitch of a muscle, caused by a brief thought or feeling, facial expressions tell it all. These expressions can work wonders in communicating with your peers without uttering a single word. At the same time, your expression can blow your cover when you're in a bind (unless, of course, you're a world poker champion who can bluff his way to win the grand prize with a single pair against four of a kind).

In this chapter, I walk you through building the simplified muscle structures to show you how expressions are formed. In addition, I illustrate various expressions and explain how to add wrinkles to show age.

If you're new to drawing facial muscles, read Chapter 4 first. That chapter goes over the basic head structure, which you need to know to get the most out of this chapter.

Including Geometric Planes and Shading

In this section, I show you how to define the head's geometric planes based on the line drawings from Chapter 4. Geometric planes help give the head a more realistic and three-dimensional appearance. Defining the planes also helps you when you start to add muscles and expressions to the face.

In this section, I also show how lighting methods create depth and atmosphere when they're applied to the head's plane structures.

Despite what you *think* you see in the mirror from the front, don't forget that the head is ultimately a round object. This means you still see a small portion of the side planes even from the front view.

Defining geometric planes

For this exercise, you need to have a completed line drawing of a head from the front, side, and back angles, as I describe in Chapter 4. Because the vertical guidelines are no longer necessary, you can either erase them or, even better, trace the drawing of the head — sans guidelines — to a new piece of paper. I find that tracing actually saves time, frustration, and grumbling from accidentally erasing the lines I really need. (I discuss tracing paper and other tools in Chapter 2.)

As you go through the following steps, think of yourself as a stone sculptor who carves a head out of a block of marble. Each line represents a cut you make with your sharp chisel. This imagery helps reinforce that you're creating a three-dimensional object on a flat, two-dimensional space.

1. **Lightly draw the guidelines to horizontally divide circle 1 into quarters.**

 In Figure 7-1, I label the lines 1 through 5.

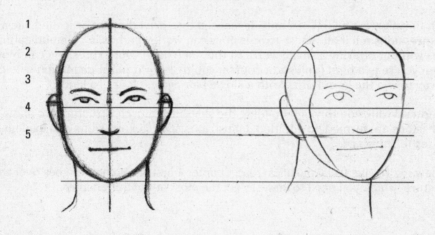

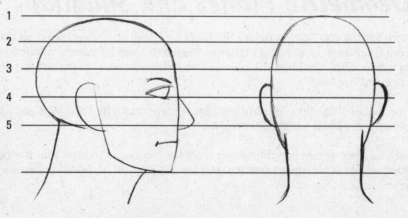

Figure 7-1: Divide the upper head circle into quarters.

2. **Draw a line across the brow line (as shown in Figure 7-2).**

 Use line 3 as the brow line. In Figure 7-2a, I draw a horizontal straight line across the head. In Figure 7-2b, the brow line connects with the line that divides the side and front planes. It joins at the point where the arc of the dividing line meets at line 3. In the side

view, Figure 7-2c, the horizontal brow line extends $1/5$ of the width of the head above the eye. The brow line isn't visible from the rear view in Figure 7-2d and doesn't need to be indicated.

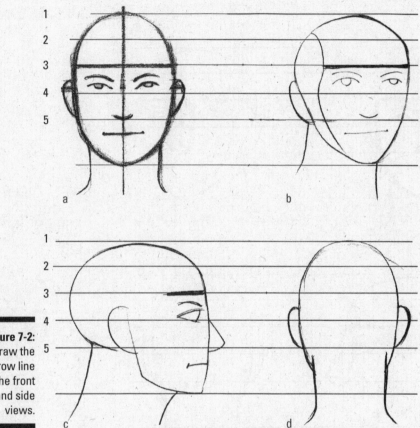

Figure 7-2: Draw the brow line for the front and side views.

3. **Draw a vertical centerline along the center of the head to establish the top and the bottom of the nose plane (see Figure 7-3).**

In the front view, Figure 7-3a, start from the top center of the brow line and draw what resembles a snow/ice scraper for your car window. The gap at the top is 1 eye width apart. From there, both sides of the nose come in at a 45-degree angle to meet at eye level and form the nose bridge ($1/2$ eye width apart).

Next, draw a thin rectangle shape (which represents the top plane of the nose bridge) that stops $1/2$ an eye width from the bottom of the nose arc. For the bottom part of the nose, draw an isosceles trapezoid.

Make sure the width of the top of the trapezoid matches the width of the rectangle. Also, make sure the bottom width of the trapezoid meets the bottom of the arc of the nose. The width of the bottom segment of the trapezoid is 1 eye width.

In addition to drawing the three trapezoidal shapes for the three-quarter angle in Figure 7-3b, add a fourth trapezoid that vertically runs down the front of the face to represent the side plane of the nose.

In the side view, Figure 7-3c, the only significantly visible plane is the triangle shape that represents the bottom portion of the nose. To draw this portion, add a slightly angled line that extends 1 eye width. Then connect the end of the line with the bottom portion of the nose to complete the triangle shape. No visible changes from the rear view, Figure 7-3d.

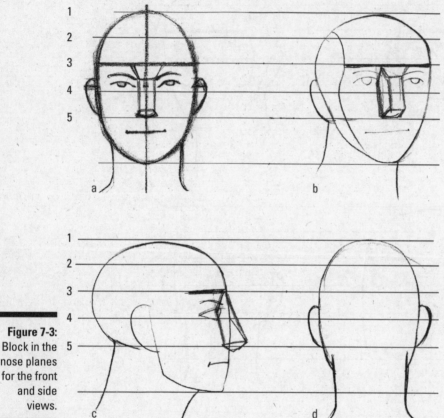

Figure 7-3:
Block in the nose planes for the front and side views.

4. Start to construct the side plane on all views of the head.

From line 2 in the front view (see Figure 7-4a), draw a 45-degree angle that connects with line 3 about 1 eye width from the outside edge of the head. From there, the line shoots back out at a 45-degree angle to connect where line 4 meets the outside edge of the head. Do the same on the other side of the front-view head.

For the three-quarter view, the side plane is, for the most part, already marked. However, adding a vertically narrow circle along the side of the head helps add structure to the side plane of the head (as shown in Figure 7-4b). This completes the side view of the three-quarter angle of the head.

On the side view, Figure 7-4c, draw a 45-degree line shooting up from the brow line (line 3) and connecting with line 2. Next, draw a round curve that mimics the outside shape of oval 3. The bottom of the curve meets the bottom of oval 3 (approximately $1/4$ distance from the right side of the head).

For the rear view, draw a shallow curve (as shown in Figure 7-4d) from line 2 down to midway of the ear. Both the start and end points should vertically align together. Repeat the same for the other side of the head.

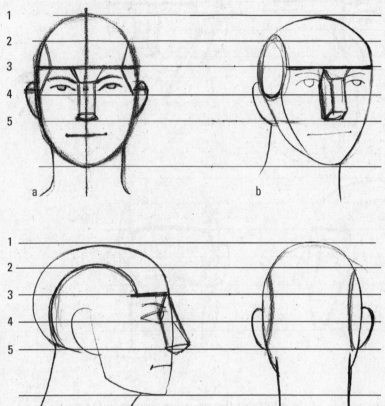

Figure 7-4:
Begin to
draw the
side planes
of the head.

5. Finish the side plane on all views of the head.

From the front view, draw a 45-degree angle line from line 4, intersecting the tip of the mouth and going down to the bottom of the chin (as shown in Figure 7-5a). Do the same for the other side of the head.

In the three-quarter angle, Figure 7-5b, draw a diagonal line from line 4 down to the bottom of the chin on each side.

For the side view, Figure 7-5c, draw a line going down and to the left at a 45-degree angle from line 3 to line 4. Then draw another line going down and to the right at a 45-degree angle from line 4 down to the chin.

In the rear view, Figure 7-5d, draw a slight concave arc along line 5, thus nipping off a portion of the oval head shape. The shape resembles a cookie that's been bitten into. In addition, draw a straight horizontal line along line 3 to connect the left and right concave arcs representing the partial portion of the side planes.

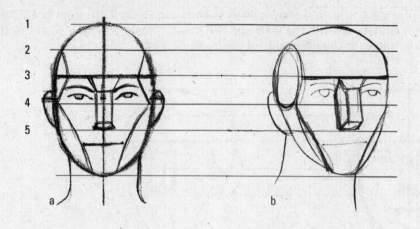

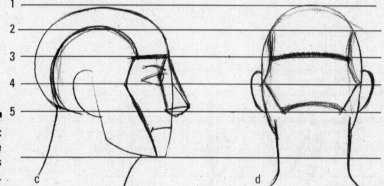

Figure 7-5:
Finish the
side planes
to the head.

6. **Draw the lower side of the plane of the eyes (as shown in Figure 7-6).**

 Start with the front side, from either side of the top of the rectangle nose plane. Draw a curve that resembles the blade of an ice skate, as shown in Figure 7-6a. The tail end of the curve ends where the side plane and line 4 meet. Perform the same operation on the opposite side and on the three-quarter view, Figure 7-6b.

 On the side view, draw the same ice-skate blade curve from the top of the bridge of the nose to where the side plane angle meets line 4 (as shown in Figure 7-6c).

 The planes of the eyes aren't visible from the rear view (Figure 7-6d).

7. **Draw the plane shape for the upper and lower lips.**

 Use the line for the mouth as the base of an isosceles trapezoid (as shown in Figure 7-7a). The distance from the base of the trapezoid to the top is $1/2$ the width of the eye. Next, measure $1/2$ the width of the eye below the mouth line and draw a narrower isosceles trapezoid. Make sure both end points of the second trapezoid connect with both side planes.

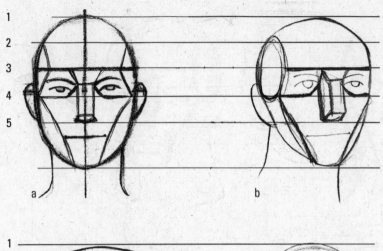

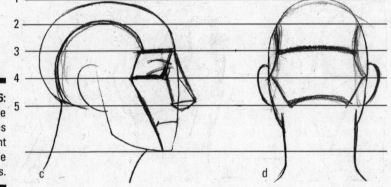

Figure 7-6: Block in the eye planes for the front and side views.

To draw the three-quarter view (as shown in Figure 7-7b), draw the trapezoids' diagonal edges facing the viewer at a slightly longer and wider angle. Make the opposite diagonal edges of both trapezoids narrower and shorter.

For the side view (Figure 7-7c), draw the plane shapes for the upper and lower lips. To get the shape from the side view to look correct, draw a quarter slice of the left side of the plane shapes from the front view (Figure 7-7a). If the face is looking to the left, draw a quarter slice from the right side of the shapes.

The mouth section isn't visible from behind. Make no changes to Figure 7-7d.

Adding some shading

After you have all sides of the face blocked in, observe what happens when I apply some dark shading in Figure 7-8! For the purpose of this example, I draw in the darks of the shadows as if the light source is coming from above (formally called top lighting; see Chapter 3 for more about this and other light sources).

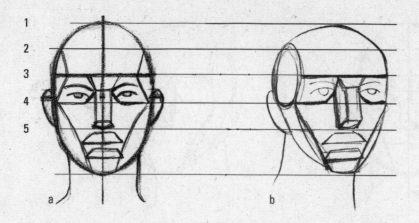

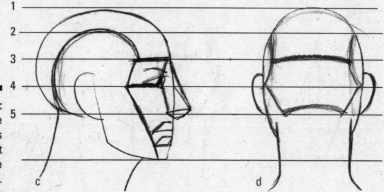

Figure 7-7:
Block in the
lip planes
for the front
and side
views.

Want a useful tip in identifying which plane shapes need to be shaded in? Keep in mind that any shape that's either parallel to or facing away from the primary light source is in the dark. Objects and planes can only get increasingly lighter in value the more they turn perpendicularly to face toward the light.

This shading technique applies to all the views that I describe earlier in this chapter (as long as each head is receiving the same directional lighting from the same light source). Follow these steps to block in your shadows:

1. **Indicate the side planes with an "S."**

 These planes will receive less light because, for the most part, they run parallel to the light source (see Figure 7-8a).

2. **Indicate the *underplanes* (the eye/eyesocket, the area underneath the nose, and the area underneath the chin) with a "U."**

 These planes will receive less light because they're facing away from the light source (see Figure 7-8b).

3. **Use either a soft, blunt drawing pencil (6B–8B) or a felt marker to shade in the areas indicated with "S" and "U" (see Figure 7-8c).**

 For quick and smooth results, I use either the flat side of my soft (8B) drawing pencil or the dull end of a soft charcoal pencil.

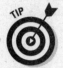

TIP

For extra credit points, I smooth out the overall texture and soften the edges between each plane of the head with either my finger or the tip of a soft cloth. This step produces a more refined finished look.

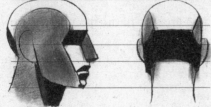

Figure 7-8: Block in the darks of the geometric planes of the basic head.

You commonly see this shading effect in a dark enclosed room with a single light source. In most natural-light settings, you're more likely to see various shades of gray within the shadows due to reflective light bouncing off the surrounding environment and back into the shadows. Especially in cases without one particular dominant light source (referred to as ambient lighting), you're likely to see various degrees of shading distinguishing the sides of the head as well as regions around the eyes, under the nose, under the lips, and under the chin — all these areas receive the least amount of light.

Putting on Muscle

It's time to flex those muscles — facial muscles, that is! Like the major muscles that move your individual body parts (see Chapter 10), your facial muscles contract each facial feature to convey your overall expressions. In this section, I show you how to draw the basic facial muscles in several views of the head. The understanding of these muscles helps you when you start to draw expressions later in this chapter.

Introducing important facial muscles

In Figure 7-9, I introduce muscle groups. Yes, at first glance you may be reminded of your worst classic horror-movie nightmare in which a monster emerges out of the dark alley and begins his sadistic (yet gleeful) pursuit while wielding his razor sharp finger talons. But before you decide to run him over with your giant 1980s-era car, try to face your fears. Don't draw anything yet. Just familiarize yourself with the following names and their associated muscle structure:

- **Frontalis:** Raises and lowers your eyebrows
- **Corrugator:** Creates that intense frown
- **Orbicularis oculi:** Controls your eyelids in a blink of an eye
- **Orbicularis oris:** Closes and puckers the mouth (you can't kiss your loved ones without this muscle)
- **Depressor anguli oris:** Moves the upper end corners of the mouth in a downward motion (to show how glum and disappointed you are)
- **Mentalis:** Regulates the chin movement (and causes those small multiple chin dimples when you're deep in thought or glum)
- **Zygomaticus major:** Moves the upper end corners of the mouth in an upward motion (helps keep you smiling)
- **Buccinator:** Horizontally moves the end corners of your mouth (break out that large grin when you're embarrassed)
- **Nasalis:** Opens and narrows the nostrils
- **Temporalis:** Helps your jaw chew your food
- **Masseter:** Also helps your jaw chew your food
- **Sternomastoid:** These large bands of muscles support and control your head and neck movement
- **Trapezius:** This large muscle structure controls the movements of the shoulder blades (the facial expressions aren't affected by this muscle structure)

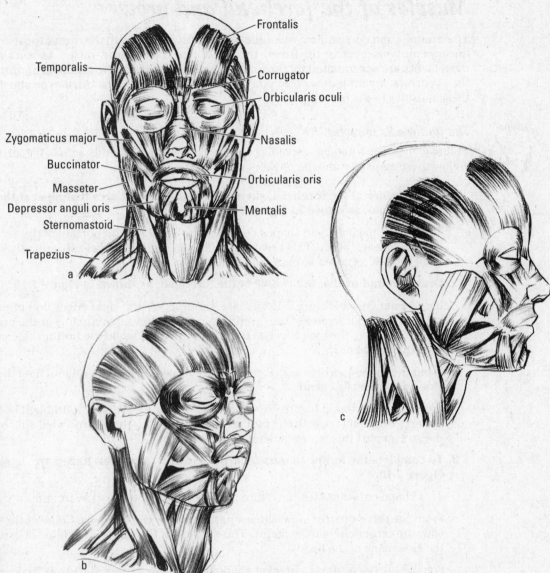

Frontalis

Temporalis

Corrugator

Orbicularis oculi

Zygomaticus major

Nasalis

Buccinator

Orbicularis oris

Masseter

Depressor anguli oris

Mentalis

Sternomastoid

Trapezius

a

c

b

Figure 7-9:
The front, three-quarter, and side views of the muscle structure of the head.

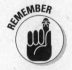

Don't be intimidated by those scary muscled anatomy figures standing in your doctor's office. Yes, a lot of muscles are crammed into that wonderful face, but you don't have to know them all to draw the head. That's why, in the following sections, I show you a simple, practical approach to mapping out the muscles. You need to have the head drawings with planes and shading that I show you how to draw earlier in this chapter.

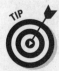

The key to making these individual shapes work together neatly is to be aware of how each end point of the line you draw connects with the edges and tips of the planes of the head. The plane shapes you complete earlier in this chapter serve as landmarks that help produce a more accurate drawing.

Muscles of the forehead and brow

The frontalis and corrugator are forehead and brow muscles that express those intense and uneasy emotions, such as the frown, the scowl, and the eyebrow-raiser. As you age, these movements are accentuated by those well-earned wrinkles in the forehead and/or between the eyebrows. If your mother told you not to scowl so much as a kid, maybe she didn't want these muscles to overdevelop.

The forehead's muscles

At first glance, the frontalis resembles a giant *m* shape that extends across the forehead. Follow these steps to draw the muscles of the frontalis:

1. **At the center of the forehead, sketch two tall *n*-shaped arcs that meet at the center of the forehead, as shown in Figure 7-10.**

 The key to making these shapes realistic is to draw the top portion of the arcs angling away from each other. This creates the illusion that the muscle structure is wrapping itself around a curved surface (the skull).

2. **Draw a round oval at the center of the forehead, as shown in Figure 7-10.**

 In the front view in Figure 7-10a, I make sure the left and right edges don't touch the sides of the front region of the forehead; instead, they align roughly at the center of the eyes. The top of the oval touches the top of the head while the bottom side connects with the brow line.

 From the three-quarter view (Figure 7-10b), draw the center oval touching the right side edge of the forehead.

 From the side view in Figure 7-10c, draw an arc for the frontalis. Although both ends of the arc make contact with the outline of the forehead, the left rounded side of the arc doesn't go past the center of where the eyes align.

3. **To complete the forehead muscle structure, draw a tunnel-shaped arc, as shown in Figure 7-10.**

 This shape encompasses the entire forehead and completes the frontalis section.

 From the three-quarter view, draw a partial arc for the frontalis. Connect the right end with the center circle from Step 1. The left side of the tunnel arc shape doesn't go past the side plane of the head.

 For the side view, draw a bracket shape that slightly tapers at the top. Make sure the left side of the tunnel arc shape doesn't go beyond the side plane of the head.

The brow's muscles

After you complete the frontalis, follow these steps to draw the corrugator muscles:

1. **Draw a thick bracket shape on each side (as shown in Figure 7-11).**

 This bracket shape resembles a pair of angled shark fins whose bottom tips connect at the center of the forehead. The outside edges of the corrugator (or the tip of the shark fins that angle away from the center of the forehead) don't connect with side planes of the head. Rather, they taper off at the midpoint between the circle of the frontalis and the edge of the side planes. In addition, note that the outside edges are higher than the inside edges, which meet at the center of the brow line.

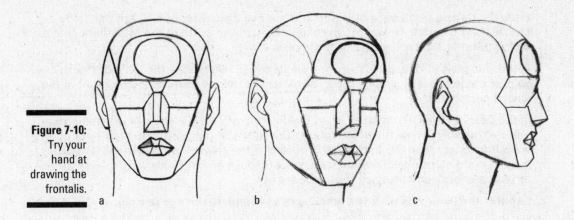

Figure 7-10: Try your hand at drawing the frontalis.

a b c

From the three-quarter view, the corrugator's shark fin shape appears almost twice as wide as the other corrugator shape, which faces away from the viewer.

From the side, draw the corrugator just as you do in the front view, but make it shorter in width and angled from top to bottom.

2. **Erase the section of the frontalis (from the previous section) that overlaps the corrugator, as shown in Figure 7-11.**

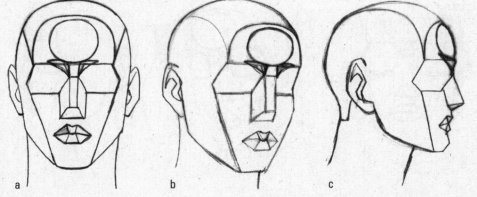

Figure 7-11: Draw the corrugator (brow muscles).

a b c

Muscles that make the eyes move

If you remember that classic "black eye" shape from cartoon episodes, the shape of the orbicularis oculi is a familiar one. Think of this muscle as a circular elastic band whose function is to conceal and expose the eye when it's compressed and contracted vertically. Although its shape is simple, its function (like the rest of the facial muscle groups) is quite extraordinary.

Follow these steps to draw the orbicularis oculi:

1. **Draw an oval on each side of the head where the eyes are (see Figure 7-12).**

 The key to understanding this shape is to think of the pair of ovals as those large aviator shades from the classic movie *Top Gun*. See what I mean in Figure 7-12a.

From the three-quarter view in Figure 7-12b, make the oval shape on the right side recede away from the viewer at approximately half the width of the oval shape that's on the left side, which is closer to the viewer.

In the side view in Figure 7-12c, draw a single oval, making sure the left side doesn't go past the frontalis *m* shape. The front of the oval aligns with the lowest point of the angled corrugator.

In the side view, it's essential to avoid making the oval for the eye shape symmetrical; observe the way I make the oval slightly skewed to the right, while the top right corner is slightly longer than the bottom right corner. If the shape is symmetrical, it appears flat and nondimensional. I recommend going through an old 1980s wardrobe (your own or your parents') and bringing those shades out.

2. **Connect the two ovals with two small arcs to complete the eye muscle.**

 These small arcs stretch across the bridge of the nose to complete the resemblance of the sunglasses shape.

 From the three-quarter view, the width of the arc is about half the width of the arc from the front view.

 From the side view, draw a thin vertical rectangle that covers the gap between the front of the oval and the bridge of the nose.

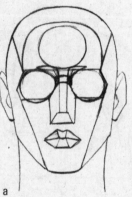 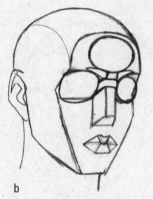 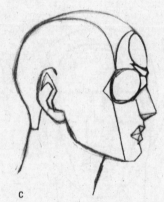

Figure 7-12: Try your hand at drawing the shape that represents the orbicularis oculi.

a b c

Muscles of the human "muzzle"

Almost nothing comes closer than the bond between an owner and his or her dog. But little do we realize just how closely our facial muscle structure resembles one another. Just like Lassie, you have a pair of "muzzle shapes" that control your mouth and cheek movements. First, I show you how to draw the primary muzzle, which is a smaller, round shape that takes care of the orbicularis oris, depressor anguli oris, and mentalis (three for the price of one)! Next, I show you how to draw the secondary muzzle shape, which groups the zygomaticus major and buccinator.

Follow these steps to draw the two muzzle groups:

1. **Draw a small circle from the bottom of the nose plane to the bottom of the chin (as shown in Figure 7-13).**

The width of the muzzle shape aligns with the pupils of the eyes (see Figure 7-13a).

From the three-quarter view in Figure 7-13b, the overall shape appears to be slightly narrow. The curve for the right side of the circle connects with the right edge of the front of the head next to the corner of the mouth.

In your side view in Figure 7-13c, draw a semi-arc for the primary muzzle starting from the bottom plane of the nose and extending down to the bottom corner of the chin.

2. **Draw two long rounded arcs for the secondary muzzle shape, which is partially hidden behind the primary muzzle (as shown in Figure 7-13).**

The arcs start from the top of the bridge of the nose and stop at the midpoint of the primary muzzle.

When drawing the three-quarter view of the muzzle, the left side of the muzzle arcs slightly wider than the right side. The curve for the right side or the secondary muzzle curves to align itself with the right edge of the face. The point where the secondary muzzle connects with the right side of the primary muzzle isn't clearly visible (just barely at the most).

When drawing the side view of the secondary muzzle, the muzzle arc begins from just below where the right side of the eye meets the small vertical rectangle.

Note how the arc slightly curves (resembling a backward *S*). This shape is important to depict the illusion of a three-dimensional object. Vice-versa, when I draw the opposite side profile view of the secondary muzzle arc, the curve then resembles an actual *S*.

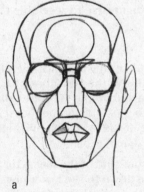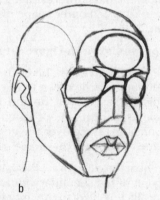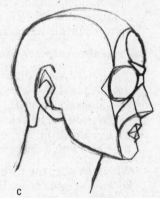

Figure 7-13: Try your hand at drawing the primary and secondary muzzle shapes.

a b c

Make sure the muzzles don't go past the front plane and cross into the side planes.

Going smaller: Muscles of the nose and jaw

In this section, I show you how to indicate the nasalis (nose), temporalis (jaw), and masseter (jaw) muscle sections, which are smaller than the muscle groups in the previous sections. Follow these steps:

1. **Draw two arcs to represent the nasalis muscles (as shown in Figure 7-14).**

 I begin to draw the arcs from the top of the bridge of the nose and stretch them down to the corner of the bottom of the nose.

 A good way to get an overall accurate shape is to make sure both arcs on each side of the nose form an oval, as shown in Figure 7-14a.

 When drawing the three-quarter view, Figure 7-14b, the arc for the right side of the nasalis is closer to the nose bridge and appears narrower than the nasalis arc on the left side of the nose bridge.

 From the side view in Figure 7-14c, I draw a single arc connecting from the top of the nose bridge (the same intersection from which I draw the secondary muzzle; see the previous section) down to the bottom of the nose.

2. **Draw an arc on each side of the head for the temporalis.**

 Make sure the arcs are slightly tilted. From the front view, a portion of the top end overlaps the visible edge of the side plane, which angles down to connect with the occuli eye shape; the bottom end of each arc connects at the eye level.

 When drawing the three-quarter view, the top of the temporalis fan-shaped curve mimics the edge of the side plane and tapers off behind the ear. The bottom side of the temporalis shape runs at a slight downward angle from the left of the occuli to the midsection of the ear. The other side of the temporalis arc shape isn't visible from this angle.

 In drawing the side view of the head, the fan shape stands out. It mimics the outside edge of the profile head before curving in to connect at the midpoint behind the ear. Personally I find this fan shape most interesting. It's amazing how the shape of the tendons mimic the curved rounded outer shape of the muscle to resemble the grip or handle portion of the fan.

3. **Draw the masseter shape, as shown in Figure 7-14.**

 In the front view, draw a short convex arc on each side of the head, connecting from the midpoint of the secondary muzzle down to the side of the jaw (about where the neckline shoots out). This arc represents the bottom side of the masseter shape, which wraps around the side plane of the head. Although the top side of the masseter shape isn't visible from the front side, I trace over the edge of the lower left and right side of the head with a darker line to indicate the shape's existence.

 When drawing the three-quarter view, draw the bottom side of the masseter curve that connects from the midpoint of the secondary muzzle down to the lower jaw. Draw over the bottom of the temporalis line next to the left eye to indicate the top portion of the masseter shape.

 From the side view, draw the same convex arc you draw in the front view, except longer. The bottom of the arc connects to the midsection of the lower portion of the jaw. Because the entire masseter shape is visible from the side view, draw a second convex arc connecting from the left of the eye down to the jaw line slightly below the bottom of the ear.

 This arc almost mimics the shape of the first short arc you draw in the side view. The final shape you get when you draw these two arcs in the side view looks almost like a submarine periscope.

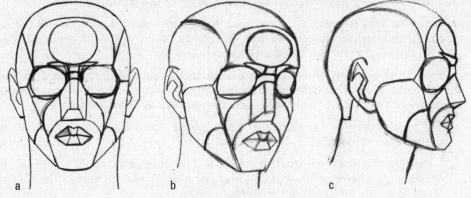

Figure 7-14:
Complete
the general
nose and
jaw muscle
shapes.

a b c

Stretching out: Muscles of the neck

Without your neck muscles, you have little chance of keeping your head from drooping side-
ways. In this section, I show you how to draw the major muscle structures (sternomastoid
and trapezius) for the neck.

The front, three-quarter, and side views

Follow these steps to draw the muscles of the neck in the front, three-quarter, and side views:

1. **Draw a diagonal, concave arc starting from the top of the edge of both sides of the
 jaw and going down to the center base of the neck (see Figure 7-15).**

 Make sure you leave a gap between the two arcs you draw in the front view in Figure
 7-15a. You need this space to draw in the top side of the sternomastoid, which I show
 you in Step 2.

 For the three-quarter view in Figure 7-15b, draw the left side of the mastoid longer than
 the right side facing away from you. I draw the left side of the mastoid at a steeper
 angle (approximately a 45-degree angle) than the line for the mastoid on the right.

 For the side view in Figure 7-15c, draw the same concave arc descending diagonally.
 Start slightly left from where the jaw and bottom of the ear connect.

 Note how in both the front and side views, the diagonal line isn't completely straight,
 but slightly curved down at the center.

2. **Complete the top edge of the sternomastoid shape with two convex curves that start
 from the midpoint of the left and right side of the lower jaw line.**

 From the front, the convex curves connect with each other at the bottom center of the
 neck to form a rounded bottom *V* shape.

 When drawing the three-quarter view, the gap between the upper and lower edge of
 the sternomastoid is wider on the left side (facing toward the viewer) than it is on the
 right side (facing away from the viewer).

 From the side view, the convex curve starts from the midpoint of the bottom side of
 the lower jaw and goes slightly past the front of the neck and sharply tapers off with a
 curve to complete the shape.

3. **Draw the lower portion, the clavicular head, of the sternomastoid.**

I draw two short lines that curve away from each other on each side of the neck below the sternomastoid shape. The outside edge of the curve for the clavicular head aligns with the edge of the neck and sternomastoid.

From the front view, the edge of the neck doesn't represent the outside edge of the clavicular head. This flat wide muscle structure wraps around toward the side of the neck and tucks underneath along the sternomastoid behind the ears.

The inside curve for the clavicular head extends from the midpoint of the lowered edge of the sternomastoid.

When drawing the three-quarter view, the left curve of the clavicular head connects at the angle where the upper and lower jaw meet. The right side of the clavicular head starts from the midpoint of the sternomastoid.

From the side view, the right side of the clavicular starts from the midsection of the sternomastoid. Observe how the bottom end of the shorter right side of the clavicular curves in the opposite direction.

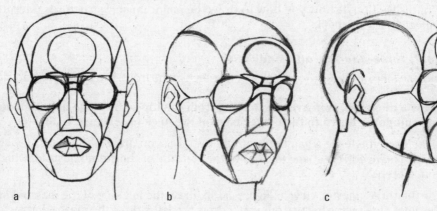

Figure 7-15:
Completing
the muscles
that lie on
the neck.

a b c

The rear view

The muscles of the neck in the rear view require different steps than those for the previous views (no worries, I got your back covered!):

1. **Draw two slightly curved lines (one on each side of the base of the head) resembling parentheses, as shown in Figure 7-16.**

 Leave a gap between the curves to fit in the trapezius muscle.

2. **Draw the trapezius muscle.**

 Start by drawing a straight vertical line from the center of the skull. Then draw two opposing *S*-shaped curves (one on each side of the center line), making sure they intersect with the parentheses you draw for the sternomastoid in Step 1.

 The opposing *S*-shaped curves start from the midpoint between the center line of the trapezius muscle and the starting point of the sternomastoid.

The top portion of the trapezoid muscle resembles two symmetrical shoe-like shapes placed heel-to-heel against each other. Note how the top of the trapezoid muscle, which connects to the back of the head, is narrower than the entire width of the skull. The sternomastoid shape is visible behind the trapezius.

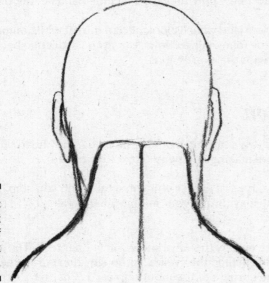

Figure 7-16:
The back view of the neck muscles.

Once More with Feeling

Face it, your expressions are a dead giveaway to how you feel. If you've watched someone try to lie about those "missing" cookies on the kitchen table, you can testify to just how tightly connected feelings are with the facial expressions.

Are you into sports? (For me, it's watching my favorite baseball teams, the Mets and the Red Sox!) Next time you go to see your favorite team play, take a look around you and observe the types of facial expressions among the fans who surround you. For example, when the home team hits a home run, what kind of expression does one fan make in contrast to someone rooting for the opposing team?

After watching the various types of expression, you can see how this visual exercise translates into drawing. In the following sections, I focus on the following basic expressions: worried, scared, angry, sad, surprised, and happy (along with a few others). Before starting out on your wild emotional escapade, however, you need a neutral expression to compare and contrast to the shift of expressions. The neutral face is startlingly similar to the face you draw in the earlier section, "Putting on Muscle," but it doesn't have all the extra lines. The information on drawing basic facial features in Chapter 5 may also help you see how the features change in each expression.

For the purpose of showing how different people have different expressions for the same emotion, I place the male and female side by side for each expression. Seeing the male and

female faces also gives you the advantage of observing how a single expression can always be expressed in more than one way.

In some of the sections, I point out that an expression can be more effective when you bring the hand alongside the face. Although drawing the hand isn't a requirement for connoting a general expression or emotion, it certainly adds more character and panache. On your next trip to the museum or gallery, see how many portrait works include hands in the picture.

One useful suggestion that carries some face-value is looking at a mirror while mimicking each of the facial expressions in the following sections. Doing so is effective because it encourages you to personally relate with the expressions.

The neutral expression

Allow me to introduce Jake and Jane. On a normal workday morning, they head off to work at the office of, let's say, a large coffee-making company (I just love coffee).

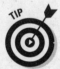

Think of the neutral expression as the type of expression you wear when you step outside to get a cup of coffee on a normal Tuesday during your midmorning break. You're neither happy nor sad.

In Figure 7-17, I draw the eyes and nose exactly the way I show you in Chapter 5. The gaze is set forward with a portion of the iris hidden behind the eyelids. Although I don't draw the mouth with an open smile, I slightly turn the corners of the mouth upward (Chapter 5 explains how to draw a basic mouth). This upward tilt of the mouth prevents the overall expression from becoming blank or zombie-like. Remember, Jake and Jane aren't mannequins!

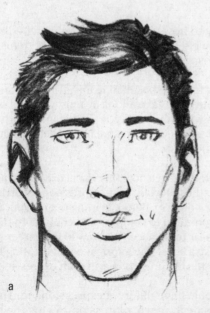
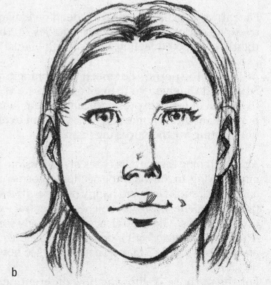

Figure 7-17:
Introducing
Jake and
Jane in
neutral.

a

b

The worried face

Jake and Jane get to their office only to realize something isn't right. Everyone is shredding papers and scurrying around with his or her personal office belongings. Jake and Jane are definitely worried!

For Jake in Figure 7-18a, I make one eye slightly wider open while half closing the other by drawing a fuller eyelid. I raise the eyebrow of the wide-open eye while lowering the eyebrow of the half-open eye. Also, raising the right lower lid slightly higher gives a sense of disbelief, as if he's saying, "Dude, what's going on here?" In addition, pay attention to the way I curve down both ends of the mouth to create a slight upside-down smile; when you draw this curved mouth, just adjust the direction of the arc bend (see Figure 7-18a). I lightly draw a short curved line to indicate the primary muzzle movement to suggest that his alert senses are starting to twitch.

For Jane in Figure 7-18b, keep the eyes the same size as the neutral expression in the previous section. I arc one eyebrow while drawing the other eyebrow in a convex curve. Turn the neutral mouth to an upside-down smile that isn't as extreme as Jake's. For added effect, I draw her hand holding up her chin as if to say, "I don't like the look of this!"

In both cases, the nose remains the same as it is in the neutral expression.

Figure 7-18:
Uh, oh!
Expressing
worry.

a b

The scared face

Jake and Jane are told that the company has just folded after a trading scandal. All the stocks they had are now worth nothing. Oh, the horror! In Figure 7-19, I give you a couple of examples of expressions that are typically associated with fear.

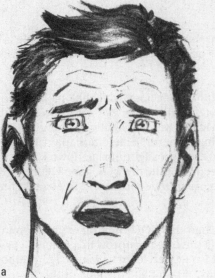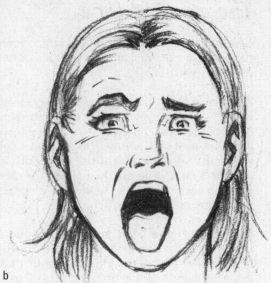

Figure 7-19:
Showing fear with raised eyebrows and open mouths.

a b

Jake's eyebrows in Figure 7-19a arch upward as his eyes grow wider. Pay attention to the way I slightly skew a portion of the top lid so it angles from down (in a neutral expression) to up (the skewed top lid gives a little space between the upper eyelid and the iris and pupil). The lower lid is slightly raised and overlaps the bottom of the iris. You end up with a puppy-eye effect (you know, the stuff that makes you go "awww!"). At the center of the forehead, draw a couple of lines that loosely mimic the shape of the eyebrows. (Those are the forehead muscles that I describe earlier in this chapter at work!) I draw a rounded polygon for the mouth; note how the top portion of the mouth is slightly higher than the bottom. I recommend drawing the mouth slightly skewed to create a more realistic expression (facial features that are too symmetrical appear static and contrived). Don't forget to include those muzzle lines that start from the side of the nose and travel down to the corners of the mouth. Because the corners of the mouth are pulled down with this particular reaction, the muzzle lines are longer and visibly prominent. (I describe the human "muzzle" in more detail earlier in this chapter.) The width of the mouth causes the nostrils to flare out.

Facial wrinkles resulting from fear are a result of muscle groups pressing and pulling against or away from each other. When the fear includes surprise, the frontalis muscle structure pulls up the eyebrows, causing the compression of the forehead skin and a series of wave-shaped wrinkles that, for some individuals (such as myself), run parallel to each other. When the fear includes pain and/or anguish, the corrugator contracts the eyebrows together to create wrinkles between the eyebrows. A good example is to compare the face to a sheet of fabric. When you push or pull sections of the fabric against each other, you get the same "skin wrinkle" effect.

Jane has a similar expression in Figure 7-19b, except her mouth is wide open as if she's screaming or gasping for breath. I arc the lower eyelids higher to conceal a portion of the bottom of the iris. This technique reflects how her cheek muscles press against the eyes. When drawing the eyebrows, I draw one side angled and higher than the other to show how she's freaking out. To slightly indulge my artistic freedom of expression, I make the eyes slightly smaller to enhance the sense of sudden fear mixed with surprise. Because

most heads tilt back when reacting to fear, I draw the eyes lower. Last but not least, Jane's nostrils are slightly wider with the help of the nasalis muscle structure, but not as wide as Jake's because her mouth movement is more vertical than horizontal.

Generally, people tilt their heads slightly backward when reacting from fear (it's just in our nature), as Jane does in Figure 7-19b. Therefore, when the mouth is open, you're more likely to see more of the upper teeth than the lower teeth.

The angry face

The news is out! Jake and Jane's firm has just been bought out by a large competing herbal tea manufacturer. If they want to stay with the company, they must now drink ginseng tea at work. Life without coffee?! I think not!

In Figure 7-20a, I draw Jake in an aggressive stage of rage; his teeth are bared and gnarled. Draw his left cheek higher than his right by raising the left *C*-shaped curve higher than the opposite backward *C*-shaped curve. Also, pay close attention to the way I tilt down the eyes as well as the eyebrows. By burrowing the eyes behind the eyebrows, you increase the tension (compliments of the corrugator). The lower lids of the eyes are slightly raised and concave (a result of the cheek muscles contracting up toward the eyes). Next, I widen the cheeks (caused by the gritting and bearing of the jawbone structure), which then stretch the width of the nostrils. Adding the frown lines and small wrinkles between the eyes and above the bridge of the nose gives a kick to the expression. You can also draw some arcs above the raised eyebrow to show how wide he's opening his eyes (with the help of the orbicularis oculi muscles that I describe earlier in this chapter). Although the amount of change varies depending on the individual, I widen the neck and draw some vertical lines for the tendons and muscles that contract when he grits his teeth together (I cover neck muscles earlier in this chapter). Draw the muzzle lines from both sides of the nose to the edges of the mouth.

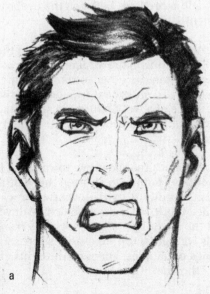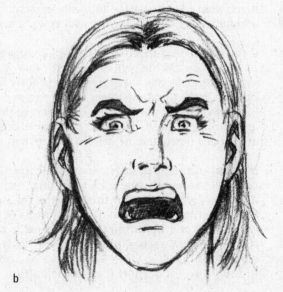

Figure 7-20: Expressions that show anger.

a

b

For Jane in Figure 7-20b, I draw only a short line or two between the eyebrows, which angle in toward the top of the bridge of the nose. Be careful not to add too many wrinkles for women. I widen her nostrils at a slight angle to give an overall softer quality. Drawing the mouth open is another way to show anger with a hint of shock. In this case, make the opening resemble a kidney bean. Don't forget to break the symmetry and drop either the left or right side slightly lower than the other side. Finally, I draw a slightly concave curve beneath the upper lip for the upper teeth.

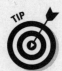

When you map the individual features of an expression, avoid making the two sides of the face too symmetrical. An asymmetrical face not only prevents the facial expression from being static, but also gives viewers more visual information to relate to the figure's psychological state.

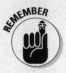

Many students first starting out tend to overexaggerate the facial shapes and sizes when drawing extreme expressions, such as anger; the result of this overexaggeration is the overdone cartoon-ized face. I think students tend to overdo it at first because they're already so used to seeing oversimplified facial icons (such as the smiling "have a nice day" icon) that they forget to take time to think about how wide, small, or large these individual shapes actually are in relation to one another. Exaggerating forms is important only when drawing expressions in a narrative format (such as graphic novels, comics, cartoons, and caricatures).

The sad face

The slow, sinking reality sets in for both troubled co-workers when they realize that they have no hopes of paying for their nice but expensive vacations! The two make haste to join their co-workers in packing up their belongings.

As shown in Figure 7-21a, Jake has both eyebrows raised toward the center of his forehead. I add a couple of short wrinkle lines to show the pressure between the eyebrows.

If you want to increase the intensity of despair, add more lines between the eyebrows. In addition, consider placing the eyebrows at a slightly higher angle.

If you observe figures that contemplate in sorrow, their eyes are either fixed to the ground or raised toward the high heavens for mercy. Even though I draw Jake's eyebrows a bit symmetrical, I make sure one eye is slightly higher than the other to retain an interesting balance. Note that both lower lids are raised higher. To show that he's on the brink of tears, I add larger highlights in the pupils to give the sense of a wet texture. To show that the eyes are starting to swell, draw a short convex curve that begins beneath the tear duct of the eye and angles down and away from the nose.

Next to both sides of Jake's nose, draw the muzzle lines that go down toward the bottom edges of the mouth. The trick to getting the mouth to pout is to shorten the width while creating an *M*-shaped line for the center of the lips. In addition, mark down two bracket-shaped indentation marks below both end corners of the mouth. I also draw an upside-down bracket under the lower lip to add to the dimension of the lower lip sticking out away from the chin. As the lips draw closer to the nose, the nostrils widen. To top things off, some sad expressions have the glum chins that appear as a series of dimples. I demonstrate this effect by drawing a series of short lines at the bottom of the chin.

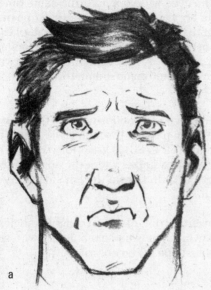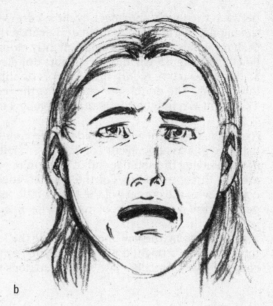

Figure 7-21:
Ready to
sob with
sadness.

a b

Just when you think Jake is having a hard time, let's turn to poor Jane, who's totally losing it in Figure 7-21b. When drawing a crying face, be sure to slightly darken the eyebrows to enhance the furrowing effect. Note how the inner ends of the eyebrows abruptly tilt up toward the center of the forehead; this expression leads me to draw two angling wrinkles on the lower forehead to loosely form a *V* shape. Under the eyebrows, I draw two thick arcs for the eyes, which are clamped shut from the intense crying.

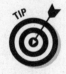

The key to getting this shape right is to make the outer ends of the eyelids thicker. In addition to lightly drawing the arc lines for the upper eyelids, don't forget to include the lower convex arcs (the same ones you draw on Jake) under the eyes. These arcs give more definition as well as an overall three-dimensional appearance. For kicks, I draw a tear streaming down her left cheek.

Don't go overboard with the size of Jane's bawling mouth. A common mistake beginners make when drawing the mouth away from a live model is to resort to the classic *O* shape. As I demonstrate later in this chapter, this narrow and round shape is more often than not found on surprised or shocked expressions. What's closer to reality is that the crying mouth resembles a lima bean or a trapezoid shape. When the corners of Jane's mouth widen to try to suppress her tears, the nasalis muscles react by contracting the size of the nostrils (the opposite of Jake's nostrils, which widen).

The surprised face

Fret not, Jake and Jane just got notice of a huge severance package that will help them well into the future! Heck, it's enough money to keep them afloat for the next ten years!

For Jake in Figure 7-22a, I draw the arc-shaped eyebrows that resemble macaroni curves. I center the iris and pupil between the upper and lower eyelids. To make some space

between the upper and lower eyelids, I draw the eyes wide open. At the same time, I make the pupil and iris a tad bit smaller. Because the bottom jaw of the mouth drops open in an *O* shape, I narrow the width and slightly elongate the length of the lower half of the head. Finally, make sure you draw the short double-arc shapes for the back of the tongue as well as the lower teeth. Before drawing this double-arc shape, I recommend first drawing the lower teeth. The double-arc shapes for the back of the tongue mimic the upper lip shape. The result is a tongue shape that resembles a heart.

Avoid shading in the entire inside of the mouth with a dark uniform value. Contrary to what many people assume, plenty of detail is visible when peering through a wide open mouth. I find that using the soft flat end of a graphite pencil (6B to 8B) is great for covering the large areas of the open mouth. For the detailed edges (for example where the edges of the tongue connect with the corners of the back of the teeth), I switch from the flat side of my drawing pencil to the pointed edge of my drawing pencil.

When elongating the jaw line, make sure the lower portion of the jaw slightly angles in rather than dropping straight down (unless you're drawing strong muscle builders with square, chiseled jaws). As Jake's jaw widens, so does the shape of the nostrils.

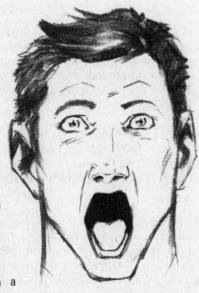
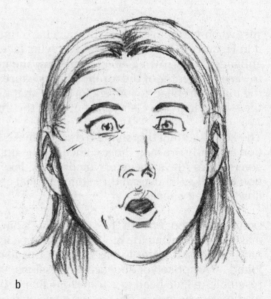

Figure 7-22:
Wow!
Showing
surprise.

a b

For Jane in Figure 7-22b, draw the iris and pupil shapes slightly cross-eyed to give a cuter, more innocent appeal. Illustrator Gill Elvgren (one of my personal favorites) actually uses this expression quite a lot in his figures. To give the slight exaggeration that her eyes are wide open in disbelief, I draw a couple of lines underneath the bottom eyelid. I draw female lips fuller than the lips of the male. Especially when pursing them together, the key is to make the upper and lower lips rounder. At the center, I leave a small gap so the overall mouth shape doesn't look too stiff. As a final touch, I draw two opposing curves (one short, the other longer) at the top and bottom of the lips. This gives the lips a more

three-dimensional appearance. As Jane's lips pucker together, her nostrils contract to become narrower.

The happy face

Well guess what? Jake and Jane meet each other for the first time as they leave the office and decide to join forces to open their first coffee shop. Who says love can't brew at first sight!

In Figure 7-23a, Jake's eyes grow narrower as his smile widens. Notice that both eyes are now narrower when compared to the previous surprised expression. Because the upper portion of the lips stretches across, the upper teeth are more visible (for others, the lower teeth may poke out a sliver from behind the lower lip). His smile is so wide, I draw a pair of bracket shapes (one on each side of the mouth) to show the lower flesh of the mouth compressing together. I also raise the eyelids along with the high arching eyebrows. As his smile widens across, so does Jake's nose.

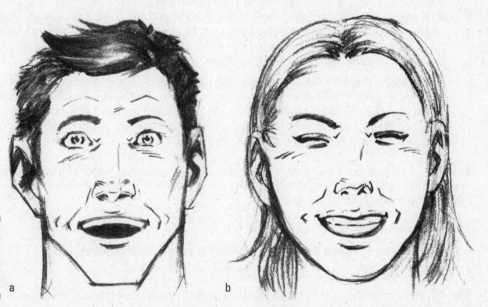

Figure 7-23: All is well in these happy expressions!

a b

Jane, on the other hand, is so happy she can't keep her eyes open in Figure 7-23b. It's as if she's about to scream with joy. For the overall expression, I draw the eyebrows angling down with her eyes almost squinted shut as if she's about to hold back tears of joy. I lower the upper eyelid while slightly raising the lower lid to the point where it overlaps both the top and bottom edges of the iris. Keeping the top lip fairly straight (it still curves a little), I curl the top lip end up into the cheek muscles. As the lower lip wraps tightly around the bottom teeth, keep in mind that because the cheek muscles are tugging at the lips from the side, the lower lip arc isn't a complete rounded hemisphere. The cheek muscles stretch the nostrils wide. Lastly, pay attention to the *S* curves under the cheeks. Watch how the ends curl around both sides of the mouth.

Other emotions

In Figure 7-24, I illustrate a few other emotions. I list them in the following order:

✔ **Bored:** The mouth is an upside-down banana shape. Draw the eyes half closed while letting the direction of the gaze remain straightforward (see Figure 7-24a).

✔ **Mischievous:** Draw the outside edges of the eyebrows starting up and angling down. I draw a wide grin with the corner edges of the mouth turned upward (see Figure 7-24b).

✔ **Embarrassed (ashamed):** Keep the facial features lopsided. I draw the left eyebrow angling upward while the other angles downward. For the smile, make the left corner of the mouth pulled down while the right corner turns upward. The nostrils are slightly wider to reflect the heavy breathing (see Figure 7-24c).

✔ **Disgusted:** The eyebrows angle down while you raise the cheek muscles, which cause the lower lids to rise (see Figure 7-24d). The top lips are raised in an *m* shape, which results in wider nostrils (similar to Jake's sad expression).

✔ **Annoyed:** To draw this expression, I lower the left eyebrow while raising the right as if to say, "This is intolerable; how can anyone stand this?" Though I angle the mouth so the left end is higher than the right end, I indicate the tension that surrounds the mouth by pulling down the corners on both ends. The left nostril is slightly wider than the nostril on the right (see Figure 7-24e).

✔ **Witty:** Draw the left side of the eyebrow slightly raised higher than the right eyebrow. The key to getting this delicate expression is to lower the right eyelid to cover a top portion of the iris. While making the right side of the mouth higher than the left, observe the difference between the corners of the mouth, which twist up as opposed to down in the annoyed expression (see Figure 7-24f).

Take time to assume each of the preceding expressions as you stand in front of the mirror. See whether you identify with the illustrations in Figure 7-24. Here are some questions to ask while going through this exercise:

✔ Which eyebrow do you raise?

✔ Do some expressions call you to tilt your head in a certain direction?

✔ What are your favorite expressions?

✔ Do you recognize any of these facial expressions on your friends? If so, how do they differ compared with yours?

Showing Your Age with Wrinkles

Adding lines along the planes of the face gives the illusion of age advancement. Although wrinkles vary depending upon the person, common physical patterns form the wrinkles on the face. In addition, common parts of the facial features start to change shape as we age.

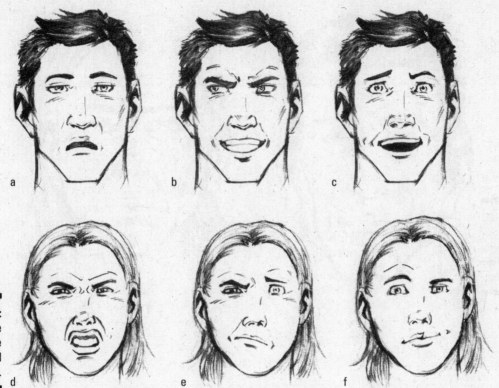

Figure 7-24:
A wide
range
of facial
expressions.

As you draw the lines and curves for the wrinkles, keep your line quality light and rounded. This gives the overall soft and round look of the aging face (in contrast to the darker and angled lines you use for a younger and chiseled face).

Here are some key places where I include wrinkle lines (see Figure 7-25):

- Underneath the eyes and around the upper eyelids
- Next to the eyes in the eye sockets
- Across the forehead
- Down the cheeks as well as under the chin
- Under both ends of the mouth

Figure 7-25:
Adding in
wrinkles
resulting
from age.

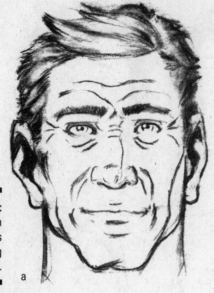

a

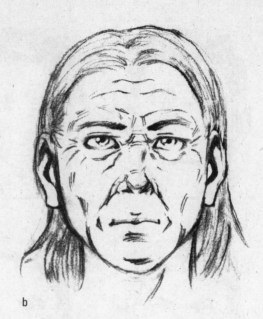

b

Part III
Building the Body

In this part . . .

After you know the basics of drawing the head, it's time to attach it to a body. In this part, I walk you through three progressions toward building the figure. First, you draw the stick figure (which is a lot more than your common hangman character!). Next, you build up the figure by using basic geometric shapes. And finally, you embellish the structure with muscles. Don't be intimidated by those thick encyclopedic anatomy books tucked away in the basement of your library. I simplify the overall muscle structure to emphasize general shapes that pertain to drawing the figure.

No figure is complete without examining basic figure actions. I start by demonstrating several basic properties that apply to a lot of natural postures you're likely to witness on a frequent basis. These postures include asymmetry, diminution, foreshortening, and elimination. Then I introduce more advanced poses, ranging from casual sitting to more dynamic jumping.

Ready to spring into action? Here we go!

Chapter 8

Examining Figure Proportions and Bone Structure

* *

In This Chapter

▶ Measuring proportions with the head count method

▶ Becoming familiar with the body's skeletal structure

▶ Discovering bone "landmarks"

* *

Having a grasp of basic proportions and bone structure is crucial in drawing the human figure consistently, realistically, and — most important — artistically. Think of the skeletal proportion guide as a compass. Without it, you have a hard time seeing whether the whole figure you just spent time piecing together, shape by shape, is accurate or not. By the time you attach one shape to the other, you want to make sure the figure as a whole is heading in the right direction. If the body is too big in relation to the head, the rest of the figure will look like your model just came back from an appointment with the witch doctor — even if each shape is completely realistic on its own.

In this chapter, I go over the head count method of measuring the body's proportions and describe the basic human skeletal structure. In addition, I show you a method of drawing properly proportioned figures by using what I like to call bone "landmarks."

Using the Head Count Method to Determine Proper Proportions

When I use the term *proportions,* I'm talking about using the height and width of the front view of the model's head to figure out how tall and wide the figure needs to be. In the following sections, I introduce the concept of head counts and describe the proper proportions of humans at different ages by using the head count method.

Getting started with head counts

A *head count* is a method in which the length of the head is used to determine how tall and wide to draw the sections of the body in relation to other individual parts or group sections. People at different ages have heights of different head counts:

✔ The average height of an adult human figure (male and female) is 7¹/₂ heads tall. However, it's simpler, more efficient, and more aesthetically dignified to draw the human figure as 8 heads tall. Many anatomy and drawing resources approach the human figure as 8 heads tall. To avoid any confusion, I go with the 8-heads count throughout this book.

✔ Teens are hard to pin down because girls hit puberty earlier than boys do, but they're approximately 6 to 7 heads tall.

✔ Children measure around 5¹/₂ to 6 heads tall.

✔ The average head count for toddlers (about 18 months to age 3) is 4 to 5¹/₂ heads tall.

✔ The average infant (up to age 2) has an approximate measure of 3 to 4 heads. At this age, the head size versus body size is oddly unbalanced due to the large head.

As long as the facial feature's shapes and placement are accurate, you can use the length and width of the head to gauge the head count or proportions of the figure no matter how large or small you draw the head.

Because this proportion is a theory-based principle, not all the models you draw from life will have this 8-head count. I encourage you to use the proportion guideline to check the size of the figure that you draw away from a live model, but don't rely solely on this theory when you draw from a live model.

I remember as an art student being frustrated during a figure-painting class where the model was a fashion model. I couldn't figure out why the figure in my drawing looked so awkward when my proportions were set at an 8-head count. I soon realized that the model was actually 10 heads tall!

When you draw from life, tailor the proportions of the live model to that particular model's head length and width. Sometimes, when the model has a lot of hair, it's difficult for me to assess where the top of the skull is; in that case, I take the entire measurement of the hair plus the head and call it 1 head count. Sometimes, grouping objects together is quicker and more efficient than trying to take into account each piece.

Measuring or aligning sections of the body either vertically or horizontally is easier and more accurate than guessing where the shapes fall. Here are some useful tips that I recommend using to determine the head count of a figure:

✔ When drawing from a live model, hold your drawing pencil as if you're extending a bouquet of flowers toward the model. Be sure to keep your elbow straight as you hold your pencil up to the model. Align the tip of the eraser end of the pencil to the top of the head while adjusting the position of your thumbnail (on the hand that's holding the pencil) so it's level with the bottom of the model's chin. The distance between the tip of the eraser and your thumbnail is 1 head length; use this measurement to assess the rest of the body proportions.

✔ When drawing the figure sans model, place a sheet of paper next to the head of the figure and mark the top and bottom of the head size on the sheet. Use this as your measuring unit as you draw the body.

✔ If a live model is seated or reclining, hold your composition grid (Chapter 2 tells you how to create this useful tool) toward the figure to gauge how large the head is in relation to one of the smaller subdivided boxes inside the grid. Use this size relation to determine how large or far apart the other body sections need to be.

✔ If your model is bending forward, don't measure the head count along the bent figure; instead, with your elbow straight, hold your pencil up next to the model's head or feet. Use the straight edge to assess where the body shapes align in relation to the edge of the head or foot. (If you place the edge of the pencil next to the feet, I recommend using either the front or the back of the heel.)

Don't grow too attached to or obsessed with relying solely on the head count for accuracy (especially when you draw from life). This method is only a theory adapted to instruct and help students. Ultimately, the process of measuring and checking the head count serves as one of many ways to train and hone your observation skills. Often a figure drawing ends up looking stiff and off balance even after you apply proper proportions (this happens especially when drawing from a live model). As I explain in detail in Chapters 11 and 14, incorporating factors such as body rhythm and placement composition are just as important when creating a good figure drawing. As you gain more drawing experience, you'll need to refer back to this measuring method less often. (Another method for working on proper proportions involves bone "landmarks," as I explain later in this chapter.)

Distinguishing adult male and female proportions

In Figure 8-1a, I illustrate adult male proportions based on the 8-head count I explain in the previous section. Here are some features to keep in mind:

✔ The first head count marks the distance from the top of the head down to the bottom of the chin.

✔ The second head count ends right beneath the armpits.

✔ The third head count ends at the navel section below the rib cage.

✔ The fourth head count ends at the crotch region.

✔ The fifth head count ends at the fingertips when they're placed flat against the hips.

✔ The sixth head count ends right underneath the knees.

✔ The seventh head count is slightly below the midpoint of the shin.

✔ The eighth head count ends where the feet meet the ground.

✔ The measurement from shoulder to shoulder is $2^{1}/_{2}$ heads wide.

✔ Wrists rest at the halfway mark of the figure.

Figure 8-1b shows adult female proportions. Here's how they're different from adult male proportions:

✔ The neck is narrower and longer

✔ Shoulders are narrower ($1^{1}/_{2}$ heads wide versus the male's 2 heads wide)

✔ The second head count may end at the nipples (depending on the size of the breasts) rather than beneath the armpits

✔ Arms are narrower, and hands/fingers are rounder and more slender

Head counts in art through the ages

The average adult head count proportion in modern art is 7¹/₂ heads to 8 heads tall. When you observe artwork from past centuries of classical figure paintings and studies, however, you find that artists quite commonly exaggerated the head count to attain whatever aesthetic quality and dignity were considered popular at that particular time. The Greeks and artists during the Renaissance portrayed figure proportions that were 8 to 10 heads tall. During the Mannerism Era, body limbs were intentionally elongated disproportionately to the head or body to portray the graceful elegance of the overall human figure. Artists such as Parmigianino painted proportions that went as high as 11 heads! Talk about quite a head count!

✔ Rib cage is narrower (1¹/₄ heads wide versus the male's 1¹/₂ heads wide)

✔ Hips are wider and rounder (2 to 2¹/₂ heads wide versus the male's 1¹/₂ to 2 heads wide)

✔ Upper legs are rounder and wider at the top

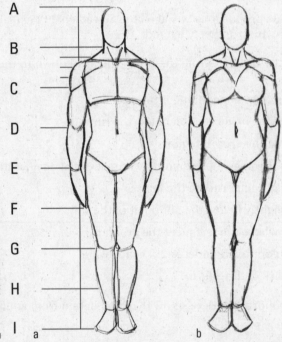

Figure 8-1: Adult female proportions are slightly different from adult male proportions.

Looking at infant and child proportions

In Figure 8-2, I draw the front views of infant (0 to 18 months old) and child (5 to 10 years old) proportions. The following lists give you some interesting facts that occur throughout the physical growth transition. First up, infants:

✔ The head length of the infant starts out nearly the same width as the shoulders.

✔ The first head count starts at the top of the head and goes to the bottom of the chin.

- ✔ The second head count ends right above the navel.
- ✔ The third head count ends at the knees.
- ✔ The fourth and final head count ends where the feet hit the ground.

And here are some basics to keep in mind when drawing children:

- ✔ The shoulder width is approximately 1¹/₂ heads wide.
- ✔ The first head count starts at the top of the head and goes to the bottom of the chin.
- ✔ The second head count ends right below the sternum of the rib cage.
- ✔ The third head count ends at the crotch.
- ✔ The fourth head count ends at the knees.
- ✔ The fifth head count ends above the ankles.
- ✔ The final half head ends where the feet connect with the ground.

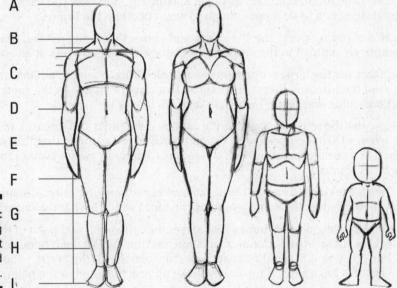

Figure 8-2: Looking over infant and child proportions.

Boning Up on the Human Skeleton

At first glance, the skeleton is a bone-chilling sight, especially to an artist. You may be asking, "Are you saying that I need to be able to identify as well as draw *every bone* to become a competent figure-drawing artist?" Absolutely not; you need to know every bone only if you plan on becoming a medical doctor! This popular myth is unfortunately reinforced by those large, thick, hardcover anatomy "figure drawing" books that expect you to digest detailed individual parts and don't tell you how to actually process the overall structure.

Knowing as many bones as possible is certainly helpful, but you don't have to know all the names or draw the entire skeletal structure from memory to have fun drawing the human figure. As I walk you through different skeleton sizes in the following sections, keep in mind

that the skeleton in figure drawing ultimately functions similarly to the wire frame that supports the structure of a clay human sculpture. (Familiarizing yourself with the skeletons in this chapter helps you understand the simplified stick frame that I describe in Chapter 9.) Also pay close attention to where parts of the bones slightly protrude out of the body to serve as "landmark" guides, which help you place body parts in the accurate position to each other (as I explain later in this chapter).

The adult skeleton

I illustrate the adult skeleton structure in four different views (front, three-quarter, side, and back) in Figure 8-3. Here are the names of the major bone structures that you need to be familiar with. (Note that I only say "familiar" — you don't have to be able to draw them all from memory. I won't quiz you on all 206 bones in the adult body!) I also note commonly made mistakes that I see over the course of teaching and from my own personal experience. Keep these notes in mind as you continue to study and draw the figure (I apply some of these points in Chapter 9):

- **Skull:** Protects the brain. Common mistake: Making the side view too narrow (the backside of the head needs to be large enough to accommodate the brain).

- **Clavicle:** Holds and supports the shoulders and joints. Common mistake: Drawing the bones completely parallel to the ground (in reality, each slightly tilts at an angle).

- **Humerus:** Controls the large movements — like elevating, pushing, pulling, and swinging — of the forearm. Common mistake: Drawing the humerus the same length as the forearm (ulna and radius) when, in fact, it's longer by $1/2$ head.

- **Ulna:** Helps twist the wrist. Along with the radius, it supports the forearm, which is generally weaker than the upper arm. Common mistake: Assuming that the bone is always fixed in a parallel position with the radius (it actually twists around the radius when the hand rotates).

- **Radius:** The shorter counterpart of the ulna serves the same function. Common mistake: Drawing the radius the same length as the ulna (which is slightly longer).

- **Carpus:** A group of eight small bones that strengthen the wrist and palm of the hand and support the metacarpals. Common mistake: Assuming that each bone is independent and has great mobility and/or that these bones make up the entire palm of the hand (as I show in Figure 8-3, they clearly make up less than half of the palm).

- **Metacarpals:** Five sets of bones that support the fingers to grasp, hold, and perform other sophisticated functions. Common mistake: At first glance most beginners assume that because of their elongated shape, the metacarpals are part of the finger joints. In fact, they actually make up most of the palm and some of them have little or no mobility at all (see Chapter 9).

- **Phalanges:** A group of 14 bones (three per finger, two per thumb) joined together with tendons. Common mistake: Falsely assuming that the "finger muscle" groups stretch all throughout the phalanges (the fact of the matter is that hardly any muscles surround the fingers; most of the strength is generated by the flexing of the tendons).

The phalanges I list here are separate from the set of phalanges for the toes. Although both the feet and the hands have 14 phalanges, and share the same function, the phalanges in the hand are longer.

- **Rib cage/sternum:** Protects the heart and lungs. Common mistake: Drawing the rib cage perpendicularly vertical to the ground (it slightly tilts at an angle).

- **Pelvis:** Helps protects the lower intestines and, in the female, give support to a baby during pregnancy. Common mistake: Aside from making the pelvis too narrow for the female or too wide for the male, most beginners don't adjust the angle of the pelvis bone when the figure shifts his/her weight to either side.

- **Femur:** Helps carry the upper body weight. Common mistake: Drawing the femurs straight and parallel to each other (the femur from each leg angles toward the other at almost a 30 degree angle).

- **Patella:** A loose bone held in place with ligaments that protects and guards the knee against bumps. Common mistake: When the knees are bent, this bone isn't as visible. The box-like shapes that are visible are mostly due to the femur and tibia, which are located above and below the patella.

- **Tibia:** The larger of the two bones of the lower leg that connect from the bottom of the femur down to the ankles. Common mistake: Drawing one tibia parallel to the tibia from the opposite leg (although they don't angle in as much as the femur, they aren't completely straight).

- **Fibula:** Thinner/shorter bone that helps the tibia support the weight of the upper body (especially when sprinting or carrying heavy objects up the stairs). Common mistake: Assuming the tibia and fibula are the same width and length (the tibia is twice as dense as the fibula and more than an inch longer than the fibula).

- **Tarsal:** Otherwise known as the "ankle bones," this cluster of seven bones supports the tibia and fibula. Think of them as the carpus of the feet. Common mistake: There's a subtle (yet beautiful) arc formed by the tarsals and metatarsals that beginning students miss. This small tweak makes a huge difference in accentuating the slenderness of the overall leg structure.

- **Metatarsals:** Five elongated instep bones that make up part of the bridge connecting the heel to the *phalanges* (also known as the toes). Common mistake: Metatarsals *don't* rest flush against the floor as commonly thought (this misperception is partly due to the fact that people wear shoes). Rather, as I illustrate in the side views of the feet, metatarsals that face inward elevate slightly at an angle to form an arch that acts as a shock absorber.

- **Phalanges:** An intricate group of 14 bones (two bones in the big toe, plus three bones in each of the other toes). Common mistake: Lining up the end of the toes in a flat line rather than drawing them at a slightly curved angle.

- **Scapula:** Commonly known as the shoulder blades. Common mistake: Placing the scapula too close together and forgetting that the clavicle (collarbone) wraps around the front of the rib cage to connect to the edge of the scapula.

- **Spine:** Connects and supports the entire upper and lower body structure from the back. Common mistake: Drawing the spine too straight; actually it has a slight *S* curve.

Overall, the female bone structure is lighter and thinner than the male bone structure. The female skeleton has wider hips that tilt a bit more forward, which causes the back to slightly arch farther and the pelvis to protrude. In addition, a female has a narrower rib cage than the male. These differences give the female figure an "hourglass" look. In addition, the female sternum is slightly lower than the sternum of the male; this gives the neck a longer appearance. A less noticeable difference lies in the back section of the cranium — the female posterior of the occipital section slightly protrudes to give the back of the neck more of a slope. Other than that, there's not much of a difference aside from muscles and fat (which I discuss

in Chapter 10). Although major skeletal differences (such as the hip and neck length) also apply to the teen skeleton structure, the less noticeable differences, such as the cranium, aren't as pronounced until young adulthood.

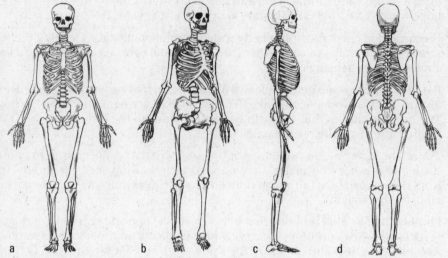

Figure 8-3: A side-by-side comparison of the front, three-quarter, side, and back views of the human adult skeleton.

a b c d

The skeletons of an infant and a child

In Figure 8-4, I illustrate the front views of an infant's skeleton and a child's skeleton. Observe the size of the head versus the size of the body in the adult, the child, and the infant:

- The skull is larger in proportion to the rest of the skeletal structure at birth. Infants start out with more bones pieces than the adult (a whopping 350, to be exact). These individual segments, such as the sections of the skull, fuse together as the individual matures.

- Unlike the adult's solid bone structure, a child's skeleton consists more of soft and flexible cartilages. These cartilages slowly grow or fuse together and eventually are replaced by bone structures by the age of 25.

Using Bone "Landmarks" to Build the Right Proportions on a Figure

Bones that protrude from the body, which I call "landmarks," are an important part of building a solid figure drawing with the right proportions. The benefits of using landmarks are two-fold:

- You can use landmarks to gauge how wide or far apart parts of the body are in relation to one another.

- You can use the points from the landmarks to create a series of smaller shapes to double-check the proportions of the larger sections of the body.

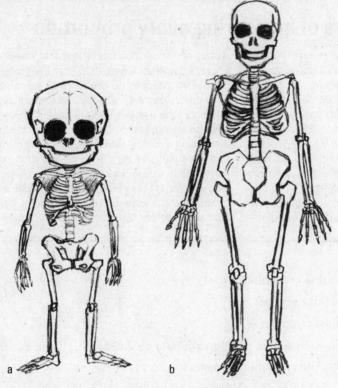

Figure 8-4:
Comparing the skeletons of an infant and a child.

a b

Identifying the landmarks

You can use a lot of specific bones as landmarks. Here's a list of potential landmarks that you see from the front of the body:

- The edges of the shoulder where the clavicle meets the scapula (shoulder blade)
- The lower edge of the sternum; bottom edges of the rib cage
- The center of the clavicle
- The end tips of the ulna and radius (wrist)
- The edges of the pelvis (hip bone)
- The metacarpals (knuckles)
- The patella and top of the tibia (knees)
- The lower end of the tibia and fibula (ankles)
- The lower phalanges (toes)

You can see these landmarks from the back of the body:

- The back of the occipital section
- The point where the spine meets the top of the rib cage
- The top edges of the scapula

The dangers of measuring every proportion

The German painter and printmaker Albrecht Dürer performed extensive mathematical research and studies in the quest to understand the perfect human proportion in his work *Four Books on Human Proportion* (1528). In the end, however, he concludes that overanalyzing the human figure loses its artistic purpose and connection with the artistic practice. Many beginning students enter a figure-drawing/anatomy class wanting to measure every square inch of the human figure before making a mark on the paper. Although this passion is to be commended, the main goal of figure drawing isn't recording a photo-realistic, perfectly calculated replica of the model. If this is your first time drawing the figure (either from life or away from the model), becoming overly attached to the need of measuring every body part is counterproductive and potentially harmful. Students who use this method end up drawing figures that appear stiff and off-balanced. One of the beauties of developing a unique style is taking the basic foundations and principles of figure drawing and then letting your interpretation take control. Part of your subconscious interpretation takes place when you physically lift your pencil after drawing a certain section of the figure to then start another separate section.

- The end tips of the ulna and radius (wrist)
- The top of the ulna (elbow joint)
- The edges of the pelvis (hip bone)
- The two dimples on each side of the leg, opposite the knees
- The lower end of the tibia and fibula (ankles)
- Achilles tendon (located between the edges of the tibia and ankle bones)

Drawing the figure from the center out with landmarks

Earlier in this chapter, I talk about measuring the vertical proportion of the figure by using the head count method. But getting the horizontal measurements of the figure can be tedious and time-consuming with that method — especially when you're drawing from a live model, and when you're drawing the body's narrower parts. Having landmarks minimizes the amount of guesswork you need to do when you're assessing how wide or far apart objects need to be. The shorter the distance your pencil needs to lift off the paper to jump from one point to another, the easier it is to correctly assess the correct relative placement.

For example: Narrow objects, such as arms, are tedious to measure by using the head as a benchmark. Most beginning students draw the outside surface of the arm after having completed the head and shoulders only to realize that the distance between the head and the inside of the arms is either too far apart or too cramped, leaving little space to include the details of the torso. Having landmarks, such as the center of the clavicle, the sternum, or the rib cage indentations, helps bridge the gap between one side of the figure to the other without having to make a riskier guess.

Regardless of whether you're new to drawing the figure or not, completing the outside line drawing of the figure first and then trying to fit in the smaller body details isn't an efficient method. Even if your outside line shape seems to be right on the money, as your drawing pencil travels a longer distance from point A to point B, the probability for error increases. Just think of all the erasing that you need to do (not mention the time wasted on making that carefully drawn line)!

Before I walk you through the process of drawing the figure's front view with landmarks, take a moment to study the earlier section on the adult skeleton structure.

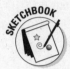

I'm not saying that drawing the figure from the outside in is impossible, but you'll find that constructing the figure from the inside out is not only easier and quicker, but also more accurate. When I'm drawing a challenging pose, I ask myself, "Which landmark can I use to get from this side to the other?" In Figure 8-5, I illustrate an effective approach of using landmark points to develop the figure from the inside out (I focus on the front view).

For this particular exercise, pretend this stick figure represents a live model and that you haven't yet set up the head count. The figure isn't your conventional 8-head figure, so you're not going to use the head count to gauge accurate proportions in this exercise.

1. **In Figure 8-5a, I draw a *u* shape to mark the center of the clavicle, and I draw a slightly curved line angling up toward the ends of the clavicle.**

 I start at the center of the clavicle, where the line for the neck meets with the torso beneath the chin. I work my way across the shoulders to the next landmark, which is the opposite end of the clavicle.

 After I establish those distances, I now have not only an idea of how wide the torso is, but also a better sense of how wide the shoulders need to be. Because I draw right up to the shoulder landmark before gauging the distance between the left and right shoulders, I'm able to better assess how wide to make the entire figure. This method beats trying to guess the width of the outside edge of the upper body first, only to find I don't have enough room to fit in the arm without making the torso either too narrow or too wide.

2. **As I assess the length of the torso, rather than making a giant jump from the center of the clavicle down to the navel, I choose to first stop at the bottom of the sternum (see Figure 8-5b).**

 This step helps me get a better sense of how long the torso needs to be in relation to the width I establish in Figure 8-5a. As a dance instructor advises her students, "It's all about taking baby steps!"

3. **From the bottom of the sternum, I sketch in the bottom edges of the rib cage (see Figure 8-5c) and then draw the navel and crotch region (as shown in Figure 8-5d).**

4. **Complete the arm shapes by connecting the shoulders landmark to the elbow landmark before finally reaching down to the wrists (see Figure 8-5e).**

5. **From the outside edges of the pelvis landmark, I draw the outside shapes of the upper leg to the inner side of the patella or knee joint landmark (as I show in Figure 8-6a).**

 I use the sartorius muscle line to help carry my line across toward the inner side of the legs.

6. **I complete the rest of the leg by drawing the outer edge of the lower leg down to the ankle landmark and then drawing down to the phalanges of the feet (as shown in Figure 8-6b).**

The overall path of my lines is rhythmic shapes that weave in and out (similar to the *S*-shaped curve).

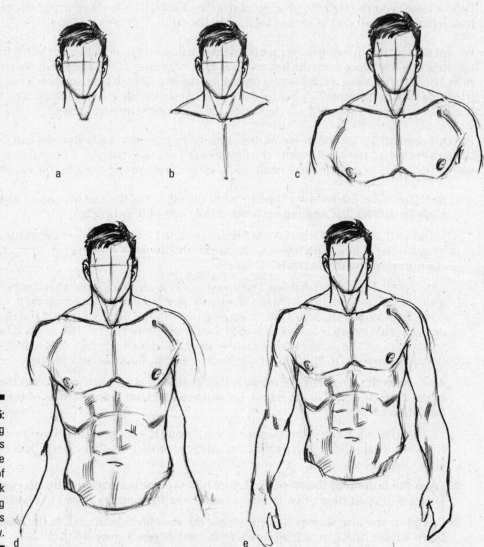

Figure 8-5:
Using landmarks to limit the amount of guesswork in drawing the figure's front view.

Creating small "stained glass" shapes between landmarks

You may remember those days when you were a kid, coloring in those cute workshop craft books. Did you ever connect a series of dots that revealed a surprise image in the end? Well, using the landmarks of the body in figure drawing is similar. Landmarks are great for creating smaller shapes within the human figure to ensure that the larger forms are proportioned accurately.

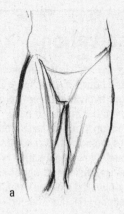

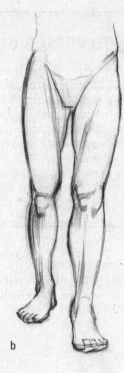

Figure 8-6:
Draw the
lower half
of the body
by using the
landmarks.

A good analogy is to adapt this concept to the stained glass windows in a chapel. Although the shapes that make up the images in the windows are small and abstract, when you look at them from a distance they form a beautiful image. If one glass segment is formed differently, the entire image doesn't work. In essence, you're using the landmarks to create the smaller shapes (like the small stained glass pieces) to form the larger shape of the figure. If the smaller shapes are correct, the larger form will be correct. This method is especially useful, for example, when you're drawing large close-ups of the torso on an 18-x-24-inch pad.

Laying in the smaller shapes to complete the larger shape is an effective method I teach my students. As I mention in Chapter 3, the larger the shapes grow, the more difficult it becomes to keep track of the overall accuracy of the picture.

In Figure 8-7, look closely at some of the small jigsaw-like shapes I create with the help of key landmark points:

✔ Sketch the triangular shadow shapes starting from the pectoralis muscle group (see Figure 8-7a).

✔ Draw the visible muscle groups, starting with the center rectus abdominis (see Figure 8-7b).

✔ Sketch the shadow shapes of the upper and lower arm.

✔ With athletic models, the serratus muscle groups show up clearly and make great angular shapes of light and shadow.

✔ When mapping out the triangular shapes for the lower region, start with the triangular shape above the sartorious muscle band (see Figure 8-7c).

Theory and knowledge versus observation

Throughout this chapter, I talk about approaching figure drawing while you rely upon the head count theory and anatomy in addition to touching upon using your observation skills while drawing from a live model. My goal over the course of drawing from the figure — both with and away from the live model — has been to come up with a certain integration of style that combines the two methods of drawing. Both approaches — a knowledge of anatomy and the head count method, and straight observation — are equally important. I encourage you

not to completely neglect one style or approach toward drawing and studying the figure. No method is dominant over the other. Theories evolve, so keep training your observation skills. On the other hand, our eyes, from time to time, for whatever reason, deceive us into being confused about what we're looking at on the model stand. Just like every other sense, our visual sense is prone to sensory overload; therefore, you need theories and shortcuts to help you filter down the complex nature of the human figure into something you can efficiently process.

The beauty of this method is that you don't necessarily need to use the exact shapes that I show. This is also an opportunity for you to creatively come up with your own abstract small shapes. The only shape I recommend *not* using is a symmetrical rectangle (trapezoids and triangles, on the other hand, are fantastic).

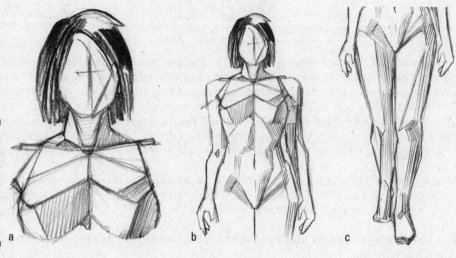

Figure 8-7: Creating smaller shapes to create the larger form of the figure.

a b c

Chapter 9

Starting Simple with Stick Figures and Mannequins

In This Chapter

▶ Drawing the simple stick figure

▶ Building basic body shapes over the stick figure

▶ Depicting basic body movements

Get your pencil and paper ready! This chapter starts you on your journey to drawing the full human figure by explaining how to draw stick figures. "Hey, wait a minute!" you say. "Is this a game of hangman?" Not quite! Stick figures aren't just for games anymore. Drawing the stick figure is important because it helps you simplify the complex bone structure that's the core of the human physique. It also helps you draw a more proportionally balanced rendering of the figure.

In this chapter, I also add basic geometric shapes to the stick figure to present a more realistic representation of the human form, called a *mannequin*. I wrap up by explaining how to make your simplified figure move in a few basic ways.

If you're a beginning art student, you'll find that all your figure-drawing classes focus on the adult form, so I concentrate on adults in this chapter, too. If you're interested in drawing the figures of infants, children, and/or teenagers, you can still follow the steps in this chapter; just shorten your stick figure to the proportions I provide in Chapter 8, and move right ahead.

Building a Stick Figure from Scratch

When you're new to drawing the human figure (or even if you're not!), working with the straight lines of a stick figure is more effective than tracing the outlines of the human form from memory or imagination. Drawing a stick figure before adding on the details (such as muscles, which I discuss in Chapter 10) serves the following purposes:

✔ It allows you to simplify the human bone structure that I discuss in Chapter 8 (after all, who wants to draw all 206 bones for every adult figure?).

✔ It helps cut the amount of time you need to set the figure in the desired pose.

✔ It aids in establishing correct size proportions. A common mistake many artists make is making the limbs and the torso either too long or too short. (I introduce the importance of proper proportions in Chapter 8.)

In the following sections, I walk you through the process of drawing the front view of an adult stick figure; I also compare the front view to the three-quarter and side views.

Blocking in proportion guidelines

When you're starting the stick figure, laying down guidelines is important because you don't want the figure's foundation to be disproportionate. These guidelines are based upon the 8-head proportions that I discuss in Chapter 8. Although the actual human proportions are $7\frac{1}{2}$ heads tall, I use the 8-head count because it's more aesthetically pleasing and easier to draw.

Keep the markings for the guidelines light so that your actual stick figure, which you draw over the guidelines, stands out. Follow these steps to draw the guidelines:

1. **At the center of the page, draw a vertical line and add a halfway division mark.**

2. **Draw a horizontal line at the halfway division mark to form a cross shape.**

 The width of this horizontal line needs to be short (approximately 1 head length).

3. **Divide the upper and lower halves of the vertical line into equal quarters.**

 In Figure 9-1, I draw four lines in the top half and four lines in the bottom half of the horizontal line. Each line, including the horizontal line, is labeled from A through I.

A

B

C

D

E

F

G

Figure 9-1:
Drawing the
proportion
guidelines
for the stick
figure.

H

I

4. **Divide the quarter section BC horizontally into thirds.**

 This division helps establish the length of the neck (see the next section for details).

Don't make these guidelines too big. Keep your initial figure drawings no larger than the size of your open hand. Making the figure larger than the size of your hand makes it awkward to control your wrist motions and create controlled lines.

Drawing the upper body

After you establish the proportion guidelines, follow these steps to draw the upper section of the stick figure:

1. **Draw an oval with a slightly pointed bottom to suggest the bottom of the chin at line B.**

2. **Add a short line for the neck.**

 The length of the neck should come down from line B to the first one-third line of the BC section (as shown in Figure 9-2a).

3. **Draw a horizontal line for the shoulders that crosses the bottom of the neck at the first one-third line of the BC section.**

 Keep the length of the line approximately 1 head length.

4. **For the upper arms, draw a vertical line approximately 1¹/₂ head lengths on each side starting from both ends of the shoulder line.**

 Each line should reach line D.

5. **Complete the arms by attaching a slightly diagonal line that angles away from the body; this line is for the lower forearms and extends from the bottom of the upper arms.**

 Each line should reach slightly below the halfway mark of the body length, at line E.

 A common misperception is that the upper arm and lower arm are equal in length. As I show in Figure 9-2b, the actual length of the forearm is 1 head length long. Both sections *appear* to be almost equal in length only when the length of the lower palm is factored in with the length of the forearm.

6. **Add a narrow oval on each side at the bottom of the forearm at line E.**

 Make the length of the oval approximately ²/₃ heads tall.

7. **Draw a straight line for the spinal column.**

 The spinal column runs from the bottom of the neck at the first one-third line of the BC section down to the center of line E (see Figure 9-2c).

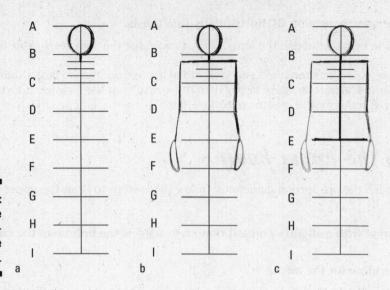

Figure 9-2:
Drawing the upper section of the stick figure.

Adding the lower body

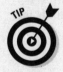

Use the following steps to complete the lower portion of the stick figure after you complete the upper section:

1. **Starting from both sides of the horizontal guideline at line E, draw two lines for the upper leg, angling slightly down toward each other.**

 Make sure the lines for the upper leg stop at line G. The end points should be 1 head width apart from each other (see Figure 9-3a).

 Because preexisting line E acts as the hip line, you don't have to go through the additional step of re-drawing the hip line.

2. **Draw a slightly curved line from the bottom of each upper leg down to the midpoint between line H and line I.**

 A common assumption is that the legs are two parallel, straight, stick-like objects when humans stand naturally erect. The legs do appear to be straight, but only because of the major leg muscles that wrap around and conceal the bones (see Chapter 10 for tips on drawing muscles). The lower legs actually curve slightly away from each other and start slightly disjointed from the knees where the upper legs end. This change in direction prevents the stick figure from looking stiff.

3. **For the feet, draw two small triangles (as shown in Figure 9-3b) that end at line I.**

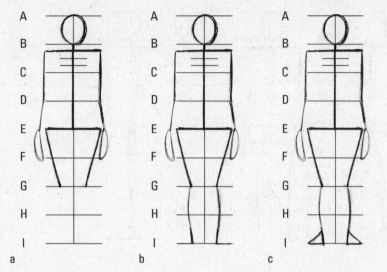

Figure 9-3:
Drawing the lower section of the stick figure.

Comparing different views of the stick figure

In Figure 9-4, I compare the front view of the stick figure with the three-quarter and side views. (The back view of the stick figure is the same as the front view with the exception of the more visible neckline overlapping the bottom portion of the back of the head, because the head faces the other way.) The distance between the vertical parallel bone structures changes as your vantage point shifts from the front side to the three-quarter view. As you compare the views, pay attention to the following:

✔ In the three-quarter view, the length of the shoulder and hip that are farther away from the viewer are shorter than the shoulders and hips in the front view.

✔ The angles of the shoulder and hip lines in the three-quarter view angle slightly in toward each other. The vertical distance between the shoulder, hip, and foot that are farther away is shorter than the distance between the shoulder, hip, and foot that are closer to the viewer. When drawing the three-quarter view, keep in mind that while the shoulder tilts down at an angle and the foot rises slightly up, the level of the hips remains straight and parallel to the ground.

✔ The head tilts slightly forward in the side view (although the neck appears to be straight up from the front view, it actually rests at an angle). The distance between the horizontal and vertical structure is the same as it is in the front view.

✔ The spinal column slightly curves in an *S* shape (this is especially visible from the side view). The direction of the *S* changes depending on whether the figure faces right (a normal *S*) or left (the *S* shape is flipped backward). A good way to make sure the spinal column is facing the correct direction is to observe the alignment with the tilt of the neck. In addition, the angle of the *S* shape slightly pushes the top of the hip shape forward (this is especially apparent in females).

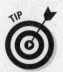

As I discuss in Chapter 11, the more action-oriented the poses you draw, the farther the neck shoots in front of or away from the body. In addition, the *S*-shaped line for the spinal column is more pronounced and accentuated.

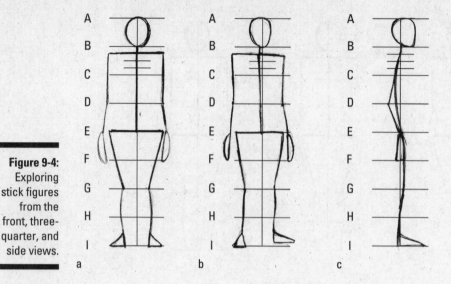

Figure 9-4:
Exploring
stick figures
from the
front, three-
quarter, and
side views.

a b c

Building a Mannequin with Geometric Shapes

After you draw the stick figure, it's time to add on geometric shapes to give the figure a
three-dimensional look and character while it's on a flat, two-dimensional surface area.
(When you add shapes to a stick figure, your figure is officially called a *mannequin;* the end
results look like the same life-sized figure on display at your local clothing store.) Using geo-
metric shapes comes in handy when you simplify the complex muscle groups of the human
figure. After all, who wants to spend a Saturday evening rendering 650 muscles that are in
the body just to draw a single pose? Thanks to the good ol' sphere, cube, and cylinder that
I show you how to draw in Chapter 3, you need not get bent out of shape! (You can add
details of muscle groups after you add geometric shapes, as I explain in Chapter 10.) After
you practice drawing individual parts on your stick figure in the following sections, I show
you how to put all those parts together into one complete mannequin.

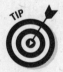

One great advantage of using basic geometric shapes for the body is that it helps artists get
a sense of dimension and space. Having this sense plays a significant role when you draw
objects that are foreshortened (I elaborate on this concept in Chapter 11).

Starting with the head and neck

Although the outline shape is similar, the head isn't just a flat oval or circle; it's a spherical
object that bends, twists, and turns by using the neck as a pivot point. Here are the differ-
ences among the four views of the head:

- ✔ For the front view of the head, simply draw an egg-shaped sphere from line A down to
 line B. As I show in Figure 9-5a, in order to draw the upside-down egg shape, I make the
 top portion of the sphere slightly wider than the bottom.

- ✔ When drawing the head from the three-quarter view, I move the bottom end of the
 egg-shaped sphere slightly toward the direction in which the head is turning (see

Figure 9-5b). This shift in position gives the illusion that the front of the face is rotating toward a different region. The bottom end represents the chin.

✔ When drawing the side view, the bottom (or "chin" end) of the egg shape moves farther toward the direction in which the face is turned (as shown in Figure 9-5c). Observe how the opposite side of the head (the backside) curves at a more extreme angle to meet the bottom "chin" end of the egg-shaped sphere.

✔ The back view of the head is the same as the front view (just giving you guys a heads up!).

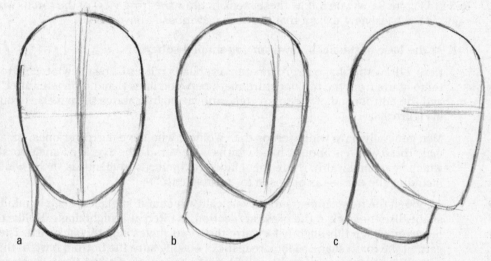

Figure 9-5: Drawing the geometric shapes for the head and neck in several views.

a b c

For the front view of the neck, draw a short cylinder; again, the back view is the same as the front view. Curve the bottom end slightly so the cylinder is slightly tilted forward. The natural position of the neck is rarely an erect, 90-degree angle from the flat ground level. A common mistake is to draw both sides of the neck perpendicular to the ground. This tilted position is clearly demonstrated in the three-quarter and side views. The left and right side of the neck from the front view are the same length.

When drawing the three-quarter view of the neck, make the back side of the neck approximately double the length of the front side of the neck (because the front portion of the head is hiding the front portion of the neck). In addition, the back side of the neck is more vertical than the front side of the neck, which angles slightly forward (making the top of the neck appear slightly wider than the base of the neck). This helps the illusion that the front of the head is in front of the torso.

When drawing the side view of the neck, the back side of the neck is still twice the length of the front side of the neck. From the side view, the back side of the neck is straighter than the front of the neck.

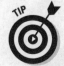

Figures that are stronger or stockier generally have wider necks. Vice versa, make the neck thinner for figures that are thinner or frail.

Be sure to check out Part II for full details on how to draw the head and neck.

Going up the middle with the torso

The geometric shape for the torso is best described as an egg-shaped sphere with a small bite taken out at the bottom (I personally think it looks like a turtle shell from the back view). This simplified shape accounts for the rib cage as well as most of the upper spinal column. I explain how to draw various views of the torso in this section.

The front view

Refer to Figure 9-6 as you follow these steps to draw the front view of the torso (which is the same as the back view, except that the back view doesn't have a hole):

1. **At the base of the neck, draw an egg-shaped sphere.**

 Here, I draw the shape approximately 1½ heads tall and 2 heads wide. The top of the torso starts from the top one-third mark between lines B and C on your stick figure, and the bottom end of the torso comes down slightly above the navel, as you can see in Figure 9-6a.

 Men generally have wider torsos than women, who have narrower ones. An average male torso width is about 2 head widths wide versus the average female torso width, which is ½ head width. (Note that I indicate the measurements as "head width" — not including the ears — as opposed to "head length.")

 Although the torso appears to be vertically erect at first glance, keep in mind that this shape, like the neck in the previous section, is tilted at a slight angle. Unlike the neck, however, which tilts slightly forward, the torso angles slightly backward. The key to getting the torso shape to look realistic is making sure the bottom base of the sphere is wider than the top portion. The width of the top portion of the torso is approximately 1¼ head widths for both sexes.

 Because the neck angles in front of the torso, when you assemble the torso and neck, you need to erase the top line of the torso over which the neck overlaps.

2. **Cut out the "bite" shape at the bottom center of the torso shape; and cut out a small hole for each of the arm sockets (one to the top left and top right side toward the top of the torso; see Figure 9-6b).**

 To draw the "bite" shape, lightly sketch a convex arc at the bottom center of the torso. Then darkly shade the convex arc shape, as shown in Figure 9-6c. The dark shape creates the illusion of an empty cavity space. The entire length of the torso stretches from the top one-third mark between line B and line C down to line D.

Figure 9-6:
The front view of the torso.

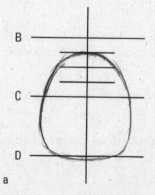

Pay attention to the positioning of the "bite" hole. It's bitten out toward the front of the bottom, and you see the back side of the inside of the torso. In addition, be careful not to place the arm socket hole shapes too high on the torso.

The three-quarter and side views

When drawing the three-quarter view of the torso, you have two factors to consider (see Figure 9-7a). First: The bottom of the torso tilts slightly forward (this is most apparent on the female torso). Second: Due to diminution (which I address in depth in Chapter 11), the side that's closer to you is wider than the side that's facing away from you. Observe how the center guideline from Figure 9-6 shifts to the right in Figure 9-7.

From the side view, the back side of the torso is flatter than the front side (as shown in Figure 9-7b). In addition, the torso is narrower from the side than it is in the front view. If I use the side profile of the head to gauge the measurements, the top portion of the torso is $^2/_3$ the width of the head profile. The bottom portion of the torso is 1 head width. In addition, the bottom of the torso tilts at an angle toward the front (25 degrees for the male, 30 degrees for the female).

Figure 9-7: The three-quarter and side views of the torso.

Keeping the stomach simple

The stomach is basically a sphere — it's as simple as that (cool, huh)? However, don't underestimate its importance. This sphere functions as one large joint that allows the torso to freely rotate and bend around the hips. In Figure 9-8, I illustrate how this useful shape snaps snuggly into the opening of the torso from the front, three-quarter, and side views. (The back view is the same as the front view, except that you don't see as much of the sphere as you do in Figure 9-8a.) The diameter is approximately 1 head long. The placement of the stomach shape in relation to the stick figure is important; it fits from the midpoint of lines C and D down to the midpoint of lines D and E.

When you snap the sphere into the torso's "bite"-shaped opening, erase a small portion of the top of the sphere to create the illusion of overlapping shapes.

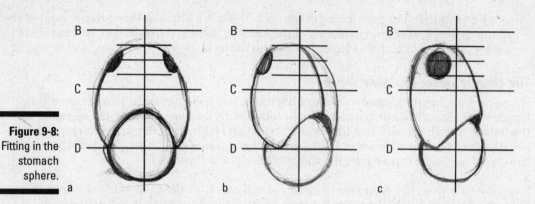

Figure 9-8:
Fitting in the
stomach
sphere.

a b c

Getting hip

Think of the hips as a three-dimensional trapezoid. The hip structure is unique among all the body shapes because it needs to accommodate the bone structure of the upper legs, allowing them to extend sideways from the hips without bursting out of the skin. Thus, having a *wedge-shaped trapezoid* (essentially a regular rectangular cube with an extra cut on each side) is helpful. You find out how to draw different views of the hips in the following sections.

Don't feel discouraged if this shape doesn't come out right the first time. This shape comes naturally with a little practice.

The front view

Follow these steps to draw the front view of the hips (which differs from the back view, because the back side of the hips is slightly higher than the front. In addition, the forward tilt of the hips exposes more of the top portion of the hip's geometric shape from the front view):

1. **Draw a rectangular cube (see Figure 9-9a) that's $1/2$ head tall and approximately 2 heads wide starting beneath line D and going down to line E.**

 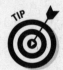

 Female figures generally have slightly wider hips than male figures do. When making the adjustments for the female figure, I add an additional $1/2$ head to the width of the hips.

2. **Cut a diagonal edge off each side of the bottom right and left rectangle (as shown in Figure 9-9b).**

 Draw a 45-degree diagonal line from the edge of the hip down to line E. Leave a slight gap at the center of the groin region. Then use your eraser to get rid of the corner section on each side so you're left with the wedge-shaped hip structure (see Figure 9-9c).

 To show that the shape needs to be hollow for a portion of the lower stomach sphere to rest upon it, I draw the two inside vertical lines to indicate the inner backside of the torso.

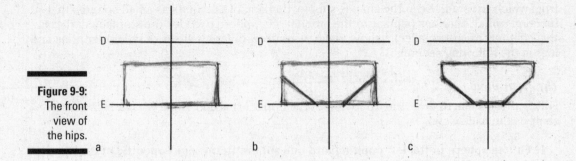

Figure 9-9:
The front
view of
the hips.

The three-quarter and side views

As shown in Figure 9-10a, you draw the backside of the hip higher than the front (the backside is a quarter length higher than the front) when you draw the three-quarter view.

Draw the rectangle shape before cutting off the wedge diagonals. Observe how the top edge of the side plane descends at a steeper angle (approximately 30 degrees) than the rest of the side edges.

When drawing the side view (as shown in Figure 9-10b), the width of the hips is, on average, 1 profile head width. Similar to the three-quarter view, the back edge of the hip is a quarter length taller than the front edge.

Although the left and right edges of the male hips are perpendicular to the ground, the side edges of the female hips skew forward at a 30-degree angle. When drawing the side view of the female hips, the shape slightly skews forward to accommodate the tilt of the torso.

Figure 9-10:
The three-
quarter and
side views
of the hips.

Attaching the upper arms and upper legs

Before adding the lower parts of the limbs, it's important to snap in the joints of the upper arms and upper legs into the proper sockets on the torso and the hips (so make sure you feel comfortable drawing those parts first). Without joints, the limbs have no pivot point

from which to rotate. Keep the shapes simple, thinking of the joints as small spheres that function as ball bearings (similar to the much larger sphere used for the stomach earlier in this chapter, except smaller). I show you how to draw different views of the upper arms and legs in the following sections.

The front view

Follow these steps to draw the front view of the upper arms and upper legs (which is the same as the back view):

1. **Fit one sphere in the left opening and one sphere in the right opening of the upper torso (see Figure 9-11a).**

 The centers of the two spheres should align at the midpoint of lines B and C.

2. **Fit two more spheres for the hips (one on each side, as shown in Figure 9-11b).**

 The top of these spheres for the hip joint align with the midpoint between lines D and E.

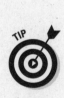

 Don't make these spheres too large. These shapes are small enough that I can easily draw the top of the upper leg shape over them.

 You want to make sure the spheres are slightly smaller than the hole so they fit snugly.

3. **For the upper arms, draw two narrow cylinder shapes over the stick figure, as shown in Figure 9-11c.**

 Make sure the tops of both cylinders slightly overlap the ball-bearing joints in the upper torso. The inner side of the cylinder for the arms intersects at the center of the shoulder-joint spheres. The length of the cylinder for the upper arm is 1½ head lengths. The length of the upper arm cylinder extends from slightly below the shoulder (top one-third mark between lines B and C) down to line D. The average width of the upper arm for the male is 20 percent wider than it is for the female.

4. **Moving back down to the hips, draw two cylinders that are slightly wider at the top and gradually taper slightly toward the top of the stick figure's knees (as shown in Figure 9-11d).**

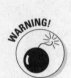

 The key to making the upper legs look realistic is to make the outside edges of the upper legs slightly more curved while making the inner sides straighter.

 If you measure the width of the cylinder at line E (the midsection of the entire figure's height), it's 1 head width for the average male and 1½ head widths for the average female. From the inner edge of the upper leg (line E) down to the knee joint (line G), the length is 2 heads for both sexes.

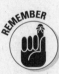

 The top opening of the cylinder is a 45 degree angle, which results in the outside edge of the cylinder being longer than the inside edge. The higher side of the outer leg contributes to the overall appearance that the upper leg is longer than the lower leg; in fact, the difference between the two isn't much.

The three-quarter and side views

For the three-quarter view in Figure 9-12a and Figure 9-12c, draw the cylinder for the upper arm and leg that are closer to you thicker and longer than the upper arm and leg that are farther away. The outer edges of the upper leg cylinder angle slightly toward the center (at about a 20-degree angle) while the inner side of the cylinder angles only slightly.

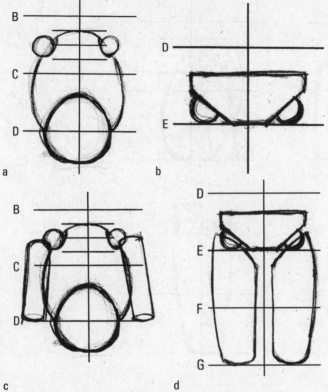

Figure 9-11: Fitting in spheres for the joints as well as the upper arm and leg shapes.

Don't forget to leave a little space between the knees! A commonly overlooked fact is that the knees don't completely touch each other even when the feet are touching.

From the side view, as shown in Figure 9-12b, the arms tilt slightly toward the back. In Figure 9-12d, the top portion of the upper leg is wider than it is in the front view (average is 1 profile head width). When drawing the side view of the upper leg, make the front a slight curve that tilts at an angle toward the back. The back of the upper leg also descends at a slight arc, but it doesn't angle toward the front as much.

Drawing the forearms and lower legs

Drawing the forearms and lower legs is similar to drawing the upper arms and upper legs; you add ball-bearing joints (in the form of spheres) first, followed by a few simple cylinders to give shape to the lower limbs. I walk you through the steps of drawing different views of the forearms and lower legs in the following sections. Before you begin, make sure you're comfortable with drawing the upper arms and upper legs.

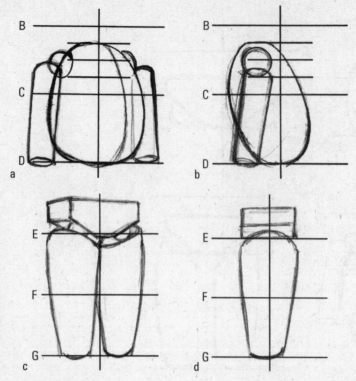

Figure 9-12:
The three-quarter and side views of the upper arms and upper legs.

The front view

Follow these steps to complete the front view (which is just like the back view) of the lower arms and lower legs:

1. **Attach a sphere at the lower opening of each upper arm for the elbow joints (see Figure 9-13a).**

 This small sphere fits into the width of the upper arm. The center diameter aligns with line D. The lower cylinder for the forearm (which I show you how to draw in Step 3) covers most of the lower half of the sphere. When the arm bends, more of the sphere is visible and needs to be drawn.

 The diameter (width) of each sphere you draw is the same as the width of the opening of the limb it fits into.

2. **Draw a set of spheres for the knees at the bottom of the upper leg openings (see Figure 9-13b).**

 The center diameter of the sphere aligns with line G of the stick figure.

3. **For the forearms, draw a cylinder on each side with the top end connecting at the bottom of the elbow.**

 Make the bottom end of the forearm cylinder slightly narrower than the top opening to allow the wrist end to be narrow enough to accommodate the hand (see Figure 9-13c). The end of the lower forearm aligns near line E.

4. **Draw a narrow cylinder from the bottom of the knee joint (as illustrated in Figure 9-13d).**

 Pay attention to how narrow the width of the lower leg cylinder is in contrast to the overall upper leg. The bottom opening of the cylinder is slightly narrower than the top in order to match the small width of the ankle. Similar to the cylinder for the upper leg, slightly curve the outer side of the lower leg to give the shape a more realistic appearance.

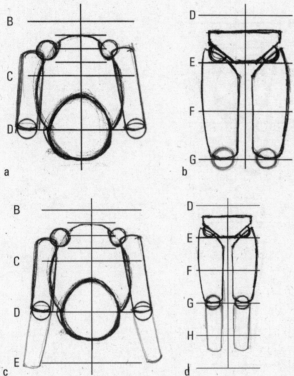

Figure 9-13: Drawing geometric shapes of the lower arm and lower leg on the front view.

The three-quarter and side views

Figure 9-14a shows some of the factors you want to keep in mind when drawing the three-quarter view. The limbs that are closer to you are slightly larger than the limbs that are farther away (based on diminution, which I discuss in Chapter 11). In addition, depending on your point of view in relation to the figure, certain limbs and joints are higher than others (based on perspective, which I discuss in Chapter 14).

In its relaxed and natural state, the lower forearm doesn't continue straight down from the upper arm; it slightly bends forward. If you draw the entire arm completely straight, it ends up looking stiff and unnatural. Look at yourself, from the side, in a mirror. You'll find that it takes a considerable amount of conscious force to push your lower forearm down so it's flush with your upper arm.

As I show in Figure 9-14b, the lower forearm bends at approximately a 30-degree angle from the straighter upper arm. The bottom of the lower forearm aligns with line E.

In the three-quarter view (Figure 9-14c), the bottom end of the lower leg facing away from the viewer tapers off slightly higher than the lower leg closer to the viewer. Also, the lower leg facing away is slightly narrower than the lower leg closer to the viewer.

In the side view of the lower leg (Figure 9-14d), the bottom end of the lower leg close by the viewer is slightly narrower than the top. The other leg is hidden behind the one seen by the viewer — that's right, you need to draw only one lower leg!

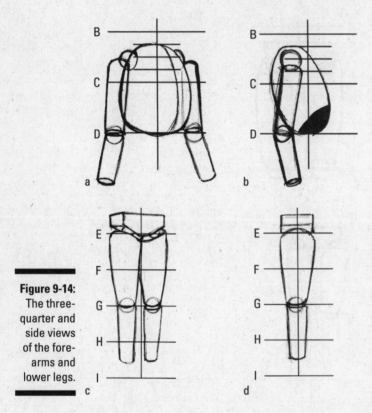

Figure 9-14:
The three-quarter and side views of the fore-arms and lower legs.

Acquiring some hands-on experience

The hands are probably the most complex and most expressive part of the human figure. Hands are such an effective means of expression that it's no surprise an entire language is made possible with a series of gestures and without a single spoken word. In this section, I break down the structure into two separate parts — the palm and the fingers — before I show you how they connect to the forearms on your stick figure. (Be sure to practice draw-ing hands on scrap paper before you add them to a finished mannequin!) I also show you both side views of the hand: the thumb side and the little finger side.

In this section, I show you, in detail, how to draw the hands up-close. However, when you're drawing the simple basic shape on the finished mannequin, you don't need to go through all the steps to create this refined, detailed version of the hand. I show you later in this section how to draw a simplified hand that works best for the mannequin figure.

The best way of improving your hands-on experience and getting your fingers in the groove is by practicing drawing your own hands. When I give my students the assignment to draw their own hands, I recommend they draw their hands in a series of relaxed, natural positions. You'll start to find that in reality you need to master only a handful of basic positions.

The palm

At first glance, the palm by itself has an awkward appearance that resembles a hamburger spatula. It's hard to believe that this almost flat-looking object that doesn't seem to move much is packed with 13 bones! For the purpose of explaining this part of the body, I divide the palm into three shapes, each with its own unique function. In Figure 9-15, I label the three sections A, B, and C.

- **Section A** helps the thumb's lateral and vertical movement; this function helps you hold and grip objects.

- **Section B** binds and stabilizes the index and middle fingers. This section has two of the longest bones in the hand, which help secure the fingers. What this section lacks in mobility, it makes up for by being the most stable and the strongest section.

- **Section C** groups and controls the vertical movements of the fourth and fifth finger (also known as the pinky). Although this section isn't nearly as mobile as section A, it has enough mobility (especially in the pinky) to move up, down, and sideways. Reason suggests it's there to protect the last two fingers by tucking them underneath the palm to keep them from getting banged up.

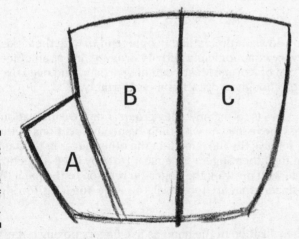

Figure 9-15: Studying the three sections of the palm.

Take a few minutes to observe your own palm while making a series of hand gestures. What kind of movement does your palm make when creating a fist? How about a pointing gesture? Now try opening your hands as wide as possible. Run through normal gestures (holding a coffee mug or waving casually) and see how these sections look.

Try your hand at drawing the front view of the palm from scratch by using the following steps (which are for the palm of a left hand):

1. **Draw the basic palm outline (as shown in Figure 9-16a).**

 When describing the shape of the basic palm, I think of the state of Washington on the United States map. The only major noticeable difference between the two shapes is that the top of the small part of the palm angles down, not horizontally.

2. **Draw a straight, vertical line to divide the center of the palm (as shown in Figure 9-16b).**

 The divided sections are as follows: B on the left and C on the right.

3. **Divide section B with a diagonal line (as shown in Figure 9-16c).**

 The new section on the far left is section A.

Figure 9-16:
Drawing the three sections of the front view of the palm.

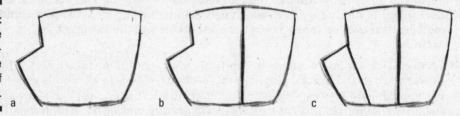

Pay attention to the spacing — look how the bottom widths of sections A and C are almost equidistant. The width of section B is narrower than the other two.

The fingers

Fingers can be tricky and, hands down, intimidating. People tend to take their existence for granted when doing virtually every common daily activity, from typing at an office job and playing the piano to opening a can of worms! Most beginning artists (and even experienced pros) struggle to know them well enough to draw them comfortably.

The key to understanding the fingers is to see how they group and move in relation to one another. Observe how the fingers move in sync with their respective sections of the palm. Each finger naturally mimics or follows the movement of the other finger in the same section. The thumb is independent from the other fingers because it rests by itself in section A. Don't be daunted if at first you struggle with drawing the fingers in relation to the palm. When starting out, making the hands with fingers that are too small, too wide, too long, too short — or even missing — is natural!

Most beginners approach the visualization of the hand as five fingers poking out of the palm like toothpicks sticking out of a cheese dish. But as you see in Figure 9-17, the fingers and the palm combined follow a "curving" movement. For visual aid purposes, I note the joints of the fingers so that the imaginary line of the arc is clear. See how the lines pass through the entire corresponding joint and knuckles that form the hand.

Figure 9-17:
The fingers
and the
palm follow
a curve.

a b c

This arc shape is what helps create a well-balanced and well-designed hand. It also helps you see the hand as an entire unit rather than as individual fingers. Without the balance of an arc, the hand you draw looks awkward and poorly contrived no matter how photo-realistic it is.

Although I use the cylinder as a basis to draw the hands up-close, cones are an excellent way to describe fingers tapering off when you're drawing hands from a distance. Cones are especially useful when drawing the fingers of the female hands (especially elongated fingers that have long fingernails). I use the cone shape frequently when drawing from and away from a live model. The concept reminds me of those elongated fingers that you can see in classic figure paintings from the Mannerism Period.

Now try your hand at drawing the fingers. For the following steps, you need to complete the palm of the hand that I show you in the previous section. Use it as your starting point to draw the fingers:

1. **As shown in Figure 9-18a, draw a vertical line extending up from the line that divides sections B and C.**

2. **Mark the midpoints of sections B and C with small notches, and extend two segments up from them, as shown in Figure 9-18b.**

3. **From each midpoint, draw an elongated cylinder that attaches to the line from Step 1 to represent the middle and fourth fingers (see Figure 9-18c).**

 Draw the middle finger slightly longer than the fourth finger. Use the division marks you made on sections B and C to determine the width of the fingers.

4. **Draw the index finger cylinder to the left of the middle finger cylinder, and draw the fifth finger cylinder to the right of the fourth finger cylinder (as shown in Figure 9-18d).**

 Note that both fingers are shorter than the middle and fourth fingers. The fifth finger is the shortest of the four. The width of the fingers should start from the middle of sections B and C and extend to the edge of the top of the palm.

 Both the index and fifth finger cylinders attach to the top of the palm shape. The width of the base of the fingers corresponds to the width between the small notches you draw in Step 3.

5. **Draw the cylinder for the thumb (see Figure 9-18e).**

 The bottom of the thumb and the top of section A are the same width. Draw the right side of the thumb, which faces the other fingers, by extending the diagonal line of

the right side of section A up and away from the fingers. The outer side of the thumb, which faces away from the fingers, should angle slightly inward.

6. **Lightly draw four arcs (see Figure 9-18f) to determine the placement of the knuckles and base of the fingernails.**

 To approximate the distance between the four arcs, divide the tallest finger (the middle one) into equal thirds. Doing so yields four arcs from the palm up to the tip top of the fingers. Use this equal spacing to create arcs that cross over the other fingers (and thumb).

 The arcs for the four fingernails are at the midpoint of the top finger joint. The only exception is the base of the thumbnail, which aligns with the midpoint of the third finger joints.

REMEMBER

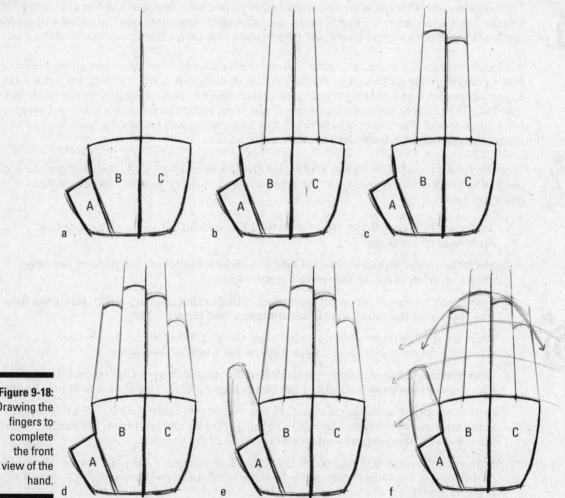

Figure 9-18: Drawing the fingers to complete the front view of the hand.

Snapping the hands into the forearms

After you're comfortable drawing the palm and the fingers together, snap them into the forearms that I describe earlier in this chapter. In Figure 9-19a, I fit in a sphere for each wrist. Make sure the spheres fit securely without any gaps between the openings at the bottoms of the forearms. Then position the hands as shown in Figure 9-19b.

The wrist aligns slightly above line E. To draw the simplified version of the hand for the stick figure, I recommend using the banana shape method where the backside of the hand curves toward the body and loops back up to connect at the wrist. The resulting shape from the front view resembles a banana with the top ⅓ sliced off.

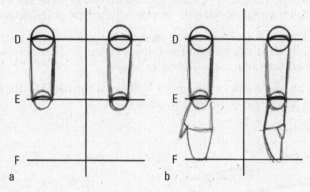

Figure 9-19:
Fitting the hands into the forearms of your mannequin.

The top plane of each hand rests flush with the forearm while the bottom side of the hand protrudes slightly outside the wrist.

Checking out the side views of the hand

You can draw two side views for the hand (in both views you see an uneven rectangle in which the top or wrist end is raised slightly higher than the finger side):

✔ Figure 9-20a shows the side view with the thumb side facing you. To accommodate section A of the palm, which naturally drops slightly below the rest of the fingers in a relaxed position, I tack on a second rectangle.

If the concept of this second rectangle confuses you, observe in the mirror the way your thumb rests when you hold it to the side. The rectangle for section A is approximately half the length of the palm and should vertically dip down to half the height of the side view of the palm.

Here are some key points to keep in mind when drawing this position:

• The length of the palm is the same as the length of the middle finger. Measure from the base of the wrist to the spot where the top of the palm connects with the index finger; use this measurement to draw the middle finger.

• The distance between the base of the wrist and the base of the thumb is the same length as the thumb (from base to tip). In addition, the distance between the tip of the thumb and the tip of the index finger is the same as the length of the thumb.

✔ In Figure 9-20b, the thumb is partially hidden from view, so only the lower half of the rectangle for section A is visible. From this vantage point, the fifth (pinky), fourth, and middle fingers are visible, in addition to the partial view of the thumb. Because the bottom of the palm naturally curves up in an *n* shape, the three visible fingers rise slightly above one another.

Here are some key points to keep in mind when drawing this position:

- To gauge the proper proportions, use the distance between the base of the wrist and the spot where the fourth finger begins as the halfway point of the entire length of the hand.

- While the bottom of the hand, for the most part, aligns flat with the bottom edge of the forearm, the top of the hand angles slightly up to meet the knuckle joint of the middle finger before angling back down toward the tips of the fingers.

- To make sure the fingers start from the proper position in relation to the palm, use a ruler to visually align the base of the fingers (including the spot where the thumb connects with the palm) at a 45-degree angle.

- Remember to leave a small gap between the bottom of the hand facing the viewer and the wrist. This gap keeps the palm shape unified.

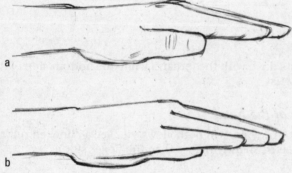

Figure 9-20:
The side views of the complete hand.

You snap the side views of the hand into the forearms just as I explain in the previous section; add a sphere at each wrist and position each hand carefully.

Focusing on the feet

Drawing the feet accurately is critically important when drawing the figure. Many beginning art students have the false assumption that the feet aren't as important as, say, the face when drawing the figure effectively. Nothing could be farther from the truth; after all, without feet, you can't stand! How high or far apart one foot is in relation to the other foot in your drawing shows viewers where the model stands in relation to his or her environment. For example, if

you draw one foot higher than the other when in reality they should be horizontally aligned, the drawn pose looks awkwardly off-centered and off-balanced. The bottom line is that your feet must be in sync with each other for your figure drawings to stand confidently and comfortably.

To illustrate this point, check out sports magazines or watch any athletic event on television. Pay attention to where the feet are placed in relation to each other when the athlete strikes a dynamic pose. How does a gymnast, for example, place her feet to keep herself from falling off a balance beam after performing a complicated tumbling routine? Where does a pitcher plant his feet in order to maintain his balance after throwing a 96-mile-per-hour fastball? How does that differ from the same pitcher throwing a series of pitches outside home plate to intentionally walk a batter? If the athlete placed his or her foot as little as a couple of inches to the left or to the right, the whole position would crumble.

In the following sections, I explain how to draw the front and side views of the foot individually and how to snap them into the lower legs on your stick figure.

The front view

Now it's time to take your first giant step toward drawing the geometric shape for the foot. Here are the steps to draw the front view:

1. **Draw a short necktie shape that's slightly skewed.**

 In Figure 9-21a, I have the tip of the necktie shape off to my right, which makes this the right foot. To draw the left foot, simply shift the skew to the opposite, or left, side.

 To avoid getting confused when you're distinguishing between the left and right foot, think of the tip of the tie shape as the rough location of the big toe.

 Don't make the necktie shape too long — you don't want to spoil the foreshortened effect. The only time you want to create a longer shape is when the figure is wearing high heels or when you're drawing the foot from above (as if you're looking down at your own feet).

 Make the shape of the necktie approximately half the length of the head.

2. **Create an arc toward the bottom of the foot (see Figure 9-21b).**

 Just as you mark the knuckle joints of the fingers (see the earlier section on drawing fingers), use this arc as a guideline when you place the toes.

3. **Map out each toe, starting with the big toe at the end of the foot (see Figure 9-21c).**

 I find it useful to first divide the remainder of the arc into four sections. This way, I have evenly spaced areas to draw in the corresponding toes. Even though your "little piggy" is shorter than the rest of the toes, the width of each toe is similar.

4. **To determine the edges of the toenails, draw a second curving arc that runs parallel and in front of the first arc from Step 2 (see Figure 9-21d).**

 Many students tend to dismiss the toenails as trivial details. On the contrary, it's important to indicate these edges; they represent where the top plane of the foot meets the front plane.

5. **Sketch the toenails along the second arc guideline (see Figure 9-21e).**

 Align the front edges of the toenails with the second guideline and the bottom edges along the midpoint between the two guidelines. When drawing the toenails, keep in mind that their bottom edges have either rounded corners or curved edges. In contrast, the front ends of the toenails, while slightly curved, are flatter than the bottom edges.

 If the overall shapes are aligned properly, the pinky toenail should barely touch the front of the foot shape. As the toes get bigger, the distance between the front edge of the foot and the nails grows larger.

6. **Erase the guidelines and add crosshatching details (see Figure 9-21f).**

 After erasing the two arc guidelines, use a series of diagonal crosshatching marks along the toe joints. This shading makes each toe appear three-dimensional and stand out from the rest of the foot.

 In addition, draw a few longer diagonal hatching lines on the outside of the foot to indicate the partial side plane. This side plane is visible only on the outside of the foot. The other side of the foot, from this view, is flatter and aligns with the lower leg shape.

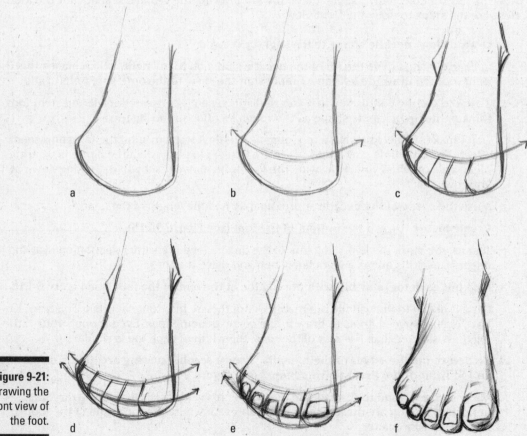

Figure 9-21:
Drawing the
front view of
the foot.

The side views

Using the front view from the previous section as your reference, draw both side views of the foot. I first draw the inner side view with the big toe facing you followed by the outer side view with the big toe facing away:

1. **Draw a right triangle shape with the top end cut off (see Figure 9-22a).**

 The length of the foot is approximately one head width.

2. **Smooth out the details of the curves in the foot (as shown in Figure 9-22b).**

 Fine-tune the foot by rounding off the edge of the bottom of the heel and creating a slight arch in the midsection. In addition, add a subtle slope leading down from the top of the ankle to the end of the toes in the front to complete this view of the foot. Figure 9-22c shows the finished foot.

 You don't need to draw the other toes because they're hidden behind the big toe.

Figure 9-22: Drawing the inner side view of the foot.

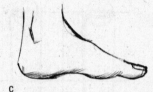

a b c

3. **For the outside view of the foot, draw another right triangle shape with the top end cut off and then draw a guideline arc as shown in Figure 9-23a.**

 Don't forget that toes have joints just as fingers do! They just don't get as much attention as the fingers do (mostly due to their lack of versatile movement). For the arc, I draw a narrow convex curve across the front of the foot.

4. **Starting from the smallest "little piggy," draw the remaining toes as shown in Figure 9-23b to complete this view of the foot.**

 Unlike the side view in which only the big toe is visible, all the toes are visible in this view.

 Observe how the ends of the toes angle down to grip the floor. Starting with the smallest toe, roughly sketch the adjacent toes, using the arc guideline as your starting point.

 With each toe shape you draw, one behind another, not only does the size increase, but the front tip also tilts at a slightly higher angle. The front of the toes aligns on a slight diagonal with the floor to indicate the visible front plane of the foot.

 When drawing multiple overlapping objects, such as toes, sometimes it's best to start with the object that's nearest to you instead of attempting to draw the distant objects first and then realizing you have little space left to draw the largest and nearest object. Figure 9-23c shows the finished foot.

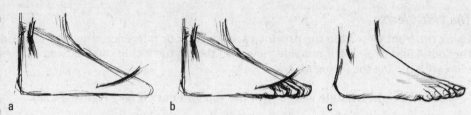

Figure 9-23:
Drawing
the outer
side view of
the foot.

Fitting the feet into place

After the feet are complete, it's time to snap them into the lower legs. In Figure 9-24a, I fit in a ball-bearing sphere for the ankles. Make sure the spheres fit securely and tightly without any gaps between the openings at the bottom of the lower legs. Finally, put the feet into position as shown in Figure 9-24b.

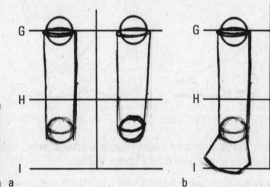

Figure 9-24:
Fitting the
feet into the
lower legs.

Figure 9-24 shows the front view of the feet and lower legs, but you fit the side views of the feet onto a mannequin in the same way.

Putting together the entire mannequin

In the previous sections, you practice drawing the geometric shapes of separate parts of the body, but here I show you how they fit together into a finished mannequin. Start with the stick figure that I describe earlier in this chapter, and follow these steps:

1. **Attach a short cylinder for the neck shape at the bottom of the egg-shaped head.**

2. **Beneath the neck shape, draw the torso structure along with the spheres for the shoulder joints.**

3. **Fit the stomach sphere inside the torso's "bite"-shaped hole.**

4. **Draw the hip shape that slips over the sphere for the stomach.**

 Don't forget to sketch in the spheres for the leg joints (one on each side of the diagonal wedge shape). This completes the main body area. From here, you draw the limbs.

5. **Draw the upper and lower leg cylinders that connect with a sphere for the knee joint.**

6. Draw the short necktie shape for the feet.

7. Sketch in the upper and lower arm on each side of the torso, connecting at the shoulder-joint sphere.

8. Draw the narrow ovals for the hand shapes.

Check out Figure 9-25 to see the finished product in four views: front, three-quarter, side, and back.

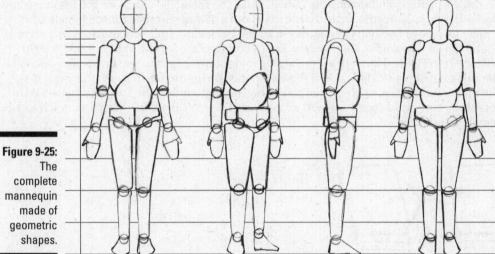

Figure 9-25:
The complete mannequin made of geometric shapes.

Drawing Simple Mannequin Movement

"Now that I built a mannequin," you're probably thinking, "*Man-it-can* move!" With all the limbs that actually move, the torso and hips are at the core of the human figure's daily activities. Even the placement of the feet is dictated by the way the hips and torso distribute the amount of weight throughout the pose.

In addition to the movements, twists, and turns by the joint spheres, the lengths of certain parts of the body shift as well. If I bend sideways while stretching my left arm over my head, the right side of my torso and the right side of my neck are now shorter. In contrast, the left side of my torso and neck appear to slightly stretch. For every action, or every body movement, you end up with a chain reaction of other body parts moving and changing shape.

In this section, I demonstrate basic patterns of movement that you expect to see in your mannequin figure. For details on drawing a finished figure in motion, see Chapter 11.

Bending forward and backward

Think of the center of the body as a giant accordion that has the ability to contract on either side while expanding on the opposite side. In Figure 9-26, I show you how a complete

mannequin bends forward and backward from the side view. Figure 9-26a shows an upright mannequin.

✔ To draw a mannequin bending forward, draw the top rectangle at a 45-degree angle above the rectangle that represents the waist (see Figure 9-26b). Make the zigzag shapes for the regions that are bent more compressed than the opposite back side region that has longer zigzag lines. Connect the two sides to get the accordion-like appearance. The average male and female have the same degree of flexibility (the male is on the left, and the female is on the right). As a result of the compression in front of the torso, the spine elongates.

✔ To draw a mannequin bending backward, make the rectangle shape for the torso angling backwards at a 30-degree angle for the male and a 45-degree angle for the female (the female has more flexibility). In addition to the backward angle, the bottom rectangle shape for the hip angles slightly forward to compensate for the shift in body weight balance (see Figure 9-26c). Draw the zigzag folds shorter for the female back to decrease the distance between the back of the torso and the hip region. You do the same for the male, but the zigzag lines aren't as short, indicating that the distance between the top of the torso and the hip is farther away and doesn't bend backward as much as the female torso does.

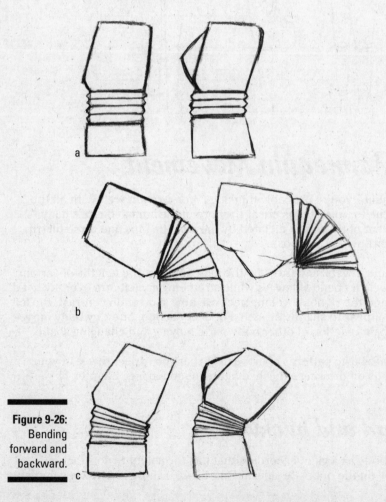

Figure 9-26:
Bending
forward and
backward.

Not all sides are created equal. As you compare the way the mannequin bends forward and backward in Figure 9-26, pay attention to how far down it goes. You see that bending backward isn't as easy as bending forward. In addition, as the side that's bent is compressed like an accordion, the other side straightens out.

Bending sideways

Figure 9-27 shows, from the front view, a mannequin bending sideways, both to the left and the right. Figure 9-27a shows upright mannequins. To draw a mannequin bending to the side, draw a top rectangle for the upper torso shape at a 45-degree angle. Draw the short zigzag shapes to show the compression between the upper torso and the hip. The distance between the upper torso and the hip is half of what it is in its neutral position when the figure is standing erect. For the other side of the torso, draw the zigzag folds slightly spread apart. The distance between the upper torso and the hip doubles to show the stretch.

The steps are the same (but in reverse) whether the figure is bending to the left (see Figure 9-27b) or the right (see Figure 9-27c). In both cases, one side of the body compresses while the other side exhibits tension as it stretches out.

Figure 9-27:
A mannequin bending sideways.

Simple twisting

Suppose your mannequin is reaching over and above to the opposite side of the body. In Figure 9-28, the sides twist around to accommodate this stretch. To show the twist, I draw two rectangular cubes (representing the upper torso and the hip) that tilt toward the viewers. I draw the upper torso angling farther down to show that gravity pulls down at the upper body. Instead of drawing the zigzag shapes to connect the sides, I draw two short parallel arcs that connect to the corresponding corner of the upper torso and the hip to complete the left side of the body. I complete the body shape by drawing a curve that's slightly longer to connect the right upper corner of the hip to the lower right edge of the torso. I shade the area between the left and right sides of the back of the body to create the illusion that the upper torso is overshadowing the front of the lower back. To the right, I illustrate a figure striking a pose that demonstrates this twisting motion.

Figure 9-28: The mannequin twist.

This twisting direction is most helpful when drawing the folds of the clothed figure. As I explain in Chapter 12, it's important to be selective when you render the kind of shape, size, and direction of the folds that correspond to the twisting motion of the body that lies underneath.

Chapter 10

Pumping Up Those Muscles

Why is it important to learn about muscles when you draw the figure? As one of my students exclaimed during an anatomy session, "There are just too many of them!" The good news is that you don't need to learn every muscle group to draw the figure, but familiarizing yourself with basic muscle groups is important in understanding how areas of the body protrude from and recede within the figure. Simply copying the outlines of the shapes of visible surface muscles results in a drawing that resembles a stiff toy action figure. Adding the structure of muscles can pump up the realism of your figures.

In this chapter, I walk you through the steps of building the major muscle groups of the body. Don't be alarmed if you don't see the entire range of muscle groups that you see in those 200-page anatomy books. I focus on drawing muscle groups that are commonly referred to by artists and art schools in the context of drawing the figure. I show you close-up views of each muscle group and different views of the entire muscled figure.

Just as everyone has a different bone structure (see Chapter 8), each person has a unique muscle build. My younger brother, for example, has an impressive muscular build while I, on the other hand, can't bench-press even half of what he does. Observe the body types that surround you daily. Do you see any of the muscle groups in this chapter manifested in others? The more aware you are of different body types, the more you'll be prepared to draw various body builds (both from life and away from a live model).

The Basic Makeup of Your Muscles

So what exactly *are* muscles besides those large lumps you see on Popeye's arms after he eats spinach? Muscles are essentially composed of *muscle cells* and *tendons*. The tendons act as binders that connect the muscle cells to the bones. These binders actually penetrate through the surface of the bone, which ensures that the muscle cells are securely fastened to the bone (as shown in Figure 10-1).

The way these muscle cells group together varies depending on the amount of power the particular body area needs. In areas that require more power, the muscle groups tend to come together in a short, overlapping, weaving manner. In contrast, the longer, parallel groupings of muscle cells are found in areas that don't need as much force to function routinely on a daily basis. (Figure 10-2 shows a grouping.)

Figure 10-1:
Muscles
fuse
together
with the
bone.

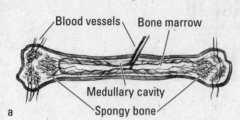

Blood vessels Bone marrow

Blood vessel

Tendon

Medullary cavity

Spongy bone

a

b Bone

REMEMBER

Keep in mind that muscle groups aren't just abstract shapes that happen to overlap one another and form a large muscular figure. Muscles are uniquely fused to bone structures that constantly change shape as they shift position. Your muscle groups are dynamic shape shifters that are always interesting to draw!

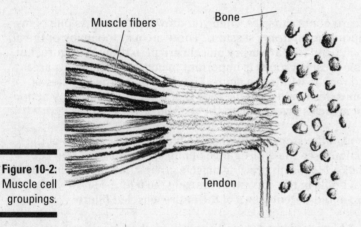

Muscle fibers Bone

Figure 10-2:
Muscle cell
groupings.

Tendon

Assembling the Muscles of the Upper Body

In this section, I walk you through constructing the basic muscle groups for the upper body, starting from the shoulders down. For details on drawing the muscle groups of the head and neck, check out Chapter 7.

REMEMBER

I recommend starting with the completed head and muscle structure before continuing on with the following sections. In addition, you'll want to have the basic geometric figure assembled from Chapter 9. However, if you're looking to just skim through rather than actively draw, you're good to go!

Beginning with the back and shoulders

When it comes to lifting or pulling down objects above or from over your head, your back and shoulder muscles play a major role. Although some of them make up the body's largest and most powerful groups, most people take them for granted because you normally don't examine your back and shoulders when you look in the mirror. Here are the major back and shoulder muscle groups that are important to drawing the figure:

- ✔ Trapezius
- ✔ Deltoid
- ✔ Latissimus dorsi
- ✔ Infraspinatus, teres major, and teres minor (treated as one)
- ✔ External oblique

Practice drawing the muscles in the first three sections before moving on to the later muscles.

Trapezius

The *trapezius* is the diamond- or kite-shaped muscle that spreads across the center of the upper body and helps the shrugging or lifting of the shoulders. In addition, it pulls the shoulder blades toward the center of the spine as well as down.

For the following steps, complete the back view of the geometric figure that I describe in Chapter 9. Ready to go? Follow these steps to draw the trapezius muscle:

1. **Lightly draw a center guideline from the center of the neck down to the lower back (see Figure 10-3a).**

 Use this center guideline to ensure that the muscle structures you draw along the center of the back are symmetrical on both sides.

2. **Draw a concave arc from each side behind the neck, sloping down to attach to the ball-bearing joint of each shoulder (see Figure 10-3b).**

 Note that the outer edges of the trapezius extend from the back of the neck and over the top of each shoulder to the end of each clavicle on the front of the torso (this placement isn't visible from the back view).

3. **Draw the lower half of the muscle group, as shown in Figure 10-3c.**

 The bottom left half of the trapezius resembles a reverse *S*-shaped curve that starts at the ball-bearing joint on the left shoulder and meets at the bottom of the rib cage along the center guideline of the figure. The bottom right half of the trapezius resembles a normal *S*-shaped curve that starts from the right shoulder and meets at the bottom of the rib cage.

Figure 10-3:
Drawing the trapezius muscle.

a b c

Deltoid

At first glance from the side, the deltoid looks like a leaf or an upside down garlic bulb. This muscle group hugs around the ball-bearing joint that links the arm to the torso on each side. Depending on the individual's build, this shape appears rounder or narrower. The bottom end of the deltoid tapers off to wedge between the upper arm muscles (which I describe later in this chapter). One of its main functions is to move and rotate the arm structure up and away from the body. This muscle group comprises three divisions: the *anterior* (front), *posterior* (back), and *lateral* (middle).

Follow these steps to draw the deltoid shape; I show you the side view of the right shoulder so you can see all the deltoid's parts. (In case you want to draw the left shoulder, all you need to do is flip each image that you complete in the following steps.) Start with the side view of the arm with the trapezius included:

1. **Draw a short curving arc for the anterior side of the deltoid (see Figure 10-4a).**

 The top of the arc starts right at the top center of the shoulder.

2. **Draw a short curve to mark the posterior of the deltoid.**

 As I show in Figure 10-4b, this curve starts from the left side of the arm and slightly curves down at a 45-degree angle to meet with the bottom of the anterior curve at the center of the arm.

3. **Draw the lateral shape at the center of the deltoid (see Figure 10-4c).**

 Draw two lines that slightly curve away from each other to form this center lateral shape. When drawing the two lines, make sure they divide the deltoid evenly.

The top portion of the shape formed by the lateral lines is open; the bottom part, on the other hand, connects with the bottom ends of the anterior and posterior sides.

Figure 10-4:
Drawing the
deltoid.

a b c

Here's a conceptual thought worth considering. In Figure 10-5, note how the deltoids and the trapezius muscle groups combine to form a "superhero cape" shape.

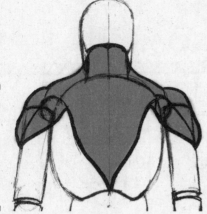

Figure 10-5:
The "super-hero cape" shape of the trapezius and the deltoid.

Latissimus dorsi

The latissimus dorsi is a symmetrical wide layer of muscle that attaches from the top of the hips and center of the spine. It then wraps around the sides of the torso and connects underneath the upper arms and shoulders. The general shape almost resembles a short goblet. The function of the latissimus dorsi is to pull the arms down toward the hips.

Use the following steps to draw the latissimus dorsi:

1. **Indicate the top of the latissimus dorsi by lightly drawing a short arc that stretches from underneath each side of the armpits (as shown in Figure 10-6a) and connects to the lower section of the trapezius muscle group.**

2. **Complete the outer sides of the latissimus dorsi as shown in Figure 10-6b.**

 On each side, draw a long line from the short arc underneath the armpit down toward the hip; make a sharp turn to connect each line at the top edge of the hip, next to the spot where the stomach sphere joins the hips.

3. **Indicate the division between the muscle cells and the tendons, as shown in Figure 10-6c.**

 On each side, I draw a slightly curved arc from the top of the hip to the bottom tip of the "cape" form of the trapezius. This line helps show just how long the tendons need to stretch out to support this particular muscle group.

Infraspinatus, teres major, and teres minor

In this section, I combine three groups of muscles — the infraspinatus, the teres major, and the teres minor — because they tightly compress together and move in a similar direction when the arms are raised above the head or forward in front of the body. Although these muscles are small, they become more visible when the figure leans forward with the arms stretched out in front of the torso.

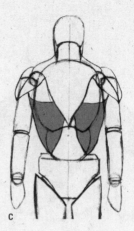

Figure 10-6:
Drawing the
latissimus
dorsi.

a b c

Go through the following steps to draw these muscle groups:

1. **Locate the triangular gap created by the overlapping shapes of the deltoid, trapezius, and latissimus dorsi muscles and draw a short segment to divide the shape in half (see Figure 10-7a) to indicate the lower side of the infraspinatus.**

 Split the triangle from the lower corner near the center of the torso to the opposing side, which is the deltoid. This completes the shape of the infraspinatus because the top end is hidden under the trapezius.

2. **From the midpoint of the segment you draw for the infraspinatus in Step 1, draw a short curve connecting to the edge of the arm (as shown in Figure 10-7b) to complete the teres major.**

 This short curve is parallel to the arc of the top portion of the latissimus dorsi. It leaves a small triangular gap between the infraspinatus, which allows space for the teres minor.

3. **Indicate the teres minor by drawing a line connecting the edge of the deltoid muscle group (see Figure 10-7c).**

Figure 10-7:
Drawing in
the infraspi-
natus, teres
major, and
teres minor
muscle
groups.

a b c

The back view of the external obliques

The external oblique muscle group, which is located on each side of the body right above the hips, is often mistaken for "flabs" hanging over a waistband. But in reality, these powerful muscles help rotate and bend the torso from side to side.

Don't let the shortness of the external obliques' appearance from the back view of the figure fool you. Although they're hidden by the latissimus dorsi, the external obliques stretch all the way up to connect with the rib cage bones.

Follow these steps to draw the obliques (one on each side right above the hip):

1. **Draw a short curve shooting out from under each side of the lower latissimus dorsi and connecting with each side of the outer hip.**

 Even though the arc bulges out, make sure it doesn't go past the width of the torso on either side (see Figure 10-8a).

2. **Draw the inside arc on each side to complete the external oblique, as shown in Figure 10-8b.**

 Include a little triangular gap between the external oblique and the latissimus dorsi. These two muscle groups connect with the hip — with no overlapping on either side!

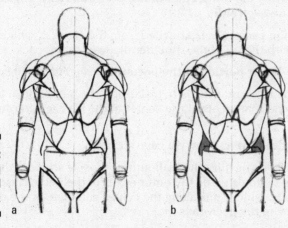

Figure 10-8: Drawing the external obliques.

a b

Getting things off your chest

Muscle groups at the front of your upper body probably receive more attention than others. Perhaps your mother corrected your posture by insisting that you keep your chin in and thrust your chest out. Beachgoers commonly suck in their guts to show off their upper-body muscles.

In this section I demonstrate how to draw the muscle groups that are important to drawing the chest:

✔ Pectoralis

✔ Serratus anterior

✔ Rectus abdominis

✔ External oblique (you see the back view earlier in this chapter; this section shows the front view)

Be sure to practice drawing these muscles in the order I present them; the shape of each muscle builds on the previous one.

Pectoralis

Commonly known as the *chest muscles* or *pecs,* this major symmetrical muscle group is one of the most noticeable parts of the figure. The muscles mostly attach from the center of the rib cage clavicle to the upper arm. This group is divided into two divisions: pectoralis major and pectoralis minor. Both function together to push objects away from the body.

Start with the front side of the geometric figure with the deltoid, trapezius, and sternomastoid sketched in (see Chapter 7 for details on drawing the sternomastoid). Then follow these steps to draw the pectoralis:

1. **Draw a center guideline, as shown in Figure 10-9a.**

 Use this guide to make sure the muscle groups you place on each side of the upper body are symmetrical.

2. **As shown in Figure 10-9b, draw the top section of the pectoralis so it angles up to intersect with the deltoids on each side.**

 This shape angles because the pectoralis is attached from the clavicle, which also angles up and out to meet with the tip of the shoulder blade from the back.

3. **Draw a concave arc for the lower portion of the pectoralis (see Figure 10-9c).**

 The key to making this shape more realistic is to make sure the outer ends of the arc tilt slightly higher than the end that meets at the center of the rib cage sternum (see Figure 10-9d).

4. **Trace over the lines of the deltoids and the rib cage sternum.**

 As I demonstrate in Figure 10-9e, the nifty thing about this muscle shape is that you can let the *S*-curved edges of the deltoids guide the outer edges of the pectoralis. Likewise, let the sternum of the rib cage, which runs along the center guideline of the upper body, dictate the inner edges of the pectoralis.

Serratus anterior

The serratus anterior is probably one of the more complex sets of muscles; it starts under the shoulder blades, wraps around to the front of the torso, and attaches to the rib cage bones.

This set of muscles is a challenge to absorb conceptually because, from the front view, this section weaves into the external obliques before attaching itself to the rib cage. (I show you how to draw the front view of the external obliques later in this chapter.) Think of it like a bunch of straws that weave into each other to form a wicker basket.

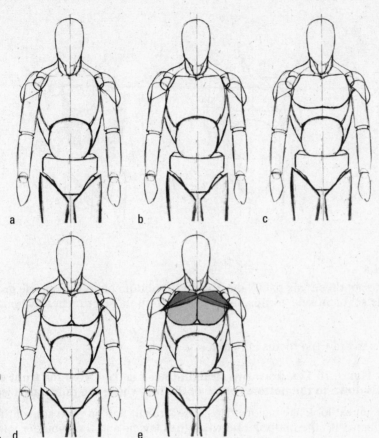

Figure 10-9:
Drawing the
pectoralis.

As I show in Figure 10-10, here's a series of steps you can take to tackle this situation:

1. **Starting beneath each side of the pectoralis, lightly draw an arc guideline that angles down to connect at the midpoint of the outer edge of the latissimus dorsi, as shown in Figure 10-10a.**

 The curve of this arc mimics the curve of the stomach sphere.

2. **Use the arc guideline from Step 1 as you draw four narrow ovals that overlap one another from top to bottom (see Figure 10-10b).**

 The top of the first oval of the serratus anterior is partially hidden behind the pectoralis. The middle two ovals are the same size, while the bottom one is shorter.

 Make sure all tip ends of the ovals rest against the arc guideline. Also pay attention to how the outer edges of the four ovals form a slight curve that mimics the rib cage (see Figure 10-10c).

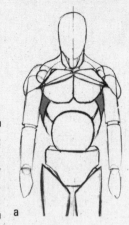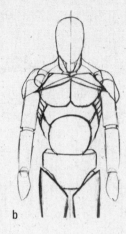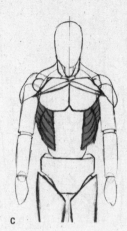

Figure 10-10: Using short-cuts to draw the serratus anterior.

a b c

Rectus abdominis

If you ever want to get those "six-pack" abs, the rectus abdominis is the muscle group you have to train! This set of muscle groups helps you perform those crunches by bending the back forward.

Follow these steps to draw the rectus abdominis:

1. **As shown in Figure 10-11a, draw two straight lines that run from the front edges of the pectoralis down to the bottom center of the hip where the pubic area is.**

 These strips almost look like bacon strips. The straight line on each side of the rectus abdominis aligns with the midpoint between the clavicle and the shoulder joints.

2. **Divide the strips into four horizontal segments.**

 Each line angles slightly downward with the exception of the top line, which runs horizontally underneath the pectoralis (see Figure 10-11b). The lower segment is longer than the others. Note the small triangular gap that forms at the top between the top horizontal line of the rectus abdominis and both sides of the pectoralis.

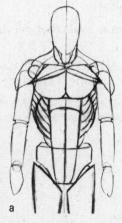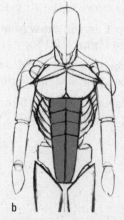

Figure 10-11: Drawing the rectus abdominis.

a b

The front view of the external obliques

From the front view of the figure, the external oblique stretches from the hip and rectus abdominis, wraps around the rib cage, and weaves into the serratus anterior.

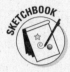

In Figure 10-12, you see how the overall muscle band is much longer than the rear view of the oblique, which I describe earlier in this chapter. I draw the sides of the external oblique curving above the hips, underneath the serratus next to the rectus abdominis, and up around the sides of the rib cage before connecting underneath the pectoralis.

Figure 10-12: Drawing the external oblique from the front view.

Bearing arms

Arm muscles are intricate and fascinating structures. The contour and forms change depending on the rotation of the wrist or upper arm. In the following sections, I walk you through the upper and lower arm muscles in their straightest positions.

The upper arm muscles

The muscles of the upper arms flex and straighten the forearm at the elbow joint; they also control the vertical movements of the forearm and the movements of the arm across the front of the body. Last but not least, they help stabilize the entire arm with the shoulder joint when it's in active motion.

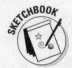

To start drawing the upper arm muscles, draw the deltoid of the right arm, which I describe earlier in this chapter. Then follow these steps to draw the brachialis, the biceps, and the triceps:

1. **Slightly to the left of the end tip of the deltoid muscle, draw the brachialis (as I show you in Figure 10-13a).**

 Begin the front edge of this thin little slug-shaped muscle by drawing a straight line from the bottom left of the deltoid down to the bottom of the upper arm's front edge.

Next, add a line that curves away from the front edge you just drew and reconnects at the bottom of the upper arm's front edge. As I show later in this section, most of this shape is hidden by the other muscle groups of the arm.

2. **Draw the front biceps as shown in Figure 10-13b.**

 To complete this shape, draw a curving line that stretches from the front center of the deltoid and ends at the bottom of the upper arm.

3. **Draw the triceps at the back of the arm.**

 As I demonstrate in Figure 10-13c, I first draw a line for the front side of the triceps, which slightly overlaps the back edge of the brachialis before sharply curving past the back of the elbow joint to connect with the back of the forearm. For the back side of the triceps, draw a line with a small convex bulge at the top (the lower portion is flatter). Extend the line past the elbow joint to connect at the spot where the front side of the triceps joins the forearm.

Figure 10-13: Drawing the muscle groups of the upper arm.

a b c

When you're working with more intricate structures, such as the upper arm, building your shapes from the center out is best. It increases your chances of getting a more accurate size and shape.

The lower arm muscles

The forearm has a greater number of muscles than the upper arm. These muscles are mainly responsible for controlling the flexing of the fingers and other detailed motor functions of the hand (such as clenching the fist). One aspect that makes this muscle group unique is that the lower half of the forearm consists mostly of tendons and ligaments as opposed to muscles.

Here are the key muscle groups of the lower arm:

- Long supinator
- Long radial extensor of wrist
- Short radial extensor of wrist
- Common extensor of fingers
- Ulnar extensor of wrist
- Anconeus
- Short extensor of thumb
- Abductor of thumb

Follow these steps to draw the lower arm muscles:

1. **As I show in Figure 10-14a, draw the front side of the long supinator by drawing a convex curve from the gap between the brachialis and the triceps down to the front edge of the forearm.**

 The curve straightens out toward the bottom of the wrist.

2. **Before completing the other side of the long supinator, draw the bottom of the long radial extensor of wrist (as shown in Figure 10-14b).**

 Draw a slight curve that starts underneath the triceps, runs parallel to the front edge of the long supinator, and connects at the midpoint of the wrist.

3. **Draw an *S*-shaped curve to divide this muscle group equally to create the long supinator and the long radial extensor of wrist.**

 As shown in Figure 10-14c, divide the large shape equally to get two accurate, smaller muscle groups. This technique is simpler than drawing the two smaller shapes side by side; when you do that, you risk making the overall shape either too large or too small.

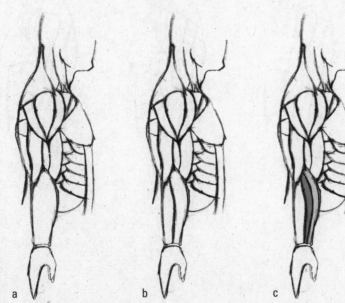

Figure 10-14: Starting to draw the lower arm muscle groups.

a b c

4. **Draw a dividing line (see Figure 10-15a) for the larger shape that represents the common extensor of fingers and the short radial extensor of wrist.**

 Start the line where the long radial extensor of wrist connects with the front of the triceps. Pay attention to the way this line connects to the back edge of the hand. Avoid making this line completely straight (draw this line as a slight arc).

5. **Draw a dividing line that separates the common extensor of fingers from the short radial extensor of wrist.**

 Start at the back for the long radial extensor of wrist and draw a curving line that mimics the dividing line you draw in Step 4. The curve connects at the back of the wrist. Figure 10-15b marks the completion of the front side of the forearm profile.

6. **Draw a curving line from the bottom of the triceps down to the back of the wrist to start drawing the back side of the forearm (see Figure 10-15c).**

7. **Draw a dividing curving line to form two separate muscles, the ulnar extensor of wrist and the anconeus (see Figure 10-15d).**

 This line extends from the back side of the forearm to the tapered end of the triceps. Make sure you begin drawing the line from the point where the long radial extensor of wrist meets the triceps.

8. **From the lower midsection of the common extensor of fingers, draw two parallel lines that diagonally cross over the short radial extensor of wrist, the long radial extensor of wrist, and the long supinator.**

 These lines form the combined muscle group of the short extensor of thumb and the abductor of thumb. The lines angle down toward the front of the forearm.

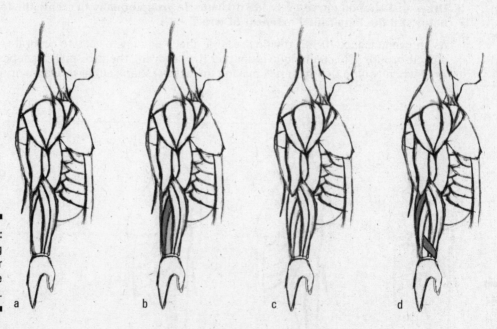

Figure 10-15:
Completing
the lower
arm muscle
structure.

a b c d

All hands on deck

Don't let those bony fingers fool you; your hands are jampacked with small, powerful muscles and ligaments. If you look at one of those thick anatomy books, you'll see that much of the muscular structure is found in the palm. You'll be relieved to know that you don't need to know all the muscles to draw the hand. In fact, for the purpose of drawing the figure, simplifying this structure is best; I show you how to do that by grouping some of these tiny muscles into categories.

When you're drawing something as expressive as the hand and fingers, you don't need to slave over the anatomy of the muscles. The knowledge of these particular muscle groups, while important to know they exist, is secondary to recognizing the arc structure that I talk about in Chapter 9 (see Figure 10-16a). Pay close attention to the way the muscles in Figure 10-16b resemble Figure 10-16a.

Figure 10-16:
Transform-
ing the
hand's basic
geometric
shape into
the muscle
structure.

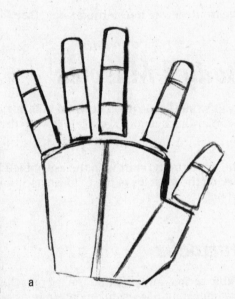

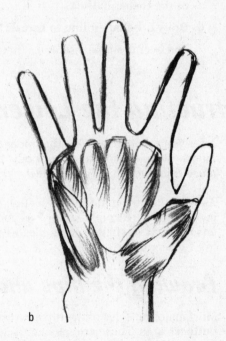

a

b

Here are the differences you need to know to complete drawing the muscles of the hand and fingers (I show the right hand with the palm facing up):

1. **Connect the fingers and thumb with the geometric palm shape by drawing around the edges of the entire hand while ignoring the gap between the base of each finger and the palm.**

2. **Erase the lines that represent each finger and thumb joint so you're left with the basic outline of the hand.**

3. **Starting from the fifth (pinky) finger, draw four elongated ovals that align with the four fingers.**

 Make sure the tips of the ovals form an arc that mimics the arc formed by the tips of the fingers. (These ovals are the lumbricales, which aid in flexing the fingers.)

4. **From the corner of the base of the pinky, draw an elongated oval that represents the abductor/short flexor muscle groups (I like to call them my pinky muscles!).**

 The oval diagonally overlaps the lumbricale of the pinky finger to connect at the base of the palm's left side. (These muscle groups are also referred as the hypothenar muscles.)

5. **From the corner of the base of the thumb, draw a short, thick oval that represents the short abductor/short flexor/opponens.**

 The oval diagonally overlaps the lumbricale of the index finger to connect at the base of the palm next to the hypothenar muscles. (These muscle groups are also referred to as the thenar muscles.)

6. **Draw a _V_-shaped line to connect the hypothenar and thenar muscles.**

 The overall shape resembles that of the front view of the sternomastoid (see Chapter 7).

Constructing the Lower Body's Muscles

After you practice drawing the upper body, it's time to move on down to building the muscle structure for the lower body. In the following sections, I explain how to draw the muscles of the hips, legs, and feet.

As I recommend in the earlier section on the upper body, start with the assembled basic geometric figure from Chapter 9 as you work on the muscles in the following sections. This ensures that you have a secure leg to stand on!

Drawing the hips and buttocks

Most major muscles of the hip area are visibly tucked away behind the leg muscles in the buttocks area. These groups of muscles are important and useful in determining where the center of the weight of the pose is. In my class, I refer to this particular set of muscle groups as "butterfly" muscles because, well, they look like a butterfly.

Aside from the spine and shoulder blades, the landmarks on the backside of the figure aren't as plentiful or as visually interesting as the landmarks in the front. Although the back has a lot of interesting muscle shapes, unless the figure you draw is a huge body builder, most of those muscle shapes in the back view aren't as prominent. However, the distinct muscles located behind the buttocks make great landmarks for shaping the proportion of the hips. After you establish these shapes, you can use them to align the position of the legs and feet.

In the following steps, I show you how to draw the gluteus medius, the gluteus maximus, the tensor fasciae latae, and the iliotibial band (be sure to work on the back view of the geometric figure with the upper body muscles completed):

1. **Draw a heart shape for the gluteus medius along the centerline of the hips (see Figure 10-17a).**

The top of the curves of the heart go past and over the trapezoid shape of the hips.

2. **Draw two egg-shaped ovals that lean against each other to connect at the centerline of the hips (see Figure 10-17b).**

 This is the gluteus maximus muscle group, which overlaps the gluteus medius. This shape is slightly rounder and wider for the female figure.

3. **For the tensor fasciae latae, which connects with the iliotibial band, draw a long curve along the outside of each hip (as shown in Figure 10-17c).**

 This curve extends from the middle of the hip down to the knees. The iliotibial band is basically the "scotch tape" tendon that connects to the tensor fasciae latae. (Keep reading to see how it also connects to the gluteus maximus.)

4. **As shown in Figure 10-17d, extend the shape of the gluteus maximus to intersect with the side of the iliotibial band.**

 To create this shape, draw a concave curve that hooks from the bottom outer sides of the gluteus maximus down to the bottom outer edges of the upper legs. See how the shape resembles a horn.

Figure 10-17: Drawing the "butterfly" hip and buttock muscles.

a b c d

Having a leg to stand on

The muscles located on the legs make up the strongest group of muscles in the body. Similar to the arm muscle structure, the upper leg has a larger muscular presence than the lower leg (which has fewer muscles and more tendons).

The upper leg muscles

The upper leg muscles do a lot of work for you! They help extend the lower legs, which comes in handy when you lift your upper body from a squat or sprint off the starting block at a track event. In addition, they flex and rotate the thighs and hip joints, lift your knees, and aid in flexing the lower leg muscles. In this section, I simplify these groups of muscles down to the following:

- The adductor group/gracilis
- Sartorius
- Rectus femoris
- Vastus lateralis
- Vastus medialis

Try your hand at the following steps to draw the general upper leg muscles (be sure to work on the front view of the geometric figure with the upper body muscles completed):

1. **From the bottom outside corner (more or less) of the trapezoid hip shape, draw a diagonal line that wraps across the front of the leg to the inside of the knees; this line represents the sartorius muscle.**

 As you see in Figure 10-18a, this line separates the adductor group/gracilis (which are mostly thigh muscles and tendons) from the rest of the upper leg muscles. Drawing this line first is important because it helps you divide and sort out the larger muscle shapes before dealing with the smaller muscle shapes.

 Think of this muscle as one of those string meshes that tightly wraps around a ham or sausages that you see dangling from the meat market ceilings.

2. **Draw the outer line curve of the vastus lateralis.**

 In Figure 10-18b, the vastus lateralis begins where the tensor fasciae latae meets the iliotibial band (see the earlier section on drawing the hips for more details). Draw the line down to the ball-bearing joint of the knees.

 Be careful not to draw this curve going past the iliotibial band. Although the vastus lateralis can overlap the iliotibial band, the iliotibial band needs to remain the outermost region of the side of the upper leg.

3. **For the vastus medialis, draw a raindrop shape above and to the inside of the knee, underneath the sartorius band (as shown in Figure 10-18c).**

 This shape protrudes slightly from the inside of the bottom portion of the upper leg and is crucial in establishing the rhythmic *S*-shaped curve of the overall leg muscle structure.

4. **Draw two curving arcs to create the rectus femoris, which runs from beneath the sartorius down to the ball-bearing sphere that represents the kneecap (as shown in Figure 10-18c).**

 Note that the curves I draw to create this shape mimic the outside edges of the leg. The overall shape runs slightly at an angle. In addition, pay attention to the small narrow tendon that runs across above the kneecap. Because this tendon (the band of Richer) isn't visible or essential when drawing the leg, I don't include drawing it as a separate step. Just know it's there.

The lower leg muscles

The lower leg muscles help keep you on your toes! Similar to the lower arm, the bottom half of the lower leg is mostly tendons (which is why the ankle area is considerably thinner than the upper half of the lower leg). Here are the major muscles to know:

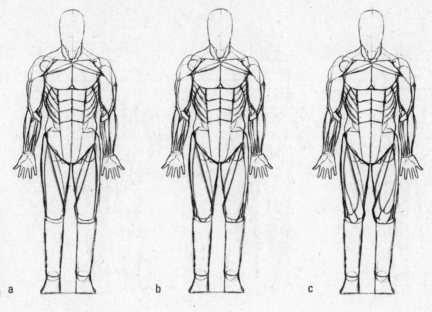

Figure 10-18:
Drawing the
upper leg
muscles.

a b c

🗸 Shaft of tibia

🗸 Gastrocnemius

🗸 Soleus/flexor digitorum longus

🗸 Tibialis anterior

🗸 Peroneus longus/extensor digitorum longus

Don't be alarmed by the fact that I list the digitorum longus twice. These incredibly thin but essential muscle groups appear on separate sides of the lower leg. Rather than drawing them twice as a single intricate object, I group them with an adjacent muscle.

Follow these steps to draw the lower leg muscles:

1. **From the ball-bearing joint that represents the kneecap, draw the shaft of tibia, which runs vertically down the center of the lower leg to the bottom of the ankle (as shown in Figure 10-19a).**

2. **Lightly draw the outer edge of the calf muscle (the gastrocnemius), which is essentially an egg-shaped oval that runs from the top down to the middle of the lower leg.**

 As shown in Figure 10-19b, the curve facing the inner leg is noticeably lower than the curve on the outer side. Although you later erase the outer shape (because it's not visible from the front), it's important to know the difference.

3. **From the midsection of the gastrocnemius, draw a curve that sharply shoots out from the tibia before vertically straightening out to intersect with the ankle (as shown in Figure 10-19c).**

 This combined muscle mass — the soleus/long flexor of toes — wraps around the calf muscle in the back to join with the Achilles tendon.

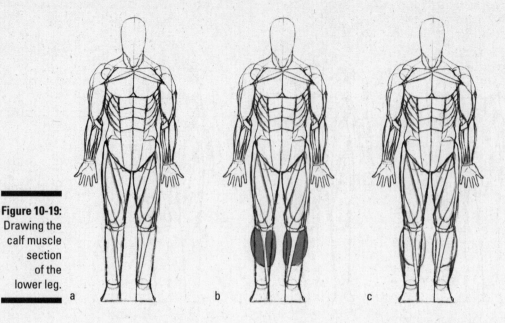

Figure 10-19:
Drawing the calf muscle section of the lower leg.

a b c

4. **Draw the tibialis anterior, which crosses over the tibia, as shown in Figure 10-20a.**

 The tibialis anterior and its long tendon overlap slightly at a diagonal angle. The tendon connects to the inner ankle and divides two separate masses of muscles; the first mass rests from the outer edge of the leg to the tibia, and the second mass is part of the calf.

5. **From the outer edge of the knee ball joint, draw a curve that protrudes outward and connects with the outer ankle (as shown in Figure 10-20b).**

 This shape accounts for the peroneus longus/extensor digitorum longus muscle masses. Bear in mind that a partial section of the extensor digitorum is overlapped by the tibialis anterior.

 Make sure the length of this mass mirrors the tibialis anterior, where the muscles become a tendon halfway down the lower leg (talk about weird tendon-cies)!

6. **Clean up your marks by erasing most of the egg-shaped oval that represents the gastrocnemius.**

 Make sure you leave a sliver of this muscle group poking out on the outside of the leg. As shown in Figure 10-20c, this sliver enhances the overall outside rhythm of the curve of the leg.

Getting your foot in the door

Similar to the hands (which I cover earlier in this chapter), muscles play a secondary role when you're drawing the feet. Most of what you see from the surface are bones, tendons, and fat that cushions the force of impact when running, walking, standing, or landing. When you're learning to draw the foot, break it down into three basic masses — the heel, balls of the toes, and the toes as one unit.

Figure 10-20: Completing the muscles of the lower leg.

a b c

If you're a jelly bean addict, you'll fall head over heels for this approach to understanding the feet. Follow these foot steps!

1. **For the bottom of the heel, draw a narrow jelly bean–shaped oval (as shown in Figure 10-21a).**

2. **Draw a slightly wider jelly bean that overlaps the narrow jelly bean from Step 1 (see Figure 10-21b).**

 Make sure the inside edges of the beans are aligned. Notice the slight overall curving trajectory that results on both sides of the overlapping ovals. The inside of the foot has more of a curve than the outside of the foot.

 The section where the two shapes overlap marks the bridge of the foot, which has less contact with the floor when the figure is standing on a flat surface.

3. **For the toes, draw another elongated jelly bean that's horizontally skewed so the inside is larger than the outside (see Figure 10-21c).**

 This step differentiates the size of the big toe versus the little toes.

Figure 10-21: Drawing the muscles of the feet.

a b c

Putting Everything Together: Different Views of the Finished Muscled Figure

After you know how to draw the individual muscle sections of the human figure, it's time to have a look at what the complete muscled figure looks like from different angles; I also show you the differences between the finished male and female figures.

If you're a beginning art student, you'll find that all your figure-drawing classes focus on the adult form, so I concentrate on adults in this section. In Chapter 9, I explain how to adjust stick figures and mannequins for infants, children, and teenagers; to draw the muscles of these figures, just keep in mind that some bulging muscle shapes common in adults aren't as prominent. In addition, the differences between the sexes are insignificant until puberty.

When you snap together the upper and lower body into one figure, it's a good idea to lightly sketch the 8-head proportion guideline that I discuss in Chapter 8, just to make sure both halves properly fit together. Many beginners take a completed section and place the upper figure either too high or too low on the lower body.

The male muscled figure

In Figure 10-22, I draw four views of the muscled male figure (I show the female figure in the following section). Pay attention to the familiar forms and angles and see how the appearance shifts and changes in size when the angle changes. In addition, note which shapes are obscured or revealed from angle to angle.

Here are some major differences among the views:

✔ From the front view (Figure 10-22a) and rear view (Figure 10-22b), the lower forearms angle slightly away from the body. This is the case only when the arms are in neutral position with the palms facing out. When the palms turn in toward the hips, the lower forearms angle slightly in toward the body.

✔ From the front and rear views, the feet angle slightly away from the body. A common mistake made by beginners is drawing the feet facing straight forward when attaching the legs to the rest of the body.

✔ From the front view, the triceps and brachialis are visible on the outside edge of the upper arm.

✔ From the front view, a small triangular gap forms between the center of the groin area and the inner edges of the upper legs.

✔ From the three-quarter view (Figure 10-22c), the side of the body that faces away from the viewer is diminished (I discuss diminution in Chapter 11).

✔ From the three-quarter view, the shoulder farther away from the viewer is slightly lower than the shoulder closer to the viewer.

✔ From the three-quarter view, the foot farther away from the viewer is slightly higher than the foot closer to the viewer.

✔ From the side view (Figure 10-22d), a distinct *S*-shaped curve starts from the top of the neck and runs all the way down the body to the tip of the toes.

✔ From the side view, the top of the trapezius curves in an *S* shape from behind the neck over the top of the torso and meets with the collarbone, which angles slightly up to the left.

✔ From the side view, the front edge of the iliotibial band drops straight down from the front edge of the tensor fasciae latae to the bottom of the knees. From the bottom of the knees, the tibialis anterior continues the straight vertical line down to the front of the ankles.

✔ From the side view, a front portion of the foot facing away from the viewer is still visible; assuming the eye level is around the waist of the figure, the partially visible portion of the foot facing away from the viewer is slightly higher than the foot closer to the viewer. Most beginners make the mistake of assuming that the entire side facing away from the viewer is hidden behind the side facing the viewer.

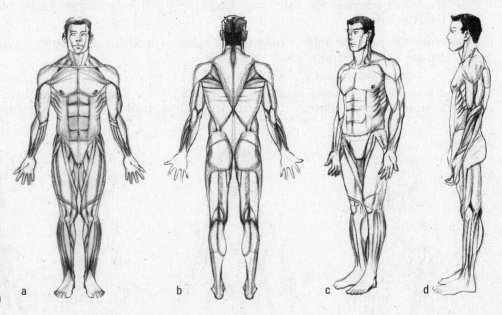

Figure 10-22:
Comparing the front, back, three-quarter, and side views of the figure.

a b c d

The female muscled figure

REMEMBER

When you make a comparison of sexes, you'll note that a handful of changes take place. In Figure 10-23, I draw the front, back, three-quarter, and side views of the female figure, complete with muscles, for you to make the visual comparison with Figure 10-22. Here are the following differences to keep in mind when drawing the different sexes:

✔ From the front and rear views, the muscles of the male sternomastoid branch farther apart (closer toward the ears, as opposed to closer toward the chin in females). This makes the male neck appear wider than the female neck.

✔ From the side view, the front of the male neck protrudes farther than the female neck. The rear of the male neck starts higher up the cranium compared to the female neck, which starts closer to the base of the cranium. This also makes the male neck appear wider than the female neck.

✔ Males have a higher and wider trapezius than females do.

✔ From the front and side views, males have rounder and wider deltoids than females do.

✔ From the rear view, males have a wider latissimus dorsi than females do.

✔ Female shoulders angle up slightly and protrude higher than male shoulders do.

✔ The male upper arm has wider and more pronounced biceps, triceps, and brachialis muscles than the female upper arm does.

✔ The male forearm has wider and more pronounced muscles than the female forearm does.

✔ From the front view, the male's serratus anterior and pectoralis are longer and wider than the female's.

✔ From the rear view, females have rounder gluteus maximus and gluteus medius muscle groups which make hips wider than males.

✔ From the side view, the top edges of the female's hips are higher than the male's hips due to the larger gluteus maximus and gluteus medius. Because female hips tilt more forward than male hips do, the female stomach protrudes farther than the male's.

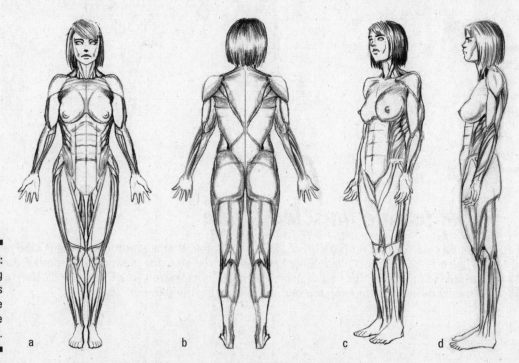

Figure 10-23: Comparing four views of the female figure.

a b c d

Cleaning up your muscled figures

Mapping down the muscle structure is an important step in rendering a refined drawing of the figure's surface visual appearance (after all, it's kind of freaky to see a figure with all the muscles exposed walking down the street). When you add the shadows and lights of the figure, I recommend placing tracing paper on top of your muscled figure (rather than erasing so many lines) and drawing the refined figure based on the diagram underneath. This way, you have the original muscle structure to keep referring back to in case you lose track of which muscle groups correspond to which shaded shapes on your tracing paper.

I provide several examples of finished, refined figures in Figure 10-24 (the front and rear views of the male and female figures). I start by lightly shading an even, light gray tone with the flat side of my drawing pencil. To apply shadow shapes, I shade the muscle forms starting with the outside edges of the whole figure. From there, I proceed to shade the individual muscles, starting with the larger groups.

Not every single muscle shape is visible from the surface unless the figure you're drawing is a seven-foot-tall bodybuilder flexing with all his might. Muscles that don't stand out on the surface of the skin (compared to the sternomastoid or pectoralis, for example) include smaller muscle groups in the forearm and the lower leg and the latissimus dorsi on the back. It's important to apply the shading based on the body's landmarks.

After I establish the basic shadow shapes, I use my kneaded eraser to pull out the highlights of the muscles. In the front view, I wipe out highlights under the shoulders, pectoralis, breasts, stomach, and knees, and along the collarbone. In the rear view, I pull out highlights along the top and inner edges of the shoulder blades, to the right of the spine underneath the rib cage, the elbow joints, the buttocks, and the calf muscles of the lower legs.

Larger muscle groups that protrude farther from the body (such as the breasts, buttocks, and joints) have brighter highlights than smaller muscle groups that lie flat against the figure (such as the forearm and leg muscles).

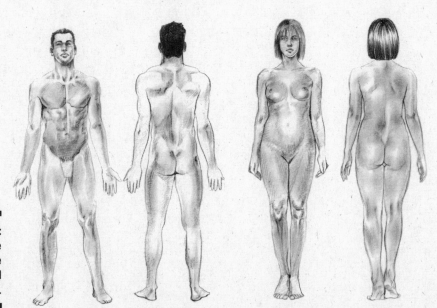

Figure 10-24:
The male and female figures, all cleaned up.

Chapter 11

Drawing Figures in Motion

. .

In This Chapter

▶ Understanding some basic techniques for drawing movement

▶ Mapping active and relaxed poses

. .

*E*arlier in this book, you find out what you need to know about the basic anatomy and structure of the human figure. In this chapter, you take those basics and add motion and rhythm to dynamically enhance your figure-drawing experience. Motion and rhythm breathe new life into your drawings. Although drawing accurate figures in a standing position is important, drawing them in action — whether they're running, jumping, slouching, or stretching — is just as important.

A large part of drawing a figure in motion is discerning which parts of the body are more important than others in communicating the message of the pose to the viewer. A common mistake most beginning artists make is thinking that every single shape of the body *must be* rendered accurately in order to deliver a powerful action. Nothing is further from the truth. As an artist, it's more important to develop the techniques I describe in this chapter, along with your observation skills, to emphasize the more important aspects of the body in a pose. With these skills, you, as the artist, can create more contrast between the forms within the figure, which leads to more dynamic poses.

In this chapter, I explain four basic methods for drawing figures in motion: contrapposto, foreshortening, diminution, and elimination. I also demonstrate some pointers in drawing a variety of dynamic and casual poses.

If you're new to adding mobility to your figure drawings, read Chapters 8 through 10 before continuing with this chapter. Building a figure in motion is easier if you start with a properly proportioned stick figure performing the basic movement, add geometric shapes to create a mannequin, and then fill in the details of the muscles.

Keeping a Few Important Concepts in Mind

When setting up to draw a figure in motion — in other words, any figure that isn't standing still — think of how the body is giving in and resisting nature's gravitational pull. The objective of drawing a figure in motion is tricking the viewer's eye into believing the figure is actively finding that comfortable, sustainable, balanced posture.

In the following sections, you discover how to apply rhythm by using *contrapposto* so your figure's overall appearance doesn't look stiff or contrived. In addition, I walk you though the

basic techniques of *foreshortening,* in which you angle parts of the figure toward the viewer, and *diminution,* in which you push objects back and forth in space. I wrap up by describing *elimination,* in which you de-emphasize less important parts of the body to bring attention to certain features.

Curves ahead: Contrapposto

The Italian term *contrapposto,* which means "counterpoise," is a great place to start when trying to understand the equilibrium between the posture of the body and the gravity that pulls against it. Where there's any gravitational pull against any parts of the body, there's tension that needs to be resolved with the least amount of discomfort. This is the basic concept behind drawing this type of pose. The figure appears more natural and less rigid when more weight is distributed on either foot, which triggers a series of off-axis reactions (when parts or joints on the opposite side of the body respond to counterbalance weight distribution). When teaching contrapposto to my students, I describe this rhythmic activity as an *S*-curve shape that weaves in and out of the body.

In the following sections, I show you the differences between figures with and without contrapposto and describe what contrapposto looks like from several angles. I also provide some useful info on how to draw a contrapposto figure.

Comparing figures with and without contrapposto

Observe and compare the differences between the posture in Figure 11-1a (sans contrapposto) with the posture in Figure 11-1b, which is based on the classic contrapposto pose. Notice how Figure 11-1a is symmetrical and, as a result, appears static and rather boring in comparison to the asymmetrical pose in Figure 11-1b — even though both examples are proportionally correct. Figure 11-1b comes across as more natural and aesthetically pleasing than Figure 11-1a.

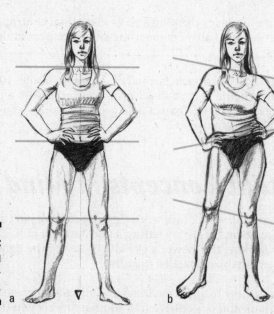

Figure 11-1: Studying contrapposto.

To fully understand the differences between the two figures, take a closer look at the way the angles of the head, shoulders, hips, and knees in Figure 11-1b tilt in an off-set manner alongside the horizontal axis of the entire figure. Compare Figure 11-1b to Figure 11-1a, in which all the levels of the joints and limbs are parallel and horizontal to one another.

Checking out contrapposto from different angles

Because contrapposto is such an important concept, I draw an additional three-quarter angle and a side view that shows the same flow of rhythm from Figure 11-1b.

- ✔ You see the outside curves of the edges flowing into one another more clearly in Figure 11-2a. It's almost as if a conversation is taking place between the two sides in which a curve represents a spoken phrase; when one side makes a comment, the other side listens before responding with a curve of its own.

- ✔ In Figure 11-2b, the front side of the neck angles in toward the torso to start the sequence of curves that turn in and out until the last curve from behind the lower leg flows into the ground. If I simplify the sequences of curves in Figure 11-2b, I get a single line that curves in and out from top to bottom.

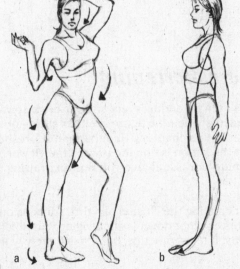

Figure 11-2: Observing contrapposto from the three-quarter and side views.

Drawing a contrapposto stick figure

When learning to draw the contrapposto figure, I recommend starting with the stick figure. In Figure 11-3a, I map out the basic 8-head proportions that I discuss in Chapter 8. Then I make the appropriate angle adjustments of the shoulders and hips in Figure 11-3b. From there, I block out the rest of the stick figure, as shown in Figures 11-3c and 11-3d. (To complete the figure, follow the guidelines on adding shapes and muscles in Chapters 9 and 10.)

When you're identifying where the figure is placing the most weight, ask yourself, "Which part of the body does the figure absolutely need to have stationary in order to hold the pose without collapsing?" Most of the time, that section (which in standing poses often is the hip) of the body that carries more weight is at a higher level than the opposite section.

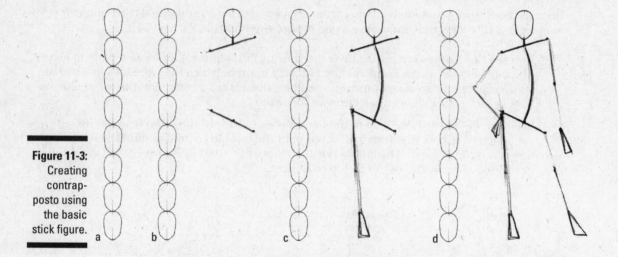

Figure 11-3:
Creating
contrap-
posto using
the basic
stick figure.

a b c d

Coming right at you: Foreshortening

Foreshortening occurs when body shapes aren't standing erect and are tilted toward the viewer. Typically, a foreshortened pose occurs when the figure is either sitting or reclining (I describe these poses in more detail later in this chapter). Understanding foreshortening is useful in drawing action poses in which the action is coming toward the viewer. In the following sections, I explain how foreshortening works and give you tips on drawing foreshortened poses.

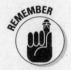

Understanding foreshortening is crucial in creating the illusion of a three-dimensional object on a flat two-dimensional space. Getting this concept down is challenging, but don't get discouraged if you don't get it down right away. It takes practice, but it's definitely worth it!

Understanding how foreshortening works on a single body part

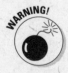

Poses that exhibit foreshortening are a challenge to many artists (both beginning and advanced). Over the course of teaching, I find that most students are thrown off by the length of the foreshortened object because it appears a lot shorter than they think it is. This is especially the case with extreme foreshortening, in which a body shape tilts at such an extreme angle that the overall outside edge of the shape is no longer recognizable at first glance.

For example, take a look at your arm. In Figure 11-4a, the arm is lifted with its fist toward the viewer. Although this image is clear in daylight, pay close attention to what happens when I reduce the shape to a single silhouette in Figure 11-4b. The length of the arm based on the silhouette of the fist seems too short and close to the body. These vantage points are a challenge because most people have the preconceived image that an arm is a certain length.

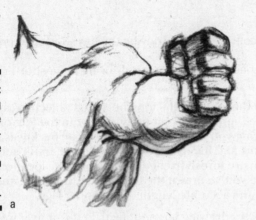

Figure 11-4: Observing the change of the overall outside shape with extreme foreshortening.

a

b

Stand against a white wall in front of a bright, single, direct light source (I recommend using a tungsten clamp light). If you don't have a white wall, a white sheet does just fine. Wear something tight against your body, or at least avoid wearing baggy clothing that obscures your body. While assuming a series of poses (standing, sitting, pointing, and so on), watch your body's shadow against the wall morph from one shape to another. With your back against the wall, try some action poses (for example, delivering a knockout punch) while watching the results; you'll be amazed at how many different types of shadow shapes you create.

Comparing foreshortened and nonforeshortened body parts

Because understanding foreshortening is such an important and useful concept when drawing realistic figures, allow me to elaborate. Turn your attention to Figure 11-5, in which I draw a figure's torso and arms. I compare the length of the left and right arms to the length of two cylinders so you can clearly see the effects of foreshortening. The arm on the right is angled toward you (foreshortened), while the arm on the left faces away (not foreshortened, side view). Watch not only the angle but also the length of the cylinder that I place in the corresponding side. As I make the body shape longer, the foreshortened effect diminishes. In contrast, as I make the body shape shorter, the foreshortened effect increases. A common mistake is making the foreshortened body parts too long.

Figure 11-5: Comparing foreshortened versus nonforeshortened body parts in a single pose.

Longer = Flat Shorter = 3D

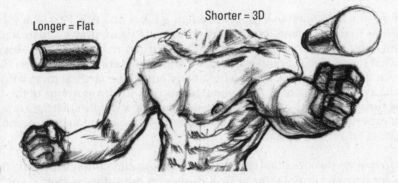

Drawing foreshortened poses

Here, I list some helpful tips for you to consider when drawing the foreshortened poses:

- ✔ If you see foreshortened body shapes, experiment with drawing them shorter than you normally think you'd draw them.

- ✔ Identify and use the positioning of the joints of the foreshortened objects to ask yourself where they rest in relation to either the nearest body part or to the feet or head. Suppose a model is seated and facing you with his hands resting on his knees. If you nail down the placement of the arms and hands in your drawing but aren't sure how long to make the upper legs, which are foreshortened, simply plot the location of the nearby knee joints based on where you've drawn the hands. Use the established knee joint positions to assess and draw the accurate length of the upper legs.

- ✔ Using the mannequin in Chapter 9, try drawing larger objects first (for example, the front of the fist that's punching toward the viewers) because they obscure the joints or shorter/thinner/smaller limbs that fall behind.

Moving away: Diminution

Diminution is a simple yet dynamic figure-drawing technique that pushes objects back in space by decreasing the size relation between one limb and another. While foreshortening focuses on bringing objects forward, diminution focuses on pushing objects backward into space. This technique is great when you're drawing exaggerated action poses; an example is a climbing pose in which an arm is extended in front to reach for the next rock while the other arm is behind, securing the climber's position. On a side note, diminution is also useful in drawing crowds (which I explain in Chapter 14).

In Figure 11-6a, I draw the right arm and shoulder that's closer to the viewer slightly foreshortened and, therefore, larger than the left arm. At the same time, I draw the left arm and shoulder slightly diminished by making them narrow and small. If you're drawing from a live model, don't worry if you don't notice the size differences; they aren't pronounced unless you're standing close and at an extreme angle to the model. Notice that the pose in Figure 11-6a is more lively and more dynamic than the image in Figure 11-6b, in which both arms and shoulders are the exact same width.

Knowing just how much diminution to apply to a figure takes practice. Personally, I recommend learning how to draw diminution the way my favorite figure-drawing instructor taught me at art school — by trial and error. I find that it's important to balance your observation skills (seeing what the model is doing) versus your knowledge and interpretation (deciding how much diminution you need based on which body part is the farthest away). However, if you're working away from a model, it's helpful to map out the proportions of the three-quarter view of the figure (using either a geometric figure or a simple stick figure; see Chapter 9) and experiment with applying various degrees of diminution on the side of the body that faces away from the viewer.

Be careful not to overdo the size differences when applying diminution within the figure. If the size difference between arms is too large, it throws off the entire proportion of the figure. The result is a figure that looks a bit cartoonish.

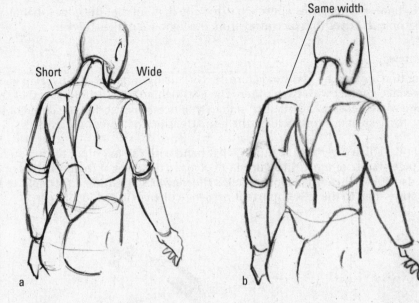

Figure 11-6:
Using arms and shoulders to exemplify diminution.

A disappearing act: Elimination

Elimination is the art of de-emphasizing the significance of parts that aren't as important to the action of the pose. This is especially useful when drawing short, timed poses from a live model. In these circumstances, you don't have time to complete the entire pose. Use it to decrease the attention of certain body shapes so that other shapes that are more important to describing the action of the pose can stand out. I describe important elimination techniques in the following sections.

Thinning or eliminating lines

One elimination technique is leaving outside edges/parts of the body either thin or incomplete. In Figure 11-7, I leave the top edge of the hair incomplete. By doing so, I bring more attention to the hand and back.

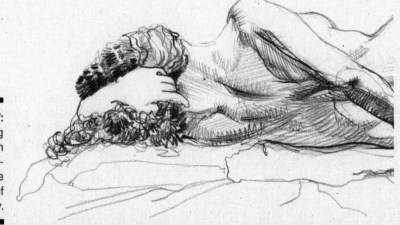

Figure 11-7:
Using elimination to de-emphasize objects of the body.

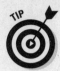

The trick to understanding this approach is to keep in mind that the edges that face the light are lighter/thinner. Edges that face away from the light are darker/thicker.

Fusing shapes

The elimination approach I show in Figure 11-8 is "fusing" objects that overlap each other or physically make contact with each other. The idea behind this technique is that by unifying objects, you're decreasing the number of lines you need to describe the detail of the object. Ultimately, the less detail you include, the less attention the object receives.

In Figure 11-8a, I fuse together the model's left hand with the left hip. This fusion helps the arms and face stand out more. In Figure 11-8b, I leave the ends of the fingertips open so the hand blends with the head. This fusion helps the viewer's attention go straight to the facial features rather than to the less important presence of each individual finger.

Figure 11-8:
Fusing
objects
together.

a b

Applying light shading over unified shapes helps convey the sense of separate objects being unified as one.

Striking a Few Poses

After you're familiar with the fundamental techniques that I describe earlier in this chapter, you're ready to apply them to the poses in this section. Here, I cover dynamic poses that range from running to climbing and relaxed poses that include sitting and stretching. For these poses, I recommend building up your figures from the basic stick figure and mannequin

that I describe in Chapter 9. After you feel comfortable drawing the stick figure and mannequin, go ahead and add the details of the muscles (see Chapter 10). In addition, seize the opportunity to experiment with foreshortening and diminution.

Before you read any further, let me say the following as a disclaimer (as well as a word of encouragement): Drawing figures in motion is a challenge that even many experienced professional artists struggle with. Thanks to photography (especially increasingly affordable digital photography), artists can capture and analyze the complex beauty of the action of, let's say, a picture-perfect swing of a baseball bat hitting a grand slam at the bottom of the ninth inning. Prior to photography, illustrators were left with little choice but to record and draw from memory or assumption based on the other poses that were at hand.

As part of your photo reference library (see Chapter 13), you may want to start a collection of action photos you find in sports magazines and newspapers. The Internet is also a great source for finding action references; just make sure that if you print an image, it has enough dpi (dots per inch) to print clearly.

Dynamic poses

Although so many dynamic poses are worth covering in this section, I go over running, jumping, and climbing. Pay close attention to the way the arms and legs work together. Most beginning students make the false assumption that dynamic poses are defined by the amount of force and power generated by an individual limb instead of taking into account how the entire body works together in rhythmic unison.

Bodies naturally balance themselves symmetrically. For example, if one arm reaches forward, the other arm reaches back. The legs work in *opposite-pair unison* with the arms (when one arm moves forward, the opposite leg moves forward). Next time you casually stroll to the kitchen to fix yourself a cup of coffee, see which arm swings forward with which leg.

Running

Running poses vary depending on how fast and/or how tired the athlete is. They also vary depending on the stage of the running the artist happens to capture on paper. Even when exploring various marathon photo references, an illustrator may use a pose in which the athlete doesn't seem to be running fast (say the leg positions in the photo are close together). The following are guidelines to drawing different running poses, as shown in Figure 11-9:

✔ In general, the farther apart the legs and arms, the faster the athlete is perceived to be running (see Figure 11-9a). Pay attention to how the back leg is close to the ground to propel the body forward while the front leg is in the air reaching forward to secure a footing. Even with the athlete's entire body suspended in midair, you still see the classic *S* shape created as he strains his neck forward and pushes his hips forward to give him proper momentum and balance.

To indicate the giant strides the figure is taking, I draw a shadow shape on the ground for added effect to show how far off the body is leaping in relation to the ground.

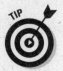

TIP

✔ The closer the arms and legs are positioned together, the slower the runner appears to be moving (see Figure 11-9b). I slightly diminish the width of his right shoulder and left leg as they go back in space.

When a figure slows to a walk, the arms straighten down more toward the sides of the body (however, they're hardly ever in a completely straight line). The legs straighten more, and the distance between the feet narrows to an average of one foot.

✔ In Figure 11-9c, you see a fast, explosive run from the three-quarter view. The figure's limbs are parallel to the diagonal tilt of the torso. Observe how high the knee is raised as the sprinter makes a dash to the finish line. I diminish the figure's right arm, which is bent at an angle behind his back, and the left leg, which is farthest from the viewer. I foreshorten the left arm, right leg, and torso, which are angled toward the viewer.

✔ In Figure 11-9d (the front view), I apply extreme foreshortening and diminution to the arms, legs, and torso to give the illusion that the entire body is lurching forward at an angle toward the viewer. The shoulder angle of the arm in front is tilted down. This tilt gives the illusion that the figure is leaning or lurching forward.

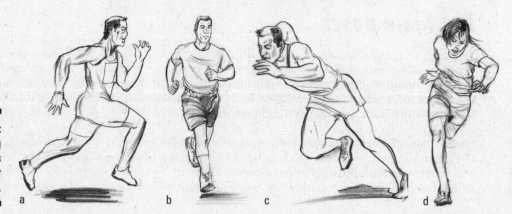

Figure 11-9:
Examining
various
needs for
speeds.

a b c d

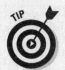

TIP

The key to giving the running pose a dynamic "kick" is to tilt the angle of the torso/spine forward. Even running poses that reflect a slower pace need to show a certain degree of tilt.

Here are some other key points to keep in mind when drawing your runners:

✔ Runners at full sprint speed (at a track racing event, for example) keep their elbows bent at a 90-degree angle. The torso of a full-sprint runner is almost parallel to the finish line. The arms don't cross over the front of the torso.

✔ Runners at a slower pace typically cross their arms over the front of the torso at a bent angle. In addition, the shoulder and torso slightly angle to follow the lead of the crossing arm.

✔ Don't forget to synchronize the arms with the legs; when one side of the body is in front, the opposite side of the body needs to be sent back.

✔ Pay attention to the bend of elbows and don't make them completely straight, even when you draw a walking figure (unless, of course, your figure is a robot from the '60s).

✔ Make sure that while the neck is tilted forward, the chin is tilted straight up so the head is parallel to the ground.

✔ When drawing foreshortened running poses, don't hesitate to apply elimination with some of the lines of the objects, such as the forearm and lower leg and foot, receding toward the back.

Jumping

The energy it takes to defy gravity and leap into the air opens up various types of interesting poses, as you can see in Figure 11-10:

✔ In Figure 11-10a, I draw a leaping and catching pose. This pose requires the figure to squat down to channel the power before the release, which propels the body into the air with maximum height. This pose works for baseball and beach volleyball.

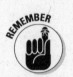

Contrapposto applies to this vertically extended pose. I indicate this in the figure with the arrows that describe the interweaving direction of the rhythm. If the figure reaches farther backward for the catch, the figure will show a backward *C*-shaped curve.

✔ In Figure 11-10b, the figure is jumping over an obstacle. Pay attention to how the front view's foreshortening resembles Figure 11-9d. The arms spread out to the side to balance the abruptly assumed position. Most importantly, the head and torso curve forward as part of the motion of pulling the legs up.

A good way of thinking of the action of this type of jump is to picture an airplane retracting its landing gear after takeoff.

✔ The leaping forward/lunging pose, as I show in Figure 11-10c, is something you see frequently in action movies, comic books, and contact sports (such as football). Notice how the posture is angled at a diagonal. Also notice the use of extreme foreshortening on the figure's torso, arms, and right upper leg. I diminish his left upper leg and left shoulder.

I recommend drawing the hands before completing the rest of the foreshortened arm structure. As I mention in the earlier section "Drawing foreshortened poses," drawing the closer objects first helps you assess a more accurate distance and size relation between the hand and body. If I concern myself with trying to first fit in the forearm structure (which, for the most part, is hidden behind the hands), the chances of making the arm too long increase and the hands become proportionately misplaced.

Here are some other things to keep in mind when drawing jumping poses:

✔ One leg is higher than the other.

✔ Aggressive poses have the torso and head leaning forward.

✔ Arms are spread out either to the sides or in front.

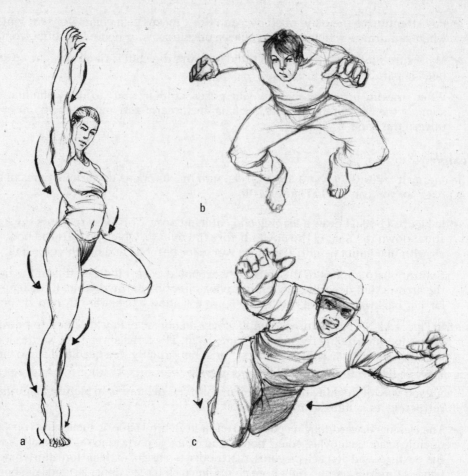

Figure 11-10: Drawing poses that jump off the page.

a

b

c

Climbing

Climbing actions require the most collaborative effort from all the muscle groups. The body needs to not only maintain its adherence to an incline surface but also generate enough force to propel itself upward. Figure 11-11 shows several climbing poses:

- In Figure 11-11a, I draw a figure engaged in rock climbing. At first glance, the climber from the side resembles a slinky-like arc. Although one arm reaches out to secure a foundation to move up from, the other arm dangles behind to do what climbers refer to as "detoxify." The lower legs spread out slightly to stabilize the body from swinging left and right when they're not pushing forward off the rocks. If you look at the overall sequence of climbing movements, they resemble an inchworm inching itself up the tree while keeping its body close to the vertical surface.

 I diminish the figure's left shoulder while foreshortening the right shoulder. Also observe the arc of the body created by the arms and neck thrusting forward to grab hold of the rock to secure a position against the mountain.

- From the front, I draw another variation of the climbing figure in which the figure is tired and struggling to make the next grasp (see Figure 11-11b). Some things to note are the way the head angles down toward the spot where the effort is concentrated (which

is the desperate, open, foreshortened hand). Pay attention to how I use extreme fore-shortening on the upper body and the left arm reaching toward the viewer. The lower half of the torso is completely concealed behind the upper torso.

✔ In Figure 11-11c, I show a less rigorous form of climbing — climbing a ladder. The legs move in a vertical back-and-forth motion. I enlarge the right arm not only because it's closer than the left arm, but also because that's where the viewer's attention needs to be directed — toward the hand that's just made the next grasp. In addition, I fore-shorten the figure's right knee, which is angled toward the viewer.

Figure 11-11:
Drawing climbing figures in action.

a b c

Here's a list of some things to keep in mind when drawing the overall climbing figure:

✔ The head is angled upward and parallel to the incline surface.

✔ When one hand reaches upward, the opposite leg bends upward (similar to running, which I discuss earlier in this chapter).

✔ The extreme reach of the arm pulls along the torso to tilt upward.

Relaxed poses

Take a moment to step back from the heavy-duty action. In this section, you discover the basic characteristics of drawing casual poses, including sitting naturally, folding the arms, having the hands on the hips, and stretching. Unlike some of the quick action poses, in which a camera sure comes in handy, casual poses are everyday poses you see around you. For the most part, these poses are stationary and easier to capture on paper without having to use a camera. (But feel free to draw casual poses from photos if you feel they're helpful!)

Be careful of the common myth that "casual" means static and nondynamic. Plenty of rhythm and gestures make casual poses just as exciting to draw as dynamic poses.

Although the number of casual poses is limitless, it's important to pay attention to and observe all types of casual poses. I can't stress enough how important it is to develop the good habit of keeping a small drawing sketchpad with you whenever you venture out in public. You never know when you'll come across an opportunity to draw a cool relaxed pose.

The natural seated position

You can tell a lot about a person's psychological state of mind when he or she takes a seat. The figure's posture lets the viewers know whether your figure is excited/tense or relaxed/bored. Everyone relates to what it feels like to assume a seated position under various circumstances — and that makes these poses a delight to capture on paper. In this section, I focus on the natural seated position; check out the next section for details on the extremes of slouching and sitting erect.

In Figure 11-12, I draw a figure seated in a natural position that I find is a good default to begin with. Take note of the following in Figure 11-12a (the side view):

- ✔ The back is slightly angled (refer to the imaginary spine line). Most beginning artists make the mistake of drawing the back and neck straight at a 90-degree perpendicular line to the ground. This posture isn't natural and is visually painful to see.

- ✔ The arms bend slightly to follow the contour of the front of the torso leading down to the hips.

- ✔ One leg typically extends farther than the other, which bends slightly backward. This prevents the pose from appearing bound or stiff.

In Figure 11-12b and Figure 11-12c, you see how the natural view appears from the front and three-quarter angle views:

- ✔ I let one hand pass farther in front of the other hand (it doesn't really matter which one as long as they aren't in an exact symmetrical position).

- ✔ In the front view, I foreshorten the upper legs, which angle toward the viewer.

- ✔ In the three-quarter view, I apply diminution to the left half of the figure's torso, which is farther away from the viewer.

- ✔ From both the side and three-quarter views, the front of the neck leads toward the curve of the back to create a contrapposto curve.

Figure 11-12:
Drawing the natural seated position.

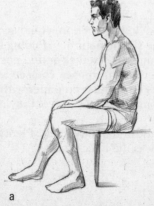
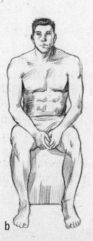
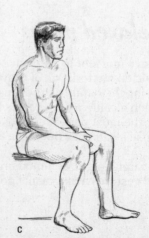

a b c

Avoid drawing both legs clinging to each other. The pressure from the weight absorbed into the buttocks causes the legs to slightly angle away from the center of the hips.

Any seated pose, drawn with or without a live model, provides insight into the figure's personality and emotional state. Are the hands buried into the pockets from boredom, or do they simply fall to the side to show they're relaxed? Are the figure's feet touching the ground, or does the figure fold one foot across and over the other? Also think about the tilt of the neck and direction of the head. These things all play together to give meaning to the pose.

I encourage you to experiment and document your own natural seated position. Walk over to your favorite couch and have a seat (just don't fall asleep yet!). Observe how your upper body slides backward into the cushion, and compare this position to sitting upright in your studio chair. Which side do you tend to lean toward? Do you cross you legs or arms? The next time you draw a seated model, see whether you can identify with the pose the model assumes.

Slouching and sitting erect

In Figure 11-13a, I draw the figure in a slouching position; the entire body slopes downward. Observe the figure's diminished right arm and upper legs.

The foreshortened torso makes the head appear disproportionately unbalanced, even when accurately measured. The fact that the neck is hidden behind the torso and head makes the head stand out even more. Before you erase and redraw the entire pose, I recommend drawing a portion of the couch (no need to go into detail — simple lines to indicate the general shapes are sufficient). You don't even need to draw the entire couch; just include enough information around the seated figure so that viewers, as well as you, can see where the figure rests in relation to the surroundings.

When figures slouch, they typically spread out their arms to the side, next to the lower hips. This pose prevents them from sinking too far down and spilling onto the floor like melted butter!

In Figure 11-13b, it's time to get upright and uptight! This rigid pose (which reminds me of my first meeting with an art director) appears proper enough to out-do Mary Poppins. Don't forget to draw the elements of contrapposto in which the back of the torso swings in toward the front of the stomach, which then swings back into the hips. The angle of the neck (which tilts forward) keeps the head from appearing stiff and mannequin-like.

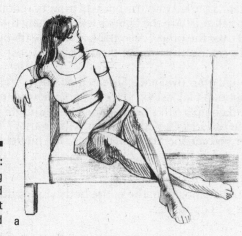

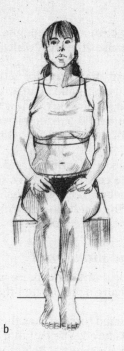

Figure 11-13:
Exploring
slouched
and erect
seated
positions.

a

b

Take this a step further by drawing a portion of the edge of the chair to show viewers how she's literally on the edge of her seat.

Arms folded and hands on the hips

Although arm positioning has quite a few variations, a couple of them come to mind when I'm choosing the most common poses. After all, it's boring to think that the only way of communicating with our arms is just letting them dangle to the side. Here, I show you tips on drawing arms folded and hands on the hips.

Folded arms is one of many poses that communicates attitude with grace. Don't let the overlapping arm shapes confuse you. The key to understanding this shape is to imagine a trapezoidal shape as I show in the front view, Figure 11-14a. Although the two arm shapes appear symmetrical, pay close attention to the different hand positions. The overlapping arm's hand tucks underneath the opposite arm. The hand of the arm that lies underneath loosely wraps around the biceps of the overlapping arm. In addition, observe how the upper arms are shorter due to foreshortening.

When drawing folded arms, I notice students trying to complete one arm before drawing the other. The problem with this approach is that after completing the first arm, students realize that it's either too long or too close to the torso and that there isn't enough room to fit in the other arm. I recommend treating and drawing both arms as a unified parallelogram shape. I have students lightly draw this shape over the folded arms to make sure the positioning is correct. (If it helps, start by posing a stick figure with its arms folded; from there just build a mannequin, as I explain in Chapter 9.) The parallelogram changes to an isosceles trapezoid when drawing the front view of a figure with arms crossed.

In Figure 11-14b, I show the figure with her hands on her hips. Note how the symmetrical hand and arm positions create a triangular negative space between the sides of the torso; the space farther from the viewer is smaller (diminution). Because the torso is tilted away at an angle, only parts of the fingers of the hand that's farther away are visible.

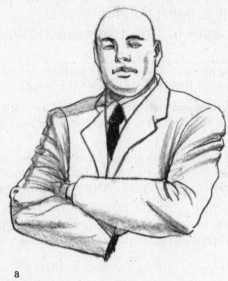 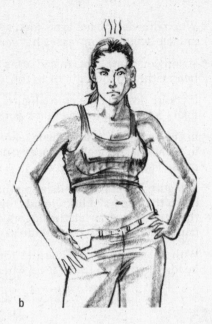

Figure 11-14: Positions of arms folded across the torso and hands placed on the hips.

a　　　　　　　　　　　b

Don't let the fingers of the hands throw you off — you usually see the index finger, which angles upward, while the rest of the fingers tilt downward. When drawing the hand that's partially hidden on the other side of the upper body, all you need to draw at first is the index finger, which hooks around the waist at an upward angle. Then add the three top joints of the third, fourth, and fifth fingers, which angle downward in parallel fashion. (The thumb hooks behind the hip to make sure the hand doesn't slide down.)

What makes the hands-on-hips pose dynamic is the contrapposto rhythm that starts from the neck. The shoulders are at a slight tilt compared to the ground. This tilt is the result of the hands pressing against the hips to lift one shoulder slightly higher than the other. Imagine arriving 15 minutes late to a first date. You may very well find your date assuming this pose and giving you a look that says, "Well, it's about time you got here!"

Stretching

Stretching is one of my favorite poses to draw because I can relate to it every time I pull an all-nighter illustration project (trust me, it doesn't get easier with time!). When referring to Figure 11-15, think of that popular tune that drives people to mimic the hand motions: Y-M-C-A! I know, these poses don't necessarily copy those exact movements (it's a *stretch*), but it sure can make drawing them fun!

Although all these poses are diverse in form, they share the same function of stretching either the back or the chest pectoralis muscle groups (refer to Chapter 10 for more on muscle groups). The following are some guidelines to keep in mind when drawing these yawning/stretching poses:

✔ In Figure 11-15a, the back of the torso pushes toward the front of the stomach, which helps arch the back. In addition, the arms are raised at a 30-degree angle from the body; keep the elbows facing back. Men tend to have the bottom of the fist facing toward the viewer, while women tend to bend the wrist so the bottom of the fist faces upward.

When drawing raised arms, don't forget to include the small bump for the deltoid muscle, which compresses between the shoulders and upper arms.

✔ When you draw bent, raised arms at a symmetrical level (see Figure 11-15b), tilt the head either to the right or to the left.

If you're drawing the entire figure, keep in mind that the side to which you tilt your figure's head is the side that has the higher hip; this hip carries the weight of the pose.

✔ In Figure 11-15c, watch the level of the shoulder that rises upward along with the arm. In addition, the neck tilts away from the arm that's raised. Also, make sure the bottom of the fist faces the viewer.

✔ In Figure 11-15d, use unification (as I describe in the earlier section "Fusing shapes") to mesh the fingers of both hands together. Treating both hands as one is more effective than trying to draw all the fingers overlapping each other. Make sure the palms of the hands are facing up toward the sky.

✔ With the exception of Figure 11-15c, note how all the stretching figures have their heads tilted down to the level where the chin touches the top of the torso.

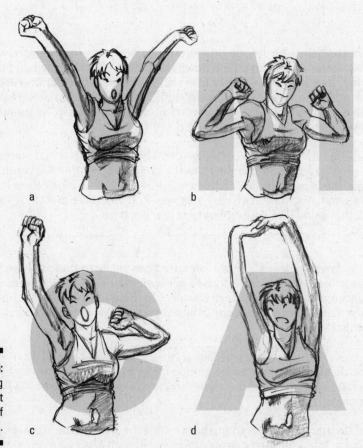

Figure 11-15: Drawing different positions of stretching.

a

b

c

d

Part IV
Sharpening Your Figure-Drawing Skills

The 5th Wave By Rich Tennant

FIGURE DRAWING CLASS AT BUSINESS SCHOOL

"Nice figure, but I'd like to see more zeros."

In this part . . .

It's time to address those well-deserved wrinkles — clothing wrinkles, that is! In this part, I show you how to get fashionable when you're drawing clothing. Don't be intimidated by all the details in those elegant ballroom dresses and spiffy tuxedos you see in fashion magazines. After you understand the basic principles, drawing clothing is much easier. But don't forget about going that extra step; in this part, I show you how to draw shoes that'll knock your socks off.

In this part, you also discover techniques that help your figure look even more dimensional. I provide some tricks with shading and crosshatching to give the figure more definition and the appearance of texture. I also talk about the do's and don'ts of using photo references for figure drawing. Working from lousy references, as I show you, wastes your valuable time and builds frustration.

But wait, that's not all! I also share with you some templates and simple tricks to create effective compositions around your figure. I walk you through basic and intermediate perspective lessons, which are essential to creating dynamic compositions. You'll see just how fun and exciting it is to create narrative scenarios around your figure.

Chapter 12

Accessorizing Your Figures

Although drawing nudes is essential to understanding the fundamentals of figure drawing, the fun continues with learning to draw the clothed figure. Clothing and fashion are important in not only accentuating the rhythm of the figure's pose, but also highlighting the figure's personality.

I start this chapter with the basics of drawing folds; in addition, you discover various effects to create clothing textures and patterns. Then I demonstrate the application of these basics on drawing both loose and tight clothing. Finally, just so you can get your foot in the door, I walk you through drawing different types of shoes (ladies, don't get too excited now).

For this chapter, you need to be familiar with basic geometric shapes. If you're new to drawing clothing, I recommend reading Chapter 3 before proceeding. In addition, I talk about building a reference library of images in Chapter 13; as you do so, it's a good idea to collect a diverse range of clothing. You can find images anywhere from magazines with the latest fashion trends to simple clothing catalogs. Basing the clothing you draw on popular preexisting fashion trends is more efficient than coming up with your own clothing ideas.

Drawing Folds, Patterns, and Textures

In general, clothing, with all its detailed folds, patterns, and textures, tends to overwhelm many students (even professional artists struggle to learn something new). Many students complain they can't draw folds, patterns, and textures as if it's a sign of a lack of innate talent. I strongly encourage students (especially beginners) not to be intimidated. Believe it or not, you don't need to be able to draw every single detail of the clothing that you see on the model or in fashion magazines to make the overall drawing convincing. In fact, one of the common mistakes many beginning artists make, especially when working from a photograph reference, is copying *too much* detail into the drawing. When you do that, the drawing looks too busy and contrived.

When you're drawing a clothed figure, the most important objective isn't to see how much detail you can cram in; ultimately, an effective, eye-catching, clothed figure drawing needs to depict either the physical shape of the figure that lies underneath or the action that the figure is performing. I make it a point throughout the following sections on folds, patterns, and textures to demonstrate the process in choosing which attributes to emphasize.

Coming into the fold

Folds — we've all seen them! From napkins to gowns, they're everywhere around you. Just in case you mistake the term for the expression for giving up your hand in a bad-luck poker game, *folds* are a series of protruding tubular shapes that occur when sections of the material are moved or shifted in opposing directions. The more folds you see in a material, the more tension there is within the material due to the amount of shift. In the following sections, I describe different kinds of folds, explain how they're created, show you how to draw them, and help you figure out which ones to emphasize in your drawings.

The types of clothing that create round and sharp folds

Here are two simple rules regarding folds:

✓ **Softer and looser clothing materials create larger and rounder folds (as shown in Figure 12-1a).** Examples of soft materials include kimonos, pajamas, loose T-shirts, and sweatshirts. Think of the figures wearing this kind of clothing dumping a jug of fabric softener into the washer.

✓ **Tougher and tighter materials make sharp (or crisp) folds (as shown in Figure 12-1b).** Examples of tighter folds include business suits, tight T-shirts, and stiff leather jackets. Think of the figures wearing this type of clothing hosing down their wardrobe with a year's worth of starch.

Figure 12-1: Comparing the folds of softer/ looser and tougher/ tighter materials.

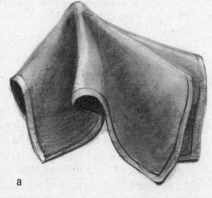
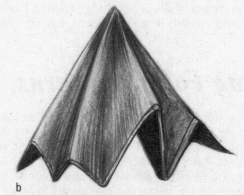

a b

The general effects of tension on folds

Folds are caused by a tug, pull, pinch, or other tension on the surface of a fabric. The direction, size, and number of folds in a figure's clothing depend on the tension caused by the figure's

twisting, bending, and stretching (see the next section for details). Like the epicenter of an earthquake, tension always has a source of origin. The folds simply point toward that source.

Pay attention to the following when drawing folds in clothing. Exceptions exist, but for the most part, the following list has withstood the test of time:

- ✔ As folds fall away from the source of tension, they get wider (looser fabrics with less tension grow wider than tighter fabrics under more tension).

- ✔ As folds come closer to the source, they get narrower (tighter fabrics with more tension grow narrower than looser fabrics under less tension).

- ✔ Under natural gravity, folds angle down and away from the source of tension.

- ✔ Under natural gravity, folds are almost never parallel to each other.

The different types of tension: Compression and stretch

Two types of tension result in folds within the clothing: *compression* and *stretch*. Both types interact by merging into each other to follow the rhythmic flow of a figure's actions. Figure 12-2 depicts the two types of tension. Here's more info on each:

- ✔ **Compression tension:** This type occurs when body parts are pressed against or overlap each other. Compression folds happen when the model bends, flexes, or folds the arms; crosses the legs; sits down; or bends over. I use arrows to point to the compression folds in Figure 12-2a.

- ✔ **Stretch tension:** This type occurs when limbs are stretched outward and away from the center of the body. For example, when a baseball player swings his bat, his shoulders tug at his jersey, which causes elongated folds to form from the shoulders down to the waist (see the twisting arrow in Figure 12-2b). Other actions that create stretch tension include stretching the arms above the shoulders, kicking, and reaching.

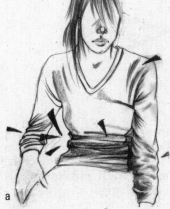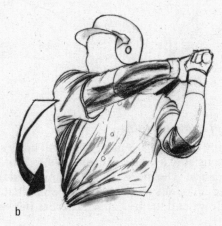

Figure 12-2: Comparing the two different tensions.

a

b

Having trouble understanding the difference between compression tension and stretch tension? Take five minutes to stretch in front of a mirror. Observe the way your clothing reacts when you stretch your arms high above your head. What happens when you stretch one arm

across the front of your torso? Each exertion you make (regardless of how little or great an effort you make) creates tension points that cause folds to break out in your clothing:

✔ If you're wearing something tight that hugs your skin, the sections where you feel the fabric rubbing against the skin are where you're experiencing *stretch tension.*

✔ If you're wearing something bulkier (such as a wool sweater), the spots where you feel the fabric bunching together are where you're experiencing *compression tension.*

When deciding where and when to place these tension folds on the clothed figure, bear in mind that these types of folds work in a "yin-yang" fashion. If one side exhibits a compression fold, the opposite side responds with a stretch fold. As I demonstrate in Figure 12-3, both tensions not only accentuate the contrapposto flow (Figure 12-3a), but also boost the energetic motion in an athlete throwing a baseball (Figure 12-3b). In both examples, observe the markings I create near each side of the figure: "C" for compression and "S" for stretch.

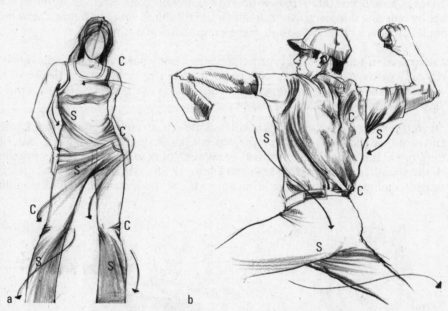

Figure 12-3: Placing and identifying the positions of compression and stretch tension folds on the figure.

The basics of drawing folds

You commonly see folds around cylindrical body shapes such as the arms, waist, legs, and neck. They consist of a series of curving lines that follow the contour of the cylindrical form beneath the fabric. The more tightly compressed the fabric is (suppose the model has his sleeves rolled up or sits in a very tight T-shirt that hugs the waist and stomach), the more curves you draw, and the less space there is between each curve.

Imagine you're drawing a model who's wearing loose jeans and has his leg bent at the knee; the top of the knee is the source of tension. Follow these steps to create the folds:

1. **Draw two slightly curved diagonal lines angling left from the source of tension (as shown in Figure 12-4a).**

The top end of the line of the fold closest to the knee overlaps the second line. As the lines recede away from the knee, the gap between them widens. Starting from the knee, the lines taper off from thick to thin.

2. **Draw two lines angling down from the source of tension (as shown in Figure 12-4b).**

The first line angles straight down, indicating the weight of the fabric being pulled down by gravity; the second line stretches across the edge of the lower leg. Starting from the knee, the lines taper off from thick to thin. While the first line starts at the top of the knee, the second line starts lower (around the midpoint of the width of the lower leg). As the lines angle down, the gap between them widens.

3. **Draw a third line starting underneath the second line (as shown in Figure 12-4c).**

Draw the third line shorter and more angled than the second line. Starting from the knee, the line tapers off from thick to thin.

To create the bottom of the jeans, draw a cylinder around the sides and bottom of the leg (see Chapter 3 for details on drawing a cylinder).

4. **Using the flat side of a soft pencil (6B or higher), draw a series of broad single strokes to the left of all the fold lines (as shown in Figure 12-4d).**

Decrease pressure on your drawing pencil to create thick to thin strokes; each stroke grows thinner as it recedes from the knee.

5. **To create texture, lightly apply a series of zigzag strokes on top of the shaded strokes (as shown in Figure 12-4e).**

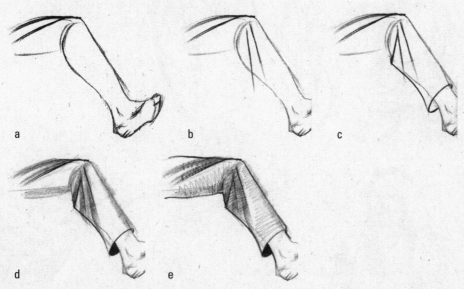

Figure 12-4:
Drawing
basic folds.

Knowing which folds to focus on

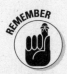

Many students complain about the intricate details of the clothing folds they generally see. Selecting only the folds that are essential to the rhythm and energy of the pose is important. Even with the body hidden under fabric, you have enough information from the wrinkles to interpret the movement of the nude figure underneath. Check out Figure 12-5 and the following tips on selecting which folds to accentuate:

✔ **Zoom in on folds around the body's protruding joint areas.** Observe the examples in which I pick up the folds that drop down from a single source of tension, such as the elbows, knees, and shoulders.

✔ **Focus on folds that wrap around larger forms within the body.** In addition to the larger joints, such as the knee, I use the folds to wrap around the shapes of the major muscle groups, such as the breasts, stomach, hips, and buttocks. The more folds you draw to describe the larger objects (especially in tighter clothing), the more three-dimensional your figure will appear. Also, the shadows that wrap around larger shapes are generally darker than the shadows on folds that wrap around flatter parts of the body.

✔ **Accentuate long folds that run diagonally across the body areas.** As I mention in Chapter 14, objects that run diagonally are attention-getters, as opposed to folds that drop vertically or horizontally.

✔ **Look for folds that are symmetrical on both sides of the body.** Take, for example, the hands-in-pocket position (Figure 12-5a), in which I focus on the wrinkles around the elbows in addition to the symmetrical folds on the upper arms, stomach, and hips.

✔ **Spend less time drawing the folds that are faint.** These folds tend to be what's commonly referred to as "memory folds," which happen when portions of the fabric remain creased or wrinkled for a period of time before straightening out.

Figure 12-5: Be selective when choosing which folds best describe what the figure is doing.

Picking apart patterns

Drawing patterns is a chance to add character and taste to your figure's fashion. In the following sections, I introduce you to both simple and elaborate patterns.

Although this tip is dangerous for chronic shoppers, I recommend keeping clothing catalogs as references to keep up with trendy styles. Because fashion changes constantly, you may also want to visit department stores to search for inspiration (if you're a credit-card shopper, leave home without it!).

Simple patterns

In Figure 12-6, I illustrate clothing that has simple patterns, such as polka-dots, stripes, and other simple geometric patterns. Stripes are probably most commonly used throughout trends.

Figure 12-6:
Observing simple patterns found on male and female clothing.

a b c

Resist the tendency to simply slap shapes onto clothing; otherwise, the figure is going to look flat, like paper-cut projects in which the tab folds over to hook itself to the paper-cut doll. All basic patterns follow the contour of the body. If you're new to drawing patterns, don't worry if you're not completely sure about every contour shape of the figure at first. Apply the following suggestions:

- ✔ Patterns closer to the front and bottom of the clothing appear larger than those toward the top and those that recede toward the sides (see Figure 12-6a).
- ✔ Line patterns (including plaid) curve around the figure instead of going straight across (see Figure 12-6b).

- ✔ The direction of patterns is likely to alter along the seam changes. This change is commonly visible between the transition of the torso and the sleeves.

- ✔ Men's clothing patterns are generally thinner, smaller, and/or more subdued than patterns typically found in women's clothing (see Figure 12-6c).

Elaborate patterns

In Figure 12-7, I draw more elaborate patterns. In general, more elaborate patterns are found in either women's clothing or boys' clothing. For adult males, fashion tends to stick with simplicity; the only exception is the necktie (which may have more decorative patterns). Here are some handy guidelines for drawing elaborate patterns:

- ✔ The edges of shapes don't touch edges of the clothing (see Figure 12-7a). Edges of shapes that touch the borders of clothing (otherwise known as objects that "kiss the borders") are a big no-no in composition. Having abstract shapes fall off the edges is better than rendering realistic shapes that kiss the edges of the clothing.

- ✔ Horizontal lines follow the contour of the figure underneath the fabric (see Figure 12-7b). The distance between each line is the same. What makes this pattern a bit complex is that the lines on the sleeves are angled, not horizontal.

- ✔ Designs like those in Figure 12-7c are usually placed to the lower left or right or, in frequent cases, to the left of the buttons. A pocket on the opposite side balances the overall composition.

- ✔ One of my favorite designs is abstract organic shapes overlapping simple geometric shapes; in Figure 12-7d, I draw a flower overlapping a shaded circle. The contrasting darker value of the circle pushes the flower shape forward to create an interesting composition that doesn't overwhelm the viewer. Like the dress in Figure 12-7a, the shapes don't kiss the edges of the top.

Experiment with values when you draw elaborate patterns. See what happens if you change the negative space in the background of this top from white to black. How about altering the shading of the circles from gray to white? The sky's the limit!

- ✔ Although the men's shirt in Figure 12-7e is simple in comparison with women's clothing, I jazz up the design by changing the distances between the stripes at the top. Just for kicks in contrast, I shade in one of the stripes.

By applying large shadows, zigzag patterns, and short diagonal hatching marks along the folds at the front of the shirt, I suggest to the viewer that the shirt has an overall dark color (perhaps it's dark blue?). I enjoy adding textures and strokes that give more character to a piece of clothing than just a solid shade in a single value.

- ✔ On a men's tie, I draw a series of diagonal lines that are spaced randomly (see Figure 12-7f). The direction of the lines on the knot is different from the direction of the lines on the main part of the tie. This shift in pattern is common with ties because the knot is formed by a section that wraps behind and around the neck.

Having references makes drawing clothing patterns a quicker and easier process, but don't become overly obsessed with getting elaborate patterns as exact as the reference photos. After creating a few patterns based on current trends or styles, I recommend taking parts and bits to incorporate your own patterns to make a unique fashion statement.

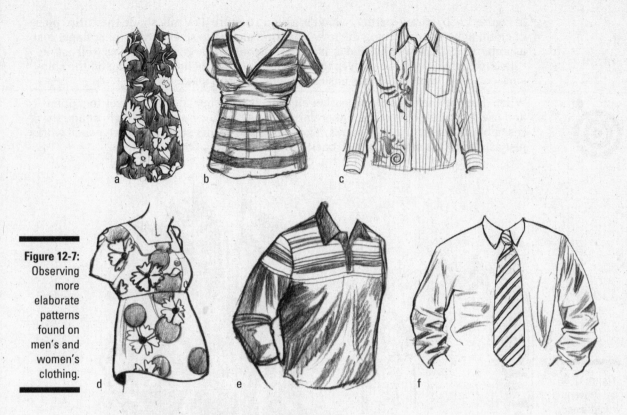

Figure 12-7:
Observing more elaborate patterns found on men's and women's clothing.

Getting a feel for textures

When creating textures, controlling the edges of the clothing is key. Unlike patterns, in which two-dimensional designs rest on a flat surface, textures are three-dimensional forms that protrude from the flat surface. Depending on the type of fabric used to manufacture the clothing, the outline of the outer edges can take on a range of appearances, from soft, hard, jagged, smooth, or even incomplete with gaps. In the following sections, I demonstrate how to use lines and values to create the appearance of different textures.

Use a sharp lead/charcoal pencil for hard edges and textures and a dull, soft lead/charcoal pencil for soft edges and textures.

Matte and shiny textures on stiff materials

In Figure 12-8, I demonstrate how to draw matte and shiny textures on stiff materials:

✔ In Figure 12-8a, I draw a matte dress shirt; I use the sharp point of the pencil to show its stiffness. Because I want to show that the shirt has some softness (after all, it's made of cotton), I use the flat edge of the pencil to give a light, smooth shade close to the edges of the fabric.

The key to giving thin clothing realism is to leave an unshaded sliver along the edges of the fabric (such as the collar).

✔ In Figure 12-8b, I draw leather, which is a shiny texture. I evenly shade the entire piece of clothing before darkening the form shadows along the sleeves and collar flaps. Just as important, I use my kneaded eraser to bring out the large highlights as well as the reflective lights along the sleeves that occur as a result of light bouncing off the shiny surface. (See Chapter 3 for the basics of highlights and shadows.)

When drawing the folds along leather sleeves, I shape my kneaded eraser to a point and use it to erase out (commonly referred to as "pulling out") a highlight shape that resembles a series of zigzag marks. The eraser end of any standard office pencil works just as well (I just make sure I go back and soften some of the edges).

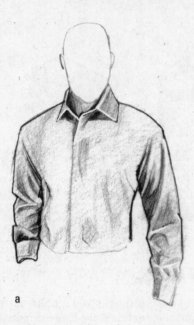
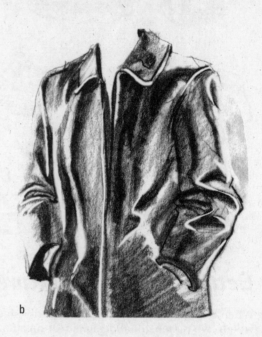

Figure 12-8:
Drawing matte and shiny textures on stiff materials.

a b

Soft textures

In Figure 12-9, I show you how to draw different types of soft textures:

✔ For the wool jacket and turtleneck in Figure 12-9a, I use the softer edge of my charcoal pencil to lightly block in the shapes. After I draw the outer edges of the clothing, I use my finger to blur and soften all the edges. To show the thickness of the material, I place the shadows farther away from the edge. I soften the edges of the shadows as well. I add two parallel lines for the grooves that run along the collar of the turtleneck. To further emphasize the roundness of the collar, I have the groove lines curve to follow the contour of the collar.

Don't forget to slightly darken the value of the grooves so the texture appears three-dimensional. Contrast between values makes forms pop.

✔ With fur garments (see Figure 12-9b), I keep the initial outer edges very light. Use these light edges as a guide, and use the broad flat side of your pencil to gently create light hatch marks that angle away from the body (see Chapter 3 for details on hatching).

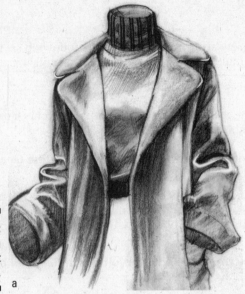
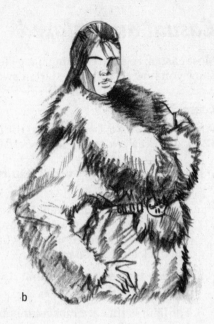

Figure 12-9:
Drawing
fluffy soft
textures.

a

b

The fluffier the surface texture is, the less definite the edges become; they appear obscured by the individual strands of material sprouting.

Draping Clothes on Your Figure

Drawing clothing on the figure seems challenging when you look at all those complex details that wrap around the figure. All the detail that's up there on the model stand can easily become overwhelming. The good news is you can put away your aspirin bottle as well as the ice packet for your forehead. In the following sections, I give some tips and general shortcuts that help decipher the myth of confusion that surrounds the art of clothing your drawing.

I use a general outline of the figure to show how the clothing matches the body. If you're new to drawing the figure, refer to Chapters 8, 9, and 10 before continuing.

When I draw clothing away from a live model, I draw the outline of the body and add the shape of the fabric and folds before I erase the parts of the body covered by the clothing. However, when I draw a clothed figure from a live model, I map out the abstract shapes of the folds and fabrics and then apply shading and hatching, instead of treating the body and the clothing separately. Why?

- I don't have time to draw so many objects.

- Because the model's body and proportions are unique, the clothes drape differently on her than they would on others. Study and draw the shapes that the clothing makes and let those shapes dictate the structure of the pose and the model's physique.

Casual and relaxed

Most casual, relaxed clothing hangs loosely around the body. In the following sections, I show you how to draw a T-shirt, a sweatshirt, a skirt, and a loose-fitting suit.

Loose T-shirt

Who doesn't own a T-shirt or two (or five or ten)? Follow these steps (and check out Figure 12-10) as I draw a loose short-sleeved T-shirt for a man:

1. **Lightly sketch the overall T-shirt shape over the general figure outline (see Figure 12-10a).**

 Many beginners mistakenly make the shoulders and outside sleeves too horizontally and vertically straight. Make sure each side angles down and away from the body. Men's sleeves drop down to right above the elbow joint. Draw a rounded curve around the neck for the collar.

2. **Draw a long stretch fold that drops from the shoulder joints at a diagonal angle and wraps around the biceps.**

 For figures that are muscular in build, I draw several stretch folds from the bottom of the pectoralis muscle to emphasize the large size that protrudes farther out from the rest of the torso (as shown in Figure 12-10b).

3. **Apply light shading along the folds of the sleeves as well as the compression folds that run across the lower torso.**

 In addition, darken the cast shadows on the bottom of the sleeves, next to the torso. The soft edges I use to render these shadows suggest that the shirt's texture is soft cotton, even though the model's physique is rock hard.

When drawing loose T-shirts for females, I raise the sleeves higher, so the bottom of each sleeve is approximately at a 45-degree angle. In addition, the neckline arches slightly lower. As I illustrate in Figure 12-10c, I place the folds under the breast shape.

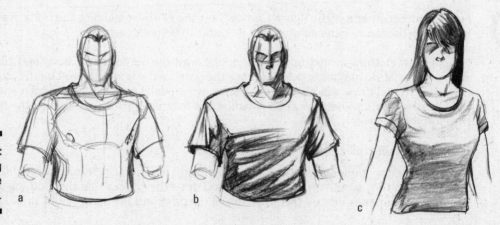

Figure 12-10: Sketching a loose T-shirt.

a b c

Sweatshirt

The key to drawing sweatshirts (as well as other loose wear, such as sweaters) is keeping the overall shape and folds rounded. Check out these steps and Figure 12-11:

1. **As in Figure 12-11a, lightly sketch the general shape, which resembles a cork from a champagne bottle, over the general figure outline.**

 Keep the overall shape loose and round at this initial stage.

2. **Add the shoulder compression folds and the compression folds on the sides of the torso, as shown in Figure 12-11b.**

3. **Partition the sleeve folds in two sections.**

 The upper arm generally has one or two folds cross diagonally from the outside of the arm toward the inside. On the lower forearm, lightly draw compression folds that resemble diamond shapes. I later erase or cover up the light marks with shading.

4. **For the front hood section, draw two slightly rounded triangles that hug the neck opening.**

 To add more depth to the fabric, I break the inside line of the triangle with overlapping folds. For texture, I add grooves around the cuffs and waistband.

5. **Use the wide flat side of your lead/charcoal pencil to create broad strokes for shading the round folds (see Figure 12-11c).**

 Pay attention to the way I shade inside and around the diamond shapes along the lower sleeves. The key to making these folds look three-dimensional is to keep the shading on the lighter side. The shading gives the illusion that the clothing is made of soft fabric.

When drawing the female, as shown in Figure 12-11d, I draw a couple more shading lines underneath the breast section to suggest folds.

Skirt

Skirts come in various lengths and shapes. In addition, skirts may have straight bottom edges or be pleated at the waist, which results in teeth-like shapes along the bottom edge. Draw a basic skirt with the help of these steps and Figure 12-12:

1. **Lightly sketch the general shape of the skirt over the hips (see Figure 12-12a).**

 In the skirt I'm drawing, the edges hug the contour of the hips before dropping down.

2. **Refine the shape by adding the folds for the pleats that trace along the contour of the hips starting from the waistband (as shown in Figure 12-12b).**

 Some of the compression folds drop farther down to the bottom of the skirt, while others stop at the midsection. In addition, I redefine the bottom of the skirt shape by using wider curves at the front and narrow, smaller curves toward the sides.

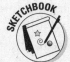

 To make the skirt look three-dimensional, make sure the curves on the front are lower and overlap the smaller curves that are toward the side. Also note how the shapes of the curves correspond with the cascading compression folds at the front of the skirt.

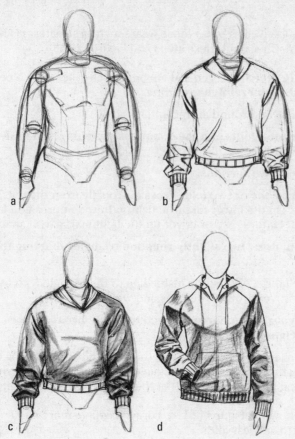

Figure 12-11:
Sketching a sweatshirt.

Avoid making the shapes too symmetrical. Note how the shapes of the curves slightly vary.

3. **As shown in Figure 12-12c, add texture with a tiny set of parallel zigzag lines that runs across the hips to give the illusion of frills.**

4. **Add shading behind the compression folds of the skirt to provide more dimension.**

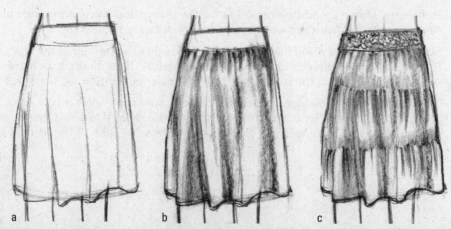

Figure 12-12:
Drawing a skirt.

Loose suit

When drawing a man's loose suit in Figure 12-13, the objective is to keep the overall shape round without losing the definition of the shoulders and joints. Follow these steps:

1. **Sketch the general shape of the loose suit (see Figure 12-13a).**

 When blocking in the shapes for the top half of the suit, I leave some breathing space between the arms and sleeves. In addition, the sides of the jacket drop straight down (unlike the fitted tuxedo later in this chapter, where the sides angle inward). The lower portion of the pants also drops straight down toward the feet and doesn't taper off like the fitted suit does.

2. **As shown in Figure 12-13b, refine the details of the suit.**

 First draw the triangular opening of the suit that drops down to the midsection of the suit. When drawing the collar, pay close attention to the angle of the drop on the torso. The left flap of the jacket folds over the right. The sleeve drops down slightly past the wrist. The bottom of the pants extends down over the feet.

 I draw a series of folds that go across the midsection of the arms as well as the bottom of the feet. I add compression folds along the upper and lower arms and stretch folds at the center of the jacket as well as the knees.

3. **Add shading by using the flat end of your lead/charcoal pencil (see Figure 12-13c).**

 Keep the shadows light and simple along the joints and the ankles. Lightly map down the form and cast shadows caused by the compression folds along the sleeves and above the model's right foot. Also, shade the stretch folds at the front of the torso and the lower left leg. Darken the value of the shirt and draw a series of vertical lines to give the shirt texture.

In comparison to a man's loose suit, the woman's suit is more snug (see Figure 12-13d). The woman's jacket opening is higher than the opening of the man's jacket. In addition, the skirt of the suit is wider at the bottom in comparison to more formal suits, in which the skirt wraps more tightly against the legs.

Not all suits are created alike! Many beginners falsely assume that all suits button up the same way. As I show in Figure 12-13, a man's suit has the buttons on the model's right side, and a woman's suit has the buttons on the left side. This means when you draw a buttoned man's suit, the *left* jacket flap folds over the *right* jacket flap; on a woman's suit, the *right* jacket flap folds over the *left* jacket flap. It's a small detail, but I hope it suits you well!

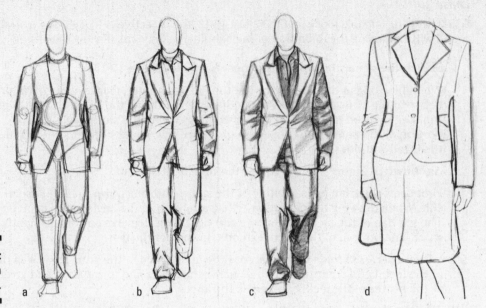

Figure 12-13:
Sketching a
loose suit.

a b c d

Snug and sharp

The following sections on halter tops, jeans, dresses, and tuxedos are tailored for those of you who want to show off your flat stomachs and thin legs and those of you looking to dress to impress. While the fashion industry continues to market tighter, more revealing clothing to women, snug outfits such as tuxedos have men looking to impress just the same!

Halter top

Halter tops are simple yet diverse in style. They range from simple and casual sleeveless tops with lower necklines to long, ornate evening wear with elaborate textures. In the following steps and in Figure 12-14, I illustrate the basic halter top and then compare it to two elaborate counterparts:

1. **Lightly sketch the straps, the neck opening, and the bottom edge of the halter top, as shown in Figure 12-14a.**

 Sketch a *U*-shaped neck opening with a series of light pencil marks. To the left and the right of the neck opening, lightly sketch in two curving *L*-shaped lines that head away from the center of the torso.

 Because I diminish the width of the model's right shoulder, the starting point for the reverse *L* shape on the model's right shoulder is closer to the neck opening compared to the starting point of the normal *L*-shaped curve on the model's left side.

 Using the same light line quality, sketch the line that wraps around the front and sides of the torso.

 The bottom edge of the halter top wraps around a cylindrical body part. Draw the line slightly dipping downward before curving back up toward the sides of the torso. Beginners often make the mistake of drawing a straight line across the body.

2. **Tighten up the lines and draw the folds (see Figure 12-14b).**

 Observe the folds that wrap around the midsection of the torso. Some folds wrap fully across while others have gaps.

 Draw in stretch folds by using short lines that taper from thick to thin from the outside edges of the halter top to the center of the rib cage.

3. **To change the basic halter top into a halter top appropriate for a night out (as shown in Figure 12-14c), change the neck opening to a *V* shape that tapers off slightly past the breasts.**

 Add a short horizontal strap at the bottom of the neck opening to secure the left and right sides. Make the texture of the fabric thicker by raising the neck straps slightly higher than those on the basic halter top.

 At the bottom, draw a series of diagonal stretch folds that taper off at the center of the rib cage. To add dimension, draw the stretch folds on the right overlapping the stretch folds on the left. The overall appearance resembles a bow tie.

 Finally, add diagonal and zigzag crosshatching marks under the breasts to show the tension of the fabric around the breasts. Draw a series of stretch folds from the top of the shoulder straps that taper from thick to thin.

4. **For comparison in Figure 12-14d, I draw a more ornate halter top in which the shoulders and most of the upper portion of the torso above the chest are bare.**

 I first apply light shading over the entire top. Using the sharp point of my pencil, I draw dark, thin lines along the top edges of the halter top for the hem.

 Along the neck opening, I add a series of narrow *U* shapes for the embellishment. I use a combination of compression and stretch folds at the neck opening; using a soft pencil, I shade the gaps between alternate compression folds to create the illusion of some compressed folds coming forward and others receding back in space.

 I keep the compression folds that wrap tightly around the breasts and torso narrow to show the amount of pressure that bunches the fabric together. I draw the loose folds on the center front of the body starting the same size but ending wider.

 To give the fabric more dimension, I use the tip end of a kneaded eraser to pull out the highlights of the folds facing the light (in this case, the folds on the chest and the folds that drop down the front of the torso).

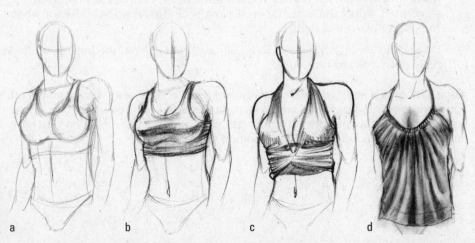

Figure 12-14:
Drawing halter tops.

a b c d

Tight jeans

Because tight jeans cling tightly around the legs, drawing a tight jean shape is like drawing the shape of the bare legs with tight compression folds at the waist and knees. Follow these steps and check out Figure 12-15:

1. **Lightly indicate the compression folds that stretch from the sides of the hips toward the center of the hips (see Figure 12-15a).**

 Hint at the folds with small bumps at the side of the knees and around the kneecap.

 For women, the compression folds along the hips stretch from the groin to the top of each femur. The folds along the knee angle diagonally toward the kneecap, which is the source of tension.

2. **Refine the details of the jeans, including the waistband, belt straps, fly, and side pockets (see Figure 12-15b).**

 When drawing the waistband, I draw the left flap fastening over the right side of the jeans (men and women button their jeans the same way). To draw belt straps, simply draw two thin rectangles at the front of the jeans (one on each side). For a three-quarter view like the one in Figure 12-15b, draw another belt strap along the side seam.

 For the fly, sketch a dividing line from the center seam to the top of the waistband. On the model's left side (the viewer's right side), draw a thin line that resembles a reverse *L*, starting below the waistband and going to the bottom of the center guideline.

 The bottom of the fly on women's jeans is approximately two inches higher than the fly on men's jeans.

 Different designers have their own style of pockets, but generally the opening of the front pocket resembles a hockey stick — or *L* shape — that curves away from the center of the pelvis. To emphasize the tightness between the fabric and knees, I make the lines on both sides of the knees darker and thicker. For the bottom of the jeans, I draw the edges of the lower pant leg, which slightly widens at the bottom.

3. **Apply shading by using the flat end of the lead/charcoal pencil to give definition (see Figure 12-15c).**

 Lightly shade the entire shape of the jeans except the center strip of each upper leg. (Don't worry if you shade the entire region — you can later pull out the highlights with a kneaded eraser). Along the hips, draw short strokes that taper from thick to thin following the compression folds you drew in Step 1; darken the model's left leg next to the crotch. Apply the same tapered strokes along the sides of the waistband to create the coarse texture of denim.

 On each lower leg, draw long stretch folds that fall from the bottom of the knee diagonally down toward each foot.

As fashion trends shift, so do the waistline of jeans and the way the leg tapers off. Keeping your references updated with recent jeans styles is always a good idea. As I write this book, waistlines hang low with the leg tapering slightly wider at the end. Men generally wear waistlines that are higher and wider than women's.

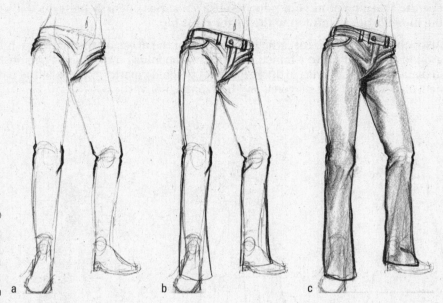

Figure 12-15:
Tightening
up jeans
with style.

a b c

Dress

Women's dresses vary in style. Some semiformal dresses either have shoulder straps or are strapless, leaving the shoulders exposed. Follow these steps and refer to Figure 12-16:

1. **Sketch the general shape of the dress, starting with the top hem of the dress (see Figure 12-16a).**

 The top of the dress shape stretches across the upper torso before angling downward to connect with the curve of the back. The bottom of the dress shape, which I block in, flows all the way down past the feet and puddles onto the floor.

 Because the weight of the model's pose is on her right leg, the amount of space between her lower right leg and the dress is narrower than the amount of space between her lower left leg and the dress.

2. **To refine the shape, as shown in Figure 12-16b, lightly sketch compression folds along the waist and stretch folds that flow from the waist down the front of the dress.**

 I also draw the seams, which run from the top edge of the dress down to the waist.

3. **As shown in Figure 12-16c, draw the values with the flat side of your lead/charcoal pencil and pull out the highlights by using your kneaded eraser.**

 Larger and lighter highlights give the material an overall glossier appearance. For dresses made from matte fabric, such as cotton, simply limit or get rid of the highlights altogether.

4. **Use the sharp point of your pencil to draw a series of curvy patterns that run from the model's upper left top to the lower right hip.**

Also, observe how the cascading loose folds of the dress on the model's left hit the ground and puddle into a bunch of compression folds on the floor. To show the change in planes, sketch a series of short diagonal hatching marks to block in the path of the new planes, which are diagonal and horizontal, not vertical.

Figure 12-16: Dressing up for the occasion.

a b c

Fitted tuxedo

If you're fascinated by penguins, this is your style! Unlike the casual suit that I describe earlier in this chapter, formal suits, such as the tuxedo, accentuate the contours of the figure. Follow these steps and check out Figure 12-17:

1. **Block out the angular shapes of the tuxedo over the basic figure outline (see Figure 12-17a).**

To exaggerate the masculine, "heroic" presence of the form, I block in the shoulders slightly wider than the outline. This, as a result, makes the waist narrower and tighter. The sleeves taper at the wrist. To help the sides look more trim, I draw both sides angling toward the body.

When drawing the pants, I draw a straight outer edge from the hips down and don't widen at the bottom.

2. **As in Figure 12-17b, sketch the details of the front jacket opening, which is narrower than the loose suit's front opening.**

Also different is the lower flap, which is longer and takes more space in the front. The bottom of the sleeve tapers at the center of the hand.

3. **Draw the bowtie and the triangular collar, which overlap on top.**

In addition, I add the button studs.

Unlike the loose suit, the sleeve from the dress shirt shows underneath at the jacket cuff. Draw a curving line across the wrist just below the spot where the base of the thumb connects with the forearm; this line loosely mirrors the end of the sleeve and is slightly wider than the wrist. Complete the shape by connecting both ends of the curve to the edge of the jacket cuff.

4. **Use the flat end of your lead/charcoal pencil to apply light shading to the overall shape; then apply the darker values of the core shadows (the dark shadows that separate the light half and dark half of an object; see Figure 12-17c).**

 Darken the compression folds of the right arm as well as the compression and stretch folds of the left arm. At the top of the shoulders, draw a series of short diagonal hatching marks that taper from thick to thin toward the front of the torso and the deltoids. (This hatching establishes the roundness of the form the jacket drapes over.) Using a soft pencil, shade the objects that are by nature dark in value, such as the tie and cummerbund; then shade the insides of the upper legs as well as the areas below the knees.

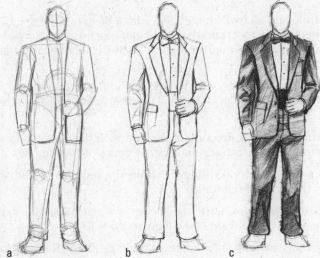

Figure 12-17: Drawing the tuxedo with cool.

a b c

Stepping Up with Shoes

In the following sections, I provide tips on drawing a wide variety of shoes, from dress shoes to boots, sandals, and sneakers. When drawing shoes, keep in mind the basic foot shape underneath. Some footwear, such as athletic sneakers, presents more of a challenge because it has thicker protective cushioning as well as various designs and patterns. However, when it comes to putting your foot down, the overall shoe design mimics the basic anatomy and function of the bare foot.

Some instructors insist on first drawing the bare foot before drawing the shoe shape on top of it, but I feel this technique is tedious. Unlike clothing, where the fabric bends and folds easily to the contours of the body, shoes are made out of tough materials, and a lot of popular shoe styles don't reflect the shape of bare feet. So rather than first drawing an accurate foot shape and trying to fit the shoe shape around it, drawing the shoe shape while comparing its structure to that of the human foot is more efficient (see Chapter 10 for the basics of drawing feet).

If you're new to drawing shoes, I recommend going through your shoebox and pulling out a pair for live reference as you draw.

Men's dress shoes

Men's dress shoes are an excellent starting point for drawing shoes in general because the thin leather closely follows the contour of the foot. Use Figure 12-18 as a reference for the following tips to drawing men's dress shoes:

- Start by sketching a circle and an oval shaped like a lima bean (see Figure 12-18a). The circle represents the heel of the foot, and the lima bean represents the front of the foot. Because this shoe is at a three-quarter angle, I draw the front shape slightly lower than the back shape.

- Connect the heel and the front portion with a dark line, and add a sideways *U* shape (it's the opening for the foot to slide in). The heel falls between the gap of the circle and the lima bean shape (see Figure 12-18b).

- Contrast the convex curve on the outer side of the foot with the concave shape on the side of the foot facing inward. The tongue mimics the curve of the lima bean shape.

- The side facing in has a flatter general surface than the opposite, outer side, which curves around toward the front of the toes.

- The seams that run around the front of the toe section are crucial landmarks that separate the top plane from the front and side (see Figure 12-18c).

- When drawing the top tongue of the shoe, observe how the shape follows the top arching contour of the foot.

- I leave some negative space to separate the body of the shoe from the ground (as a result of the heel).

- Use the flat end of a soft pencil (6B or higher) to lightly shade the entire shoe before darkening the spots where the edges of the front, rear, and top planes meet with the side plane (see Figure 12-18d).

When deciding which parts of any shoe to darken, darken the edges of a plane that just transitioned from another plane. For Figure 12-18d, darken the left edge of the front plane as it makes the transition from the adjacent side plane of the shoe.

- Pull out the highlights from the side of the shoe with a kneaded eraser.

- Use thin, dark lines to add details (such as seams along the top and the buckle).

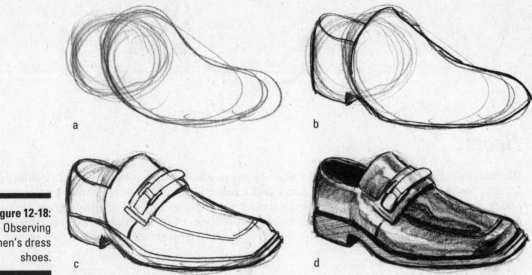

Figure 12-18: Observing men's dress shoes.

Women's dress shoes

Female dress shoes are even more revealing than men's dress shoes, because the top portion of the foot is completely exposed. Different types of dress shoes have various degrees of height and differing amounts of foot exposure. Generally, conservative dress shoes tend to be slip-ons that cover the back of the heels for support in lieu of elaborate straps that secure the feet from the back and from the front of the ankles.

Use Figure 12-19 as a reference for the following tips to drawing high heels:

✔ Women's dress shoes are narrower than men's dress shoes.

✔ As shown in Figure 12-19a, the ovals for the heels are more elongated than the ovals for men's dress shoes that I draw in the previous section.

✔ When drawing the front of the shoe, imagine the shape as a cone.

✔ The upper and lower edges of the oval and the cone connect smoothly (as shown in Figure 12-19b).

✔ The top edge of the shoe's side runs parallel to the bottom of the shoe. Some trendier shoes don't have sides at all (the entire half of the foot is exposed).

✔ To create the shape of the heel, simply cut out the negative shape from the bottom of the oval. The shape resembles a sideways *7*.

✔ I keep an *S*-shaped guideline as I draw the back end of the heel. More conservative shoes with lower heels don't have as much of an *S* curve because the body of the shoe is closer to the ground. The bottom of the heels for these types of shoes is also wider than the one in Figure 12-19.

✔ Shade the edges of the front plane with the flat end of your pencil (see Figure 12-19c). Because the light source is above the shoe, I also shade the side plane as it curves in to connect with the bottom plane.

 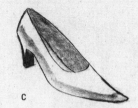

Figure 12-19: Observing women's dress shoes.

a b c

Boots

When drawing boots, you'll note that some shapes mimic the form of the foot more than others. Women's boots tend to be slimmer and longer than men's boots, which are usually wider. Generally speaking, women's boots have a wider range of fashion; although some are geared toward sports and outdoor activities, plenty of others are made for more fashionable formal occasions. Men's boots, however, tend to emphasize outdoor activities and withstand wear and tear.

Use Figure 12-20, where I compare both men's and women's boots, as a reference for the following tips:

- Although both men's and women's boots have heels, many women's boots have high heels (see Figure 12-20a).

- When mapping out the shapes for women's boots, I use a rounded rectangle in place of the skewed oval shape that I use in women's dress shoes (see the previous section).

- When drawing women's boots, experiment with various types of texture (such as alligator skin, shiny leather, or suede). Apply the compression folds you see on the sides of especially tall leather boots for women.

- When drawing men's boots, vary the line quality of the shapes that encompass the foot. As shown in Figure 12-20b, I use the flat end of my pencil to apply a series of zigzags along the planes. Make the strokes shorter and darker at the front of the boot to describe the round form of the toes, which face away from the light source. In contrast, I shade the top and side planes, which face the light source, with lighter marks.

- If you want to make men's boots look brand-new, simply apply even gray shading with the flat end of your pencil with limited zigzags.

- When creating the textures for men's boots, white gaps between shading marks create the illusion of a rugged surface.

- Boots for men tend to have grooves along the bottom of the heels for traction.

- Have fun experimenting with decorative objects, such as buckles (see Figure 12-20c) and faux laces/buttons.

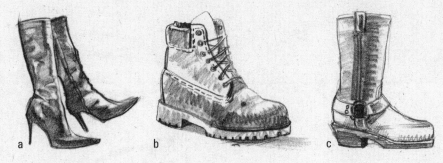

Figure 12-20: Observing men's and women's boots.

Sandals

Sandals are fun and easy to draw (especially if you enjoy drawing bare feet). Think of the overall visual design as footprints without the details of the toes. Although a sandal is essentially a rubber sole that loosely secures itself to the front of the foot, you always have room for additional bling and décor.

Use Figure 12-21 as a reference for the following list of pointers on drawing sandals:

✔ As shown in Figure 12-21a, start the sandal shape with an elongated skateboard shape. For the top of the sandal, which holds the foot in place, draw an oval in the shape of a kidney bean facing down.

✔ Even sandals aren't completely flat on the bottom — I make sure to draw the heel, which slightly elevates the back of the foot, higher than the front toe section.

✔ As shown in Figure 12-21b, use the bean as a visual guide to sketch in the top of the sandal. When you draw flip-flops for men and women, secure a strap between the big toe and the smaller adjacent toe.

✔ Use light zigzags around the rim of the base and light diagonal hatching marks to diminish one side from the other (see Figure 12-21c).

✔ Generally, women's sandals have straps at the back of the heels and may even wrap across the front of the ankles by using buckles. In these cases, the front strap that runs between the toes is replaced with a thicker band that stretches over all the toes to secure the entire front of the foot (see Figure 12-21d).

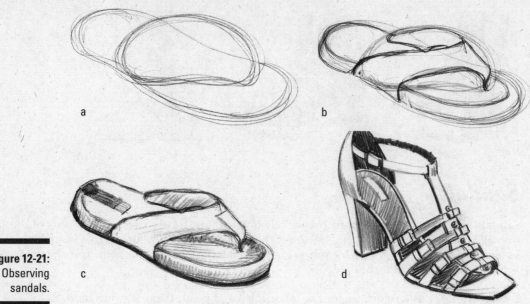

Figure 12-21: Observing sandals.

Athletic sneakers

Although they're the most common shoes you see every day, casual sneakers are the toughest to draw. One reason, as I mention earlier in this chapter, is all the padding and design detail. Different manufacturers have their own shapes, which are specifically built and tailored for specific purposes. Walking into a shoe store and seeing all the various categories — ranging from "tennis" shoes to the "casual walking" shoes — is enough to shoo some people away!

In Figure 12-22, pay attention to the general foot shape and how its position and structure relate to the outside. Here are some tips to keep in mind when drawing athletic sneakers:

> ✔ When sketching the general shapes of the sneaker, make both ovals wider than you do for dress shoes (see Figure 12-22a).

> ✔ Similar to the men's dress shoe that I describe earlier in this chapter, the inside curves of the shoe are concave while the outside curves are convex (see Figure 12-22b).

> ✔ The bottom traction pads at the end of the toes curve up to protect the tip of the toes.

> ✔ Sketch the heel of the shoe followed by the bottom of the foot before completing the top portion. I find that securing the bottom of the foot first helps establish the general direction in which the foot is pointing.

> ✔ I draw the back heel of the shoe slightly higher than the toes at the front.

> ✔ When drawing the laces, don't worry if you don't fit in every single "X" pattern that the laces make from crossing over the top of the shoe (see Figure 12-22c). Getting the overall feel of the laces crossing over each other is more important. When sketching the

laces, I first draw the knot right in front of the shoe tongue before filling in the rest of the laces that weave in and out of the top portion of the shoe.

✔ With the flat end of your drawing pencil, shade the values of the design (see Figure 12-22d). If you're not sure which patterns to make darker, I recommend first lightly shading a few lines before balancing the placement of the darker patterns.

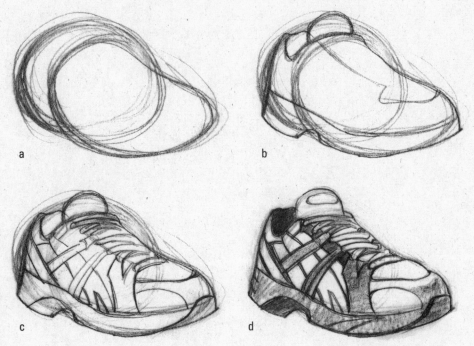

Figure 12-22:
Drawing
the general
athletic run-
ning shoe.

Chapter 13

Taking Your Work to the Next Level with Advanced Drawing Techniques

In This Chapter

▶ Varying the edges of your figure drawings

▶ Using advanced shading to accentuate form and rhythm

▶ Expanding your horizons with fun drawing methods

▶ Building and using a photo reference library

After you're acquainted with the basics of drawing the human figure, the fun doesn't stop! In this chapter, I demonstrate techniques you can use not only to create more realism in your figure drawings but also to open new doors to creating a personal style. I encourage you to draw the figure with different methods while increasing your hand-eye coordination and boosting your confidence in your drawing ability.

Adding Some Edge to Your Drawings

Although good anatomy and composition are essential to completing a solid figure drawing, the way you draw lines to describe the edges of the figure makes a huge difference between drawings that stand out versus those that don't retain the viewer's attention. I find that using the same line quality to draw figures' edges becomes dull and monotonous; the use of both soft and hard edges gives variety to your figures.

A good comparison is watching a foreign movie that's been dubbed into English but has the same voice actor playing all the parts. No matter how good or famous the voice actor is, hearing the same voice all the time is enough to drive the movie straight to the rental shelves!

In this section, I show you how to modify the edges of your figures to create more realism and texture. For the basics on using your drawing tools to create various types of lines (hard, soft, thick, thin, and more), check out Chapter 3 before proceeding.

Though many beginning students prefer to draw the figure by using lighter lines first, I encourage you to use bold lines instead of applying repetitive softer and lighter strokes. Beginners hope that each repetitive stroke will lessen their fear of making mistakes, but from my teaching experience, not only does this slow down the process of drawing the figure, but it also increases the amount of erasing a student needs to do before finally getting the desired line quality. Using repetitive strokes is fine, just as long as you do it with the purpose of either emphasizing the rhythm or the weight of the pose. I use softer or lighter strokes only when I plan to go back over my lines later with either my finger or a kneaded eraser to soften the edges and add texture.

Your first decision: Using correct edges in relation to the light

When first deciding which edges of the figure to make softer versus harder, I treat the lines facing the light with softer/lighter edges. Consequently, I make lines facing away from the light harder/darker. The result is a series of balanced shapes. In Figure 13-1, the light source is above and to the left of the model. I use soft, light edges on the shoulders, the arms, the front of the upper torso, the hair, and the head; I use hard, dark edges on the bottom edges of the upper arms, the right foreshortened arm, and the hip.

Figure 13-1: Drawing the figure with soft and hard edges in relation to the light source.

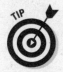

A question I ask myself when I decide whether to draw an edge on a figure soft or hard is "Where do I want my viewers to look first?" In situations where I'm not sure which part of the model I want to emphasize or where viewers should focus, I look at the light source for inspiration. Under different lighting conditions, certain parts of the body stand out over others (receiving either more light or more shadow). In Figure 13-1, for example, the model's right arm receives more shadow and strikes me as an interesting shape to choose to emphasize by making the edges and values darker than the rest. Because the size of the arm is relatively small in comparison to the entire drawing, the bold lines don't overpower the rest of the composition.

Occasionally, students try to "direct" poses by asking a model to move a certain part of the body until they get a favorable light source that emphasizes the certain body part(s) they want to draw. While I applaud the initiative to learn, I encourage students to leave the direction role to their instructors as they lecture on the figure. Often, the best drawings are rendered when students unexpectedly stumble across interesting shadows in a pose they didn't expect to get under direct lighting.

Depicting the texture of skin, hair, and clothing with hard and soft edges

A commonly overlooked aspect of drawing is using various types of edges to provide information about the texture of the figure (such as the skin surface and hair) as well as the material (types of clothing). I explain what you need to know in this section.

Showing the quality of skin with hard and soft edges

Avoid the popular assumption that the surface of the human figure has no specific texture other than feeling spongy, smooth, or soft. Unfortunately, many artists who rely solely on amateur, poorly lit photographs to guide their work miss out on a lot of visual information about the surface of the body. Make no mistake; the usage of photography in today's art freelancing industry is absolutely essential (especially with so many tight deadlines)! I discuss this topic in depth later in this chapter. However, working from a live model is important; it gives you the chance to see firsthand how the skin stretches and folds across the muscle and skeletal structure of the human form. In Figure 13-2, pay attention to the difference in the way I treat the edges of certain areas of the figure:

- ✔ As shown in Figure 13-2a, when skin or muscle presses up tightly against the bones (such as joint areas and bone landmarks), use harder, angled edge lines to describe the tension of the skin texture.

- ✔ In rounder, fleshier areas, such as loose skin tissue or fat, use softer, rounder edges (as shown in Figure 13-2b).

I usually apply more soft edges on women than on men. In particular, the features (from the eyes to the cheeks) of women are generally rounder and softer than those of the male.

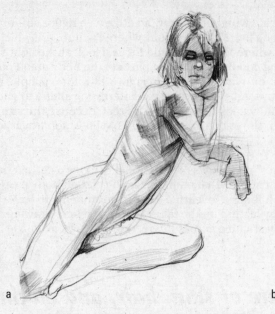

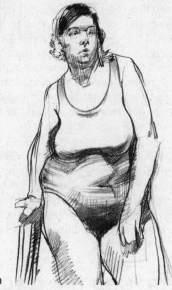

Figure 13-2: Depicting tight and loose skin with hard and soft edges.

a b

Drawing hard edges for the texture of body and facial hair

Edges aren't limited to just the outermost contour lines of the figure. In Figure 13-3, I show you the differences in the edges of the smaller shapes of body and facial hair within the larger figure.

✔ In Figure 13-3a, I break the exterior line of the male figure to make space for the texture of the body hair to stipple out. This technique gives the overall feel a unique character that's based on not only photo-like representation but also the artist's reaction to the model. Because the hair on the model's arms is fairly thick and abundant, I use a series of lines that taper from thick to thin. For parts of the body where the hair is finer or less visible (on the chest and under the jaw), I make marks with softer edges.

✔ For Figure 13-3b, the stippling/zigzag shading under the lower chin in lieu of a solid line gives the model a more "haggard" and scruffy appearance. (See Chapter 6 for full details on drawing facial hair.) I apply dark, hard edges for the goatee around the model's mouth and for his short, coarse hair.

Using soft edges for the texture of hair on the head and clothing

A good rule of thumb is that soft, loose clothing (such as wool), and especially loose curly hair, have softer edges.

✔ As I show in Figure 13-4a, using my fingers to soften the edges of the hair gives a more realistic appearance as opposed to a shape that looks like something produced from a cookie-cutter. (See Chapter 6 for more on drawing curly hair.)

✔ In Figure 13-4b, I soften the edges of the clothing by lightly dabbing my kneaded eraser over the lines. For added style, as the edges recede farther from the light source, they become even softer. Depending on the material, I go as far as erasing the lines and letting the shading of the clothing blur into the background.

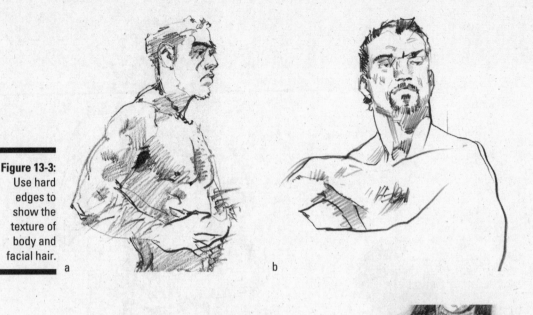

Figure 13-3: Use hard edges to show the texture of body and facial hair.

a b

Figure 13-4: Drawing soft edges on hair and clothing.

a b

Showing pressure against objects with hard edges

Areas of the body that press tightly against each other or against outside objects (such as the chair, floor, and so on) have harder line edges that are commonly referred to as *accents* (or what I like to refer to as my "darkest darks"). Accents give the shapes of the figure the semblance of pressure. Check out Figure 13-5 for a couple of examples:

✔ In Figure 13-5a, I apply an accent in a basic sphere shape — right under the point where the weight of the sphere makes first contact with the ground.

✔ As shown in Figure 13-5b, I place my accents where the lines under the upper arms meet the torso, on the left shoulder blade, on the side of the face, on the center of the lower spine, and under the lower left forearm. (Other places where you see accents from this view are between the buttocks, where the upper legs and the lower buttocks meet, and under the feet.)

Figure 13-5:
Edges that show pressure against objects.

a b

TIP

I recommend using a sharp pencil when you make accent marks. Don't be afraid to really "dig into" your drawing paper with your tools. The distinct marks you make for accents help your figures appear more realistic.

REMEMBER

Accents are so dark because two objects are compressed together with enough pressure that reflective lighting has no room to bounce back between the gap. The human figure is commonly seen in overlapping shapes, such as under the eyelids, between the upper and lower lips, the inner ear, under the arms, and between the fingers of a closed palm. In your next figure-drawing session, you'll notice the accents under the body shapes where the figure makes contact with the ground (such as the buttocks in a seated pose and the bottom of the feet in a standing pose).

Trying Advanced Shading Techniques

After you're familiar with using basic shading (see Chapter 3), taking it to the next level is only several additional strokes away. In this section, I introduce you to three types of advanced shading that give more depth and contrast to your finished figures — interweaving hatching, crosshatching for rounded objects, and selective shading.

TIP

As you go through these techniques, don't grip your pencil too hard — it makes your muscles tense up.

Interweaving hatching

In interweaving hatching, you use a series of short parallel lines that overlap in order to build up darker values. This type of hatching is great for building up lines that separate light from shadow, and it's commonly found on areas of the figure where there's a transition between planes (for example, from the front plane of the head to the side plane, which doesn't receive as much light as the front). In the following sections, I explain how to practice the technique on a simple shape, and then I show you how to apply the technique to a figure.

Here's a helpful image to keep in mind when you perform this hatching technique: Picture a sculptor who uses his tools to chisel away at a block of sandstone to complete his masterpiece. The hatching lines you place down are equivalent to each cut into the sandstone block. The deeper the "cut" into the surface, the darker you need to draw the hatching lines to show a deeper surface.

Practicing on a simple shape

In Figure 13-6a, I use regular hatching marks to define the plane of a rectangle. In Figure 13-6b, I overlap hatching marks to create interweaving for each additional cut into the rectangle. The more planes there are, as seen in Figure 13-6c, the more hatching marks you need to make. With each cut that turns away from the light, I make the lines darker by building up the number of hatching strokes that weave over one another.

Figure 13-6:
Showing how interweaving hatching marks define the edges of planes.

Adding interweaving hatching to a figure

After you're familiar with the way interweaving hatch marks behave when applied to simple shapes, see how I apply them on the head and torso of the figure in Figure 13-7.

- Figure 13-7a shows a series of regular hatching marks that follow the planes of the cheek. I draw a series of interweaving hatching marks where the cheek plane shifts to the front plane of the forehead and to the bottom plane of the chin.

- In Figure 13-7b, I draw multiple interweaving hatching marks along the deltoid, the sides of the pectoralis, and the upper left and lower center abdomen.

These hatch marks don't have to be perfectly parallel to the edge lines. In fact, the overall feel of the figure is more natural when the hatch marks interweave at different angles that aren't parallel to the edge.

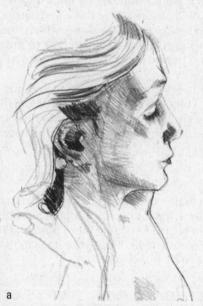
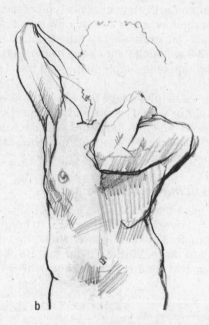

Figure 13-7:
Applying interweaving hatch marks to the head and the torso.

a

b

Combination crosshatching for rounded objects

One crosshatching technique I use often is a combination of the curve crosshatching technique and the zigzag crosshatching technique (refer to Chapter 3). This method is effective for embellishing rounded forms such as the muscles or rounded joints of the figure. In the following sections, I start with some practice on a sphere, and then I show you how to apply the technique to the human form.

Practicing on a sphere

Keep the sphere in mind as you practice applying this technique to the human form. In Figure 13-8, I demonstrate how this technique applies to the basic sphere in three-quarter lighting (see Chapter 3 for more about this type of lighting). While the curve hatchings describe the rounded form within the shadow, the zigzag hatchings show the transitional gradation from dark to light. Depending on the size of the object you draw, the size of one type of shading is dominant over the other.

As a rule of thumb, the values of combination crosshatchings facing the light source are lighter than the values of combination crosshatchings facing away from the light source.

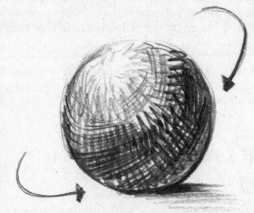

Figure 13-8: Observing how combination crosshatching applies to a sphere.

Applying combination crosshatching to a figure

After you practice the combination crosshatching on a sphere, try your hand at applying it to the human form (see Figure 13-9).

✔ In Figure 13-9a, I apply the technique to the lower stomach and the rounded edges at the bottom of the rib cage.

✔ In Figure 13-9b, I use the technique on the deltoid, the triceps, the biceps, the brachialis, and the side of the pectoralis (see Chapter 10 for more on muscles).

✔ In Figure 13-9c, I apply the technique to the model's rounded high cheekbone.

Figure 13-9: Applying the combination hatching technique to parts of the figure.

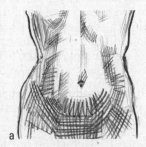 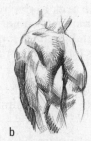

a b c

REMEMBER

When applying this crosshatching method, remember this principle: Based on the value scale you create in Chapter 3, remember that the darkest value for the shadows that describe rounded body shapes that face the light *can't* get any darker than a value 3, although the darkest value for the shadows that describe body shapes that face away from the light *can*

get as dark as a value 5. The only exception to this rule is when you apply the accents that I describe earlier in this chapter. The flip side holds true: The brightest values that describe body shapes that face the dark side *can't* get lighter than a value 3. I want to make this concept clear because many students are often fooled by the reflective light that they see in the shadows, and they make it too light.

With this concept in mind, experiment with varying the pressure of the crosshatching marks to create lighter values in the planes that are facing the light as opposed to darker values on the planes of the body that face away from the light.

Accentuating a figure's rhythm with selective shading

A popular myth may lead you to believe that in order for a figure drawing to look convincing, all the parts of the form need to be rendered with hatching. Although rendering is a great way of training your hand-eye coordination, over-rendering produces figure drawings that are too busy and saturated. As a result, perfectly proportioned drawings run the risk of appearing as stiff as a board.

Rather than spending hours agonizing over which hatching mark to use for every body part, be selective in deciding which overall body shapes are more important to the pose and worth spending more time to render in the hatching details. In Figure 13-10, I choose which side or parts of the figure are more essential to the flow of rhythm of the pose, and then I apply shading to draw attention to those parts.

✔ In Figure 13-10a, I select sides and shapes of the figure by using labels A through D. These labels correspond to the contrapposto rhythm of the figure (see Chapter 11 for details on contrapposto). The direction of the hatching marks from point A carries the viewer's eye from the back of the neck to the front of the breasts and back toward the back of the torso. The hatching marks for point B bring the viewer's eye toward the front of the stomach. Curving hatching lines for point C bring the flow down and across the hips. Finally, hatching marks for point D bring the viewer's gaze down from the buttocks toward the lower legs.

During longer poses for which I have the time to go back and add some hatching marks to other parts of the body, I make sure the hatching marks I place to define the rhythmic flow of the body are darker.

✔ In Figure 13-10b, I take a different approach to the figure. I select which portions of the body to define with hatching by posing the following question: Which part of the body carries the weight of the body in such a way that removing it from its current position would prevent the figure from sustaining the current pose? In this case, the model uses both arms to lean against a table (which I don't show in the drawing). If either arm is either removed or shifted, the model is likely to fall forward and hit the table. To emphasize the amount of importance both arms carry, I add more hatching to both arms.

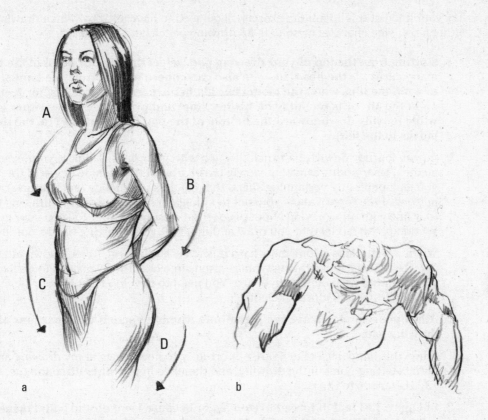

Figure 13-10:
Applying
selective
shading.

a b

Experimenting with Fun Drawing Exercises

During figure-drawing sessions (which can last up to five hours), I find it useful to change the pace of my drawing method. In this section, I introduce several figure-drawing exercises that are fun and carefree — the objective isn't as much as to deliver a convincing, accurate figure as it is to encourage you to experience drawing the figure from a different perspective.

Blind contour figure drawing

Contour drawing essentially means drawing the outside edges of the figure. *Blind* basically means you're drawing the contours of the figure without looking at the paper. Part of my goal is to keep my eyes and concentration focused on the edges of the model who stands in front of me for as long as possible without peeking at what my hand is doing and without lifting my drawing tool from the paper.

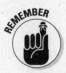

The objective of this study isn't to produce a finished, accurate rendition of the figure. Many students are abhorred when they glance down for the first time to see what kind of creature they just created. Rather, the ultimate goal of this popular study (which is used at many art institutes) is to hone your hand-eye coordination. Most importantly, it develops confidence in your drawing process as you get used to trusting your hand with the drawing tool.

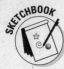

Try your hand at this 15-minute exercise. You need to have an 18-x-24-inch drawing pad and either a soft vine charcoal or soft 6B–8B drawing pencil, and *no* eraser.

1. **Starting from the top of your drawing pad, select the highest point of the figure (in many cases it's the head, but you also can choose to start from the hands, the feet, or even the hips when the model has his/her arms raised, has his/her feet propped up in the air, or is reclining on his/her side) and proceed to move either left or right while moving down toward the bottom of the pad (in Figure 13-11a, the drawing moves to the left).**

 As you journey down, don't rush through with your lines. Think of your eyes as those medical laser body scans that slowly crawl around the outside edges of the figure. If you encounter an overlapping shape that catches your fancy (such as an arm crossing in front of the torso), allow yourself to indulge in switching over to drawing that contour line without worrying about proportion. Just remember to keep your eyes on the section of the model that you draw and don't lift your drawing hand from the paper.

 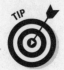

 When my students tell me how hard it is to resist the urge to look down at their drawing, I tell them it's like taking typing lessons in which the eyes need to be fixed on the screen rather than on the keyboard. You need to develop trust in your typing fingers to become faster and more efficient.

2. **Allow your hand to leave the paper only when the pencil/charcoal runs off the drawing pad.**

 When this happens, I take a rare opportunity to peek down at my drawing and find the initial starting point of the drawing, and then I go in the other direction (so, in Figure 13-11b, I move to the right).

3. **In Figure 13-11c, I'm forced to stop again because I run off the pad; I make a rough estimate of how wide the ankle is and resume from that point.**

 In the end, my lines don't match up perfectly with the other half of the figure. That's to be expected; students rarely draw a complete outline shape of the figure.

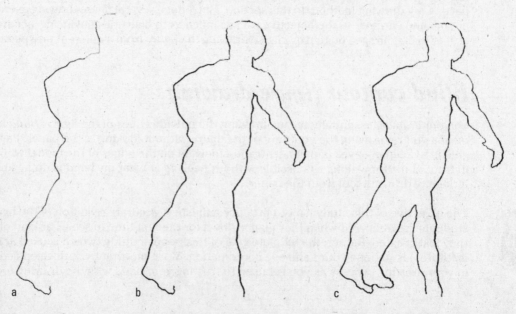

Figure 13-11:
Progression of the blind contour figure drawing.

a b c

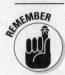

I find the final drawing reveals two important discoveries distinctly unique to you:

- ✔ The body parts that are larger in size likely indicate the body shapes you subconsciously enjoy drawing.

- ✔ The lines that you produce throughout the drawing show your line work at its most raw and subconscious state. If the lines for your figure drawing become too stylized, it's helpful to refer back to the blind contour lines.

Blind cross-contour figure drawing

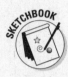

Cross-contour figure drawing is essentially the same concept as the blind contour drawing from the previous section except you add another stage of contour drawing. In this stage, you follow not only the path of the outside shapes of the figure, but also the smaller inside shapes within the figure. In Figure 13-12, I demonstrate the progression.

1. **As I start my way down one side of the figure, I make intermittent pauses to cross horizontally across the body shape over to the other side (shown in Figure 13-12a).**

 Focus on crossing over the large landmarks of the figure. These include the breasts, the abdomen, the midsection of the hips, and the knees. In addition, I recommend going for the parts of the body that overlap each other because this creates an interesting "terrain" for the eye to explore.

 While drawing cross-contour lines, I often think back to my geology class, where I had to look at a topography map and decipher the elevation of the terrain based on the "ring" shapes and the adjacent numbers. In a sense, you're doing the same thing with the figure — exploring and recording a dimension of three-dimensional body parts and shapes on a flat, two-dimensional surface from an aerial view.

 Slow down your drawing pace as you make your assessments about what it might feel like to trace over the dimensional shapes that lie between the outside edges of the body. I find that breathing slowly and deeply helps my concentration.

2. **After I get to the other side, I repeat the crossover action until I get down to the bottom of the pad (as shown in Figure 13-12b).**

 This process challenges you to think three-dimensionally about the body shapes that rest within the overall figure.

If the figure I'm drawing is reclining or seated, I don't move the pencil from side to side. As shown in Figure 13-12c, I instead tilt my cross-contour lines (again, without peeking down at my paper) so that my pencil is drawing what my eyes see as they move from behind the figure and around toward the front side of the figure (and back again).

In most cases after you're done with the drawing, your contour lines don't align consistently with the overall outside shapes of the figure. Don't fret — this is a good sign that you're concentrating well on the shapes in front of you (it also means you resisted the urge to take a peek at your drawing progress). Ultimately, this additional stage of the blind contour exercise helps hone your observation skills in cases where smaller shapes within the figure (such as the pectoralis and biceps) are used to correct the overall larger figure.

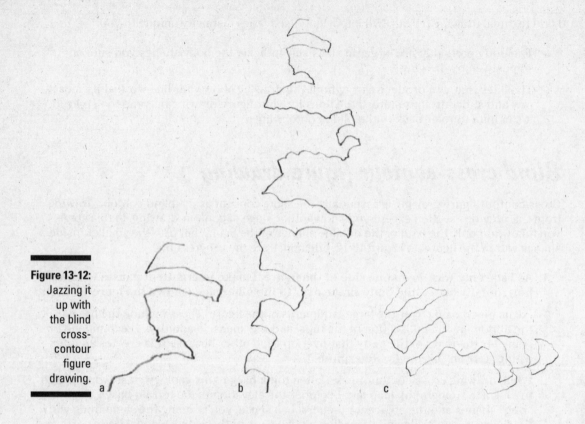

Figure 13-12:
Jazzing it
up with
the blind
cross-
contour
figure
drawing.

a b c

Shifting among short straight lines, long curvy lines, and squiggles

One drawing method that's useful for loosening up your drawing hand and giving you a mental break is alternating between short and long lines for figure drawings. In general, I use short straight lines for the sections of the figure for which I want a more calculated, precise approach. Conversely, I use longer curving lines for shapes when I want to show more fluidity and rhythm. Squiggles are useful for capturing the energy and action of different poses.

Going for precision with short straight lines

An old saying indicates that the most efficient and direct distance between two points is a straight line. One fun exercise to try is to use a series of short straight lines to map out your figure; these lines almost resemble a "dot-to-dot" strategy. When you use this method, observe the model while keeping the mannequin that I describe in Chapter 9 in the back of your mind. While you don't superimpose the mannequin directly onto the model, you do simplify some of the curved shapes you see with short straight lines, which may resemble the mannequin in the end. After you block in the outside shapes of the figure, you draw in the shadows and any visible muscle definition. Keep the lines light at first; go over them later with thicker lines to refine the drawing.

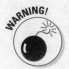

Don't draw lines to describe all the muscle shapes you don't see on the model. This makes your drawing look like a comic book superhero (you can reserve that for a later time). Stick to drawing the shapes and lines you see on the model. The downside to this method is that overusing shorter lines makes the figure look a bit choppy and stiff.

Check out Figure 13-13 for examples of drawings that use only short, straight lines:

✔ In Figure 13-13a, I use the dull point of a soft drawing pencil to simplify the curves and shapes of the facial features and the neck with short, light, angled lines. Then I go back with a darker line to refine the details.

✔ In Figure 13-13b, I use short lines to map out a complex seated pose where the model is sitting on a large, box-shaped object. I draw straight lines to determine the general angles of the limbs, which ultimately helps establish an accurate negative shape between the arms and the body. (See Chapter 14 for an introduction to negative space.) Even without drawing the seating, viewers can tell the model is sitting on something solid and not floating in the air.

✔ In Figure 13-13c, I use short lines to tackle a symmetrical pose that causes many students (both beginning and advanced) grief due to the fact that people's hand-eye coordination isn't symmetrically balanced from the get-go. (If you've ever drawn a sphere that was lopsided or skewed, this problem needs no further explanation.) By using angled straight lines to make sure that one side of the outer edge of the body is tilted the same way as the other side, it's easier for me to symmetrically align the rest of the smaller body parts.

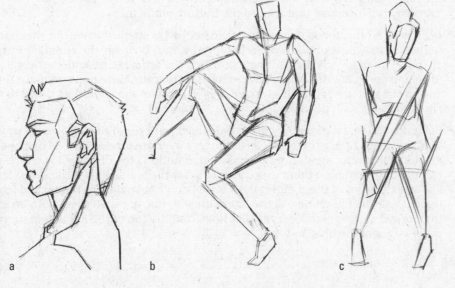

Figure 13-13:
Using only short straight lines for precision.

a b c

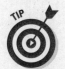

This method is especially useful when you're drawing a larger figure on your 18-x-24-inch drawing pad where smaller drawing errors easily add up to a larger, disproportionate drawing. Use straight lines to map the proportions of a larger figure.

Focusing on gestures with long curvy lines

Long curvy lines are great for quick gesture drawings where your objective is to record the overall experience of what the pose of the figure is about, not to capture what the figure looks like. The question I ask when drawing gestures is "What does it *feel* like for the figure to bend, twist, or stretch to get to that current pose?" When you're drawing from a live model, these gesture poses are anywhere from 30 seconds to two minutes.

When you draw gestures, the first thing to look for is any *C*-shaped or *S*-shaped contrapposto curves to find the rhythm in the drawing (see Chapter 11 for details on contrapposto). After you spot a curve in a pose, draw the side of the body where the curve starts. I encourage students to be bold and exaggerate the curves of the body by either slightly elongating the limbs or making the lines darker over others. More often than not, you're not going to have adequate time to complete all the outside edges of the pose. Therefore, it's key to be selective in choosing which shapes best capture rhythm.

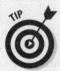

As you become more proficient in identifying and mapping down curves, you may find that you want to first sketch in the rhythmic curve and return to it with darker lines after you spend time adding detail to other parts of the body (such as the back of the head, the hair, or some of the facial features).

Take a look at Figure 13-14 for examples of drawings that use only long, curvy lines:

✔ In Figure 13-14a, I sketch in the rhythmic curves starting from the bending back. Instead of drawing the individual overlapping limbs, I treat the overlapping shapes of the arms and legs as a unified shape. This step gives me time to render the curves of the hair. I darken the lines of the shoulder that curve to the back of the triceps, followed by the forearms that lead to the bottom of the toes.

✔ In Figure 13-14b, I focus on the rhythmic hourglass shape. I leave out the details of the body because most of it is hidden behind the hair. Because the shoulder curves are strong enough to indicate the angle at which the arms are extended, there's no need for me to complete the outside edges of the forearms. More important are the normal and reverse *S* curves that are formed from the top of the shoulders down to the opposite outer edges of the lower legs.

✔ In Figure 13-14c, I darken the curve of the back with repetitive strokes to emphasize the bending of the upper torso. Because the legs overlap, I treat them as one shape; first I establish the outer edges, and then I use diminution (see Chapter 11) on the right leg by applying shading (I don't even need to draw the inside line of the lower left leg to show it's in front of the right leg). Because I don't have time to render the features, I opt to describe the texture of the hair with soft, fine lines. I darken both lines that form the normal and reverse *S* curves that flow from the top of the shoulders down to the outer edges of the hips and legs.

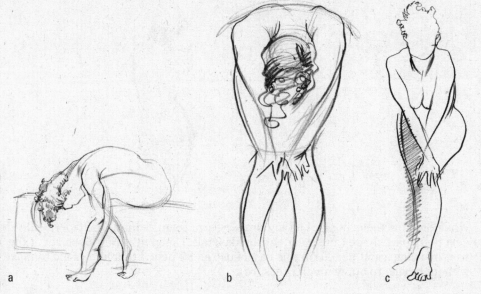

Figure 13-14:
Using long
curvy lines
for figure
gesture
drawings.

a b c

The following tips may come in handy when you're working on drawings with only long, curvy lines:

- There are no "rules" as to where to begin when starting the gesture pose, but I recommend starting from the top of the head or the top of the back curve of the spine.

- In Figure 13-14 I go over my strokes in a repetitive fashion to emphasize those curves of the parts of the figure that accentuate the rhythm of the pose. Most of the curves that I usually repeat coincide with the sides of the contrapposto.

- Try experimenting with drawing these gestures at different sizes. Although drawing smaller sizes allows me more time to complete drawing more parts of the body, I find that drawing larger figures helps me loosen up my arm because of the larger motions needed to capture the rhythmic gestures.

- Using a thick charcoal stick on larger pads may loosen up a stiff arm or shoulder.

Capturing energy with squiggly lines

Not all curvy lines follow the outside contour of the figure. Although some curves flow within the outer edges, others flow past beyond the edge of a figure drawing before curving back (as you can see in Figure 13-15). This exercise helps loosen the arm at the beginning of drawing the series of figures.

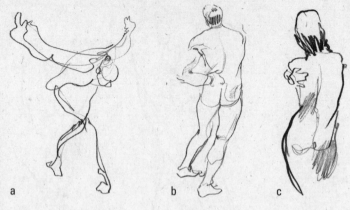

Figure 13-15:
Using squiggles to capture the energy of a pose.

a b c

When drawing these poses, I let my drawing arm roam around the paper while I look for my next body part shape (muscular and/or skeletal). I keep my lines loose yet at the same pressure by using a soft pencil (in this case, I use an 8B pencil that allows me to make dark lines without having to apply much pressure).

Keep your pencil/charcoal in constant motion — don't stop to think about correcting your mistakes (after all, your reaction to a pose isn't the same as anyone else's reaction, so recording your experience on paper isn't the same either). At the same time, don't feel rushed. If there's a shape you particularly enjoy drawing, either slow down the pace of your pencil or spend time rendering in the shadows and details of the shape.

Although the lines I place are loose and experimental, I'm mindful of the structure and rhythm that lie underneath. I don't want to let my mind wander off into the distance. Rather, my focus is on capturing the energy of the pose. I keep the muscle structure at the back of my mind and use it to help me identify muscle shapes I want to describe.

Working from Photos

It's a shame that humans (and especially artists) lack a photographic memory with unlimited storage capacity in the brain — no, wait, that's a bit too freaky. After all, where's the fun in research if you don't have the urge to explore new knowledge?

Gathering and using references as you draw — photos, in particular — are an important part of discovering how the figure works. Especially when trying to capture figures right in the middle of a rapid action, you have just too much information to digest and store, and photos of similar actions can help you fill in the gaps. In this section, I provide tips on building your own photo reference library and working on drawings from photos.

When it comes to learning to draw the figure, relying on photos as your main resource isn't a good replacement for drawing from life. As long as the camera is limited to a single lens, images you take don't have the same depth and dimension that your two lenses (eyes) can document. You also need to consider that most consumer digital cameras, while capturing realistic images, slightly distort the subject. For example, if you take a close-up shot of someone's profile and make an accurate tracing off that photo without adjusting the proportions of the head, you're going to find that the center of the profile (around the ear) is very wide, which makes the face appear really narrow.

Building a photo reference library

One common myth indicates that you're not an accomplished artist if you need to look at photos or refer to any other outside source beyond your current knowledge or imagination. Although that myth is a wishful thought, even the most accomplished artists need to gather quality information that's easy and straightforward to access and use. This information ranges from academic anatomy encyclopedias to clippings from sports magazines. Better reference quality means more efficient usage of time to produce the final result. In the following sections are tips and ideas to consider when gathering and storing your references.

Finding and selecting references that work for you

You have plenty of options for finding reference photos:

- Most of the models I use in photos for my realistic drawing studies are my own friends or the friends of friends.

- Sometimes you're the best model you have; I have a mirror in my studio that I use to model facial expressions when applying them to some characters in my graphic novel. Just remember not to copy the exact same facial expression for all your drawings — all of them may end up looking like you!

- You never know when you might find a billboard or an advertisement that features a figure you want to document as part of your reference library. Having a compact digital camera to capture these images is a great idea (especially nowadays, when owning one is becoming more affordable than ever). I recommend carrying one with you as often as possible when you venture out in public.

- Fashion magazines are excellent sources not only for the latest fashion trends but also for beautiful facial features, hands, and feet.

- Popular Web browsers such as Google and Yahoo! have built-in search-engine tabs specifically designed to seek out images posted on the Internet.

- While costly, online stock photography resources have high-quality resolution images available for purchase.

While searching for a reference to use for a figure drawing, the objective is gathering enough information to fill in the missing link. Think of a reference as a general guide or tool that helps resolve some of the murkiness of a certain pose. Here's a list of tips to keep in mind when choosing a reference photo:

- **The angle of the pose:** Beginning students often try to use a photo reference of a pose similar to the one they want to draw except from a different angle. Depending on the angle of the pose I want to draw, I make sure the figure in the reference has as close to the same pose as possible.

 Here's an example: I had a student struggle with trying to use an athlete jumping over a hurdle. The only problem with the reference was that the athlete in the photo was jumping the mirror-opposite direction. A simple flip of the image made the reference easier to work with.

- **Clothed versus nude:** Whether the figure is nude or fully clothed, I make sure the reference I use corresponds to my figure drawing.

Even when you find a pose that's the right angle, your reference is guaranteed to give you a headache if the model in the photo is wearing a spacesuit while the figure you're drawing is a scuba-diver (well, it's an obvious exaggeration, but the bottom line is less information results in more guessing and a larger chance of error).

✔ **Quality of the reference:** Be mindful of starting with reference photos that are either small in size or resolution. Examples include magazine clippings the size of a business card and low-resolution Web images that are enlarged and printed on letter-sized photocopy paper. Once again, the less information you have to begin with, the harder it is to decipher.

All said and done, however, no reference is 100-percent perfect. When the photo reference lacks the information I need, I use my own reflection in the mirror to fill in the missing gaps.

Storing photos digitally

It doesn't seem that long ago that I was in art school, making frequent trips to what was called the picture library to rent pictures to use for references in my illustration projects. Now, in this digital age, I *strongly* recommend creating a digital library in which you scan and store your images on a computer or hard drive. For example, I have a 500 GB external hard drive that's actually cheaper (and will likely become even more affordable by the time this book sees print) than going to an office supply store to buy sets of binders and labels to store your pictures. With computers and scanners that are more affordable than ever, I can easily produce high-resolution scans of my references and organize them under as many categories as I choose.

Make sure your scans are set to at least 300 dpi (dots per inch). Setting the level of dpi any lower decreases the quality of the image when you want to print it. After you scan the images into your computer, save them as either a *jpeg* or *tiff* image format. Although professional artists recommend using software products such as Photoshop to scan the images, the software on the CD that comes bundled with your scanner includes the basic necessary scanning software to get you started.

Keep your references on a separate hard drive. Avoid using your main computer disk space to store all the references. If your computer crashes or is destroyed, the library is safe on a different physical drive.

To quickly add more folders to your reference library, just do the following:

1. **With your mouse pointing anywhere that's empty on your desktop, press down on the button on the right side of your mouse.**

 A new menu pops up.

2. **Scroll over to the tab marked New.**

3. **Select the Folder icon.**

 A new folder icon appears and gives you the option of creating a file name.

Filing a small number of hard-copy photos

Although I strongly recommend storing reference photos digitally, I have some photos and clippings that I do store for sentimental reasons; in these cases, throwing them away after scanning them just doesn't sit well with my conscience. When I do make the exception, I put the hard copy in one of my limited number of binders, which I label as follows:

- ✔ Faces
- ✔ Arms
- ✔ Legs
- ✔ Clothed figures (includes loose and tight clothing)
- ✔ Shoes

I keep these folders down to a minimum because maintaining large amounts of documents is not only a space-hog, but also quite heavy (another reason to opt for a digital library).

Drawing on top of photos

Many beginning students think that drawing on top of photos is "cheating." Unless you trace over a copyrighted image and falsely claim the final drawing as your own, however, you have nothing to worry about. On the contrary, working over photos or even drawings is, in my opinion, a smart way to work because it saves time and resources.

Be mindful how you use your reference if it's based on other people's copyrighted images. If you make a direct tracing of it or replicate it for purposes other than personal learning, you need to seek permission from the owner.

Drawing on top of photos saves time and gives you the chance to study action shots that otherwise would be impossible to capture and draw. Follow these steps to draw on top of a photo:

1. **Place tracing paper over the photo and sketch in the mannequin shape based on the figure in the photo.**

 Although some tracing papers are thin and transparent enough to see through down to the image underneath (see Chapter 2), having a light box helps facilitate the overlay drawing more quickly. I make sure both my reference and tracing paper are taped to the surface of the light box. If you don't have a light box readily available, tape the original reference to the window of your studio during the day and place the tracing paper over the reference. Let natural daylight be your light source.

 If you're drawing from a close-up head shot where the image is distorted (commonly referred to as "pincushion" distortion), lightly sketch the geometric planes off the photo and tweak the drawing later to compensate for the amount of distortion by either making the head narrower or making the front of the face slightly wider.

2. **Sketch in the placement of the facial features.**

 Unless you're trying to do an exact portrait of the person in the photo, you should block in the placement of the facial features only. You later go back and add the details of the specific features.

3. **If the figure is nude, sketch in the muscle shapes instead of tracing the outline of the body in the photo.**

 When a figure in a photo is too small for you to make out the details of the smaller muscle groups, refer to the basic muscle structure in Chapter 10.

4. **Modify the clothing.**

Using preexisting clothing shapes is an extremely useful time saver. For example, if the figure in your photo is wearing a T-shirt and you want to have the figure wearing a basic halter top, simply trace the collar of the shirt, cut off the sleeves, and raise the waist toward the rib cage.

If I plan on drawing from a reference for more than 15 minutes, I make it a point to turn off my light box periodically to check the progress of my current drawing without the distraction of the reference material shining through.

Chapter 14

Working with Composition and Perspective

Even with the most gorgeous and experienced model at your hands, you'll always feel that your drawings are lacking that certain something without solid composition and basic knowledge of perspective. Even the most realistically and meticulously rendered figure needs a sense of belonging to an environment or atmosphere; this sense of belonging is key to giving the viewers more information about what the artist is trying to communicate about the pose.

In this chapter, you start with theories that are important to understanding how composition works and how it gives more pizzazz to your figure drawings. I introduce you to my favorite composition templates, which help you determine where to place figures and objects so they're aesthetically pleasing on paper. Finally, I offer tips and demonstrations to show how the basic three points of perspective work and provide you with neat perspective tricks you can use to create elaborate-looking compositions.

Compose Yourself: The Basics of Composition

When you define *composition* in figure drawing, the art of planning and arranging the figure(s) and surrounding objects within a distinct boundary line dictates where the drawing begins and ultimately ends. Unfortunately, many students are so eager to get on with drawing the figure before the session ends that they don't bother to take a moment to think where to place the head in relationship to the entire paper. This common mistake usually ends with a disappointed artist running out of room for the rest of the limbs because the initial head placement was too low on the drawing paper.

Although I include the words "planning" and "arranging" in my definition of composition, I'm *not* saying you should calculate everything to the point at which you have no room to subconsciously execute some decisions. After all, where would the fun be if figure drawings at the art museum all looked alike? In fact, some of the more interesting compositions that I see or have drawn involve even erasing and re-drawing the borders around the figure in favor of a better, yet completely unexpected, result.

In the following sections, I explain the importance of starting the composition of a drawing by creating borders and describe the basic elements of composition. (Later in this chapter, I show you several templates that are useful in composing your drawings so they're fresh and interesting.)

Creating borders for your composition

Drawing borders around your drawing establishes where it starts and ends. Many students either keep forgetting to draw borders or make the false assumption that the edges of the paper serve the same function. Some insist that they prefer to add the borders *after* the drawing is complete. This doesn't work because, by nature, we lose sense of spatial awareness when we're absorbed in a single-minded task. It's like the veteran hockey goalie who taps both sides of the goal post with his stick to psychologically reassure himself that he knows the width of the net even before the puck is dropped, or a baseball slugger who taps both sides of home plate each time he steps up to bat even after 15 consecutive seasons, just to keep his senses aware of the strike zone. Taking ten seconds to quickly draw the borders along the outside edge of the paper is no different and just as crucial. As I show in Figure 14-1, your lines don't even need to be perfectly straight! I show the border for the portrait format (Figure 14-1a) and the landscape format (Figure 14-1b).

Figure 14-1: Drawing borders is a crucial first step in composition.

a b

Just to show you how much fun (as well as how useful and important) borders are to framing your composition, take 15 to 20 minutes to complete the following exercise. You need a self-timer in addition to extra-soft vine charcoal sticks and an 18-x-24-inch sketchpad.

1. **Draw a small rectangle or square border at the top of your drawing pad.**

 Because you'll draw multiple borders in this exercise, make these frames no larger than the size of your open palm.

2. **After setting the timer for three minutes, fill the first border with a series of abstract shapes around your environment.**

 Because you have only three minutes, draw these shapes at a steady pace, but don't rush through them. The goal is to fill the entire box with abstract shapes as I show in Figure 14-2a.

3. **Draw a different size and shape border that fits under the first completed frame.**

 The key to keeping the sequences of shapes interesting is alternating between horizontal and vertical rectangular or square-shaped frames (see Figure 14-2b). Avoid making the shapes either too large or small (no larger than your open palm).

4. **Repeat Steps 2 and 3 until you have five frames completed (see Figure 14-2c).**

 Each time you place a box, you're making two creative decisions on building your unique composition. You dictate the size of the mini-frames, and you decide the overall direction of how and where your drawings span across the page.

Figure 14-2:
Filling a series of borders with abstract shapes.

Brushing up on the elements of composition

Throughout this chapter, I refer to several basic tools (or theories) in applying composition: focal points, balance, and positive and negative space. If some of these terms aren't familiar,

don't lose your composure; after you read the following sections, you'll have a better understanding of their application.

Focal points

A drawing's *focal point* is the center of attention where the viewer's eyes are led. When setting the focal point on the figure, consider specifically which part of the body you want the viewers to focus on. If the drawing is strictly personal, another way of approaching this topic is to ask yourself, "What's so special about this model that makes me want to document him/her on paper so that I can experience that same sensation when I look at it years from now?"

A basic rule for bringing attention to a single focal point is to create contrast between the object of attention and the surrounding environment. Although the surrounding objects may vary in size and value, they need to be placed in such a way that they guide the viewer's eye toward the areas of the figure you want to emphasize. Later in this chapter, I show you a few templates that help guide you in arranging objects effectively.

Turn your attention to Figure 14-3, which is a study I did of my friend, Becky, sitting in the kitchen making coffee. Despite all the detail I draw into her kimono, hair, French press, and mug, the focal point I want viewers to look at is her face (even more specifically, her wondering, beautiful eyes). Contrast in value or size draws attention, so to call attention to her eyes, I make the values of her hair and clothing darker than other objects. Her eyes are placed at the center of the composition. In addition, her head is one of the larger objects in the foreground. Last but not least, I tilt her head to create a diagonal guideline that draws attention when compared to the rest of the background items, which are vertical and horizontal.

Figure 14-3:
Identifying the focal point of a figure drawing.

Don't leave a single dominant focal point hanging there all by its lonesome self. Like in those action movies, no main character is complete without his trusted loyal sidekick to make the plot interesting. Having three points form a triangle creates a strong composition.

In the case of Becky, my eyes shift toward the large, coffee-filled French press that her hand is resting on. From there, the focal point moves toward the empty white coffee mug (making it the third focal point).

Here are some key issues to keep in mind when planning your focal points:

- ✔ **Consider placing your second or third focal points lower than the primary focal point.** The eye travels down more easily than it resists gravity to look up.

- ✔ **Don't place the second focal point too far away from the main focal point.** This poses the potential risk of stealing away the center spotlight. If the primary focal point is at the center of the composition, the secondary focal point should remain close to the center. In some cases, the secondary focal point may shift to the left or right of the main focal point as long as it's close to the same horizontal level where the primary focal point rests. Secondary focal points that stray either to the upper left or right are too far away.

- ✔ **Experiment with different ways of increasing the contrast to strengthen the focal point.** When two focal points are competing for the same attention, I darken the lines of the focal point that I want viewers to see first or add more detail to the primary focal point (such as the shading in the hair to the details of the skin or clothing). Try darkening underneath the eyes, nose, and lips.

Balance

Balance is the process of finding a stable arrangement between a drawing's main focal point and the surrounding objects within the middle ground and background. A balanced composition has contrasting shapes (dark/light, large/small) that are evenly distributed. In general, larger, darker objects come forward while smaller, lighter objects recede from the viewer's attention. In addition, wider, harder, darker lines come forward while thinner, softer, lighter lines recede. Finally, objects with more detail come forward while objects with less detail recede.

Figure 14-4 is a quick study I did of a student drawing a model (it's nice sometimes to have the option of drawing other figures besides the model). I wanted to capture the sense of the classroom environment cluttered with drawing chairs.

- ✔ In the foreground, I place a large drawing chair.

- ✔ In the middle ground, I have my main subject, the student.

- ✔ In the background, I sketch in more chairs.

Because I want viewers to ultimately go toward the student, I make her lines darker (especially around the front of her body). Although I make the foreground chair large with a fair amount of detail on the seat and leg (viewers need to know what they're looking at because a good chunk of the chair goes off the page), I make the lines light and loose. Watch how I diminish the front edge of the chair toward the student, which helps guide viewers' attention to her. Because I want to emphasize her expression of serious concentration, I diminish her hands and feet by leaving out the details of the fingers and lightly shading out the detail of her right leg. To increase the depth of field, I make the student's right arm lighter and the left arm darker (the right arm is farther away from viewers than the left arm). I add more detail to her face and clothes with darker, thicker lines. Finally I keep the details of the background chairs to a minimum and make the lines light.

Overall, the stronger contrast between the student and the chairs in the foreground and background complement one another and establish a balanced composition.

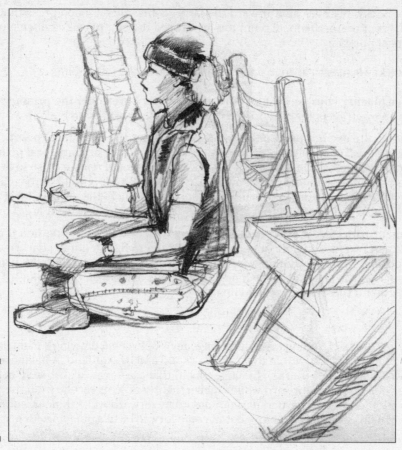

Figure 14-4:
Balancing
your
composition.

Although there's room for making certain portions of the chair in the foreground darker (such as the shadows and portions of the seat's underside), I prefer not to add many more darker values that would end up taking the attention away from the student.

According to the Gestalt Theory, people group similar objects together. Making generalizations helps people psychologically process information more quickly and function more efficiently. So as you balance your composition, consider pairing darker, detailed, larger shapes in the foreground versus lighter, simpler, and smaller shapes in the background. If you have the time to fine-tune the balance in your drawings, a good habit is to start sketching the shapes from light to dark.

Positive and negative space

Positive space and *negative space* describe the physical relationship between the human figure and the space that encompasses it. A common misperception is that when drawing the figure, the aim is to draw only the positive space — the actual figure — and neglect the negative space shapes that surround it. I remember my mother, a fine arts painter, telling me when I was little that the negative space between the spokes supports the drawing of the wagon wheel. Interesting and well-thought-out negative shapes enhance the strength and balance of the composition of the figure.

In general, part of what makes a pose interesting to draw is that there are at least three negative shapes created by the pose. Check out the figure drawing in Figure 14-5a and compare it to Figure 14-5b, which depicts the use of positive and negative space. I make the positive shape (the figure itself) white and shade the negative space black, and I label the three negative shapes:

- **A:** The largest shape surrounding the entire outside edge of the figure

- **B:** The shape between the arm, the prop, and the body

- **C:** The triangular shape between the left and right upper legs; this shape is generally the most stable and commonly found negative shape around the body

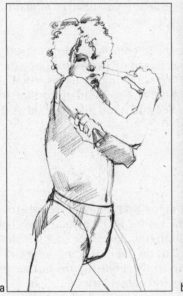 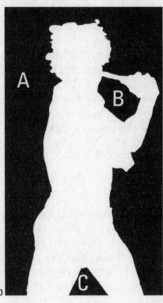

Figure 14-5: Using positive versus negative space.

a

b

In a solid composition, the amount of negative space balances the amount of positive space.

Identifying Useful Composition Templates

In Figure 14-6, I draw four useful templates that are great in organizing composition:

- Box composition
- *L*-shaped composition
- Diagonal composition
- Yin-yang composition

Figure 14-6: Four useful composition templates.

Bear in mind that there's more than one way of applying these templates to the human figure, as I show you in the following sections. I also explain how to combine these templates for truly unique compositions.

Without the borders that I discuss earlier in this chapter, establishing these various types of composition frames isn't possible. Start with the borders; if you need to adjust them later, that's better than not drawing them at all.

As you become proficient in applying these templates to your figure drawings, try challenging yourself by moving around the body shapes based off the actual pose the model is assuming. If this task sounds intimidating, try starting with simpler forms, such as altering the look of the hair or bending the fingers. This not only helps build up confidence and skill, but it also gives you the freedom to take what you see and mold it to fit what you want it to say in relation to the overall composition.

Box composition

More common than not with portraits, the box composition template serves to draw attention to the object in the center (in other words, the center is the primary focal point). This is probably one of the most widely used composition templates because it's simple and straightforward. However, it also has the potential to be the most overused and boring template (especially when you limit yourself to drawing only single figures or close-ups of the shoulders and head). Here are some tips that help add some variety:

✔ **When using the box template to draw a close-up portrait, consider using crosshatching or other shading techniques to create a vignette.**

In Figure 14-7a, the dark-to-light transition in values helps create an elegant atmosphere around the head of the figure. (Flip to Chapter 3 for details on various shading techniques.)

Pay attention to the way I crop the figure in Figure 14-7a. A common mistake for many beginners drawing portraits is to end the drawing at the bottom of the chin or neck. I call this Creepy Severed Head Syndrome. One of the reasons why drawing the border is so important (as I explain earlier in this chapter) is that it helps remind you that the composition of the figure doesn't end until the lines hit the border lines. Be sure to at least include the shoulders and, better yet, a portion of the top torso as part of your positive space.

✔ **When drawing the box template around a single figure (as you see in Figure 14-7b), off-set the balance of the composition with shadows or surrounding objects.**

Because the portrait composition is symmetrical, try picking up on objects or body parts that break that symmetry. A symmetrical pose within a symmetrical composition

tends to be boring when overdone. With my drawing, I move one leg closer to the floor while letting the other stand erect. (Breaking the symmetry also allows you to pick up more negative space shapes, such as the triangular space between the figure's right arm, left lower leg, and torso.) I also darken the shadows that are cast on the right side of the model. (See Chapter 3 for an introduction to shadows in figure drawing.)

✔ **As I show you in Figure 14-7c, the surrounding box frame doesn't need to be limited to open space or patterns.**

A classic illustrator, Howard Pyle (1853–1911), was known for dynamic compositions in which larger foreground figures (even objects) lead the viewer's eyes toward the main focal point. In my drawing, I combine the girl and the doorway of the house to form a box composition frame around the center focal point (her date). Even in the midst of all the overlapping positive shapes (from the figures to the doorway), the negative white space around the man's head not only nicely frames his head but also guides the viewer's eyes back toward the girl by connecting to her face. By using multiple figures or forms, the narrative of this figure drawing is a much deeper (and hopefully romantic) experience!

Figure 14-7: Various ways of balancing the composition with the box template.

a b c

L-shaped composition

The *L*-shaped composition template is great for setting up seated and reclining positions as well as *establishing shots*. I explain how to use this template in these types of illustrations in the following sections.

Seated and reclining positions

In Figure 14-8, I share with you three figure drawings done from life (using models in seated and reclining positions). I use not only the body of the figure, but also the background and even the shadows to help complete the *L*-shaped composition.

✔ In Figure 14-8a, I use the curtain backdrop as a part of my *L* shape, which leads the viewer's eyes toward my focal point — the seated figure. The curving body, legs, and forearm bring the composition to the ending shape, the cube. The negative space (the background in the upper right corner) balances the positive space (the curtain, the figure, the floor, and the box). I apply dark values to the figure's hair and swimsuit to create contrast and push the figure forward from the lighter background, but because

the value of the swimsuit isn't as dark as the hair, I still have room to play around with contrast by adding dark cast shadows under the buttocks. These shadows push the lower half of the figure forward.

✔ In cases where there is more negative space in comparison to the figure, I include shadows as part of the positive space (see Figure 14-8b); this inclusion also increases the number of negative shapes in the drawing. Even with the face in shadow, the focal point still rests at the top of the head, which has the darkest value as well as the greatest contrast with the wall. To bind the figure to the shadow, I make the values between the front of the face and the shadow the same. I use dark bold lines for the curving shape at the back of the neck to swing the *L* shape toward the dark thick lines of the figure's deltoids and arms.

✔ In Figure 14-8c, I draw narrow bars on the back of a chair, which support the weight of the figure's arms; from this vantage point, if it weren't for the three negative shapes between the bars and the arms, the arms would appear to float! I use my darkest value in the figure's hair to start the *L*-shaped composition, strengthen the primary focal point, and provide contrast to the white negative shapes around her. From there, the shadow values and shapes guide the viewer's eyes down the torso and through both arms. So other shapes don't detract from the primary focal point, I simplify the hands by fusing the right hand to the left forearm and leaving out the details of the fingers.

 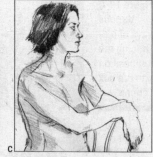

Figure 14-8: Applying the *L*-shaped composition to the live model.

a b c

Don't underestimate the usefulness of shadows. Shadows are not only values that help fill the composition but also fingerprints that uniquely describe the shape of the figure that casts them. Whenever you see cast shadows against the wall or on the floor while a figure is standing or seated, take full advantage and be sure to include them in your drawing. (Check out Chapter 3 for more about shadows.)

Establishing shots

Establishing shots are typically used in the first opening frame of *storyboards* (a sequence of same size framed images that tell a story from beginning to end) and comic books/graphic novels. In an *L*-shaped composition, the goal for the artist is to provide the viewers with enough information to present the setting scenario and introduce the key figures to the viewers for the first time.

In Figure 14-9, I draw two examples of establishing shots. The variety of *L*-shaped composition shots are so widespread, chances are you don't realize the number of times you

encounter them during a normal day. Unlike the other composition templates, you'll see that while the figure is a key focal point, the environment takes up much of the balance in composition. As a result, you end up with a psychological bonding between the two — the environment becomes a powerful influence in which the figures thrive.

✔ In Figure 14-9a, I illustrate a figure waiting inside the airport for the plane to dock at the gate. I balance the composition by grouping darker values along the left and bottom to form the *L* shape. Although the action of the composition is clearly happening within the figure who's passing time on his MP3 player, the interior of the empty airport and outside runway (environment) take up most of the space to complete the composition (the walls and floor). I balance the composition by adding the small gateway dock to the open space outside the window. Without it, the composition looks empty and lacks information. I have a little fun with positive and negative space by darkening the human figure and the foreground, thus introducing a secondary focal point (the vacant terminal gate outside) while maintaining the primary focal point (the figure). The vertical window bar compensates for the large amounts of white space in the center.

✔ In Figure 14-9b, the figure sitting at a café occupies much of the foreground to form the *L* shape. Nevertheless, that psychological connection still binds him to the public environment; viewers are left wanting to know what it is about his surrounding figures that's affecting him even though he seems to be passively drinking his coffee. This composition presents an interesting scenario in which the positive and negative boundaries aren't clearly defined.

While some people point out that the negative space is the wide open sky that starts above the bushes and tall buildings, I feel from a narrative vantage point that the figure in the foreground is dominant enough in size to stand alone as the positive shape, making the rest of the composition negative space (I throw in the ground as part of the positive space due to its dark value, which competes with the value of the figure's hair). The eyes and facial features are large enough that together they act as the focal point, even though the left side of the face is partially cropped out.

Figure 14-9:
Telling the story with the *L*-shaped composition.

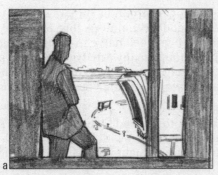 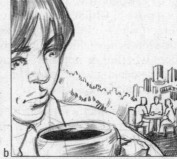

a b

Figure 14-9b presents a great opportunity to play around with the balance of the composition to embellish the narrative. What happens if you darken the value or add more detail to the group sitting at one of the two tables? Now the figures that seemed trivial are suddenly a part of the big picture (literally)!

The L-shaped composition in art history

Dutch painter Jan Vermeer used the *L*-shaped composition frequently in his paintings; the walls and interior décor frame the figures that go about their daily routine. In addition, Michelangelo posed some of his figures in an *L*-shaped composition in the Sistine Chapel. Other notable artists who favored the *L*-shaped composition include French painter Edouard Manet, Japanese wood block artist Utagawa Hiroshige, Dutch painter Rembrandt van Rijn, and French painter Nicolas Poussin.

Diagonal composition

Got a need for speed (and action)? Look no further than the diagonal composition template. This composition is one of my favorites; I constantly use it when drawing graphic novels. Our eyes are accustomed to seeing objects that run horizontally and perpendicularly (perhaps because we're used to seeing the flat horizon of the land and the vertical exteriors of buildings). But as soon as objects tilt at an angle, the neurons begin to fire and our senses are heightened. As you go over each drawing in the following sections, try to identify the diagonal line that runs through the frame.

Tilting the figure's position

Sometimes simply changing your point of view by tilting the figure positioning adds zing to your drawing experience. Check out Figure 14-10 to see what I mean:

✔ Take Figure 14-10a, for example, in which the figure is leaning against a chair covered with a blanket. The model's entire body forms a diagonal line across the bordered frame. I use the diagonal stretch folds of the blanket as part of the positive space because they mimic the same diagonal angles as the figure and balance out the negative space of the floor and wall.

Although a crowded drawing room makes moving around a bit awkward, if you're stuck with a long pose in which your angle of the model is uninteresting, ask your instructor or the person who's moderating the session if you can move to a different open seat where the view is more inspiring to you. Although many artists debate and philosophize about whether or not there's such a thing as a "bad model," I know one thing for sure: If you're dealing with poses that aren't worth forcing yourself to get inspired, all you need is a simple relocation.

✔ In Figure 14-10b, I select a scene from my creator-owned series titled *JAVA!* Here the main character, Java, is having a serious conversation with her side kick, La-Te, in the background. Rather than drawing the figure straight on as if I'm standing right in front of her face, I slightly tilt the camera angle so that the top of the torso is at a slight diagonal. Even with the open space I need to leave for the word balloons (and there are many), the diagonal composition helps retain the reader's attention.

Showing figures in action

In Figure 14-11, I illustrate figures in action. In Figure 14-11a, watch how the football player is running at a 45-degree angle while avoiding tackles. I establish the middle-ground character as my primary focal point by tilting the foreground figure on the right and the background figure on the left to guide the viewer's gaze toward the center of the frame (resulting in a sandwich-like composition). To increase the number of negative shapes and strengthen the composition, I make several body parts run off the edges of the frame.

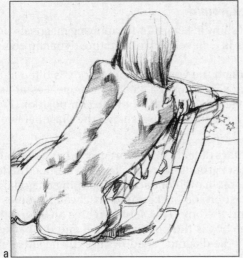

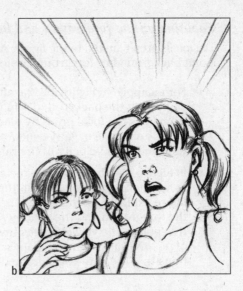

Figure 14-10: Tilting your point of view to find the diagonal composition.

In Figure 14-11b, a caped superhero shoots into the sky. In action shots such as these, the diagonal patterns that figures create stimulate tension and suspense. Although I have only one negative shape (the white background that surrounds the positive shape of the superhero), the exaggerated muscle forms help establish the superhero as the focal point.

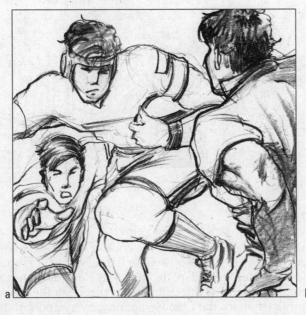

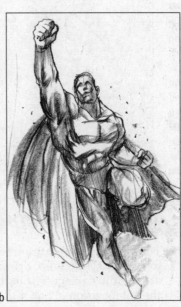

Figure 14-11: Applying action with diagonal composition.

When drawing figures in action, experiment with increasing the contrast; for example, add thicker lines or darker shadows within the body. When drawing multiple figures (as in Figure 14-11a), I add darker values to the focal point ball carrier so he stands out from the defenders in the background and foreground. In Figure 14-11b, I darken the shadows and shapes of the flying hero so he stands out from the light sky.

Focusing on the foreground and background

Diagonals aren't limited to the figure. As I show in Figure 14-12, applying diagonals to non-focal-point background or foreground objects is a clever way of creating dynamic compositions.

- ✔ For example, in Figure 14-12a, although the woman's upper body is tilted at a slight angle, I tilt the background rain that's pouring at a 45-degree angle. I establish the woman as the focal point by placing her at the center of the composition. Even though there's only one negative shape around the positive shape, the diagonal lines convey the speed and velocity of the rain.

- ✔ In Figure 14-12b, I angle the old artifact objects in the foreground at a diagonal angle in addition to the shadows in the background to create tension around the focal point figure exploring an old attic. The combination of dark, overlapping diagonal shapes in the foreground and the shadows cast on the background attic wall becomes a frame that guides the viewer's eyes toward the boy. This setup creates an interesting balance of positive and negative shapes; the boy is the positive shape, and the background sections that are in the light framed by the diagonal shadows are the negative shapes.

Figure 14-12:
Tilting objects in the background and foreground to find the diagonal composition.

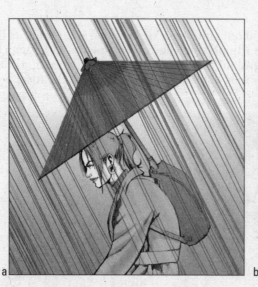

Yin-yang composition

The yin-yang composition template is probably one of the trickier composition templates to apply to your figure drawing because it gives you so much freedom to move and shift around the balance within the template. This template has a wavy diagonal line that divides the composition in half and circular shapes of opposite values placed in the top and bottom halves. The overall design template mimics the Chinese philosophy symbols of dark versus light. The challenge lies in making the figures or objects relate to each other from both sides of the composition. This template is probably used less than the previous three templates. In the following sections, I explain how to put together different yin-yang compositions.

Serene compositions

The yin-yang composition is useful in establishing evenly balanced positive and negative shapes that complement each other yet add two focal points on each side of the composition; this creates just enough contrast on both sides of the curving line to prevent the composition from being too quiet or boring. In Figure 14-13, observe how each focal figure is diminished in size in comparison to the large environment. Although each composition is divided in half, I balance it by adding figures or objects on each side of the composition to tie both sides together; examples include the couple at the beach in Figure 14-13a, in which the positive and negative shapes balance out evenly and share the spotlight, and the figure and sun in Figure 14-13b, in which the dark values of the mountain balance with the sky. I add the seated figure and the sun for the primary and secondary focal points.

In the life drawing of the horizontally reclining model, Figure 14-13c, I add a lamp to the upper left corner to balance the darker side, which has more details and darker objects. The curving shapes of the figure and the curtain balance out the composition. The white light stands out from the contrast of the dark curtains; the model's dark hair and the white background are the two focal points.

Figure 14-13: Drawing serene compositions with the yin-yang template.

Don't make the dividing line too horizontally parallel to the bottom of the border. The slight tilting of an object to break the symmetry makes a huge difference.

Studying composition in Japanese wood block prints

The wood block prints by Katsushika Hokusai (1760–1849) feature classic examples of composition that I always refer to. The way he takes complex three-dimensional nature and simplifies it into expressive lines, colors, and shapes is just mind-boggling. Hokusai was the first to coin the term *manga,* which literally means "whimsical pictures." For examples of his work, check out *Hokusai,* published by Phaidon Press. Fellow country-man Utagawa Hiroshige (1797–1858) is another excellent artist whose composition elements encompass the templates that I share with you in this chapter; one of my favorite collections on my bookshelf is *Meisho Edo Hyakkei (One Hundred Famous Views of Edo).*

Compositions with more than one figure

The yin-yang template is useful in not only composing background and foreground objects, but also in deciding how to compose two human figures in relationship to each other. Occasionally, drawing sessions feature two figures posing at the same time, and the yin-yang template helps you unify the two figures to create a single focal point. Check out Figure 14-14 for some examples:

✔ In Figure 14-14a, I draw two figures sitting close to each other. Instead of focusing on the details of their faces, I draw the female's left arm locking over and behind the male's left leg. I also use shadows to lead the viewer's eyes between both figures; the dark shadow behind the male's torso flows to the female's left arm, the shadow of the female's left arm carries the eye to the shadow of the male's left leg, and the shadow of the male's left leg directs the attention to the shadow of the female's right leg. Despite the fact that there are two figures, the intertwining shadow shapes establish the female as the focal point. I balance out the figures by combining them into a diamond-like shape at the center of the page, with the female body overlapping most of the male body.

✔ Sometimes you don't need to show complete figures to suggest that both exist. In Figure 14-14b, I draw a foreshortened view of a male figure and only the lower portion of a female figure. The male figure curves to the right to connect with the female figure; specifically, I angle his right arm upward to bring the viewer's eyes toward the female's left leg. The focal point then shifts back to the male's head from the female's right leg angling down.

I shade the male's lower right leg to balance the values of the male's dark hair and the cast shadows underneath his upper torso. The dark value of the right lower leg also helps unify the two figures by connecting to the female's right leg, and I get a nice triangular negative shape at the center of my composition. Although this negative shape isn't required for a balanced composition, it's certainly a bonus in that it simply gives the viewer's eyes a break between the complex overlapping shapes of the two figures. Finally, I use the values of the bathing suits to balance the composition between the male and female torso.

Going freestyle

As you gain experience using all four templates in the previous sections, you not only gain confidence but also learn to combine the templates together. These templates are just guides to help you map out your figures on paper more quickly. See how many different templates you can identify in Figure 14-15.

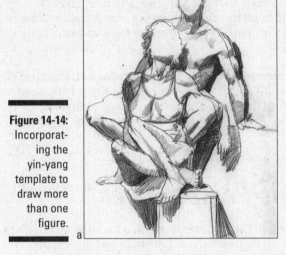

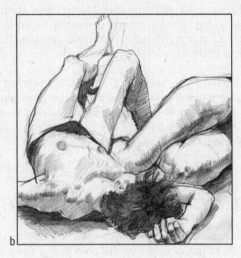

Figure 14-14: Incorporating the yin-yang template to draw more than one figure.

a

b

I use the shadows of the figure's forearm and legs and the figure's pose to establish the *L*-shape composition. The figure's left arm and torso form the diagonal composition. The combination of the upper right shadow and the lower shadows create the box composition. The same shadow on the upper right contrasts with the light lower left part of the frame to form the positive and negative spaces of the yin-yang composition. The figure's dark head and the white rectangle prop are the two focal points.

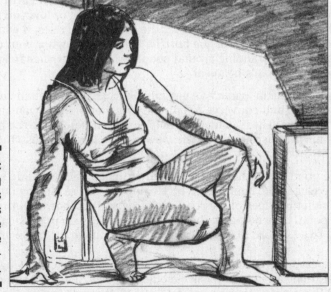

Figure 14-15: Using various templates to create a freestyle composition.

When mixing more than one template, add objects to the foreground, middle ground, and background so you have more positive and negative shapes to use in guiding the viewer's attention to the focal point. I also recommend using shadow shapes that are cast either on or around the figure.

When practicing using these templates, keep in mind that the purpose is to ultimately be able to say more with less guessing. Cramming in all the information you can possible draw doesn't mean you get an effective drawing; to the contrary, the drawing ends up being cluttered and too confusing to look at.

In Figure 14-15, the narrative of the drawing may be this: A teenager ventures into the attic where a giant bat suddenly flies out of nowhere! Thanks to the templates, I don't even need to draw what the bat looks like. Nor do I need to draw the entire attic. These templates allow me to get by with the bare minimum and let the viewer's imagination do the creative thinking. Oh yeah, a freelancer's dream!

Drawing People in Different Perspectives

Perspective is a method for creating the illusion of three dimensions on a two-dimensional piece of paper. It's a useful tool to not only push figures back and forth in space, but also enhance the composition of a drawing by helping you add multiple figures into the environment without relying on live models to use as a reference.

In the following sections, I show you how to draw three different types of perspective: one-point, two-point, and three-point. I also explain how you can convey different emotions in your drawings with these viewpoints. Here are some basic perspective terms and how they relate to drawing the figure:

✔ **Horizon line:** Also referred to as *eye level*. To determine the horizon line, simply look straight ahead. By the book, the horizon line is the point where the flat earth and empty sky appear to meet. A horizon line also indicates how high or low you're looking at the figure in relation to the ground. The higher the horizon line rises, the lower you are to the ground. In contrast, the lower the horizon level is, the higher your eye level is off the ground. When you're standing around people who are the same height, your horizon level is where the people's heads are.

✔ **Perspective guidelines:** These imaginary visual guidelines are drawn at an angle from the edges of a human figure and converge to either a single or multiple vanishing points along the horizon line. These guidelines help the artist determine the placement and size of the figure in relation to not only the viewer's eye level, but also the surrounding environment.

✔ **Vanishing point:** The point on the horizon line where the perspective guidelines (which measure the edges of the figure) converge. Suppose you're looking down a long road. The point at which the edges of the road converge and disappear on the horizon line is the vanishing point. Depending on the angle from which you're looking at the figure, you may need to add more than one vanishing point along the horizon line.

If you're learning to apply perspective to the figure (or if you're still new to drawing from life in general), I recommend learning away from the live model. Although nothing beats observing and studying from the real thing, trying to draw and establish all the perspective markings and guidelines for the entire figure is tedious and frustrating not only because the model moves, but also because you're forced to work at such a large scale. If your calculations are even the slightest bit off (such as not finding the precise vanishing points or guidelines that I demonstrate for you), you'll be thrown off.

If you're dying to draw from a live model, I recommend taking and applying perspective to foreshortened sections of the live model. Just make sure these sections are small enough to comfortably manage. Using perspective to draw the front and side planes of the three-quarter angle of the head from life is another excellent option.

One-point perspective

One-point perspective occurs when the figure is facing you and the outside edges of the figure converge in a single vanishing point along the horizon line. This is the way to present a three-dimensional figure in its simplest state.

Here's an exercise in drawing and applying one-point perspective to the figure:

1. **With your ruler, draw a horizon line across your drawing paper as shown in Figure 14-16a and draw an X at the center of the line.**

 The X is your vanishing point.

 Keep in mind that you're not always required to place the vanishing point at the center of the horizon line. This simply means that the figure's head is facing straight ahead. If the figure turns his head either to the left or to the right, the X moves to the left or to the right along the horizon line.

2. **Draw the 8-head proportion measuring line (see Chapter 9) while using the horizon line as your center point, as shown in Figure 14-16b.**

3. **In Figure 14-16c, sketch two perspective guidelines that start from the top and bottom of the proportion measuring stick and meet at the X.**

Figure 14-16:
Starting to draw the figure in one-point perspective.

a b c

4. **As shown in Figure 14-17a, block in the basic geometric shapes based on the proportion measuring stick you draw in Step 2.**

 See Chapter 9 for the basics on drawing these shapes.

5. **To draw more figures, use the same perspective guidelines to create smaller or larger figures.**

 Make sure the heads and feet of the additional figures touch the top and bottom of the perspective guidelines (see Figure 14-17b).

 As I show in Figure 14-17c, the figures I draw appear closer to the viewer as I set the guidelines farther apart. As I shrink the distance (making it narrower), the figures stand farther away. Set the guidelines as far apart or as close as you like.

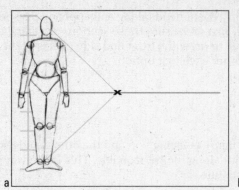
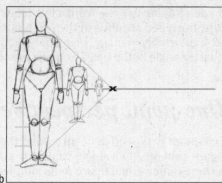

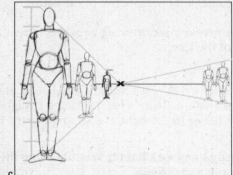

Figure 14-17:
Drawing
a figure in
one-point
perspective.

Two-point perspective

Next I add another figure to my drawing from the previous section, except she's standing at a three-quarter angle from my viewpoint. Two-point perspective provides more viewing flexibility where the side and front angles of the human figure are visible simultaneously. To draw this shift in position so it convincingly stands in the same environment as the figure facing the viewer, I add a second vanishing point along the horizon line. You now have two separate sets of guidelines converging rather than one.

Adding two-point perspective figures with figures drawn from a single one-point perspective strengthens and adds depth to the overall composition. After all, seeing a crowd of people all facing the same direction is unnatural.

Continuing from where you left off from the previous section on one-point perspective, follow these steps to draw the two-point perspective:

1. **Mark a new primary vanishing point on the left end of the horizon line and add a second vanishing point (tag it as point B), as shown in Figure 14-18a.**

 As I show in Figure 14-18a, I place a fair amount of distance between the two vanishing points.

2. **Draw an 8-head proportion measuring line where you want to place you figure (as shown in Figure 14-18b.)**

 Use the horizon lines to first establish the center mark of the proportion measuring stick before determining the rest of the proportion.

3. **From each vanishing point, draw two lines that connect to the top and bottom of the 8-head proportion measuring line (as shown in Figure 14-18c).**

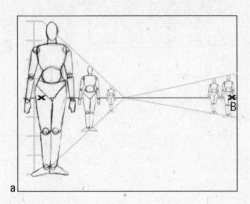

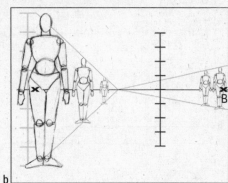

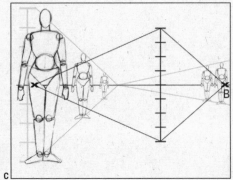

Figure 14-18:
Starting to
draw figures
in two-point
perspective.

4. **As shown in Figure 14-19a, lightly sketch the figure's oval head and rounded body shape at a three-quarter angle view.**

Rather than trying to draw the geometric shapes of the entire three-quarter view of the figure, it's easier to first roughly sketch in the figure's general shape, from the bottom of the neck down to the bottom of the feet.

The key in drawing the three-quarter view of the figure is to let the vanishing point on the side the figure is facing establish the angle of the shoulder line. In Figure 14-19a, the figure is facing left, so the top of the shoulder is angled to the vanishing point to the left.

5. **Draw the geometric figure over the general shape and erase the general shape guidelines (as shown in Figure 14-19b).**

Diminution applied on the side of the figure that faces away from the viewer is narrower than the side that faces the viewer. (I discuss diminution in Chapter 11.)

6. **Draw a couple more figures by using the two vanishing points, as shown in Figure 14-19c.**

You can either use the guidelines you use to draw the first figure in this section as you draw smaller figures, or you can draw a different set of guidelines to begin drawing figures standing at different locations.

One of the common mistakes beginners make is forgetting to align the center of the perspective measuring sticks of all the figures. The horizon line should be the center of each figure's 8-head proportion measuring line, regardless of how far apart the perspective guidelines are.

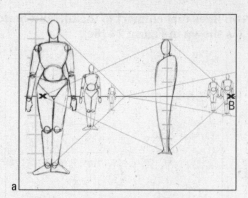

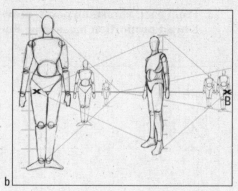

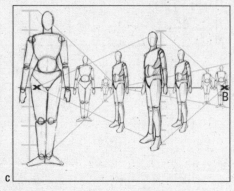

Figure 14-19: Completing drawing figures in two-point perspective.

Three-point perspective

Three-point perspective is the process of adding a third vanishing point either above or below the horizon line. These perspective shots are useful in drawing extreme up and down shots of the human figure.

In the following sections, I divide the three-point perspective into two categories: bird's-eye view and worm's-eye view. First, I show you how to draw a bird's-eye view in which the viewers are looking down at the figure from above. Next, I demonstrate the worm's-eye view in which the viewer is looking up at the figure from below (like looking up at the figure from a child's vantage point).

I recommend that students initially practice and become confident with drawing the one-point and two-point perspectives before taking on three-point perspectives.

Bird's-eye view

Bird's-eye view, which is commonly known as *aerial view,* gives the illusion that you're drawing the figure from high above the sky as if you were a bird. Try your hand at applying bird's-eye view on the human figure. When practicing drawing this perspective, I find it easier to first treat the body as a rectangle before breaking it down to the smaller detailed shapes of the body.

1. **Draw a horizon line and set up two vanishing points on each side (as shown in Figure 14-20a).**

 Mark the vanishing points as point 1 and point 2.

2. **Draw two perspective guidelines from each vanishing point to complete a thin rectangular shape, and label it ABCD (see Figure 14-20b).**

 Point A is the top of the rectangle, point B is the right, point C is the bottom, and point D is the left. This shape represents the top of the shoulders.

 While there's no set number of degrees you should set the angles apart from one another, the longer sides of the rectangle should be approximately twice as long as the shorter sides. This establishes the difference between the front edge of the torso and the side edges of the torso.

3. **From point C, draw a vertical guideline that measures four times the length of segment CB.**

 Divide the guideline into four even portions, labeled from E through H (see Figure 14-20c). This guideline isn't an 8-head proportion measuring line, but it helps you determine the height of the figure as well as the general sections of the body.

4. **Add a third vanishing point (as shown in Figure 14-20d) at point H.**

 I refer to this point as the "floater" vanishing point because it doesn't need to be attached to the horizon line the way the vanishing points in one- and two-point perspective do. Mark it as point 3.

 The farther you place point 3 from the horizon line, the less extreme the perspective of the figure's proportions will be.

Figure 14-20: Mapping out the guidelines and vanishing points for the bird's-eye view.

5. **From point 3, draw three guideline segments that attach with points B, C, and D (as shown in Figure 14-21a).**

 You trace one segment over the guideline CH.

6. **Draw guidelines that connect to points 1 and 2 from points E, F, and G (see Figure 14-21b).**

 You've now formed an elongated, partitioned rectangular cube. The partitions break down to the following general landmarks:

 - Point C is the shoulder and torso.
 - Point E is the hip.
 - Point F is the knees.
 - Point G is the feet.

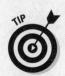

7. **For the head, either draw an oval or cube that aligns along the center of the body (as shown in Figure 14-21c).**

 Although I find it easier to use the oval for the head, a cube is handy when locating and drawing facial features. See Chapter 3 for basics on drawing a simple cube.

8. **As you see in Figure 14-21d, refine and draw the specific shapes of the figure.**

 Before sketching in the shapes, draw a straight center guideline down the front of the body that angles from the midpoint of segment CB down to point 3. Sketch in the shapes lightly before going back over them with darker lines to solidify them and align them with the center guideline.

 Sketch in the upper body (the torso and stomach), which runs down to point E. Then sketch in the hips and upper legs down to point F. When drawing the upper and lower legs, draw the center edge of the right leg (which is closer to the viewer) before completing the rest of the right leg and proceeding to the left leg. The front of the right foot aligns with point G; I draw a guideline from point 2 to align the front of the right foot with the left.

 Draw the right arm first before sketching in the left arm, which is partially hidden behind the left side of the body. By doing so, it's easier to gauge the length of the partially hidden left arm by aligning the bottom ends of the hands with point 2.

To lower the viewer's perspective, lower the horizon line. In Figure 14-22, I show some examples of lower vantage points.

Worm's-eye view

Worm's-eye view describes the view of the figure as if you're looking up at it from below. As the name suggests, you're looking at the figure from the viewpoint of a worm. The process for drawing a figure from the worm's-eye view is essentially the same as drawing the bird's-eye view (refer to the previous section). The main difference is that the floater is now above, as opposed to below, the horizon line.

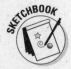

Don't rush through the following steps for drawing the worm's-eye view of the figure. Although the process is lengthy, take your time and be patient.

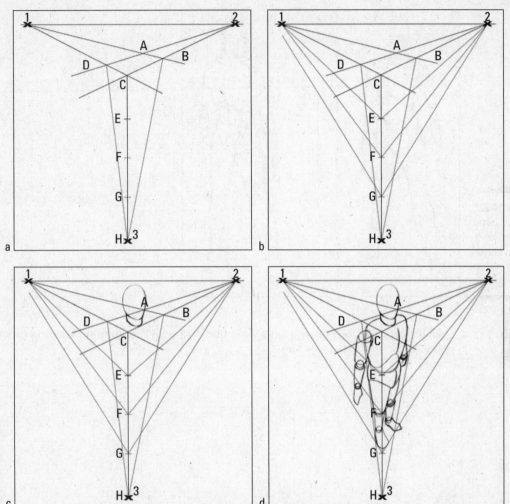

Figure 14-21:
Finishing the
bird's-eye
view.

1. **Draw the horizon line and two vanishing points (points 1 and 2) as you do in Step 1 for the bird's-eye view, and draw a vertical line through the center of the horizon line for segment AB, as shown in Figure 14-23a.**

 This line represents the height of the figure and determines the amount of perspective of the figure. Point A is above the horizon line, and point B is below the horizon line.

2. **Add two perspective guidelines from each vanishing point to points A and B (see Figure 14-23b).**

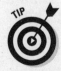

3. **Draw the floater over the horizon line and above point A (see Figure 14-23c).**

 To get a rectangular shape that has a narrow side plane for the body, place the floater slightly off to the middle.

4. **Draw two guidelines from the floater down to the guidelines that connect with point B, as shown in Figure 14-23d.**

Figure 14-22: Less extreme bird's-eye view of the figure.

a

b

Unless you want to draw a very wide body frame, I recommend keeping the width of the angle on the narrow side.

a

b

c

Figure 14-23: Starting to draw the worm's-eye view of the figure.

d

5. **Draw an oval or cylinder for the head and neck at point A (see Figure 14-24a).**

Because of the extreme foreshortening effect you get from this angle, you don't see much of the neck or lower portions of the head. In addition, you need to make the width of the head smaller the higher you make the height.

6. **Divide segment AB into 8 even division marks.**

It helps to first divide segment AB in half. Then divide each halved segment into even quarters.

7. **Use the division marks to sketch in the geometric shapes of the figure (see Figure 14-24b).**

The division marks are adjusted for the foreshortening of the shapes. They, therefore, *don't* correspond to the 8-head count that I describe in Chapter 8.

The divisions line up with the following body parts:

- 1: The bottom of the torso
- 2: The bottom side edge of the hip
- 3: The bottom of the groin
- 4: Above the knee sphere
- 5: Below the knee sphere
- 6: The midpoint of the lower leg
- 7: The ankle joint
- 8: Along the toes

I draw the right foot extending past the perspective line from point 1 to B.

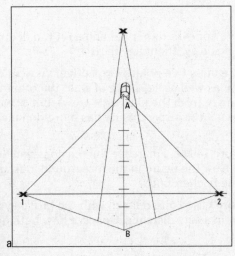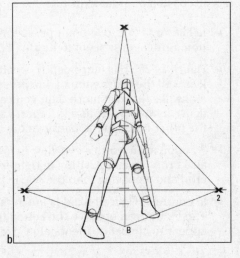

Figure 14-24: Worm's-eye view of the figure.

As with the bird's-eye view, if you want to lessen the "pinch" of the extreme perspective of the worm's-eye view, raise the floater higher and farther away from the horizon line. In most cases the floater needs to be so high off the paper that I recommend simply drawing angled lines based upon a rough idea of how high the floater might be. In Figure 14-25, I give you some examples of a less extreme perspective of the human figure.

Figure 14-25: Less extreme worm's-eye view of the figure.

Conveying the level of drama with the right perspective

Changing the perspective of a drawing can help you create and alleviate the drama of tension and suspense. In Figure 14-26, I draw and apply the four types of perspective from the previous sections to show a scenario in which two figures appear to be having either a serious discussion or argument.

✔ In Figure 14-26a, one-point perspective appears rather flat and a bit too neutral in emotion. Both figures seem to be simply posing without any flare.

✔ Figure 14-26b has more depth because of its two-point perspective. Viewers can at least tell the expression of one person as well as see more of what the other figure looks like (at least more than you can see from the plain side view). But because the figure in the foreground is larger, you get the sense that he has more dominance than the other figure in the background.

✔ By applying a worm's-eye view in Figure 14-26c, I increase the tension even further. I also crop the composition in tighter. Now the figure in the foreground looks more powerful and menacing than the one in the background.

✔ In contrast, Figure 14-26d is much more eased and relaxed with the bird's-eye view. The viewer can observe the action from a safe distance. Observe how both figures appear to almost be identical in size.

Figure 14-26: Using the four perspectives to increase and decrease tension.

Applying Perspective with Some Shortcuts

Although using perspective as a tool is powerful, it takes time to set up the vanishing point on the horizon line. In the following sections, I share some tips you can use to "fake" or create a convincing illusion of perspective without constantly drawing the guidelines from the vanishing point. These tips are great for drawing from life because applying these concepts is easier when you don't have to constantly bring out that six foot ruler to draw those guidelines!

Overlapping shapes, differences in size, and varying levels of value

Shapes that overlap, as well as shapes of different sizes and values, are handy in conveying different viewpoints, as you find out in the following sections. I use the figure in Figure 14-27a as my "control" sample to show how overlapping shapes, size, and value are used to push objects back and forth in space. In Figure 14-27b are three basic geometric shapes that represent the body shapes. I use them to explain the basic changes I make to the figure.

Figure 14-27:
I start with a regular profile of a seated view.

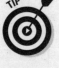

Overlapping shapes

When you draw from life, having the option of moving to a different angle is important. In Figure 14-28a, I show a three-quarter view in which shapes on the figure overlap and give the illusion of being closer to the viewer. By switching from the side view in Figure 14-27 to the view here, I see more overlapping shapes, such as the arms resting over the legs. (Check out an example of overlapping geometric shapes in Figure 14-28b.)

A shape that's closer to the front is slightly larger than the shape behind it. After I loosely sketch in where I want shapes to overlap one another, I draw the objects that are closer to the viewer first.

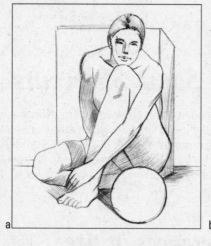

Figure 14-28:
Using overlapping shapes to create depth.

Larger versus smaller shapes

Using diminution (which I describe in Chapter 11), I give the illusion that body parts closer to the viewers are slightly larger than the parts that are farther away. (That's right; diminution doesn't apply only to figures in motion!) In Figure 14-29a, I slightly enlarge the left side of the figure while leaving the right side as is. (See the geometric example in Figure 14-29b, in which the circle is larger than the other shapes.)

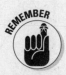

Be careful not to overdo the size relationships. If the differences between the sizes are too extreme, the overall proportions of the figure will either appear off or too contrived.

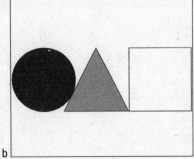

Figure 14-29:
Using size relationship to create depth.

Darker versus lighter shapes

Contrast is key when it comes to showing depth in your figure drawing. In general darker values bring objects closer while lighter objects recede back in space, but this isn't necessarily *always* the case. In Figure 14-30a, I darken smaller objects, such as the back of the chair, to help the larger object that's in front pop out more. Observe and compare both images in Figure 14-30 to see how I darken certain objects, such as the hair and chair of the model. (In Figure 14-30b, the shapes are the same size, but the dark circle looks as if it's closer to the viewer than the lighter shapes.)

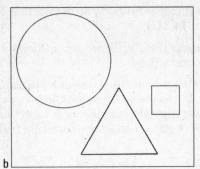

Figure 14-30:
Using contrast in color to push objects back and forth in space.

Drawing crowds the quick 'n' easy way

Although the thought of drawing a crowded public arena sends shivers down the spines of many, here's a neat trick that makes drawing crowds interesting. This technique, which I call "hanging heads," is a quick and fast way of drawing multiple figures without having to draw guidelines from multiple vanishing points.

1. **Draw a horizon line toward the top portion of your border frame.**

 Leave some room at the top (as I show in Figure 14-31a) so that you have plenty of room to draw the heads.

2. **Starting from large to small, draw an oval for each head along the top of the horizon line (as shown in Figure 14-31b).**

 The key to making the environment look realistic is to be sure to add various sizes of ovals for the heads to show depth in composition.

3. **Draw the general body structure that fits proportionately with the correct head (see Figure 14-31c).**

 As long as the bodies are proportionate to the head, all figures will appear to exist in a common setting.

I find that it helps to start out by drawing the figure closest to the viewer first. From there, it's easier to freehand the proportions of the other figures without drawing the 8-head proportion guideline. If, however, you plan to include the feet on some of the smaller figures, make sure each one truly measures 8 heads.

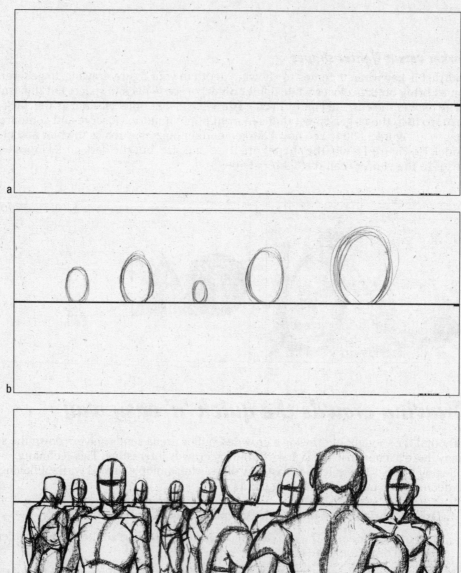

Figure 14-31:
Setting
up a high
horizon line
for drawing
crowds.

Part V
The Part of Tens

The 5th Wave By Rich Tennant

In this part . . .

It's come down to the finale — the Part of Tens is where I get to share short, useful tidbits of information and tips based on my own experience.

In this part, I list some places where you can observe and study the figure outside of your studio. It's important, especially if you're a full-time artist, not to get sucked into a "time capsule" where you shut yourself off from society. You need interaction and outside stimulation to keep your mind fresh, positive, and proactive. I also share tips on organizing, archiving, and presenting your work. Make sure you stay organized — especially if you decide to make drawing an ongoing hobby or profession. From my own experience, the more organized you are with your drawings, the better you feel about your current performance based on your past progress.

So don't whip out that farewell handkerchief yet! We still have more fun ahead of us!

Chapter 15

Ten Places to Study and Draw the Figure

A popular myth claims that as long as you're motivated and true to yourself, you don't need outside education or another artist's input to become accomplished in drawing the figure. But I don't buy it! Suppose you take your drawing equipment and the best-looking model to the top of a secluded mountain for ten intensive years of trying to learn on your own how to draw the figure. By the time you finally descend the mountain, a similarly motivated student who's been taught by the classic masters and found different places for studying and drawing still has the advantage. The reason is that the student at the bottom of the mountain is receiving education based on centuries of art training and discovery (compared to the meager ten years you spent learning on your own).

Like a five-star French restaurant that needs fresh raw ingredients to create a savory entrée, you need outside inspiration to help generate fresh ways to draw the figure. In this chapter, I present ten great places for studying and drawing the human form. (See Chapter 2 for details on what to pack when you're on the go.)

Don't worry if inspiration doesn't immediately light up like a light bulb on your first outing. You never know what switch will flip on or when, and you have to consider the very good chance that you're *already* being subconsciously inspired by your surroundings. Inspiration is a two-way street. While you actively seek it out, have patience knowing that it responds to your knocking on the door.

Continuing Education Classes and Art Schools

Naturally, a good place for studying and drawing the figure is a class on figure drawing. Chances are you're already in such a class; if you aren't enrolled but are interested in taking one of these classes, most academic institutions (both art and liberal arts) have continuing education courses that are generally held during the evenings to accommodate people with full-time jobs. Check out catalogs to find out whether your nearest schools offer figure-drawing courses.

If you're interested in pursuing a degree in art, find out what admissions requirements art schools have. Most, if not all, schools require a portfolio in addition to the standard SAT and letters of recommendation. Most schools have an application form you can download from their Web site. Here's a list of some of the current top contending schools in the United States:

- **Art Academy of Cincinnati, Ohio:** 800-323-5692; www.artacademy.edu
- **Art Center of Design, California:** 626-396-2373; www.artcenter.edu
- **Art Students League, New York:** 212-247-4510; www.artstudentsleague.org
- **Minneapolis College of Art and Design, Minnesota:** 800-874-MCAD; www.mcad.edu
- **Parsons School of Design, New York:** 212-229-7001; www.parsons.edu
- **Pratt Institute, New York:** 800-331-0834; www.pratt.edu
- **Rhode Island School of Design, Rhode Island:** 800-364-7472; www.risd.edu
- **School of the Art Institute of Chicago, Illinois:** 312-629-6100; www.saic.edu
- **School of Visual Arts, New York:** 888-220-5782; www.schoolofvisualarts.edu
- **University of the Arts, Pennsylvania:** 800-616-ARTS or 800-616-2787; www.uarts.edu

Open Sessions at Your Local Art Institution

Open figure-drawing sessions at art institutions are great, inexpensive, informal ways of honing your figure-drawing skills outside your studio. Most sessions don't provide any instructions, but a moderator usually keeps time of the poses and makes sure the sessions start and finish on time.

I find these sessions extremely beneficial and recommend that students at any skill level make it a priority to attend on a regular basis. If you can make it even once a week, you'll notice a huge improvement within a couple of months.

Art Galleries and Museums

When it comes to getting inspiration from other fine artists, art galleries and museums are an excellent resource. Galleries may not allow you to draw on-site, but most museums let the public draw from the original artwork on display for free. Be sure to contact them first!

The number of awesome art museums is too many to list here, but I do want to mention several of my favorites:

- **Metropolitan Museum of Art:** www.metmuseum.org
- **Whitney Museum of Art:** www.whitney.org
- **Frick Collection:** www.frick.org
- **Guggenheim Museum:** www.guggenheim.org
- **Art Institute of Chicago:** www.artic.edu

Don't forget to check out the Greek sculptures. Pay attention to how lighting around the room plays a role in casting the lights and darks on the figure.

Trains and Other Mass Transportation

Taking your mini-sketchbook to draw passengers on the train (or any mass transit for that matter) is an excellent idea. Many commuters I encounter on my way into the city are either asleep, reading, or intently listening to their MP3 players. They have one thing in common — they don't move much. Drawing people in public is fun and challenging. You encounter a wide range of characteristics that you can't easily find in drawing studios or textbooks.

When starting out, many students express concern that they're making a scene by looking at another person sitting across the aisle. Their worries are understandable. In those circumstances, I choose someone who's either sleeping or deeply engrossed in a book. In general, try to resist the natural tendency of looking up and down from your drawing (this usually blows your cover).

Bookstores and Coffee Shops

Bookstores and coffee shops are among my favorite places to take my students to draw. I combine these two categories because of the growing number of bookstores that also have coffee shops. I always find a lot of dynamic interaction between people who are talking, working on their laptops, or just reading books.

Needless to say, people do move around! But the objective of these sessions isn't to draw the figures accurately. If you know that your model is about to move, switch to a different "target" nearby, or pick objects in the background to draw.

Libraries

Similar to bookstores, libraries are another excellent place to sketch figures. One advantage a library has over bookstores is that libraries have more seats and tables to accommodate the public than bookstores do. If you're like me and don't enjoy sitting on the floor while drawing, going to the library is your best bet!

Parks

The park is a great place to practice drawing reclining and seated figures. If you pick nice summer-breeze weather, you're likely to find a lot of park goers and couples relaxing, sleeping, or resting on the grass. Time to pick out a nice bench in the shade and start people-watching. And don't worry — if the weather is nice, these folks aren't going anywhere soon, so you can draw for as long as you want!

Beaches

Beaches are great places to draw figures because the people around you are in swimsuits, which allow you to see most of the human figure. In addition, a lot of people are there to lie down and relax under the sun. Your models aren't going be moving anywhere in a hurry.

Make sure you bring (and wear or use) your sunglasses, umbrella, sunscreen, and other essentials. When drawing for a long period of time under the sun, you need to make sure you're prepared to face the environment.

Shopping Malls

Every town across America has a mall. Malls are close to most residences and have plenty of accommodations in case you need to take a break. You often see a lot of mothers with their children or babies. Although drawing children (especially the ones who can't seem to sit still) is a challenge, the mall is an excellent location.

Don't worry if you get in only the head or part of the clothing of the child. The goal is to become familiar with the children's characteristics and body languages. Any part you observe and record in your drawing is a good starting experience.

Public Squares

Included in the many places I like to visit to draw are public squares. They have plenty of benches to sit on while drawing as well as plenty of public activity. You don't need to be in a city to catch the public enjoying lunch or having a relaxing coffee break while sitting in an open-air public arena. Although people tend to move around more than they do in some of the other places I list in this chapter, public squares give you a good opportunity to see how figures gesture during conversations with one another.

Chapter 16

Ten Ways to Organize, Store, and Present Your Work

In This Chapter

▶ Organizing your work with ease

▶ Storing your work safely

▶ Presenting your work beautifully

After drawing many figures over and over again, your drawing pads start piling up. Make sure you spend some time here and there to organize, preserve, and present your artwork. In this chapter, I list ten handy methods you can use.

Date Your Drawings

In any typical drawing session, I come home with at least 30 to 50 figure drawings. If you draw on a weekly basis, that's up to 200 figure drawings in a month. Although letting those drawings accumulate in a pad until it fills is tempting, I recommend taking five minutes after each session to date the drawings before storing your pad. This way you can look at your drawings years from now and see your progress.

Dating your drawings really doesn't take much time, but you need to get into the habit (which is easier said than done). If you're like me and have trouble adopting this routine, use your commuting time to flip through those drawings and record the date (what else is there to do on the train?).

Do a Little Housecleaning

There's a saying that for every 20 drawings, if one is to your liking, you had a successful drawing session. If I had to save every single figure drawing I've done, I would need to rent a storage facility. Although keeping track of your drawings by dating them is important, take time every month to sort your drawings into these categories:

✔ Drawings you're proud of and that you want to either frame or post on your Web site (I discuss both options later in this chapter)

✔ Drawings you feel show promise or demonstrate progress but lack the "finished" quality they need for presentation

✔ Drawings that range in quality (these include the ones you did on your "off-drawing-days" and your "have-so-many-of-the-same-poses" drawings)

After you sort the drawings into these categories, go through the collection of drawings in the third category and toss away as many as you can.

"What?!" some of my students say. "But aren't we supposed to save all our artwork?" Many students feel personally attached to their work, which makes this task hard to do. Don't worry; distancing yourself from your work comes naturally over the course of completing many drawings. In the meantime, if you're mulling over which drawings to toss away, I recommend getting a friend or family member to decide for you. If you have a computer and scanner, you have the option of scanning those drawings before disposing them. This way you at least have a digital record that doesn't take any physical space (except the hard drive).

Digitally Archive the Work You Want to Keep

Digitally scan and save your drawings onto your computer hard drive, especially those images that fall into either of the first two categories from the previous section. One bonus is that the computer automatically records the date and time of the scan. The other added bonus is that all those images that get scanned in don't take up as much space as the originals do. You end up with a high-quality digital backup of your good pieces.

Make sure you scan the drawings at a setting of 300 dpi or higher resolution. Scan the work as color; most students make the mistake of selecting "grayscale" in order to save space on the hard drive. You get a better quality scan by using color even if your drawing is black and white.

Consider a Spray Fixative

If you work with charcoal or soft pencil, a spray fixative (available at art supply stores; see Chapter 2) helps reduce the amount of smearing that occurs while transporting your finished work. The versatility lies in the fact that you can go back and re-work your drawing even after applying the spray.

I'm a bit hesitant to use spray fixative because it's terrible for the environment and terrible for you when inhaled. I prefer to simply place a tracing paper sheet over the drawing. Because I work on a pad, the weight of the other papers keeps the tracing paper in place. However, if you decide to go along with the spraying option, make sure you use it outside or in a very well ventilated area.

If you try one of these sprays, test the surface of the paper before spraying the entire drawing. Simply spray a little on a corner to make sure the paper can withstand the spray.

Use Mylar Protective Sleeves

Because I do sketch commissions at conventions, I bring a pack of plastic protective Mylar sleeves to include with the final work. They're not exactly cheap. However, they're sturdy, transparent, and of archival quality (which means the drawing you store inside stays white and doesn't yellow over time). You can find plenty of places to purchase them online — try www.archivalmethods.com, www.bagsunlimited.com, and www.bcemylar.com. On your next trip to any comic book convention, you can also purchase them from the exhibiting vendors. These sleeves make excellent short-term storage.

If you're not up to paying extra for these sleeves, using manila envelopes is perfectly fine — just make sure you have some kind of cardboard backing so the corners of the drawing don't get damaged or bent.

Keep Your Work Safe from the Elements

A good rule of thumb is to make sure your large drawing pads are stored flat. Pads that are stored on surfaces that aren't flat bend or warp over even a short period of time. Nothing is more frustrating than trying to flatten a pile of warped drawing pads. Storing your large drawing pads on a flat surface ensures that they remain flat and are easier to access and flip through later down the road. If you plan on storing them in your basement, make sure they're off the floor where water can't get to them in case of flooding. I cover my pads with a plastic dropcloth to protect them from dust and moisture. If you have loose-leaf pages, get a large portfolio envelope to store them all together so they don't get separated and lost (see Chapter 2 for details on portfolios).

If you need to store your sketchbooks, I suggest either storing them in a large cardboard box or — even better — pack them on a bookshelf.

Display Your Work in Archival Mats and Frames

After you figure out which drawings you want to display in public, it's time to primp up the presentation. Consider getting an archival mat and a frame. Although most of the paper/presentation products you find in art stores are made from quality materials, make sure the mat is listed as "Archival Quality" (which usually means acid-free). Cheaper materials yellow over time and, even worse, potentially ruin any artwork the mat comes in contact with.

Although many art stores sell mat-cutting tools, I don't recommend buying and using them unless you're experienced. Cutting mats is actually quite time consuming and takes a bit of practice. When you factor in the time you spend on cutting and the money you waste on botched cutting jobs, your efforts may not be worth the money you're saving. You can find plenty of pre-cut and measured mat frames on sale at arts and craft stores.

Don't feel you have to splurge on frames. I find that simple, clear plastic frames at stationery stores do just fine. My rule of thumb is "simple is best" when it comes to presenting your drawings in public. Don't be overwhelmed by all those expensive frames with the frills and elegant decorations along the edges. You're showing off your artwork — not the frame! As long as the mat that comes in contact with your drawing is acid-free, your work is all figured out!

Strut Your Stuff with a Portfolio

Portfolios are protective carrying cases with clear sleeves inside to store your work (see Chapter 2). They don't have to be large or fancy. Itoya makes decent and affordable presentation portfolio cases. Pratt also does a good job with its higher-quality display products.

I recommend having at least two sizes of portfolio cases:

- ✔ Use the larger one (20 x 26 inches) to show to art directors and colleagues, and to simply transport your large pad to figure-drawing session.

- ✔ Carry the smaller one (4 x 5 inches) in your coat pocket or backpack. This size is easy to carry around, so you can quickly whip out drawings to show your art friends. I use it to store smaller reproductions of my artwork.

After a period of usage, the see-through plastic display sheets start to wear down. Replace old sheets, or even the entire portfolio case, depending on how much you use it to strut your stuff.

Set Up an Online Portfolio

It used to be so complicated to set up a personal Web site . . . but not anymore! Many inexpensive programs were designed for first-timers. Having a Web site gallery for your drawings is a great way of promoting your work to the public.

If you're busy and don't have the time to create and personalize your Web site, at least consider opening a blog site. Many professional artists use free blogging sites, such as www.blogspot.com, to constantly keep their fans updated with new work (for reference, my blogspot is www.kensukeokabayashi.blogspot.com). Web sites that are easy to personalize, such as www.facebook.com, www.myspace.com, and www.flickr.com, are also excellent sites for posting your work. For Macintosh users, Mobile Me and iLife are fun and user-friendly applications that you can use to share, post, and update your artwork. For examples, check out my Web sites at www.piggybackstudios.com and www.javacomics.com.

One reason I like having this option is that online image sizes are small enough that I can have as many pieces on display as I like (whereas I'm limited with the number of pages in my physical portfolio).

When you post your work on the Web, anyone can easily copy and save one of your images to his or her computer desktop. Popular Web browsers allow users to simply click and drag the desired image to their desktops. If you're worried about having your artwork downloaded and being misused, don't post it. Legally, an image is copyrighted by you as soon as it's visually documented. However, you have little chance of winning a copyright infringement battle unless you actually send in a copyright registration application along with a hardcopy of your work to the Library of Congress. For more information about registering your copyrighted work, visit www.copyright.gov.

Create Promotional Items Featuring Your Work

Need another venue to promote your figure drawings to your friends and colleagues? Consider creating business cards and postcards with your artwork either in the foreground or as sections in the background. Online printers, such as www.modernpostcard.com or www.copycraft.com, offer quality printing services for affordable prices.

If you don't want to spend money upfront to create printed promotional material, online companies such as www.cafepress.com offer print-on-demand services where they handle the ordering, shipping, and billing. All you need to do is digitally supply the images you want printed and let them do the rest.

Index

BUSINESS, CAREERS & PERSONAL FINANCE

Accounting For Dummies, 4th Edition*
978-0-470-24600-9

Bookkeeping Workbook For Dummies†
978-0-470-16983-4

Commodities For Dummies
978-0-470-04928-0

Doing Business in China For Dummies
978-0-470-04929-7

E-Mail Marketing For Dummies
978-0-470-19087-6

Job Interviews For Dummies, 3rd Edition*†
978-0-470-17748-8

Personal Finance Workbook For Dummies*†
978-0-470-09933-9

Real Estate License Exams For Dummies
978-0-7645-7623-2

Six Sigma For Dummies
978-0-7645-6798-8

Small Business Kit For Dummies,
2nd Edition*†
978-0-7645-5984-6

Telephone Sales For Dummies
978-0-470-16836-3

BUSINESS PRODUCTIVITY & MICROSOFT OFFICE

Access 2007 For Dummies
978-0-470-03649-5

Excel 2007 For Dummies
978-0-470-03737-9

Office 2007 For Dummies
978-0-470-00923-9

Outlook 2007 For Dummies
978-0-470-03830-7

PowerPoint 2007 For Dummies
978-0-470-04059-1

Project 2007 For Dummies
978-0-470-03651-8

QuickBooks 2008 For Dummies
978-0-470-18470-7

Quicken 2008 For Dummies
978-0-470-17473-9

Salesforce.com For Dummies, 2nd Edition
978-0-470-04893-1

Word 2007 For Dummies
978-0-470-03658-7

EDUCATION, HISTORY, REFERENCE & TEST PREPARATION

African American History For Dummies
978-0-7645-5469-8

Algebra For Dummies
978-0-7645-5325-7

Algebra Workbook For Dummies
978-0-7645-8467-1

Art History For Dummies
978-0-470-09910-0

ASVAB For Dummies, 2nd Edition
978-0-470-10671-6

British Military History For Dummies
978-0-470-03213-8

Calculus For Dummies
978-0-7645-2498-1

Canadian History For Dummies, 2nd Edition
978-0-470-83656-9

Geometry Workbook For Dummies
978-0-471-79940-5

The SAT I For Dummies, 6th Edition
978-0-7645-7193-0

Series 7 Exam For Dummies
978-0-470-09932-2

World History For Dummies
978-0-7645-5242-7

FOOD, HOME, GARDEN, HOBBIES & HOME

Bridge For Dummies, 2nd Edition
978-0-471-92426-5

Coin Collecting For Dummies, 2nd Edition
978-0-470-22275-1

Cooking Basics For Dummies, 3rd Edition
978-0-7645-7206-7

Drawing For Dummies
978-0-7645-5476-6

Etiquette For Dummies, 2nd Edition
978-0-470-10672-3

Gardening Basics For Dummies*†
978-0-470-03749-2

Knitting Patterns For Dummies
978-0-470-04556-5

Living Gluten-Free For Dummies†
978-0-471-77383-2

Painting Do-It-Yourself For Dummies
978-0-470-17533-0

HEALTH, SELF HELP, PARENTING & PETS

Anger Management For Dummies
978-0-470-03715-7

Anxiety & Depression Workbook
For Dummies
978-0-7645-9793-0

Dieting For Dummies, 2nd Edition
978-0-7645-4149-0

Dog Training For Dummies, 2nd Edition
978-0-7645-8418-3

Horseback Riding For Dummies
978-0-470-09719-9

Infertility For Dummies†
978-0-470-11518-3

Meditation For Dummies with CD-ROM,
2nd Edition
978-0-471-77774-8

Post-Traumatic Stress Disorder
For Dummies
978-0-470-04922-8

Puppies For Dummies, 2nd Edition
978-0-470-03717-1

Thyroid For Dummies, 2nd Edition†
978-0-471-78755-6

Type 1 Diabetes For Dummies*†
978-0-470-17811-9

WILEY

INTERNET & DIGITAL MEDIA

AdWords For Dummies
978-0-470-15252-2

Blogging For Dummies, 2nd Edition
978-0-470-23017-6

**Digital Photography All-in-One
Desk Reference For Dummies, 3rd Edition**
978-0-470-03743-0

**Digital Photography For Dummies,
5th Edition**
978-0-7645-9802-9

**Digital SLR Cameras & Photography
For Dummies, 2nd Edition**
978-0-470-14927-0

**eBay Business All-in-One Desk Reference
For Dummies**
978-0-7645-8438-1

eBay For Dummies, 5th Edition*
978-0-470-04529-9

eBay Listings That Sell For Dummies
978-0-471-78912-3

Facebook For Dummies
978-0-470-26273-3

The Internet For Dummies, 11th Edition
978-0-470-12174-0

**Investing Online For Dummies,
5th Edition**
978-0-7645-8456-5

iPod & iTunes For Dummies, 5th Edition
978-0-470-17474-6

MySpace For Dummies
978-0-470-09529-4

Podcasting For Dummies
978-0-471-74898-4

**Search Engine Optimization
For Dummies, 2nd Edition**
978-0-471-97998-2

Second Life For Dummies
978-0-470-18025-9

**Starting an eBay Business For Dummies,
3rd Edition†**
978-0-470-14924-9

GRAPHICS, DESIGN & WEB DEVELOPMENT

**Adobe Creative Suite 3 Design Premium
All-in-One Desk Reference For Dummies**
978-0-470-11724-8

**Adobe Web Suite CS3 All-in-One Desk
Reference For Dummies**
978-0-470-12099-6

AutoCAD 2008 For Dummies
978-0-470-11650-0

**Building a Web Site For Dummies,
3rd Edition**
978-0-470-14928-7

**Creating Web Pages All-in-One Desk
Reference For Dummies, 3rd Edition**
978-0-470-09629-1

**Creating Web Pages For Dummies,
8th Edition**
978-0-470-08030-6

Dreamweaver CS3 For Dummies
978-0-470-11490-2

Flash CS3 For Dummies
978-0-470-12100-9

Google SketchUp For Dummies
978-0-470-13744-4

InDesign CS3 For Dummies
978-0-470-11865-8

**Photoshop CS3 All-in-One
Desk Reference For Dummies**
978-0-470-11195-6

Photoshop CS3 For Dummies
978-0-470-11193-2

Photoshop Elements 5 For Dummies
978-0-470-09810-3

SolidWorks For Dummies
978-0-7645-9555-4

Visio 2007 For Dummies
978-0-470-08983-5

Web Design For Dummies, 2nd Edition
978-0-471-78117-2

Web Sites Do-It-Yourself For Dummies
978-0-470-16903-2

Web Stores Do-It-Yourself For Dummies
978-0-470-17443-2

LANGUAGES, RELIGION & SPIRITUALITY

Arabic For Dummies
978-0-471-77270-5

Chinese For Dummies, Audio Set
978-0-470-12766-7

French For Dummies
978-0-7645-5193-2

German For Dummies
978-0-7645-5195-6

Hebrew For Dummies
978-0-7645-5489-6

Ingles Para Dummies
978-0-7645-5427-8

Italian For Dummies, Audio Set
978-0-470-09586-7

Italian Verbs For Dummies
978-0-471-77389-4

Japanese For Dummies
978-0-7645-5429-2

Latin For Dummies
978-0-7645-5431-5

Portuguese For Dummies
978-0-471-78738-9

Russian For Dummies
978-0-471-78001-4

Spanish Phrases For Dummies
978-0-7645-7204-3

Spanish For Dummies
978-0-7645-5194-9

Spanish For Dummies, Audio Set
978-0-470-09585-0

The Bible For Dummies
978-0-7645-5296-0

Catholicism For Dummies
978-0-7645-5391-2

The Historical Jesus For Dummies
978-0-470-16785-4

Islam For Dummies
978-0-7645-5503-9

**Spirituality For Dummies,
2nd Edition**
978-0-470-19142-2

NETWORKING AND PROGRAMMING

ASP.NET 3.5 For Dummies
978-0-470-19592-5

C# 2008 For Dummies
978-0-470-19109-5

Hacking For Dummies, 2nd Edition
978-0-470-05235-8

Home Networking For Dummies, 4th Edition
978-0-470-11806-1

Java For Dummies, 4th Edition
978-0-470-08716-9

**Microsoft® SQL Server™ 2008 All-in-One
Desk Reference For Dummies**
978-0-470-17954-3

**Networking All-in-One Desk Reference
For Dummies, 2nd Edition**
978-0-7645-9939-2

**Networking For Dummies,
8th Edition**
978-0-470-05620-2

SharePoint 2007 For Dummies
978-0-470-09941-4

**Wireless Home Networking
For Dummies, 2nd Edition**
978-0-471-74940-0